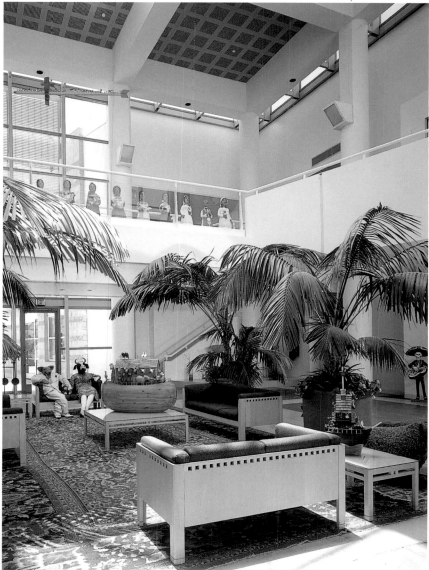

The Extraordinary
in the Ordinary

Textiles and Objects from the
Collections of Lloyd Cotsen
and the Neutrogena Corporation

Works in Cloth, Ceramic, Wood,
Metal, Straw, and Paper from
Cultures throughout the World

The Extraordinary
in the Ordinary

Textiles and Objects from the
Collections of Lloyd Cotsen
and the Neutrogena Corporation

Works in Cloth, Ceramic, Wood,
Metal, Straw, and Paper from
Cultures throughout the World

Edited by Mary Hunt Kahlenberg

Photography by Pat Pollard

Harry N. Abrams, Inc., Publishers,
in association with the
Museum of International Folk Art,
Museum of New Mexico

Editor: Adele Westbrook
Designer: Judith Hudson

Front Cover: Detail of Man's Cloth. Ewe People,
Eastern Ghana, c. 1940

Back Cover: Corn Dolly. England, 1980s.

Endpapers: Carved Doors. Artist: Marvin Oliver.
Quinault/Isleta Pueblo, Washington, U.S.A., c. 1984

Page 1: Plate 1 The Neutrogena Corporation Lobby
in Los Angeles. 1995. (Photo: Lois Frank)

Page 2: Detail of a Tunic (?). Wari culture, Peru,
A.D. 600–900.

Library of Congress Cataloging-in-Publication Data
The extraordinary in the ordinary ; textiles and objects
from the collections of Lloyd Cotsen and the Neutrogena
Corporation : works in cloth, ceramic, wood, metal, straw,
and paper from cultures throughout the world / edited by
Mary Hunt Kahlenberg ; photography by Pat Pollard.
 p. cm.
 Catalog of the Neutrogena Collection at the Museum
 of International Folk Art in Santa Fe, N.M.
 Includes bibliographical references and index.
 ISBN 0-8109-1396-8 (clothbound). —
 ISBN 0-8109-2798-5 (mus. pbk.)
 1. Decorative arts—Exhibitions. 2. Cotsen, Lloyd E.—
 Art collections—Exhibitions. 3. Neutrogena Corporation
 —Art collections—Exhibitions. 4. Decorative arts—
 Private collections—New Mexico—Santa Fe—Exhibi-
 tions. 5. Decorative Arts—New Mexico—Santa Fe—
 Exhibitions. 6. Museum of International Folk Art (N.M.)
 —Exhibitions. I. Kahlenberg, Mary Hunt. II. Museum
 of International Folk Art (N.M.)
NK535.C68E88 1998
745'.074789'56—DC21 98–10601

Printed and bound in Japan

 Harry N. Abrams, Inc.
100 Fifth Avenue
New York, N.Y. 10011
www.abramsbooks.com

Contents

Contributors

CHARLENE CERNY is Director of the Museum of International Folk Art, Museum of New Mexico, in Santa Fe, New Mexico.

LLOYD COTSEN is the former Chairman of the Neutrogena Corporation and the person responsible for the formation of the Collection.

MARY HUNT KAHLENBERG is the former Curator of the Textile and Costume Department at the Los Angeles County Museum of Art, and has worked with Mr. Cotsen to build the art collection at The Neutrogena Corporation. She is a Research Associate with the Museum of New Mexico and owner of the Textile Arts Gallery in Santa Fe.

REIKO MOCHINAGA BRANDON is Curator of Textiles at the Honolulu Academy of Arts and author of several catalogs on Japanese textiles and art, including *Spirit and Symbol: The Japanese New Year.*

JOHN VOLLMER is an authority on Chinese costume and textiles and author of several publications in the field, including *Decoding Dragons: Status Garments in Ch'ing Dynasty China.*

JOHN T. WERTIME is a writer, dealer, and lecturer in the field of Oriental rug and textile art, residing in Arlington, Virginia.

IRENE A. BIERMAN is Director of the Von Grunebaum Center of Near Eastern Studies and Associate Professor of Art History at the University of California, Los Angeles.

ENID SCHILDKROUT is Chair of the Department of Anthropology and Curator of African Ethnology at the American Museum of Natural History in New York. Most recently, she co-authored *African Reflections: Art from Northeastern Zaire* with Curtis A. Keim, due in 1998.

MONNI ADAMS is an Associate in Ethnology and Art at the Peabody Museum, Harvard University, Cambridge, Massachusetts.

WILLIAM J CONKLIN is a well-known architect, author of numerous articles on Pre-Columbian textiles and architecture, and a Research Associate at the Textile Museum in Washington, D.C.

BARBARA MAULDIN is Curator of Latin American Folk Art at the Museum of International Folk Art, Museum of New Mexico.

SANDI FOX is the former Curator for quilts at the Los Angeles County Museum of Art. She has organized a dozen ground-breaking exhibitions of nineteenth-century quilts, and has published extensively in that field.

TAMARA J. TJARDES is Curator of the Neutrogena Collection at the Museum of International Folk Art, Museum of New Mexico, and served as manuscript coordinator for this publication.

The following people wrote individual captions in the areas of their expertise: Garrett Solyom, John Guy, Tamara J. Tjardes, Nora Fisher, Judy Chiba Smith, Doran H. Ross, Stan Neptune, and Joan Lester.

Preface

BY CHARLENE CERNY

Director, Museum of International Folk Art

This volume, fittingly, begins with an essay by Lloyd Cotsen – providing a glimpse into the remarkable mind and intellect of a man who not only has achieved great success in the corporate world, but in the contemplation of "things." He reveals himself as someone who has engaged in a lifelong dialogue with the world of objects, and in diligent search of products of the human hand that silently challenge, please, astound, awe, and confound him. Yet, in the end, it is the sharing of this Collection that has brought him the greatest pleasure – first, to his staff in the Neutrogena Corporate offices, and now to the readers of this book and the fortunate visitors to the Museum of International Folk Art who are able to experience the Collection firsthand. For his generosity of spirit, we are most grateful. The wonderful gift of the Neutrogena Collection was donated in concert with Neutrogena Corporation, where Jeffrey M. Nugent, Worldwide President, proved to be an invaluable advocate. Mr. Cotsen and the Cotsen Family Foundation also contributed generous financial support, assuring that the Neutrogena Collection will remain publicly accessible and well-preserved for the benefit of future generations.

The contributing authors to this publication likewise deserve our thanks for producing such compelling and far-reaching analyses of the Collection's holdings. Under the very able supervision of editor Mary Hunt Kahlenberg, they have willingly shared their considerable expertise and their enthusiasm for the material. Their rich and rewarding essays remind us all that every piece of folk art begins in the mind's eye of an artist who is uniquely situated in a particular moment in time and in place. Tamara Tjardes, Curator of the Neutrogena Collection, must be cited for her outstanding efforts as the publication's coordinator. We gratefully acknowledge the efforts of Abrams publisher Paul Gottlieb, our editor at Harry N. Abrams, Inc., Adele Westbrook, and designer Judith Hudson, all of whom proved to be diligent partners in the realization of this publication. We salute their considerable talents.

The Neutrogena Collection is now preserved in a new, dedicated wing of the Museum of International Folk Art. This came about thanks to the effort of a number of community-minded individuals who lobbied

hard for state support. For a $1.6 million state appropriation to build the Neutrogena Wing we are especially grateful to New Mexico Governor Gary Johnson and First Lady Dee Johnson and the Forty-Second Legislature, especially Representatives Max Coll and Ben Lujan, and State Senators Liz Stefanics, Tom Wray, Billy McKibben and Tom Rutherford. Others who provided steadfast support were Willard Lewis, Jr., Betty Lattanza, Andrew Nagen, Sherry Sandlin, Laurel Seth, Sue Ann Snyder, Colleen Kelly, and especially Nancy and Richard Bloch. Also central to this effort were the then-current members of the Museum of New Mexico Board of Regents: Dr. Kent Jacobs, Nancy Bloch, Paul D. Rainbird, Susan M. Mayer, Earle Powell Bursum, and Catherine Stetson. Without the efforts of Museum of New Mexico director Thomas A. Livesay and deputy director Marsha Jackson, this project would not have become a reality. Three crucial and generous gifts made timely construction of the Wing possible. We are very grateful to the trustees of the International Folk Art Foundation, Robert L. Clarke, David C. Davenport, Jr., Willard Lewis, Jr., Bernard Lopez, Steve McDowell, Darby McQuade, and Ramona Sakiestewa; to Louisa Sarofim and The Brown Foundation, and to the principals of Davis & Associates, Mark W. Brennand, and E.B. (Bud) Watson, Jr., for these contributions and for their faith in this project.

We also owe a debt of gratitude to individual, foundation and corporate donors to the Neutrogena Wing and its endowment fund. As of this writing (February 1, 1998), they are: Charles and Harriet Alders, Elisabeth and James Alley, Charmay B. Allred, Wood and Anne Arnold, BGK Properties, Inc., Nancy and Richard Bloch in honor of Lloyd and Margit Cotsen, Joan Bokum, Barbara Bowes, Holm and Earle Powell Bursum, Mr. and Mrs. Robert L. Clarke, William Wallace Cunningham, Lowell and Rosalind Doherty, Folk Art Committee of the Museum of New Mexico Foundation in memory of Dolores "Dode" Kenney, Robert and Nancy Gardner, Phyllis and Edward Gladden, Hallmark Corporate Foundation, Amanda Haralson and Thomas A. Livesay, Julia Hunkins, Mary Hunt Kahlenberg and Robert T. Coffland, Mickey Inbody, Dr. and Mrs. Kent Jacobs, Linda and Richard Johnson, Sid and Maryanne Jones, Ellen Kenney, Nancy Kenney, Rob Althouse, Christina Kenney, M.D., Anthony Nesburn, David Kenney, Nancy L. Kenney, Kathleen Peters, Gerald Peters III, Doris F. Rosen and Ronald P. Klein, Mr. and Mrs. Allan H. Kurtzman, Bruce and Mary-Anne Larsen, Terry and Joe Learny, Dasha and Maury Lewin, Margot and Robert Linton, Marjorie R. Levi, Nancy Looney, Bill and Suzy MacGillivray, Stanley

and Linda Marcus, Tom and Jane O'Toole, Neutrogena Alumni, Jerome and Sharen Popkin, Frances Robinson in memory of Finlay Robinson, Alan and Ann Rolley, Jacqueline and Richard Schmeal, Nancy Schwanfelder, Abe and Marian Silver, Catherine Stetson, Joan and Cliff Vernick, Mike and Linda Waterman, Sol and Marsha Wiener, and two anonymous donors. Special thanks are due to the Maggie Ryan Trust for the lead gift and to the Museum of New Mexico Foundation Board of Trustees for making this gift a reality.

Lastly, this project could not have succeeded without the help and determination of many colleagues at the Museum of New Mexico. At the Museum of International Folk Art, special thanks are owed Nora Fisher, Curator of Textiles & Costumes, Paul Smutko, Collections Manager, and Deborah Garcia, Registrar, for their tireless efforts in the transfer, cataloguing, and re-housing of the Collection, as well as for the physical planning of the open storage area. They were ably assisted by former Neutrogena corporate curator Karyn Zarubica and by dedicated volunteers too numerous to name here, but to whom we express our kind appreciation. In addition, curators Judith Chiba Smith, Frank Korom, and Barbara Mauldin contributed immeasurably to interpretation of the Collection while Joyce Ice, Jacqueline Duke and Ken Segura ably assisted with overall project management. Chris Vitagliano and Darla Purdy provided much-needed support in the area of word processing.

Lloyd Cotsen and Mary Hunt Kahlenberg served as co-curators for the inaugural exhibition, and must be congratulated for envisioning such a superb and visually stunning installation, designed by Marc Treib. Kerry Boyd, John Tinker, Linda Gegick, Nancy Allen, Tom McCarthy and the entire Exhibitions Unit of the Museum of New Mexico, and Cathryn Keller, Director of Marketing and Communication, as well as Claire Munzenrider and Renee Jolly of the Conservation Unit, deserve our most sincere gratitude for their professional expertise and their extraordinary effort on behalf of the Neutrogena Wing inaugural installation. Jeff Hayward of People, Places & Design Research brought valuable insight to the project as a consultant for the interactive storage area.

Those responsible for the design, construction and project management of the beautiful new Neutrogena Wing include Ron Burton and Willard Eastman of DWL Architects and Planners, Inc. of New Mexico, Lester Swindle, Michael Bodelson, Mac Rodriguez, John Alejandro, of the State of New Mexico Property Control Division, and Robert Watson, Dub Saunders, and John Hamburg of Davis and Associates, Inc. General Contractors. We commend them for all of their fine attention and hard work!

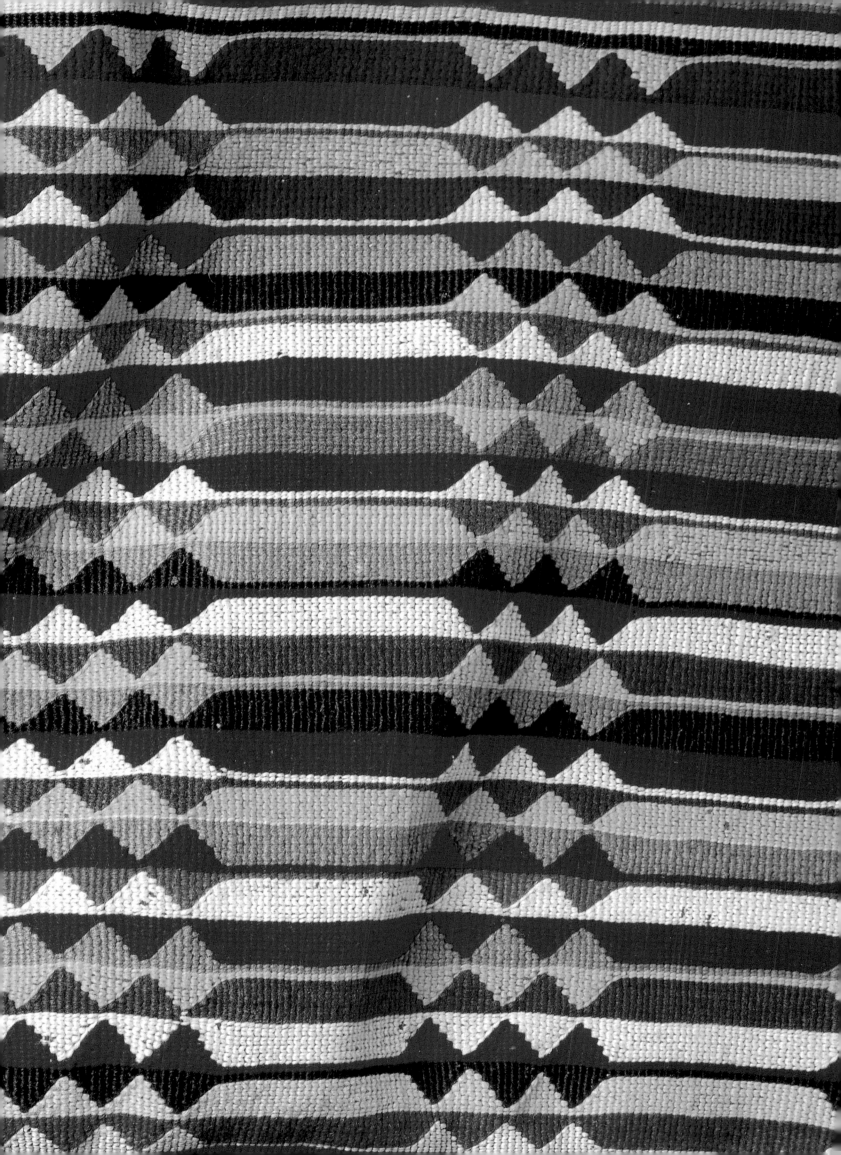

CHAPTER 1
Looking Behind My Eye

BY LLOYD COTSEN

People often ask me how I could amass such a Collection over the course of thirty-five years and then give it away. I do not think I am giving it away – instead I feel I am sharing it with more people. Yes, every object, every textile, every piece of folk art was personally selected by me. And yes, each has a special place in my heart. It matters not whether these pieces were made by a famous artist or an unidentified craftsman. To me, they speak volumes. . . they speak of extraordinary beauty with an inner capacity to bring a sense of joy and fulfillment to my eye and to my heart.

PLATE 2 (detail of plate 254)
Blanket (*Beeldléí*)
Navajo People
Arizona or New Mexico, U.S.A.

All of these objects have one thing *in common:* they strike some emotional bell within me; in short, they just appeal to me. They appeal to my curiosity, to the thrill of discovery of the extraordinary in the ordinary, to my sense of humor, to my love of pattern, color, and texture, to my search for the beauty in form and simplicity, and to my perceiving beauty in and behind the object.

I hope this Collection similarly will also speak to a viewer in a language that is both personal and moving. This book represents a culmination (or an intermission) in a thirty-five-year-long passion, which is represented by approximately 2,500 objects that now can be seen at the Neutrogena Wing of the Museum of International Folk Art in Santa Fe, New Mexico.

When did I first catch the "collecting" bug? Probably the first indication of my inner penchant for collecting goes as far back as when I was about ten years old and was picking matchbook covers off the streets, off the tables, and out of hotels! Later adolescent manifestations of this "bug" exhibited themselves in my stamp collecting mania and my collection of baseball cards. However, the first sign of serious collecting surfaced during my Naval tour of duty in Asia. I encountered Japan and was blown away by the elegance, simplicity, and form of Japanese objects and landscapes created both for beauty and for utility.

Sometime after 1960, when I had settled down with a family and a home, I began collecting in earnest, starting off with Japanese *Ikebana* baskets, a few of which are represented in this Collection. To me, they were sculptured with one purpose, fashioned in one material (bamboo), in one tradition, and under one aesthetic, but with infinite creative variations.

As my circumstances improved, after starting to work at Neutrogena (which then was a small family affair), my acquisitive instincts more than kept pace. My only constraint was the lack of space.

However, Neutrogena's growth and expansion into new facilities provided me with both the floor space and wall space for my hungry eye. From 1970 – and especially after 1980, with the advent of new corporate headquarters – I shifted my collecting from a personal object-oriented nature to a slightly more focused corporate nature, particularly in terms of textiles and folk art objects.

As the leader of the Company, I considered it part of my responsibility to create an environment in which people could take pride, and where they could find enjoyment while working amid a plenitude of beautiful objects, objects they may not have had the opportunity to encounter close-up in their own lives.

So, many Neutrogena work spaces became the repository for my collecting efforts. We tried by means of

color, by use of space, by easy accessibility, and by humor, to make the private offices and public areas appealing to one's curiosity and impart a sense of pride to the individuals working there. And, it all seemed to succeed.

For instance, there was one office chock full of alligators, which amused the medical director who worked there. In a long hall leading to production planning, there were Japanese textiles and folk arts hung to challenge the eyes of the passerby. Another corridor had African textiles hung or draped as if being sold in a bazaar. Large graphic posters decorated the manufacturing spaces.

When Neutrogena was acquired by Johnson & Johnson in 1994, one of the stipulations of the final agreement was that the Collection should be placed in a museum that would exhibit it as a whole, so as to reflect my own aesthetics and objectives, as well as the Neutrogena philosophy.

But why in Santa Fe? The Museum of International Folk Art was seen as the best museum to both understand what the Collection was about and to exhibit it as an entity. I personally felt a strong bond with the Girard Foundation Collection of folk art that had been collected from all over the world. The Neutrogena Collection could feel right at home next to all of this, in terms of color, sense of humor, creativeness, and curiosity.

Guided by my curatorial advisor, Mary Hunt Kahlenberg, we accepted the Museum's gracious proposal and offered them their choice of objects from some 6,000 items, half of which belonged to Johnson & Johnson and half of which belonged to me personally.

Today, at the Museum, you can see the Collection as chosen by the Museum and exhibited in the Neutrogena Wing and its interactive storage area. The strengths of this Collection complement those of the Museum – together they make Santa Fe a destination for the study of textiles and folk art. But hopefully, its wide-ranging scope also makes it an attraction for the casual viewer, who can find something to both delight and amuse the eye and the mind.

What kind of objects interested me? Early in my collecting career, I was fascinated by the history of objects and I was curious as to their usage in the culture from which they came.

For example, there is an ancient Coptic textile (plate 3), possibly an altar covering. Looking at it, I am struck by the strength of the figures, their gaze, and their dress…all from a period over 600 years ago. Even more intriguing is the surrounding script which looks familiar but, to date, has defied all efforts by scholars to translate it. We may ask how far back does this tradition go? Perhaps the style of dress can give us a clue.

PLATE 3 (detail of plate 150)

Hanging

Egypt or Ethiopia

Fourteenth to Sixteenth centuries (?)

Wool embroidery on plain weave cotton

20½ x 95" (52 x 241 cm.)

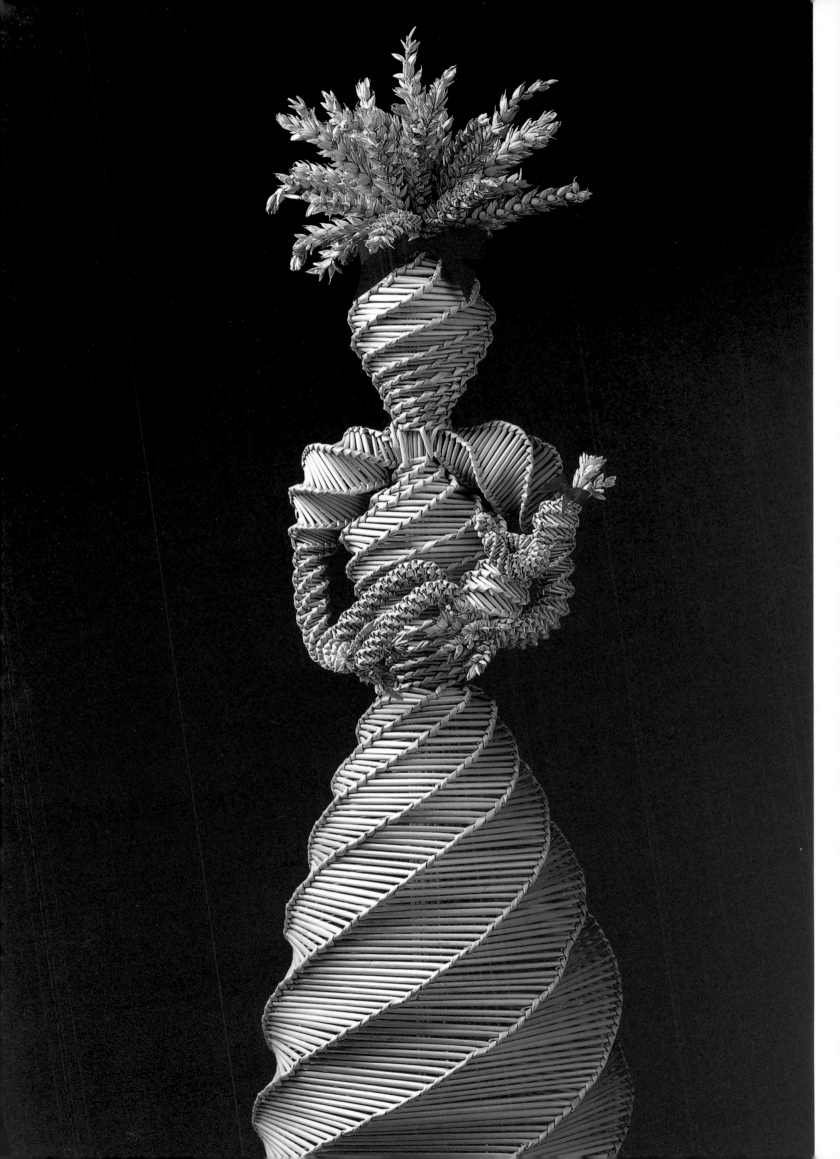

PLATE 4
Corn Dolly
England. 1980s
Wheat Straw
24½ x 7½" (62.3 x 19 cm.)

PLATE 5
Warrior Jacket
Japan. 1800–1825
Resist-dyed linen, cotton collar,
and metal chain interior
31 x 43" (78.8 x 109.3 cm.)

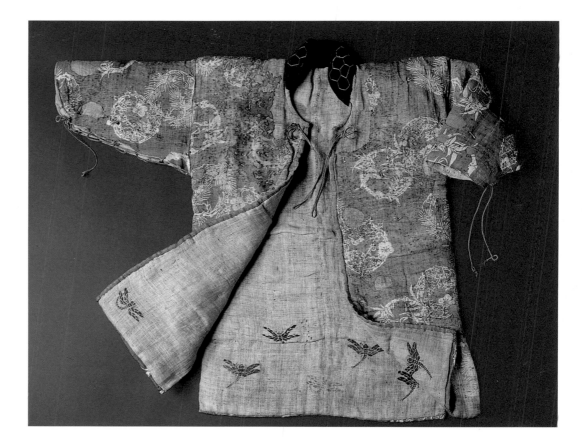

Then, there is a rather contemporary-made English corn dolly figure (plate 4), whose roots harken back to early European matriarchal societies where agriculture and the fertility of crops were supposedly assured by the sacrifices of such symbols. One can imagine that long ago the corn dollies so offered were not so very different from this one made today. In fact, the tradition of corn dollies is still strongly embedded in the folk memories and folk art of people from northern Sweden to the shores of the Mediterranean, wherever agriculture replaced the hunting/fishing societies of prehistory. Many such examples can be seen in this Collection. However, it is really the widespread survival of this tradition that continues to excite my curiosity and imagination.

From another culture comes the Japanese samurai jacket and gloves (plates 5 and 6). The iron mail protective lining of the jacket is covered by a sky blue outer resist-dyed fabric . . . but . . . on the inside lining is his personal mark, that of a dragonfly, whose agility and fleetness are characteristics of the samurai. What feats of derring-do had its owner undertaken? Despite the heavy armored garment, he is alert and moves unexpectedly.

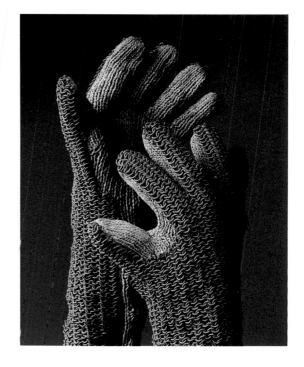

PLATE 6
Warrior Gloves
Japan. 1800–1825
Chain mail and cotton knit
12 x 5" (30.5 x 12.8 cm.)

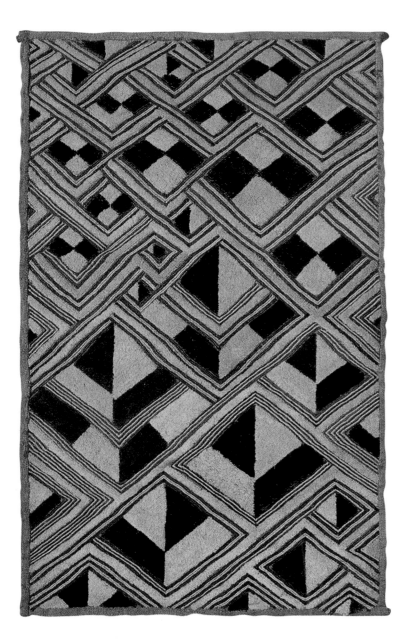

PLATE 7
Ceremonial Panel
Shoowa People, Kuba group
Congo, Africa. 1925–1950
Cut pile and linear embroidery on
plain weave raffia palm
25 x 15½" (63.5 x 39.4 cm.)

PLATE 8
Ceremonial Skirt Panel
Babunda People
Congo, Africa. Nineteenth century
Weft patterning and embroidery on
plain weave raffia palm
42 x 24½" (106.6 x 62.3 cm.)

Color and pattern were certainly features that attracted my eye and appealed to my sense of design. The elaborate patterns of African raffia pile as seen in the Kuba and Babunda textiles (plates 7 and 8) display an infinite range of sophisticated patterns, woven into textured mats from the simplest of materials, grass. In fact, these panels first attracted me because they reminded me of the traditional Japanese raked sand garden patterns. Since it would have been difficult to collect Japanese sand gardens, these textiles seemed the next best thing! Yet the Kuba sensibility had much in common with its distant Japanese counterpart. Interestingly, both used only one material to create the design: Kuba used grass, Japanese used sand, neither of which limited the variety of patterns.

However, the impact of pattern and design is not found only in textiles but also in posters of this century, as evidenced by the striking *Zipper Poster* (plate 9), or the very small *Russian Revolution Ad* (plate 10) of men running.

PLATE 9
Poster
Artist: Pierre Gauchat
Switzerland. 1945–1946
Lithograph; Ink on paper
51½ x 37½" (130.8 x 95.3 cm.)

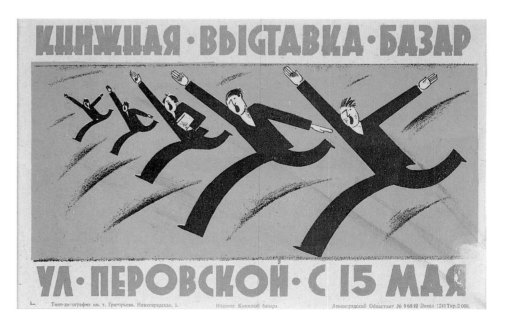

PLATE 10
Poster
Attributed to Vladimir Vasilevich Lebedev
Former Soviet Union. 1930s
Lithograph; Ink on paper
7¼ x 11¾" (18.4 x 29.8 cm.)
(Translation: Book Exhibition and Bazaar.
May 15. Perovskoi St.)

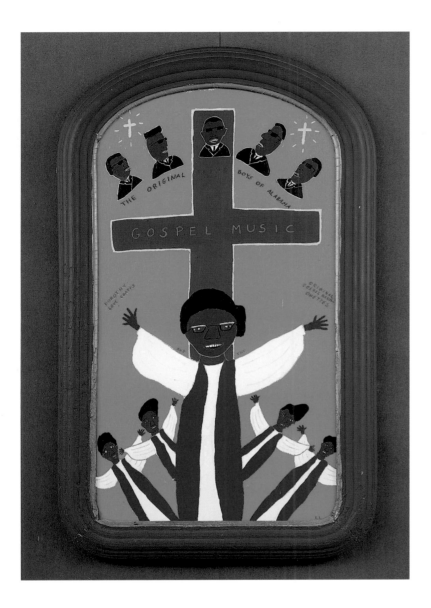

PLATE 11
Painting "Gospel Music"
Artist: Laura Levine
United States of America. 1991
Acrylic on masonite and plaster
37 x 23½" (93.9 x 59.6 cm.)

In terms of color, how can one not be taken with the exuberance and energy in a contemporary American Naive Painting (plate 11), expressing the energy of a gospel experience? Both the colors and the design make me want to stand up and stretch out my hands to the picture!

In a different part of the world, colorful Japanese outer garments (plate 12) are created out of reused, cut-up scraps in a sophisticated blending. Consistent with a society that venerates age, here is an expression of and a reverence for worn materials that were never discarded but were reused time and time again, with the greatest of aesthetic effect. The custom could be compared to the rural American tradition of rag rugs. While this coat may not be quite the multicolored robe that Joseph wore, it is a country product all the same, with both a wonderful texture and use of colors. I hope you agree with me that its overall effect is quite sophisticated, despite its popular origins. And even in unexpected places, such as painted or printed patterns on early Japanese paper garments (plate 13), there are great examples of the extraordinary to be found in the ordinary.

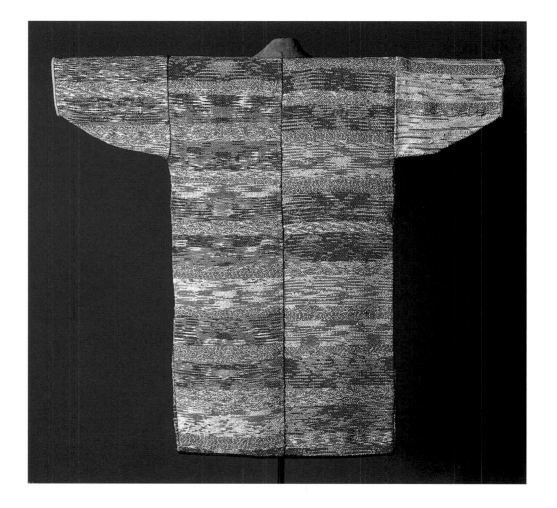

PLATE 12
Jacket (*Haori*)
Yamagata Prefecture, Japan
1875–1900
Plain weave cotton, silk, linen
24½ x 43" (62.3 x 109.3 cm.)

PLATE 13
Paper Vest of Prints
Prints designed by Masaiyuta
(a.k.a. Seto Suiseki)
Japan. 1820–1830
Wood block prints on paper
34½ x 23½" (87.6 x 59.7 cm.)

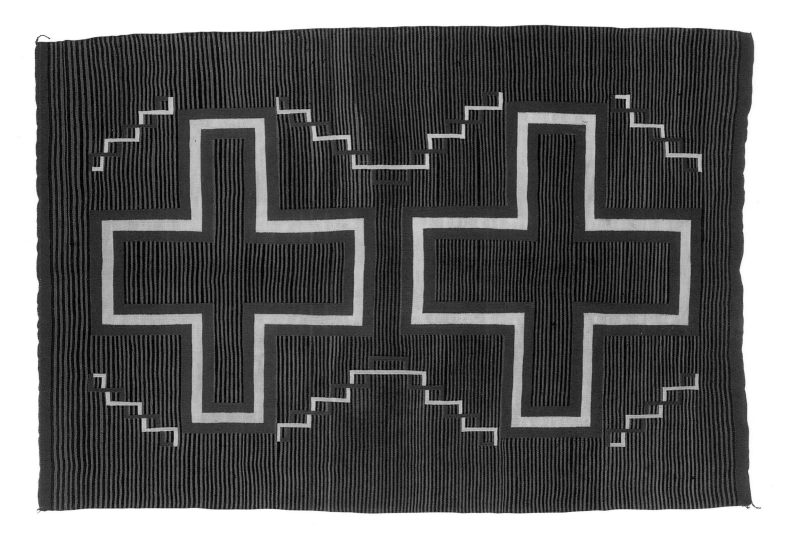

The same could be said for the Navajo Indian blanket (plate 14), with its contrasting bold red crosses on a bed of purple and black stripes. It literally stopped me in my tracks. On a more subtle note, there is the older Indian blanket (plate 2), with its striped and wavy line patterns featuring one of the earliest uses of figurative elements.

As my eye wandered over the creations of man and woman worldwide, I was always attracted to the simple…made beautiful…or the beauty and elegance in simplicity. Just look at the Spanish wrought-iron door bolt (plate 15) shaped into a spitting dragon – perhaps symbolically to keep out the unwanted. No excess of materials here.

In searching for patterns, I was taken with a large Japanese *Ema* (plate 16), found crated in storage. It was far from its original resting place in some temple where it had memorialized a battle and represented a gift by some notable. For me, there was fascination in the contrast of the hurly-burly commotion on the boat as it rode the very patternesque waves into a battle. Chaos and order… and patterns and antipatterns…elements that are still with us to this day.

PLATE 14
Blanket, (*Beeldléí*), Hubbell Style
Navajo People
Arizona or New Mexico, U.S.A. 1890s
Tapestry; commercial "Germantown" wool
84 x 57" (213.3 x 144.8 cm.)

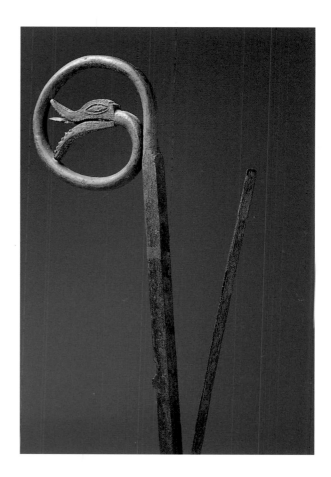

PLATE 15
Lock Bolt
Spain. Nineteenth century
Iron
25½ x 12½ x 1" (64.8 x 31.8 x 2.5 cm.)

PLATE 16
Shrine Plaque (*Ema*)
"Shoki, The Demon Queller"
Artist: Kano Asanobu
Japan. c. 1830
Paint on wood
52 x 66" (132 x 167.6 cm.)

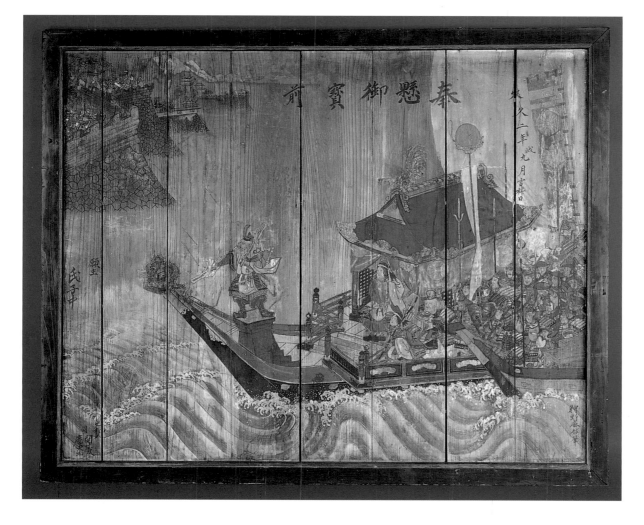

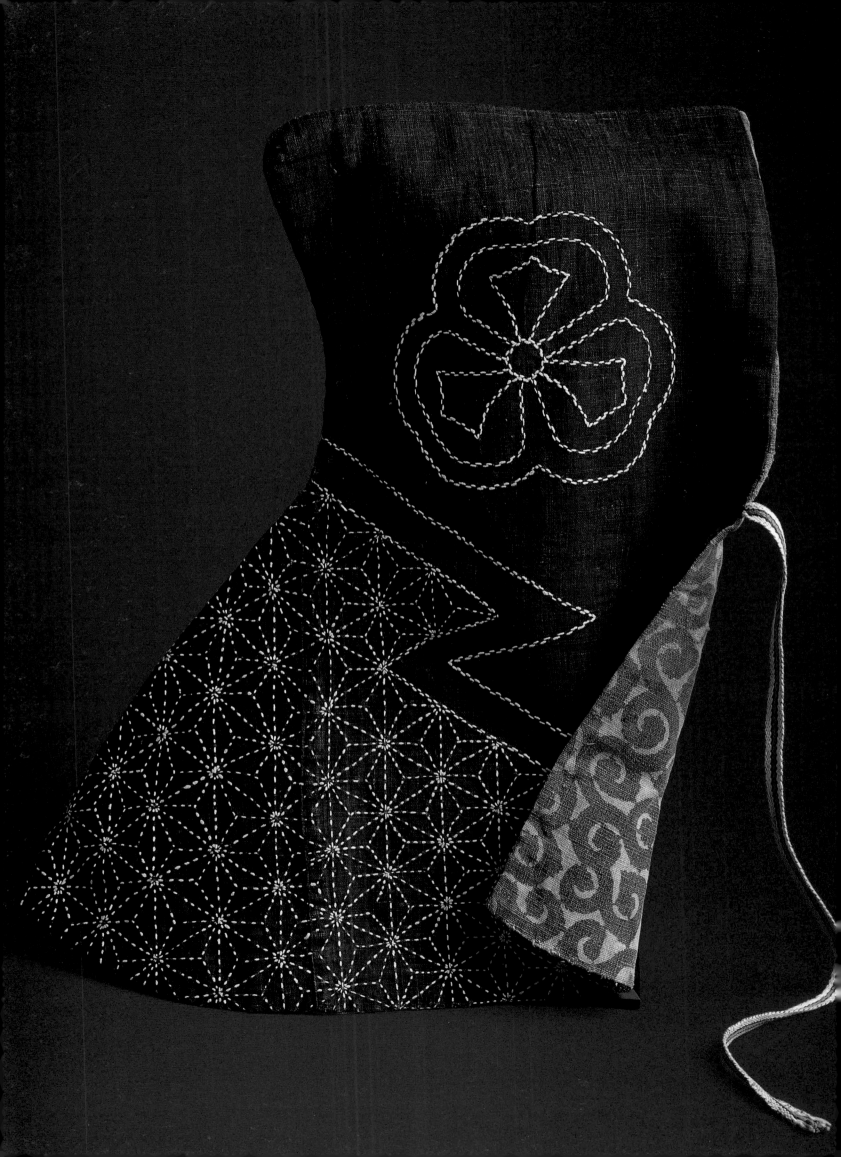

PLATE 17

Woman's Hat

Japan. 1875–1900

Cotton quilting (*sashiko*) on plain

weave cotton

19 x 17¾" (48.3 x 45 cm.)

PLATE 18

Hats

Left: Philippines

Front: Kuba People, Congo

Back: Lega People, Congo

Late Nineteenth to Twentieth century

Plaited; various grasses

Approx.: 5" h x 14½" diam (12.7 cm. h x

36.8 cm. diam)

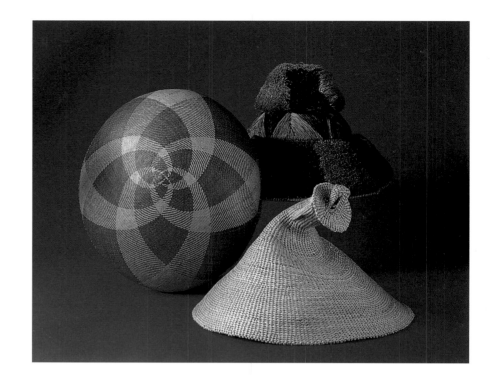

Among my favorite groups of objects, typifying for me the extraordinary-in-the-ordinary are the Japanese blue and white stitched work clothes (plate 17) of rural workers and toilers in the field. Here, old worn materials are also venerated and reused. Colors are minimal: just blue and white with white stitching that goes from simple to complex to achieve the desired design. The overall effect is an expression of love and beauty where age is respected both in the society and in the material. Each garment represents a passage of time…and its users, something akin to a time line of rural life. The patina of age imparts an extra dimension of human continuity.

More elaborate but still simple in form, although complex in technique, is a group of fiber hats from different cultures (plate 18), ranging from Africa to the Philippines – these apparently simple shapes convey an image of elegance and form. Contrast this with a Kenya arm shield (plate 19) that is also simple but quite brutal in its visual impact. Not only would it protect its owner; but its design is like a weapon that hits you between the eyes…psychological warfare for all to see and feel.

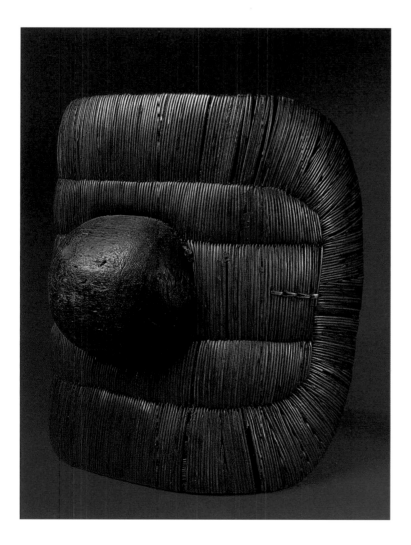

PLATE 19

Shield

Tutsi People. Rwanda, Africa

Twentieth century

Wood and various grasses

13 x 13" (33 x 33 cm.)

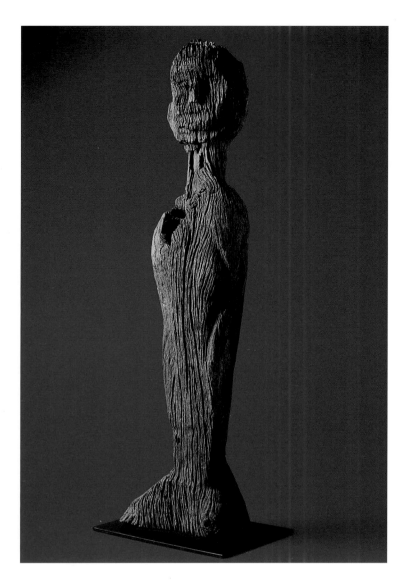

But we also live in a spatial world; creativity in three dimensions is represented by the timeworn wooden figure (plate 20) from Borneo. It conveys to me a feeling of deep mystery and power, heightened for my own sensitivities by its very erosion. Or, moving to another continent, I find a different feeling in the small African *Djenni* clay figure (plate 21) with its hands pressed so hard to its head. Small it may be, but what pain or intense feeling it expresses.

On a different note, there is a tallow-rendering vat with the heads of cows in relief (plate 22). This vat was reputedly used by an Indiana farmer to melt down the beef tallow. I saw this vat in a store in Venice, California and I had to have it. Why? Because my first product at Neutrogena was soap, made from *beef* tallow. One could say, symbolically, from this tank cascaded a virtual cornucopia of objects, now seen as the Neutrogena Collection!

While collecting, I tried not to get too serious. So, scattered throughout the Collection are nuggets or globs of humorous objects or, at least, objects that tickled my funny bone. Hopefully, they will tickle those of other people as well. This Collection should bring a smile to the face of the visitor, as it did to the Neutrogena employees.

PLATE 20
Ancestral Statue (*Hampatong*)
Dayak (?) People
Borneo, Indonesia. Nineteenth century (?)
Wood. 38½ x 10½ x 6½"
(97.8 x 26.6 x 16.5 cm.)

PLATE 21
Female Figure
Mali, Africa
Fourteenth century
Clay
8¾ x 4¼" (22.3 x 10.8 cm.)

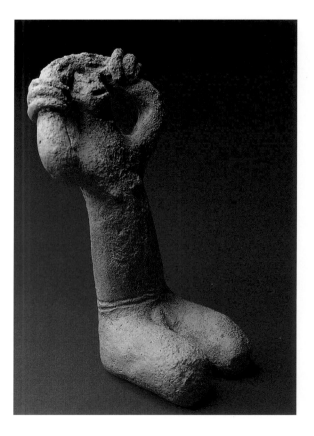

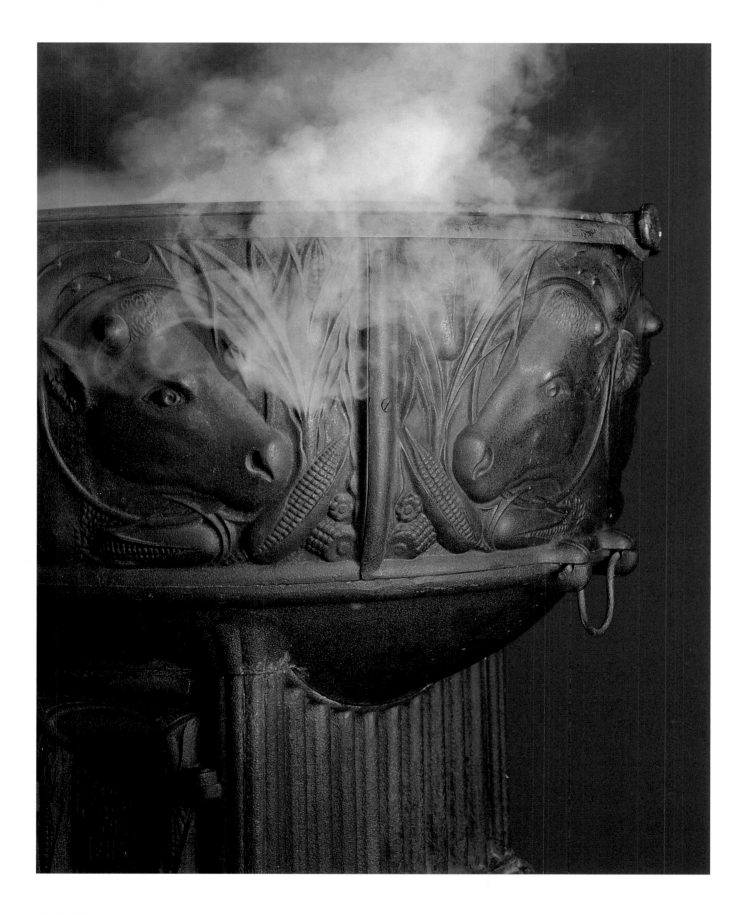

PLATE 22
Rendering Pot
United Kingdom
Nineteenth century (?)
Iron. 36 x 38½ x 43"
(91.4 x 97.8 x 109.3 cm.)

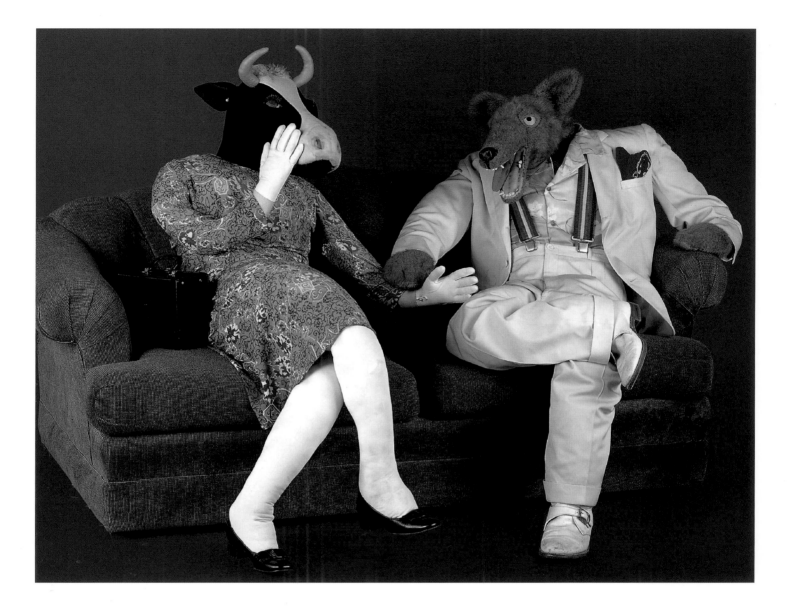

For instance, in the lobby of Neutrogena were the figures of "Ray" and "Elsie" (plate 23), a wolf and a prim old maid cow, an odd couple, if there ever was one. But all during the year they changed poses, interlocked limbs, and greeted all visitors who entered the Neutrogena premises. People immediately understood that they were in a different type of company – smiling was permitted. It was catching and also good for business.

The same thing applied to the hallways where a flock of sheep (plate 24) could be found roaming around. While actually being seats in sheep's clothing, these animals frolicked through the corridors, into offices and beneath desks during our more uninhibited moments. Once we put coffee beans under them only to have the FDA inspectors cite us for food particle violation. Humor did have its limits.

At Neutrogena, two-legged, four-legged, and no-legged animals abounded. There were big ones, small ones, and mostly imaginary ones. As mentioned, a most interesting group of alligators and crocodiles (plate 25)

PLATE 23
Soft Sculpture: "Ray and Elsie"
Artist: Susan Bowman
United States of America
1980s
Various fabrics
Wolf: 61 x 26" (170 x 66 cm.)
Cow: 71 x 20½" (180.3 x 52 cm.)

PLATE 24
Sheep Benches
Artist: James Tigerman
Illinois, U.S.A. 1975–1985
Synthetic sheepskin over wood
25 x 36 x 19"
(63.5 x 91.5 x 48.3 cm.)

Long-haired Goat
Artist: Johnson Antonio, Navajo
New Mexico, U.S.A.
Twentieth century
Goatskin over wood
18¼ x 12 x 29"
(46.3 x 30.5 x 73.6 cm.)

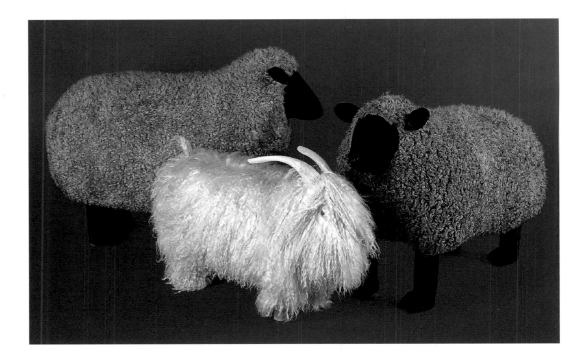

PLATE 25
Alligator (left)
Artist: Leroy Archuleta
New Mexico, U.S.A. 1994
Paint, glass marbles, wood
34 x 93" (86.3 x 236.3 cm.)

Crocodile (right)
United States of America
Twentieth century
Wood, paint, nails
26 x 73½" (66 x 186.6 cm.)

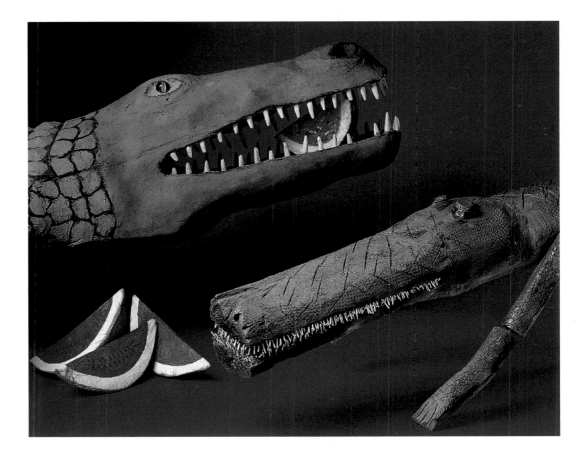

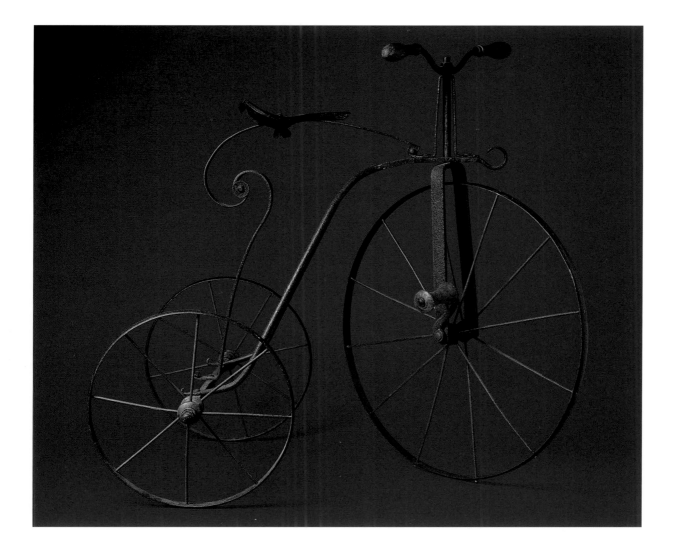

found their way from all over the world to the office of the director of medical affairs. You could say he was up to his *"derriere"* in crocs. Perhaps the largest of these with the biggest grin and the slowest bite was one made by the noted New Mexican wood carver, Leroy Archuleta. This friendly looking beast makes me smile … as long as he stays in the wood!

Another interesting piece is an early iron tricycle frame (plate 26) looking much like a geometrical skeleton from our industrial age. With its graceful balance of circles and struts, it has spatial depth. To this day, tricycles and bicycles have not changed much in either design or usage – perhaps only in their materials.

Another delightful Japanese toy (plate 27) sticks out its tongue as you roll it along the floor – a great executive stress reliever! Then there is the Japanese wood carving (plate 28) carved by the artist, Hideo…who seeks to take the traditional doll on a different path while still remaining within the bounds of age-old tradition. Moving closer to home, to Mexico, the folk art of

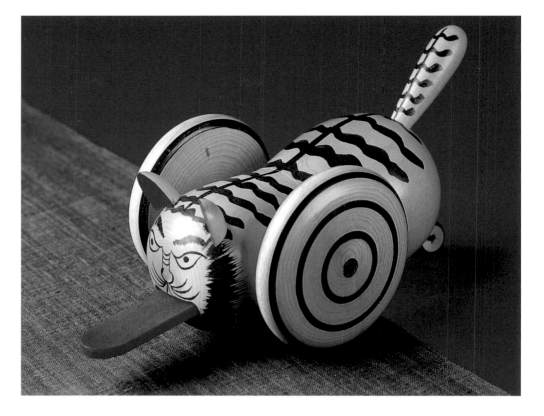

PLATE 27
Tiger Pull Toy
Japan. c. 1980
Paint on wood
9 x 4" (22.8 x 10 cm.)

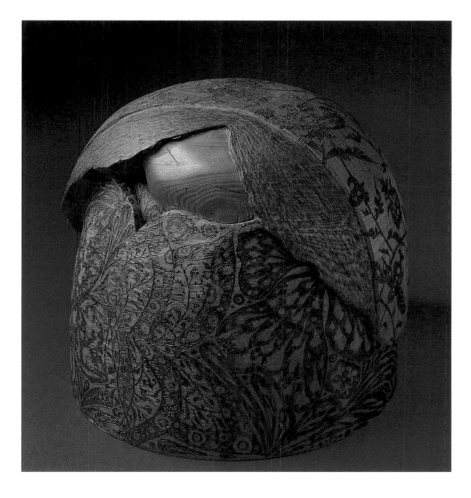

PLATE 28
Carved Figure of Girl (inscribed
on bottom: "Tsuzuri-Bana")
Artist: Hideo
Japan. c. 1980
Carved wood
10 x 10½" (25.4 x 26.6 cm.)

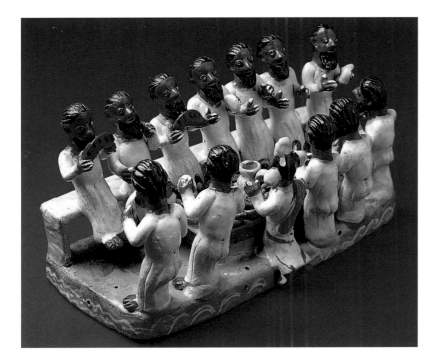

Michoacan artists give a new meaning to *The Last Supper* (plate 29) with its cast of black apostles eating watermelon. Why not? And, in the Collection, there are many individual objects that reflect the many artistic differences – as well as the sense of humor – that imbue Mexican folk art.

Finally, moving into our own era, the Company did have its own company plane … but one that no one flew in, it went nowhere, was always full of passengers, and had only one class. Hovering high above the lobby (plate 31), entertaining anyone who would lift his or her head … up, up, up beyond the row of Mexican village ladies (plate 30) by a noted Oaxaca potter, Josefina Aguilar. All those ladies, solid and formidable, waiting for the company plane to deliver their grooms?

This book represents a Collection of objects of beauty and creativity from which we can learn and receive enjoyment without any prior conditions. It is my hope that the pleasure I had in selecting these objects will be communicated to each and every visitor through some object or another. My joy now will be in sharing this Collection with others.

In conclusion, I want to thank all the Neutrogena employees, who over the years, helped to make our company a truly unique workplace, as well as the State of New Mexico, its Governor and First Lady, Gary and Dee Johnson, the Museum Director, Charlene Cerny, my curator, Mary Hunt Kahlenberg, and Johnson & Johnson, all of whom gave shelter and welcomed support for the Neutrogena Collection as represented by this book.

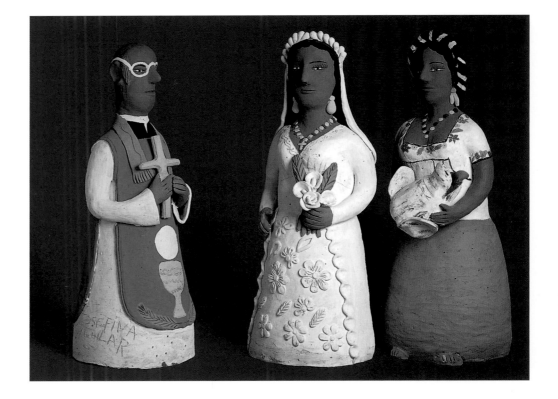

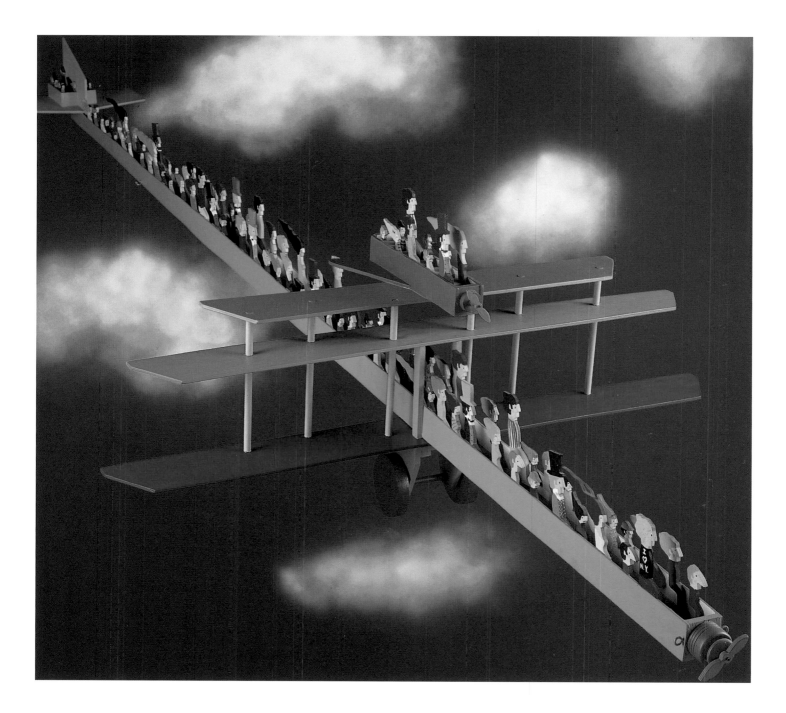

PLATE 31
Airplane
Artist: William Accorsi
United States of America. c. 1988
Paint on wood
15 x 35 x 114" (38 x 89 x 289.5 cm.)

A Collector's Pleasure

BY MARY HUNT KAHLENBERG

"Our tastes cannot be justified; or rather, satisfying themselves, finding the object that they desire, is their sole justification. It is not my reason that justifies my tastes but rather those works that satisfy them. It is in them, and not in my conscious awareness, that I find the reason for my pleasure. But I can say little or nothing about those works, except that they captivate me in such a way that they prevent me from judging them and judging myself. They are beyond judgment; they make me lose my judgment. And if I decide to pronounce judgment, I fool neither myself nor anyone else as to the real meaning of my act: I do so to give my pleasure added pleasure."

Octavio Paz.[1]

PLATE 32 (detail of plate 104)
Banner
Manchu People
China

Neutrogena's assemblage, Mr. Cotsen insists, was never a "Collection," rather it was gathered as a fertile environment to nourish the daily working lives of the employees at his company. The driving force was Mr. Cotsen's curiosity about how people express themselves: "Having the opportunity to view a wide range of creativity is a type of study of the world." The ingenuity of peoples of former times and distant places has been a source of ongoing fascination for him. He views the various technologies of different cultures, not just from the perspective of "how-to," but as an almost contagious source of invention and innovation: "Looking at these textiles and objects we can be inspired by the solutions devised by others."

To study how a person communicates a feeling and solves a problem has been one of Mr. Cotsen's primary and professed interests in collecting. How does an Amish woman decide to put wine red bars next to forest green and surround them both with purple – giving her quilt a color balance that is elegant, lively, and somber, all at the same time? How does a Kuba woman take a single triangular design motif, repeat it endlessly within a thirty-inch square, and manage to communicate the feeling of being in the center of a frenzied ring of dancers? Why did Pre-Columbian Peruvian weavers invent the scaffolding technique that increased their weaving labor tenfold, producing a textile that is extremely complex technically, yet one that appears so reductive, and visually simple? How can the bold and plain stripes of a Navajo blanket instill the force of the weaver's belief in harmony and balance? Every time we look at a textile or object, these questions are there for the asking, generating speculations and the opportunity to learn. It is Mr. Cotsen's hope that his Collection and this book will prompt others to ask those questions.

Mr. Cotsen developed the idea of niche marketing, the promotion of products to specific overlooked consumer categories, to a fine art. So, it follows that in his collecting he would seek areas others ignored. He began collecting textiles and objects at a time when few museums were acquiring or exhibiting similar materials outside of an ethnographic context. He saw the aesthetic, creative value of such objects as clearly as he had seen, for instance, the potential of marketing clear soap as a balm for sensitive skin. Mr. Cotsen could indulge his passion for collecting in uncharted areas of material culture, and he turned his corporate offices into a feast of color and pattern.

At Neutrogena's headquarters, Mr. Cotsen created a family atmosphere and camaraderie, albeit a hardworking one, with high expectations for every employee. While work has dehumanizing aspects, human beings have an extraordinary penchant for making work playful. Recently, work has become a type of religion without rites but with sacrifices. "The word pleasure has had no place in the vocabulary of work, and pleasure is one of the keys to being human."[2] I would always smile as I passed a sequined portrait of a Bolivian hero, while working at the Neutrogena offices. And, I noticed that while others might be talking on the phone they were simultaneously trying to decipher a seemingly random group of triangles of a Kuba textile hanging on their office wall. Do such activities bring pleasure to a work place? Do they free creative spirit? Do they build an innovative company? "Yes," according to Mr. Cotsen. He claims that the assemblage was "... an open window to let in a warm breeze filled with pleasurable aesthetic experience." The nature of such sensations, perhaps only momentarily, suspends rational faculties, empties one's mind of worries, and allows inspiration to enter.

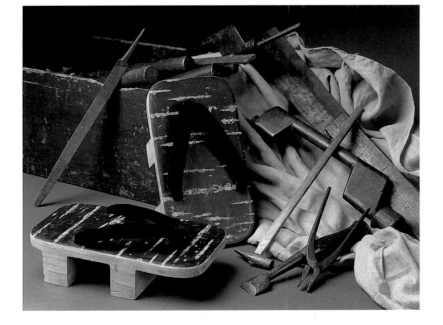

PLATE 33

Clogs (*Geta*) and clog-making tools
Japan. Nineteenth century
Shoes: cherry bark veneer, wood
and silk velvet
Tools: iron and various woods
Shoes: 9½ x 5" (24.1 x 12.7 cm.)
Tools: approx.; 7 x 19 x 8¾"
(17.8 x 48.3 x 22.3 cm.)

The tactile satisfactions and the textures of materials attracted Mr. Cotsen to the vast world of textiles. The pleasures of caressing a smooth skin or a silk textile are part of the same sensibility. Touch is one of the obvious and basic pleasures of collecting fabrics, to feel the fluidity of a Sumatran silk shawl, to understand the transparent sturdiness of a seal-gut Eskimo parka through the fingers, or to be surprised by the rough undulating mounds of stitched layers of worn, random-shaped cloth in a Japanese farmer's jacket. Such sensations connect to everyone's memories and emotions, prompting vivid kinesthetic feelings.

At Neutrogena, groups of objects including bone tools, elegant bamboo Japanese baskets, colorful toys of papier-mâché, wood, and plastic, were displayed on brightly lacquered shelves that spanned spaces between the different departments. Suspended on these bridges were unlikely juxtapositions of the strange and the beautiful, the familiar and the mysterious. This visual smorgasbord had an uncanny way of making people notice the coincidences of form. Visual analogies invited viewers to make comparisons and recognize differences, so their own discoveries could begin. People who initially expressed concerns to me about the oddities of these arrangements, would – in time – attempt to make sense of clusters of objects by building their own overarching concepts of coherence. For example, what connection might there be among a Korean brush, a spade made from an animal bone, and a child's ball printed with a fairy tale? It has often been remarked that objects

PLATE 34
Book of Eighteenth and
Nineteenth century Asian
and European Fabric Samples
Japan. Twentieth century
Variety of cotton printed and resist-dyed cotton fabrics
8 x 6½" (20.3 x 16.5 cm.)

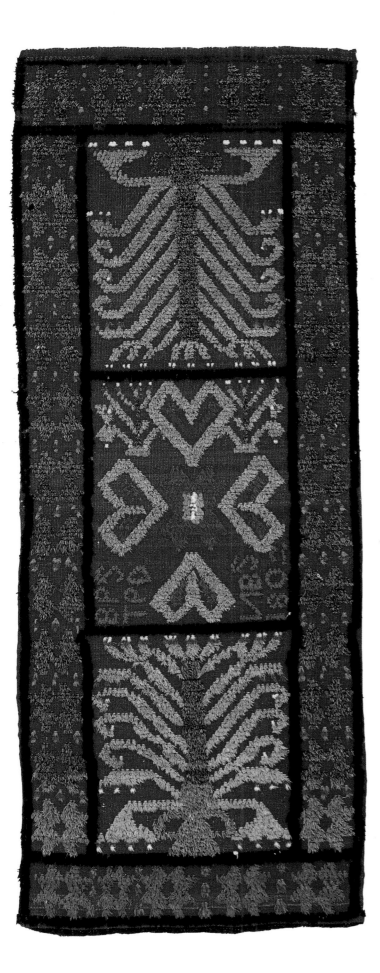

gather significance and satisfy human desires by their proximity, that, in fact, they "desire to be together."[3] At Neutrogena, collecting and arranging the art encouraged imaginative leaps, a back-and-forth process threading affinities and connections that are not easily expressed in words. And, of course, that is the special power of objects, that they can bypass the literal constructions of language and touch us so profoundly that they change us without using words.

Archaeological evidence suggests that non-woven fabrics made with such techniques as plaiting, braiding, knotting, or netting, were being made as long as eight to nine thousand years ago. Perhaps they are as old as civilization itself, at the forefront of human endeavor. Their fabrication requires a combination of manual dexterity and mental application. The production of non-woven fabrics, like the more complex loom-woven textiles to follow, also requires two strands of material, one crossing over the other at right angles. This is a binary activity, a repetitive motion of over and under, with threads at the front moving to the back, and then forward again. There is an order to lifting them up and down, back and forth. Such activity constitutes memory, perhaps our first physical evidence of the human capacity for binary thinking. Binary motion and memory are very different from linear forms such as writing, but not dissimilar to the electronic codes of ones and zeros that can magnetically store information in today's computers. Binary ideas of *time* are employed in many of the textiles and objects of this Collection.[4]

Another quality of time in textiles is their timelessness. It is not necessary to approach them as chronological markers of cultural development. By picking up a thread at any point, they invite the beholder to frame their meaning from different perspectives. For example, if we simply consider their functions throughout the span of human life – from birth to death – consider that a child's first sensation of texture after the touch of its mother's skin may be the soft swaddling wrapping that surrounds its body. And, in Pre-Columbian Peru, aristocrats were wrapped as if in swaddling clothes with hundreds of meters of fine cloth for their burials. Between these two

PLATE 35

Carriage Cushion Cover
Torna, Skåne, Sweden. 1802
Tapestry technique; wool weft
and linen warp
46½ x 18" (118.1 x 45.7 cm.)

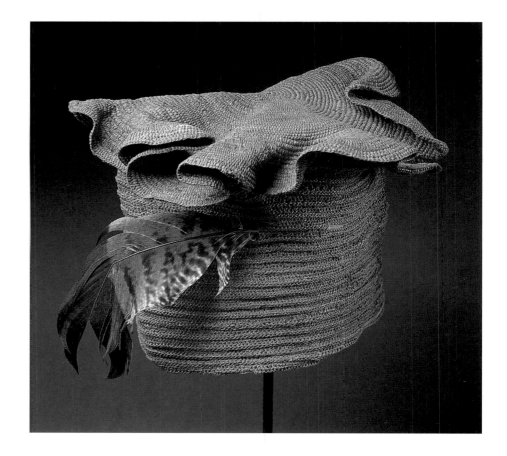

events, birth and death, we learn from Schildkrout's essay in Chapter Nine on Africa: "They wear it, worship with it, exchange it, celebrate it, transform and create themselves with it, heal and protect with it."

During the medieval period in the Mediterranean and throughout Europe, textiles were a form of family wealth and currency, held like money in a bank. Keys to a chest of textiles were carried for safekeeping by the women of the household. Regarding their value in Western Asia, Wertime writes in Chapter Six about how kings used textiles to create a royal splendor. They were spread on the ground, hung from the windows of palaces, and decorated bridges as the ruler passed by. In Indonesia, where textiles are an acknowledged metaphor for life, they are believed to be imbued with the power to cure the sick, and the power to bring prosperity to a family. Warp threads stretched taut between the two ends of a loom are the predestined elements of life, and the weft threads that move back and forth, and over and under, are life's variables. This compelling image illustrates an understanding of the balance between the philosophical concepts of cultural determinism versus free will. In such a culture, textiles are a physical embodiment and confirmation recognizing that both fate and chance affect an individual's movement through life. Religion stems from this basic need to bring a sense of order to the complexity and chaos of the world. In

cultures where there is a direct dependence on nature for daily sustenance, whether it be through the hunt or by the hoe, it is essential to emphasize the connections to the forces that establish and ensure order. Alliances between people and the gods of the forest, the water, and the sky guarantee survival and bring security to life. It is from this premise that many of the objects and textiles in the Collection draw their strength. They were made not as works of art, rather they were charged with the responsibility of facilitating exchanges between god and man, to entice good spirits to come closer and evil spirits to depart.

Baskets made for portage, pots for cooking, figures of the gods for protection, and cloth for covering the body – for all of these, humans have used whatever materials were at hand, and passed their technological skills on to succeeding generations. Around the world, nourishing the needs of the body and the needs of the spirit have been integrated into a culture's artifacts. This unification of life and art explains why in many languages there is not a separate word for art. A culture's aesthetic is embodied in the tools and necessities of daily life. There are as many design formats as there are cultures that developed them. The forms may be figurative and realistic, as in the carving of a Mexican saint who is a guardian of children's health. Or the form may be geometric, as in a diamond-shaped design on

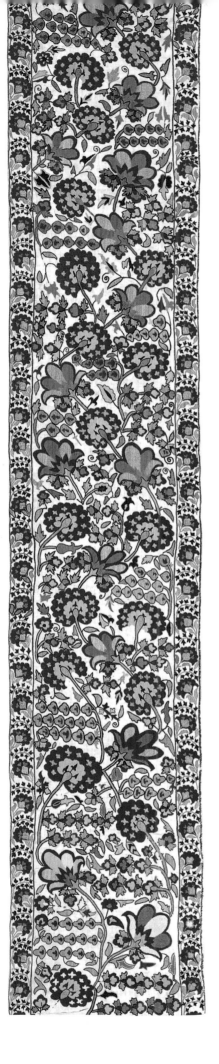

the border of an Iban textile that is the symbol of a bird, understood to be a good omen. Or, it may be the zig-zag line on a Kuba fabric, which signifies vital spirits, and is intended to attract their attention during a dance.

The Pre-Columbian Andean garments in this Collection were worn by priests, and they conveyed religious authority in much the same way as did the church vestments and tapestries of medieval Europe. Conklin writes about these garments in Chapter Eleven: They are "... like a flag to be worn for the world to see," their significance was understood by all. The complex techniques used to make and decorate them carried symbolic meaning, with a vast array of weaving techniques devised for specific garments and signaling particular symbolism. The essence of these techniques was fundamental to a culture that valued and stressed verity over visual deception.[5] What this meant in terms of their sophisticated textiles was that design and construction were unified; design was not applied but was part of the construction; the design on the front was reconfirmed by the design on the back. It also meant that in designs with blocks of solid color, each color area was considered as both a distinct section with the ability to stand on its own, and as an element essential to the overall composition. These ideal qualities were transferred to the wearer, signaling to any beholder that a person was powerful and sacred. Of course, the refined technical demands of an Andean weaving were painstaking, and vast amounts of time were required for each fabric's production. Such facts were not lost on a contemporary observer.

PLATE 37

Embroidered Valance, (*Sousani*)

Uzbek People

Samarkand, Western Asia

Early Nineteenth century

Silk floss embroidery on plain weave linen

17 x 90" (43.2 x 228.6 cm.)

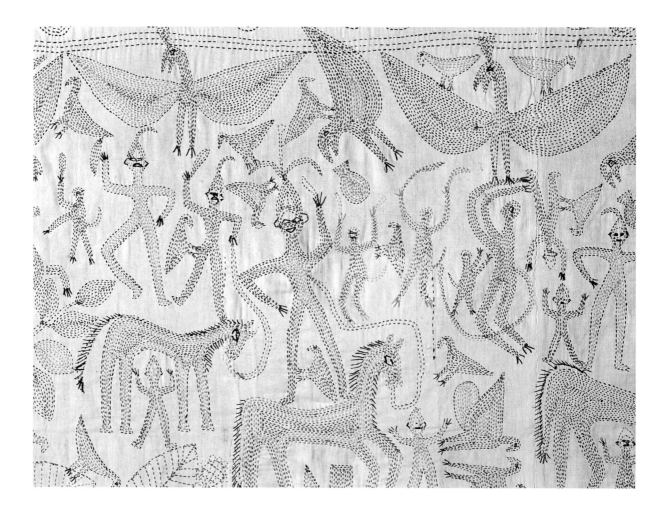

PLATE 38 (detail)

Quilt (*Kantha*)

Bengal, India. Late Nineteenth century

Cotton embroidery on plain weave cotton

74½ x 49" (189.2 x 124.5 cm.)

Scientists tell us that time is constant, but *how* we view it changes our perception of it. When we look at an embroidered Greek bed curtain, or a finely knotted carpet, it is a natural human tendency to wonder at the time it took to make it, comparing it with tasks we might accomplish. For instance, it may have taken four persons sitting side-by-side the better part of a year to complete a knotted pile carpet of fifteen by twenty feet. How many hours a day did the foursome work? What happened in their lives during that year? And, what of a young girl sitting at home embroidering a curtain? Did she dutifully spend six hours a day by the natural light of a window in order to complete such a textile, considered a requirement for her trousseau? Of one thing we are certain: she did not get up to answer a telephone or adjust a television set. She was certainly not bothered by an urgent fax or her e-mail. She had long, uninterrupted periods when she could concentrate on the task at hand. We can imagine that the rhythm of her work created its own force. Similarly, for a Sumba woman, preparation of a pair of mortuary cloths could occupy her for five years. Each shroud had to be absolutely correct, so that the identification of a person's position in the next life and his or her proper status would be guaranteed for eternity.

In many cultures, textiles serve as a type of time machine connecting the objects of the ancestors to the current generations' hope for the future. Techniques and materials of the past are honored by their continued usage in ceremonial garb. For example, barkcloth lining in a ceremonial Borneo jacket ensures the protection of ancestors, who wore only barkcloth. An Indonesian term for heirloom is *pusaka*. It is more than something simply old that once belonged to an individual ancestor. It contains both the spirit of an ancestor and extends beyond the individual, encompassing their lineage and inherited, traditional knowledge. In Southeast Asia, an ancestor's spirit is a guide through daily life, ensuring sufficient food and protecting against illness. While there are regional variations in how the ancestors are honored and communicated with, there is an overall belief that ancestors ultimately provide for the prosperity of each individual and community – as in the *sarita* from the Toraja people of Indonesia (plate 123) that had the power to bless the family, animals, and crops and protect them from disease.

In America and Western Europe, the possessions of honored forebears are often handled with respect and care. The fond memory of a friend or relative accounts for the preservation of many wonderful things. Frequently, these belongings are precious because of their association with momentous occasions in our lives, such as graduations and weddings. Clothes, mementos, and small objects – carefully tucked away in drawers – verify and connect us to our pasts. Even discarded heirlooms frequently survive in the hands of those who do not know their history – they may be redeemed and salvaged for their exotic nature or a direct delight in their formal beauty. As travelers, we often find things that fascinate us, that are different from anything we have seen before, things that we think are wonderful. The traveler's eye values and selects materials that are perhaps taken for granted by those more familiar with them. I experienced this early in my career as a textile curator. One single event profoundly affected my thinking.

After moving to California, I needed to furnish a new home. Once a month, very early on Sunday morning, I would go to the Rose Bowl Flea Market, where there were always a number of dealers who sold quilts. I would carefully look at each one, and make a present to myself of a favorite. The prices varied between $5.00 and $10.00. Many people who participated in the flea market were familiar with quilts, and I venture that many had grown up sleeping under them. Yet, as reflected by the going prices, neither dealers nor buyers shared my appreciation of their aesthetic beauty. The Sunday of my revelation, I walked into an open-air booth just as two Frenchwomen were unfolding a stack of quilts. They asked the prices. The dealer, perhaps sensing deeper pocketbooks than her usual clients, asked $25.00 each. A look of amazement crossed the women's faces. "Ah, ha!," I thought, they know they are being taken. No, I was wrong. "Incredible," was their response. To these foreign visitors, the quilts were an amazing bargain. Didn't people realize their beauty, and the skill that went into making them? How could they be so undervalued?

This lesson taught me that when we are close to home we often overlook what is in our midst – the ordinary, the everyday. We accept such things without further consideration. We do not recognize their special aesthetic qualities; rather, we use them as tools, functionally. As trends in fashion and collecting confirm, the modern world promotes the newest and the most up-to-date items. In the period when quilts were discarded, they symbolized the constraints of poverty and the homemade. The manufactured blanket that was "store-bought" was more highly prized. Generational changes in taste also account for considerable movement of objects, but such blinders are not there for outsiders. In the quilts found at the flea market, those French visitors could see careful stitching, fine old printed cottons, and playful patterns . . . and all the devoted hours that were given to its making, and the years of loving use reflected on its worn surface.

When a personal sense of history has disappeared, when the maker has left no trace beyond the object in hand, such objects are often invitations to investigate broader social and historical contexts. In what part of the country was it made? Can we find out something

PLATE 39 (detail of plate 131)
Ceremonial Shoulder Cloth (*Kain Limar*)
Malay People
Bangka or Palembang, Sumatra
Indonesia. Late Nineteenth century
Weft ikat and brocade techniques;
silk and metallic yarns
82½ x 32½" (209.5 x 82.5 cm.)

PLATE 40
Ceremonial Panel
Shoowa People, Kuba group
Congo, Africa. Twentieth century
Cut pile and linear embroidery on
plain weave raffia palm
21⅜ x 22" (55.3 x 55.9 cm.)

PLATE 41
Ceremonial Panel
Kuba People. Congo, Africa
Early Twentieth century
Linear embroidery and appliqué
on plain weave raffia palm
28½ x 31" (72.4 x 78.7 cm.)

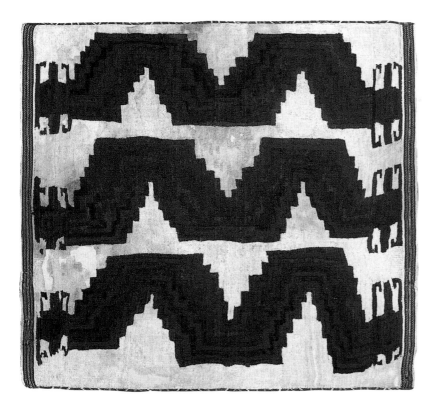

PLATE 42
Mantle
Sihuas or Nasca People
Southern Peru. 200 B.C.–A.D. 200
Interlock warps and wefts, twined
edging; plain weave alpaca
35½ x 38⅜" (90.2 x 97.5 cm.)

PLATE 43 (detail of plate 256)
Rug
Navajo People. Arizona or New Mexico,
U.S.A. 1895–1915
Tapestry technique; handspun wool yarns
93 x 52" (236 x 132 cm.)

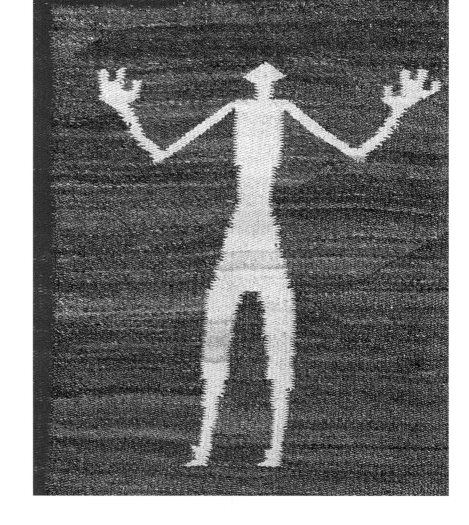

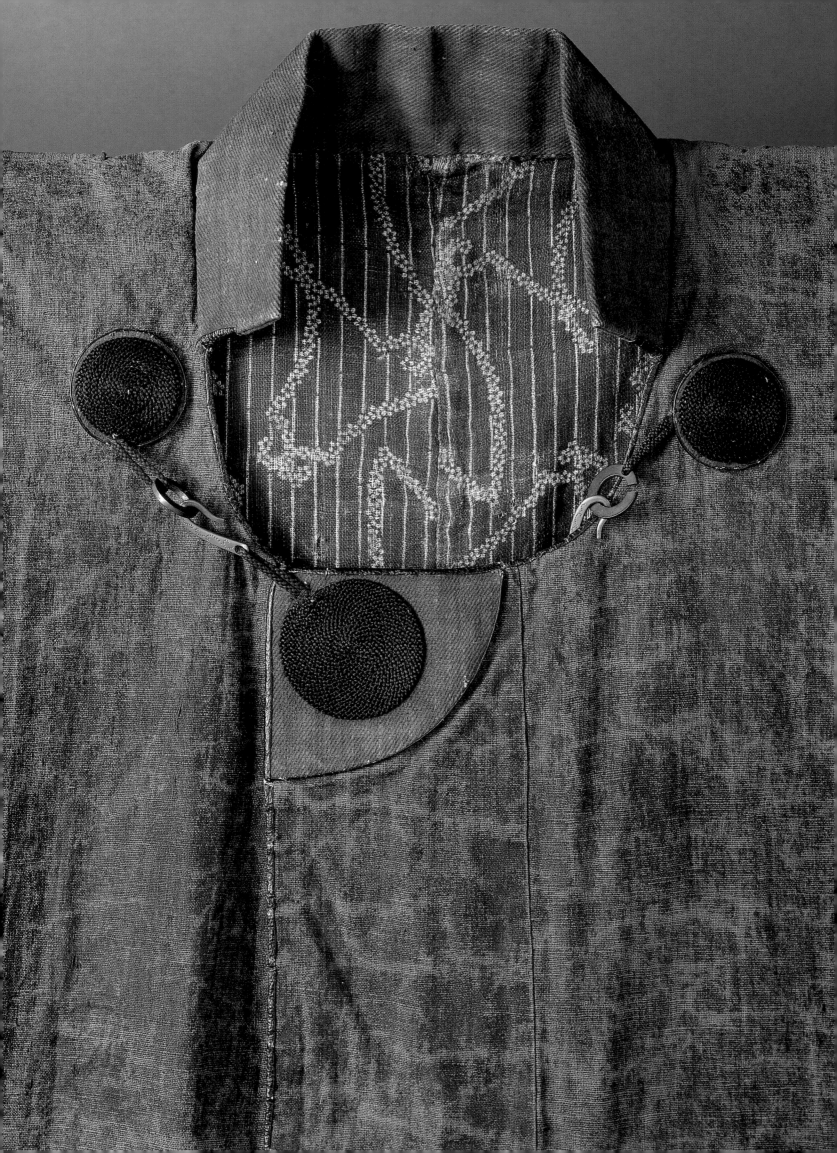

about the makers of such goods? What does the range of dates in the fabrics tell us? The "rediscovery" of American quilts is discussed in Fox's essay on North America in Chapter Fourteen. With the imprimatur of the 1971 exhibition at the Whitney Museum in New York, quilts attained the status of fine art. Since the time of that exhibition, quilts have become an important subject of study, consequently increasing our access to American history, women's history, and to our culture. Their study has produced a continuous stream of scholarship and acknowledgment, that has also opened our minds and hearts to other American homemade objects and textiles. We can see our immediate surroundings with the fresh appreciation of a traveler's eye, with that level of intense attention often reserved for materials from outside our own culture.

The delight in collecting and displaying the mixed groupings at the Neutrogena headquarters has a well-known precedent in Western European history. Beginning in the Renaissance and continuing during the great age of exploration, collections of textiles and objects were assembled from exotic materials brought back to Europe as curiosities. These "curiosity cabinets" were the precursors of the modern museum and were assembled by royal houses throughout Europe. They were filled with an array of religious paraphernalia, tools, and clothing. An ostrich egg resting against a Chinese silk was evidence of a world few could visit and get to know firsthand. Whether the materials were forms of art, or a tool, or a specimen of nature was irrelevant. Each was admired as proof that the world was filled with wonders and that other cultures looked at the world in another way – that vast differences made up the human family.

At roughly the same time, another type of collection based upon hierarchical classification arose. During the European Middle Ages, painters were organized into guilds, as were sculptors, goldsmiths and silversmiths, enamelers, glassmakers, and tapestry weavers. Materials were produced in the workshop tradition – under the direction of masters, but none were considered the creation of an individual. Religious thought dominated culture, and art was produced within established canons. All of it made for a common purpose, for the glory of God. Priests' vestments, carved saints, frescoes, and

stained-glass windows were works of the devout, all faithful servants of a Christian God. With the rise of humanism and the decline of religion in the Renaissance, this began to change. Painting and sculpture moved from the walls of the church to private homes and the galleries of wealthy new bankers, merchants, and entrepreneurs. Instead of commissions from the church to create objects of contemplation for their congregations, private patrons contracted with artists for more secular and spectacular subjects. Such wealthy patrons sought out the most talented artists to make their newest trophies. They vied with each other to possess examples of individual artists' genius. The first medium to make this transition was painting. It became the original art form of Western European culture. Painting was given

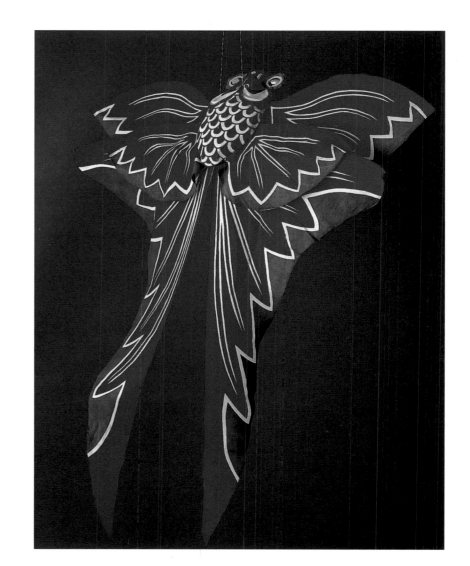

the highest place of honor, the first medium to enter the "fine art" door, and it has held this place of honor ever since. Sculpture was second. Finally, the decorative or functional arts then followed in the hierarchy of importance. Without the context of the church, the common, equalizing function of conveying spirituality no longer bound the different media together.

In the nineteenth century, the expansion of tourism and large "World Expositions" began to widen European and American views of other cultures, whetting the appetites of many for collecting. Looking back at the memorabilia from these exhibitions, the naiveté and racial attitudes of the texts of these exhibitions may be appalling to our modern sensibilities. And, yet, today we can note the good consequences. For example, materials assembled for the 1876 Centennial in Philadelphia are still housed at the Pennsylvania University Museum,

PLATE 46
Bell
Yoruba People
Nigeria. Nineteenth century
Bronze
9½ x 6½" (24.1 x 16.5 cm.)

and collections from the 1892 World's Fair in Chicago became the basis of the Field Museum. Both institutions are repositories for amazing objects no longer made by their native cultures, and, in some cases, the cultures of origin themselves are extinct. At the beginning of the twentieth century, more travelers and tourists began to collect textiles and objects on their world tours through Asia and Africa. George Heye assembled over a million objects of American Indian manufacture, the core collection of what is now the National Museum of the American Indian. A 1903 announcement published in the *Brooklyn Daily Eagle* by The Brooklyn Institute of Arts and Sciences heralded the appointment of R. Stewart Culin who was "building up great ethnographic collections, sending out expeditions for acquiring antiquities, first over all America, then over the entire world."[6] Many American and European museums today have vast holdings of "scientific specimens" that were given legitimacy by the new social science of anthropology.

While anthropologists comprise perhaps the single largest group of twentieth-century collectors of cultural artifacts, a smaller but very significant group of collectors has included Western European and American artists. Gustav Klimt, Henri Matisse, and Paul Klee, for example, all collected textiles of the Kuba People. It is fascinating for me to look at textiles with artists because they focus immediately on aspects of objects that relate to their thought processes. I find that artists frequently lead the way in recognizing art from other cultures. In 1972, I traveled to New York to borrow Navajo blankets for an exhibition that I was curating for the Los Angeles County Museum of Art. In addition to viewing museum collections in New York, I also saw the private collections of Jasper Johns, Ken Noland, Frank Stella, and Donald Judd. Each had collected Navajo blankets out of recognition that the weavers could communicate through a limited palette and range of designs and composition both a dynamic expression of their culture and their unique insights as individuals. They understood the Navajo textile as art. Since then, I have shared my own textiles with many artists. They see in them a source for ideas of optical inventiveness and conceptual structure, windows to new forms of visual realization. They single out analogies that form linkages with their own work. These artists who are also collectors are a living testimony that such linkages with the past or the foreign is a vital part of human creativity.

Art historians give the date of 1906 as the beginning of the idea of conceptualization as a means of visual expression.[7] This was the year Pablo Picasso began to paint *Les Demoiselles D'Avignon*, his first work influenced by African masks. In this large canvas, Picasso obliterated Renaissance illusion and representation.

While painting and sculpture had for centuries framed visual reality for the viewer, conceptually based work instead concentrated on conveying the artist's viewpoint and response to reality. Conceptualization allowed artists to explore the essences of an object, a place, a person, or an idea, unconstrained by the demands of representation. Braque and Picasso shattered facades in their Cubist portraits and still lifes. A face or an object was faceted into multiple viewpoints, thereby investing them with a multi-dimensional image of personality or form.

Such artistic conceptualization, while new to Western art, existed in many areas throughout the world, particularly in cultures that did not emphasize the written word and those that did not see time as linear and unidirectional. It had disappeared from Europe with the emergence of humanism and the separation of church from cultural values. At the beginning of the twentieth century conceptualization was revived, not as a religious concept, but as an intellectual one. The portraits of Braque and Picasso drew heavily on the abstractions and cognitive ideas embodied in African masks. Both artists studied African masks in Paris collections in an attempt to understand their power and formal methods. Not conceived as art, such masks were intended to invoke unequivocally such attitudes as respect, fear, power, and spirituality. The methods used to achieve this, i.e., the signs, symbols, and forms of distillation, were part of each tribe's way of seeing. Every deity was portrayed with particular attributes that were specific, recognizable, and intended to elicit a particular response.

On the wall behind my desk hangs a postcard with a photograph of Marcel Duchamp holding a book that clearly reads "I am not a role model." Like it or not, Duchamp has been a role model for many in successive generations of twentieth-century artists. Duchamp's American fame began in 1913 when his painting *Nude Descending a Staircase* was exhibited at the New York Armory Show. He used the Cubist vocabulary of Picasso and Braque, and, to many critics, Duchamp's nude in motion summed up "everything that was arbitrary, irrational and incomprehensible"[8] in European art of the time. Part of the fascination with Duchamp's work was its self-consciousness, its awareness of itself as a spoof,

and therefore "it appealed to some of the same prejudices that found it so outrageous."[9] Duchamp's most important influence has been on artists of the twentieth century, who were inspired by his concept of "ready-mades."[10] A ready-made was exactly that, an object that already existed, to which Duchamp added a title and his signature. A ready-made was not created by his hands, but by his mind's focus, by his selection of an object as art. Duchamp's first ready-made was a common, flat, galvanized, wooden-handled snow shovel that he purchased in New York during the winter of 1915–1916. He inscribed it "In Advance of a Broken Arm" and signed it "from Marcel Duchamp," and hung it on a wire from his studio ceiling. Quite simply the ready-made posed the question, "What is art?" Is it the idea or the physical example? Duchamp has provoked us to reconsider the ordinary around us and to transform it.

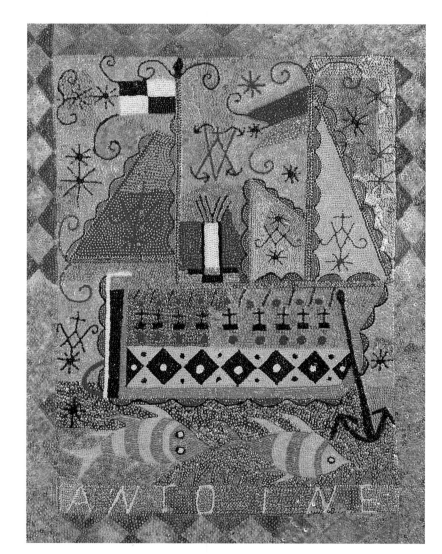

PLATE 47

Banner

Artist: Antoine Oleyani

Haiti. 1980s

Sequins on various machine-woven fabrics

39 x 29¾" (99.1 x 75.6 cm.)

PLATE 48

Fragment of a *Kari-Ori Noh* costume
Japan. Seventeenth century
Supplementary weft technique; silk floss
and spun silk yarns
18½ x 16¼" (47 x 41.3 cm.)

Duchampian thinking has generated much of twen-
tieth-century fine art. For example, Robert Rauschenberg
rolled a tire over sheets of paper, leaving a continuous
band of repeated geometric patterns made by the tire,
then he signed it. In some ways this is not too different
from the story that Monni Adams recounts in Chapter
Ten of the Kuba king, Kwete, who was unimpressed by
the gift of a motorcycle until he saw its tracks in the
sand. Then the king attached his name to the pattern.
Another example can be seen in the early geometric
work of Jasper Johns, who felt that he could divest an
object of its common associations by reducing it to its
elementary components of color, line, and shape. In this
manner he turned images of flags and toothpaste tubes
into canvases of stripes, chevrons, and circles. When we
initially see Johns' paintings or drawings we strive
to find the familiar image, but once we have found it, it
no longer seems common. By extension, Johns prompts
us to reconsider both object and painting. We can iden-
tify the object, but since our recognition no longer fits
the image, we see how to see anew.

Could Duchamp's basic questions be a model for the collecting of material outside of one's own historical or cultural sphere, a model for seeing such objects anew as art? There is a reason to say "yes." Duchamp opened up the everyday, manufactured artifacts of the world, so that we look again, and among the ever-growing audience for fine art, he changed much of the Western attitude towards "What is Art?" Of course, the *era* itself within which an idea comes to fruition in a culture is also a very important factor. Today, most of us travel, no longer confined to armchair journeys. We can travel almost everywhere, and when we are at home we can see what is happening throughout the world *live* on television. Has this given us an appreciation of the humanity that exists worldwide beyond our own neighborhood? Clearly, each area of the world has multiple and unique forms of expression. Perhaps most notable during our era of globalization and homogenization is the fierce desire expressed by many to retain their cultural nuances and differences.

While Mr. Cotsen probably never considered Duchamp a model or influence on the Neutrogena Collection, the artist's objective of opening the mind to new possibilities by amplifying the ordinary, relates to Mr. Cotsen's creative approach. Objects and textiles

were chosen for the Neutrogena assemblage because they presented a visual or design puzzle, a unique color sensibility, or displayed particular technical virtuosity. They were a visible physical record of a maker's thought processes. Objects were placed around the offices without labels – their origins, materials, dates, unannounced. Chinese objects arranged next to Mexican objects, kitchen utensils next to ancestor statues. Such juxtapositions led to explorations of correspondences or differences and frustrated the Western tendency to categorize, pigeonhole, and thereby dismiss as being somehow understood. For Mr. Cotsen, whether or not it was *art* was not the important question. He was interested in stimulating the beholder. He wanted to make us stop, and reconsider what was placed before our eyes.

Initially, Mr. Cotsen is ambivalent about knowing what a design means within the context of its culture: "First I want to interact with the piece myself without preconceptions or prejudices, letting my feelings be the guide. I respond to things gut-wise. Yet, I find that if I know something about it, it's like breaking bread with someone. We both become interested and involved and more appreciative of the other person's position. Knowledge enriches the experience. So, perhaps, both the intellect and feelings are important in a response. But the

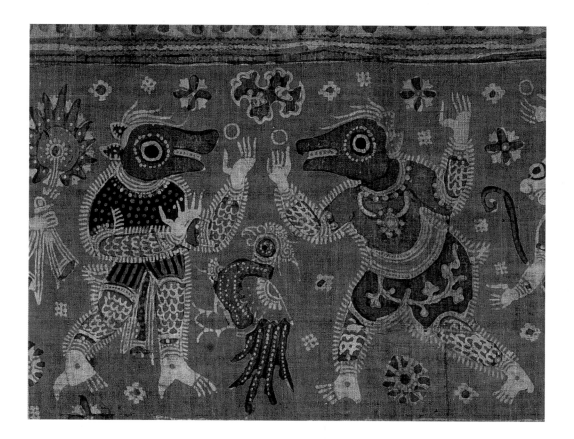

PLATE 49 (detail of plate 134)
Ceremonial Hanging
Western Indian, found in
Timor, Indonesia
Second half of the Eighteenth
century
Resist and mordant dyed; plain
weave cotton
32½ x 104" (82.6 x 264.4 cm.)

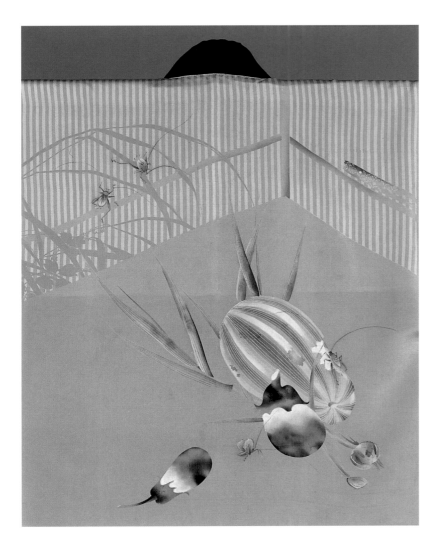

PLATE 50 (detail)
Man's Under Kimono (*Nagajuban*)
Japan. Early Twentieth century
Painted dyes (*yuzen*); plain weave silk
55⅞ x 50" (142 x 127 cm.)

feelings are most important." Mr. Cotsen's initial intuitive bond might best be designated as "connectedness." Of course, there are no signatures on the textiles and objects he has collected. As Mauldin points out in Chapter Twelve, there was never any need to know who the maker was in the cultures of their origin, EVERYONE KNEW. Rarely does this information travel with such objects. Only occasionally is it firmly attached or recorded. Sometimes the identity of the maker is physically embedded in objects, yet outsiders cannot recognize it because there was no written language in its culture, or because the maker could not write. But, "connectedness" does not rely on signatures, and intuitive "connectedness" as practiced by Mr. Cotsen is able to draw a sense of creativity, humanness, and depth of commitment from material objects. After the first stage of "connectedness," questions arise: What does the object mean? How was it made? Who owned it? Small pieces of a puzzle are assembled, such as learning the symbolism of a broken circle in a Navajo blanket, or researching the depiction of an antlered deer on a Sumba cloth. All are clues to a culture's world-view. The technology involved in constructing objects also gives us other valuable perspectives. In our world, technology changes from day to day, but a study of the technology in the textiles of this Collection tells us about the tenacity and maintenance of traditions. Consider the ancient technique of ikat, a resist-dye technique that is an extremely time-consuming though simple way in which to pattern a fabric. It remains a vital technology today in such widespread areas as Japan, Indonesia, and Guatemala. In Japan, this deference to tradition is referred to as *shokunin katagi* – the "artisan's nature" or the "artistic trait of stubbornness."

The intimacy that can often be found in textiles and other objects of daily life is basic to understanding Mr. Cotsen's selections. One can easily imagine a kite from this Collection flying through the air, a small boy at the end of its very long string. It is this sense of tenderness, of vulnerable humanity, that seems frequently to be missing in our secular age. It is to such a hands-on aspect of culture that this Collection addresses itself. And, it is for this reason that the Museum of International Folk Art was chosen as the new home for the Collection. Unlike many American art museums, the Museum of International Folk Art invites participation from its audience. Children, community members, and visitors to Santa Fe are all welcomed with exhibitions that explore objects that have been useful and pleasurable and important to people all over the world. Their presentations are concerned with a feeling for the culture rather than the analysis of styles, the hierarchy of

media, or the separation of high art from popular art. Nevertheless, there exists a division between the folk and the fine arts that harkens back to the sprawling world's fairs of a century ago. Much of this Collection, particularly in the textile portion, was not used by, or even made by "common" people, but rather for the elite of a society. Yet, this is the meaning of "folk" generally assumed. Referring to Webster's dictionary, however, we find a less narrow definition of folk as, "the masses of people in a homogeneous society or group as contrasted with the individual or with a select class . . . the great proportion of the members of a people that determines the group character and that tends to preserve its characteristic form of civilization and its customs, arts and crafts, legends and superstitions from generation to generation."¹¹ The modern American and Western European practice of placing material from outside our cultural realm into a lower class of art indicates just how awkward and ill-formed our cultural perceptions can be. Cultures that integrate their objects are still at the fringe of a Western tradition that stems from a one-point perspective, that has distanced itself from the sensual, that glories in the photograph, the movie, the video.

As a textile curator of some decades' standing, I have observed how, say, a religious textile whose heritage has not been lost, is normally relegated to the category "*decorative*." Can such textiles be recognized as more than just visually appealing? It is difficult, given our current institutional biases. Most American museums have rounded up all their textiles and put them together in one department. Obviously, the inclusion of textile departments in America's great museums offers some assurance that textiles have something more to offer, but the position of these departments is sometimes tenuous and their position within the museum's hierarchy low. In part, due to this status, textile departments assume defensive positions, and guard their territory by restricting their focus to historical and technical scholarship rather then claiming their due as art. While there is no doubt that many textile curators harbor a deep passion for the material in their charge, they can rarely express it in print. Most publications stick close to the facts, emphasizing international links in technique and tracing historical influences. Within such institutions, isolating textiles has always been defended as a conservation practice. The rationale given is the fragility of textiles and the special handing required. Unfortunately, this argument often effectively hides the material. Having cared for one of these departments and having served as curator for Mr. Cotsen's International Collection, I must admit my first love is still textiles, rather than the other cultural objects. I feel more strongly than ever that textiles offer opportunities for significant intellectual endeavor and rewards as yet little understood or appreciated. They should, in my opinion, be seen in the same context and at the same level of valuation, as, say,

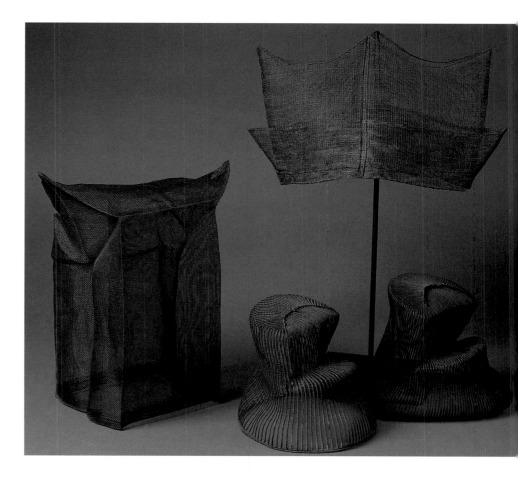

PLATE 51

Hats

Korea. Nineteenth century

Plain weave horsehair

Approx.: 7 x 5 x 6½"

(17.8 x 12.7 x 16.5 cm.)

African sculpture or Persian painting. In Pre-Columbian Peru, or Indonesia, to invoke the most obvious examples, textiles would shine the brightest in the pantheon of these cultures' art. They were the major aesthetic medium of these cultures. What a pity so many people have been denied the pleasure of seeing these wonderful materials in a multi-media context on the walls of more of our fine art museums. On the other hand, the fertile mixture of the Collection that once enlivened the Neutrogena workplace is now spread provocatively before the visitors to the Museum of International Folk Art for their pleasure and stimulation.

In conclusion, I have always thought of collecting as a gathering of friends. Not all together, in one place, but over a lifetime, a constant coming and going. An exchange of ideas that shifts my viewpoint. Sometimes this results in a decision to focus and concentrate. Other times, I need to expand my frame of reference. My approach is continually changing and restructuring itself. It is this process, guided by the materials themselves, and the ongoing learning that I treasure. As I keep on looking, my pleasure in textiles grows and grows as I look carefully at the strength of a warp and the pliability of a weft, the saturation of colors, the individual components of a pattern. It has been a pleasure working on this book, to read and reread again other texts written by my colleagues that have been useful as I actively pursued materials for the Neutrogena assemblage. As I turned my thoughts to the geographic sections delineated herein, I drew from many scholars and authors threads that I needed to connect cultural viewpoints and weave the story of fears and joys around these objects of my affection.

Editor's Acknowledgments:
Days, months, years: the time I have spent working on the Neutrogena Collection from 1978 to the present is twenty years. The last three have been focused primarily on helping make its transition to its new home, and the past year in preparing this publication. As the material will be on view for the next five years and beyond, this book is not the catalogue for an exhibition but a sense of the Collection – its concepts, its agenda, and its aspirations. How fortunate I have been to have had the opportunity to learn and work with Mr. Cotsen on the development of this Collection. There have been times when his ideas sounded bizarre to me, but for this opportunity to see differently and expand my world, I am enormously thankful.

Built like a house, each chapter in a book has its own identity and purpose. For each section I have had invaluable help and advice. For my introduction: Alvaro Lopez helped me set the tone and Malin Wilson helped me clarify it. Eudice Daly translated an impor-

tant article from French. In the geographical sections it was a pleasure to work with all of the contributors who came to Santa Fe during the cold winter months and buried themselves in textiles. For my areas, I was generously assisted by Jonathan Holstein, Ralph T. Coe and Andrew Whiteford, Roy Hamilton, Wilma Matchette, Helena Hernmarck, Richard Kahlenberg, and the many others whose names appear in the Notes.

Charlene Cerny masterminded everything at the Museum, and Tamara Tjardes, the Neutrogena Curator, did all the crucial day-to-day work, always with good humor. She was assisted by Paul Smutko, the Collections Manager, and Nora Fisher, the Museum's Textile Curator, and Chris Vitagliano, Administrative Secretary. All were assisted by able volunteers. Pat Pollard was our energetic and excellent photographer. At Abrams, our capable staff included Adele Westbrook, editor, and Judy Hudson, designer. While the foundation of this house is Mr. Cotsen and the Collection itself, the considerable time and space to construct it has been made possible due to my husband, Rob Coffland, who has lovingly provided life's essentials and pleasures while I was otherwise distracted.

Note to the Reader:
As this assemblage was not intended to be a complete collection of any historical period or geographical area, there are regions spatial and temporal that are not covered in this Collection. That is not to say that they are not worth exploring – they were either by fact of availability or for reasons of personal taste not included in this assemblage. For the purposes of the book, the Collection is grouped according to broad geographical areas. For example, the extensive Japanese material has formed one section, while the countries of Taiwan, the Philippines, Indonesia, Burma, and India form a larger though cohesive group. Each one of these sections, written by a well-known expert, has the most current scholarship available and the sense of breadth expressed by someone with a thorough understanding of the material. The Collection has an almost equal number of objects and textiles. You will note, however, that this book emphasizes the textiles. There are two reasons for this: the first is that the objects are heavily concentrated in one geographical area, Mexico, and are barely represented at all in other sections. They are brought into the text at least at one point in every section. The second reason is that the textiles take up more space, on the walls of the offices, on the pages of the book, and in the heart of this writer/editor.

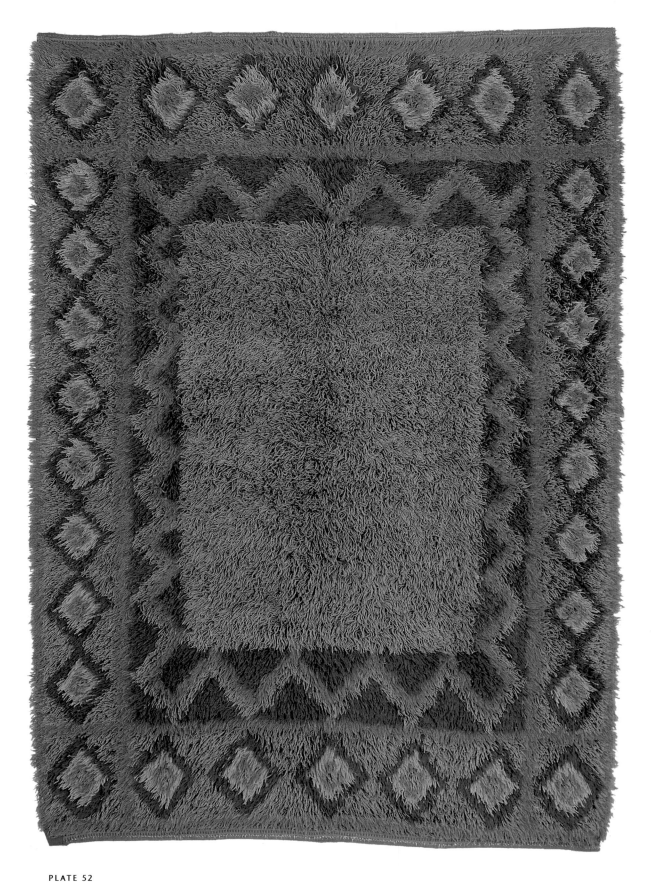

PLATE 52
Bed Cover or Rug
Sweden or Finland. c. 1850
Knotting technique (*rya*) weaving,
wool with linen weft
6'10" x 5' (208 x 152.4 cm.)

CHAPTER 3 # Japan

BY REIKO MOCHINAGA BRANDON

Under a dim light, during a freezing winter night in Tsugaru, northern Japan, a woman's hand steadily sews exact stitches to reinforce and decorate her handwoven cloth. Counting each warp and weft thread, she brings the stark white cotton strand to the surface at exactly calculated intervals. Gradually, she builds a mosaic of precise, pure white diamonds and squares over the deep indigo-blue ground.

One special characteristic of Japanese handcrafted utilitarian arts, particularly textiles, is their remarkable precision of execution. Fabrics and clothing were meticulously crafted by artisans who assiduously practiced their arts with great pride from generation to generation. Whether it was a modest indigo-dyed farmer's jacket, or a sophisticated urban silk kimono, the textile's design – sometimes spontaneously dynamic, sometimes serenely ordered – was the articulation of trained hands working through techniques of the utmost accuracy. In Japan, traditional craftsmen and women occupied a unique position in society. Although crafts are less important economically in contemporary Japan than they were in the past, the centuries-old attitude of the *saikushi*, literally "detailed craft master," still strongly survives in today's world of traditional crafts. As the term indicates, skill in handling extreme details at the finest level is the absolute requisite for being a master of a craft. Only through long and hard apprenticeship and self-disciplined study can the required level of mastery be achieved. Today, there are craft masters who still tenaciously and independently maintain traditions of exceptional precision, shunning modern mechanical devices and machine-made materials. This artistic trait of stubbornness, often held by rather eccentric individuals who are extremely proud of their profession, is fondly and respectfully described in Japan as *shokunin katagi*, the "artisan's nature." The precise beauty of Japanese textiles, and other crafts, is deeply rooted in this tradition of stubborn, individual perfection.

Japanese cottage industries reached their peak during the Edo (or Tokugawa) period (1603–1868). A money economy was widely utilized and the rapid population growth stimulated the production and consumption of goods throughout the country. Under the feudal system of the Tokugawa shôguns, each clan was expected to organize a self-sufficient economy within the borders of its assigned fief (*han*). Importing raw materials from other fiefs was discouraged. This restriction, in fact, promoted the development of numerous and distinctive cottage industries, each based on available indigenous materials. For example, crafts such as the silk weaving of the Yonezawa clan (Yamagata Prefecture), indigo dyes of the Awa clan (Tokushima Prefecture), and cotton materials of the Himeji clan (Hyogo Prefecture), played important roles in promoting their clans' economies.[1]

Artisans set up shop in the bustling castle towns that were the center of clan commerce. Wealthy customers with discriminating and sophisticated tastes demanded exceptional textiles from master artisans in these castle towns. Such connoisseurs placed tremendous trust in the craft masters and the craft shops they patronized, thus creating a unique relationship in which the wealthy client recognized the craftsman's independent artistry. This particular atmosphere helped to foster the self-reliant "artisan's nature," which reinforced each master's individual creative energy, thus providing an important impetus to the development of utilitarian decorative crafts in Japan.

In the countryside, equally capable and dedicated artisans diligently created textiles in somewhat different circumstances. Much countryside weaving and dyeing was done by farm wives during the long winter hiatus in farm work. The meticulous stitches of *sashiko* quilting or the precise *kasuri* patterns on country jackets and bed covers illustrate the outstanding skill of farm wives and mothers who honed their techniques over years of devoted work. As an expression of love and care for their families, these domestic artisans spent countless days and nights producing genuinely utilitarian, superbly made textiles as a practical necessity. The simple and sometimes naive patterns of these folk textiles may not have the sophistication of their urban counterparts, yet the textiles' unassuming beauty, born in an environment that rewarded the self-sufficient, shines through. If these craftswomen did not show the difficult "artisan's nature" of the urban master, they nonetheless took sincere pride in crafting delightful and durable creations for their loved ones who, in turn, deeply cherished these special textiles.

The country garments and furnishings included in the Collection are mostly made of handwoven cotton, dyed in colors of natural indigo. Cotton was cultivated in Japan from the sixteenth to the nineteenth centuries. After locally grown cotton became available to villagers of modest means at the beginning of the seventeenth century, a new era began in Japanese rural life. Soft, durable, and relatively inexpensive cotton fabric dyed in Japanese indigo, or *ai* (a buckwheat, *Polygonum tinctorium Lour*), produced aesthetically pleasing village garments for daily use. It was discovered that repeated dipping in the dye bath built up layers of indigo deposits around each cotton fiber, producing a remarkably durable fabric.[2] Farmers wore indigo-dyed clothes for field work, believing the natural ammonia in indigo warded off poisonous snakes. Further, the dark shade of indigo blue conveniently hid the stains and dirt that could soil a working man's or woman's clothing. Silhouetted against a green rice field, the bent figures of farm men and women

dressed in dark blue indigo cotton jackets and trousers became a well-known visual symbol of the textile culture of the common people of Japan.

One unique group of indigo-dyed cotton textiles consists of ceremonial bed covers (*futonji*) made by village craftsmen that once comprised an important part of a village girl's bridal trousseau. The vigorous auspicious images – phoenix, paulownia leaves, Chinese lions, and good-luck treasures – that joyously decorate these bed covers were created through the time-consuming *tsutsugaki* technique. The term comes from the cone-shaped applicator (*tsutsu*) that was used to draw (*gaki*) outlines of motifs in rice paste on the cloth and to cover color-painted areas. When the cloth was repeatedly dipped in an indigo dye bath these areas resisted dye penetration and retained their original coloring.[3] These conspicuous textiles, demonstrating status and wealth, proudly accompanied the bride when she joined her husband's family. Following the wedding night, they were carefully preserved as treasures and rarely used thereafter. Thus, many of these vibrant textiles have survived intact.

Another unique group is a gathering of farmers' quilted cotton *sashiko* jackets that come from the northern regions of Honshu Island. I believe everyone can sense the unpretentious, subtle beauty present in these practical garments. In northern Japan, where cotton could not be cultivated, this fabric was a luxurious item. It is not unusual to see a jacket made of several pieces recycled from old clothes. The spontaneous assemblage of various old patches can create a surprisingly delightful visual effect. To increase durability, the farmers' modest jackets were meticulously quilted with precise stitches. This technique, known as *sashiko* (literally "pierced child"), probably began when simple parallel lines of straight running stitches sewed together several layers of cloth to create a warm and strong garment. In time, elaborate *sashiko* patterns were invented. Pure white cotton threads articulated clear geometric patterns – stripes, plaids, stars, and diamonds – on the somber blue fabric, thereby transforming a modest outfit into a stunningly handsome item of apparel. The *sashiko* stitches can be so precisely placed in exact intervals they sometimes fool our eyes into believing we are seeing woven patterns.

This *sashiko* tradition is shared by another significant group of quite different costumes – dramatic firemen's jackets, *kajibanten*. These jackets represent the buoyant masculine spirit of the daredevil commoners who volunteered as firefighters. During the Edo period, every few years conflagrations would rage through entire sections of Japan's large cities. Consequently, the daring

athletic abilities of citizen firefighters (*machi hikeshi*) were much admired.[4] Fire, a catastrophe for its victims, was mythologized as "the flower of Edo." Its hero, the firefighter who under showers of flaming debris clambered over roofs to pull down buildings in a fire's path, became an icon of masculine bravery lionized by urban commoners. The fireman's jacket was made of several layers of heavy cotton fabric reinforced with tight *sashiko* stitches to provide strong protection from heat and flames. The logo of the fireman's group was printed outside and, most remarkable of all, vivid pictorial images created by *tsutsugaki* or direct painting decorated the jacket's inside. Common images show martial deities, legendary heroes, samurai warriors, and magical animals engaged in combat with the evil enemy, fire. On ceremonial occasions the owner wore his jacket inside out, showing the dramatic images across the whole of his back, thus publicly boasting of his daring profession as fireman.

Another highlight in the Collection is a superb assembly of Ainu garments, which are distinctively different from their mainland Japanese counterparts. The Ainu are a unique, Caucasian tribal group that once lived on all the major islands of Japan. Because of centuries of Japanese political domination, they now are found largely on the northernmost island of Hokkaido and have been extensively assimilated into Japanese culture. The textile art of the Ainu, which is deeply expressive of their ancient shamanistic religion, speaks strongly of the Ainu culture's special nature. Ainu weavers used local natural materials – bark from elm or linden trees – to make many traditional garments; others were fashioned of cotton that was secured in trade with mainland Japan. Characteristic of Ainu outer garments is a stunningly bold surface embellishment, consisting of dynamic graphic patterns created by appliqué and embroidery. Solid indigo blue, black, or white cotton fabrics cut into swirling net-like patterns were appliquéd on the ground cloth, and over the appliqué animated linear designs were embroidered in contrasting colors. These efficacious patterns were concentrated around a costume's neck, sleeve openings, and bottom in the belief that they would prevent evil spirits from entering these vulnerable openings. The wide use of appliqué by Ainu artisans stands out as unique within Japanese textile culture, where appliqué has never been evident in the mainstream of textile design.[5]

The Collection also contains exceptional Okinawan textiles coming from the opposite extremity of Japan. Okinawans believed, as did the Ainu, that a woven garment enfolding the body would protect the soul (*mabui*) residing within. Typical garments worn by Okinawans utilize an unusual fiber taken from the wild banana plant, *liukiu-bashô* (*Musa sapientum*, L. var *liukiuensis Matsumura*). Fibers from sixty banana stalks were required to make one kimono of "banana-thread cloth," or *bashôfu*.[6] Lustrous and durable, *bashôfu* garments are cool to the touch and elegant to the eye. Most of the *bashôfu* kimonos in the Collection are dyed in fine *kasuri* patterns. The art of *kasuri* was introduced from Southeast Asia before the seventeenth century, when Okinawa was an independent kingdom engaged in extensive inter-Asian trade. Local artisans who learned the imported technique (called *ikat* in Indonesia) developed stunningly intricate patterns to decorate their garments. The *kasuri* process involved the tedious work of tie-dying warp or/and weft threads in predetermined patterns prior to weaving. The correct weaving of the pre-patterned threads was another time-consuming undertaking. The entire process, from growing the *bashô* plants, to tie-dyeing the threads, and weaving the fabric could involve two years of effort. To the women of Okinawa who made *bashôfu* fabric, their endeavor was very much like a life ritual spanning many seasons. Okinawan *bashôfu* textiles certainly stand out as unique within Japan.

In stark contrast to the reserved, if often dynamic, folk textiles of Japan just described, the Collection contains many sophisticated ceremonial robes, children's costumes, and men's under kimonos dyed in *yûzen* resist technique designed for urban wear.[7] They were meticulously crafted of precious silk or delicate ramie, reflecting their owners' elegant tastes and their makers' singular workmanship. *Yûzen* dyeing was developed in Kyoto during the seventeenth century in response to numerous sumptuary edicts issued by the Tokugawa government. The most severe law in 1683 prohibited the making or wearing of luxurious garments, specifically those decorated with gold brocade, embroidery, or elaborate tie-dye patterns.[8] Avoiding the forbidden methods, a group of Kyoto artisans began using the *yûzen* dyeing technique to make sophisticated and exceptionally beautiful garments that would appeal to their wealthy clients. *Yûzen* designs were made partly through *tsutsugaki* rice-paste resist technique, using an extremely fine tipped applica-

tor (*tsutsu*) and by painting patterns directly on the cloth surface.[9] Without dip-dyeing, the *yûzen* technique created fragile flowers, birds, and animals, delicately outlined in white, that glow in subtle and varied shades. Bold, country *tsutsugaki* textiles and exquisite, urban *yûzen* fabrics were outgrowths of the same fundamental paste-resist process. But while the two types of textile began their journey together, they arrived at quite different destinations. The visual and spiritual distance between the two became substantial, perhaps showing that our textile heritage stems directly from the hearts of people living in particular times and particular places.

Today, to our amazement, Japanese artisans still continue to make most of the handcrafted textiles described here. Perhaps the long tradition of independent *shokunin* with their stubborn "artisan's nature" has helped craftsmen persevere in spite of the great technological changes that have occurred in the twentieth century and in spite of the devastation of the Japanese economy during World War Two. Japanese culture today embraces both the traditions of past eras and the inventions of our electronic and computer age. If we enter one of Tokyo's or Osaka's enormous department stores, we will encounter a flood of machine-made, chemical-dyed textiles, ranging from inexpensive synthetic underwear to name-designer silk clothing. Yet to our delight, in a section of one bustling floor we will see counters devoted to traditional indigo-dyed *sashiko* jackets, *kasuri* kimonos, and *tsutsugaki* room dividers (*noren*). And, if we proceed to one of the small streets that run off Tokyo's fashionable Ginza Avenue, we will find a tiny shop hidden between towering high-rise buildings where handmade *tabi*, or socks, or perhaps handwoven *obi*, are sold. In front of the shop there will hang a serene indigo-blue *noren* that proudly bears the shop's giant logo. Perhaps we will meet the craftsman who makes these traditional objects, a person who has the same determined, stubborn air typical of Japanese *shokunin* down through the centuries.

A major contribution to the survival of traditional textiles in Japan is the national government's unique preservation policy begun in 1950. Under the Protection of Cultural Assets Law *(Bunkazai Hogohô)* crafts of unique value are recognized as Important Intangible Cultural Assets *(Jûyô Mukei Bunkazai)* and important master artisans or groups are identified as Craft Preservers (*hojisha*). In 1991, seven textile artisans and five textile groups were among those so honored.[10] This national effort soon stimulated prefectures and cities to establish similar laws honoring regional crafts and local artisans.

In western Japan live several generations of the Nagata family of Izumo City who have been designated an Important Intangible Cultural Asset of Shimane Prefecture. They continue to produce huge indigo-dyed *tsutsugaki* wrapping cloths that are decorated with longevity images of cranes and turtles. These felicitous textiles are ordered by clients for family weddings. I remember Mr. Nagata standing calf deep in the clear flowing water of the Takase River fronting the Nagata dye shop, diligently washing off rice paste to reveal the deep blue hues of a new wedding gift, while cars and trucks rushed indifferently by.

The remarkable value of traditional crafts in today's society is now recognized not only by scholars and craft collectors, but by youthful connoisseur consumers as well. Some young Japanese, who have become sated with contemporary slickness, have discovered qualities of beauty, tradition, and utility in the honest folk textiles produced by dedicated regional artisans. Surely, as long as the profound human touch of contemporary *shokunin* is appreciated by some individuals in each generation, Japan's traditional textile culture will continue to enrich our daily lives by connecting us to the past and to history. It is a joy to know that individual handcrafts are alive in contemporary Japanese society.

The superb Japanese textiles in this Collection comprise an important repository of a living art that is both beautiful and practical, an art that wonderfully mirrors the spirit of the Japanese people.

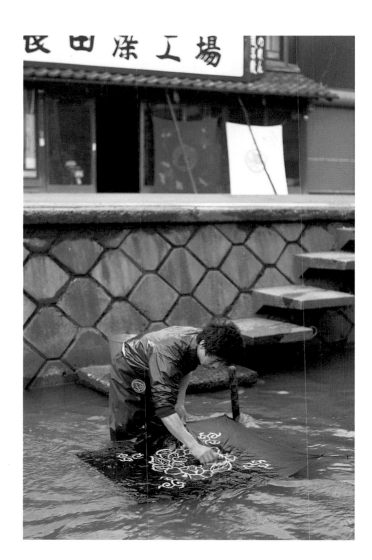

PLATE 54

Nagata Shigenobu, *tsutsugaki* dyer of Izumo City, stands in the Takase River, scraping off the rice paste from a finished ceremonial wrapping cloth. 1986. (Photo: James R. Brandon)

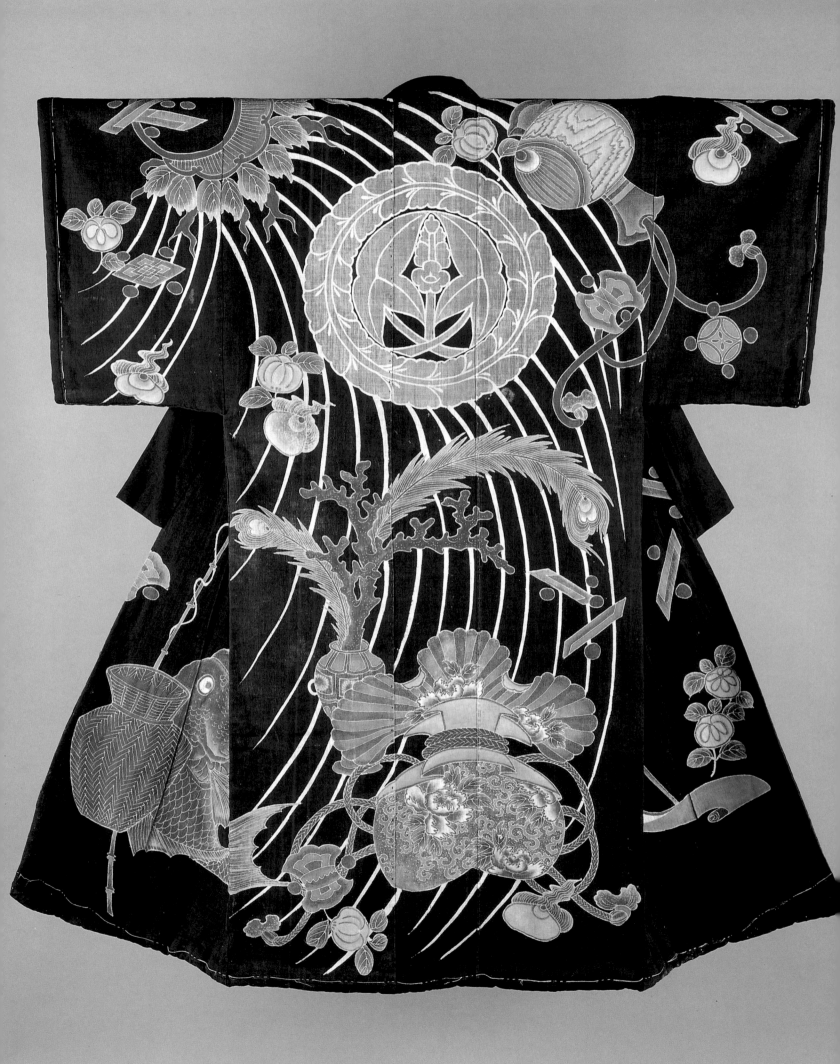

PLATE 55 and PLATE 56 (detail of Plate 55)
Bridal Sleeping Cover (*Yogi*)
Probably Kyushu Island
Western Japan. Nineteenth century
Rice-paste resist (*tsutsugaki*), painted
pigments; plain weave cotton
64½ x 56" (164 x 142 cm.)

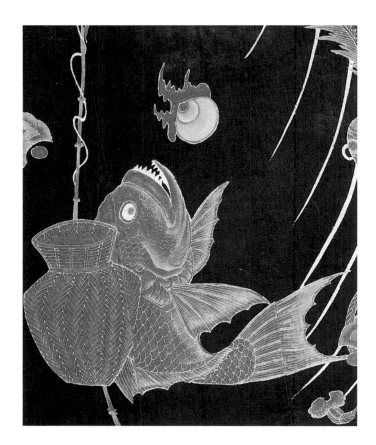

The countryside of western Japan is the birth-place of a great many *tsutsugaki* wedding textiles. A young farm woman and her family would spin the cotton and weave the cloth for special textiles that would become an important part of her wedding trousseau. After artisans in the local dye shop drew auspicious *tsutsugaki* motifs on the fabric and dyed it indigo blue, the color-ful material was sewed into *furoshiki* (wrapping cloths), *utan* (chest covers), and *futonji* (bed covers) by the bride-to-be, her mother and sis-ters, and other female relatives. The work could take as long as six months to a year to complete. On her wedding day the bride would travel in a grand procession to her new family's home, each item in her trousseau conspicuously covered by a beautiful, new *tsutsugaki* textile. One item in the trousseau of special interest was an unusual coverlet called *yogi*, literally "night wear," made in the shape of an extra-large kimono (an addi-tional panel of cloth in the back widens it con-siderably). *Yogi* first came into use in the Edo period (1603–1868). Because of its shape, it fits tightly around the shoulders and neck, provid-ing excellent protection against the winter cold.

This wonderfully luxurious *yogi* is decorated with brilliant images of traditional good-luck motifs commonly known as *takara zukushi* (Col-lection of Treasures). An abundance of good fortune showers down in streamers from the right shoulder of a *kakure mino*, or hiding cape, that makes the wearer invisible. An *uchide no kozuchi*, or mallet of good fortune, on the right shoulder pounds out good luck, while an ele-gantly decorated *kanebukuro*, or money bag, at the bottom, bulges with the promise of wealth.

Images of other treasures – the *tachibana* (orange flower and leaves) promising succulent fruits, *shippô* (Seven Treasures) in a lozenge shape, and *fundô* (merchant's weight), a symbol of wealth – are scattered across the ground. Joining these classic good-luck symbols are peacock feathers and coral in a vase, both symbolizing wealth and luxury. In addition, perhaps the most delight-ful and unusual image on this *yogi* – a huge red snapper (*tai*) accompanied by a fisherman's creel and fishing pole – decorates the lower left front (plate 56). This delicious fish is a popular good-luck symbol because its name is a homonym of the word *medetai*, meaning "auspicious." Serving a dish featuring a whole *tai* was expen-sive, and reserved for special guests on an important occasion such as a wedding feast. This majestic, realistically drawn red snapper humorously leans against a creel that is much too small to hold it. This surprisingly lively, imaginative design – a *tai* "harvested" on an auspicious bed cover – is from the hands of a talented country artisan, unrestricted by rules or fads that often controlled the city craftsman. In the midst of these celebratory motifs, a large family crest of *fujiwa-omodaka* (wisteria ring and water plantain) conspicuously testifies to the status and wealth of the owner.

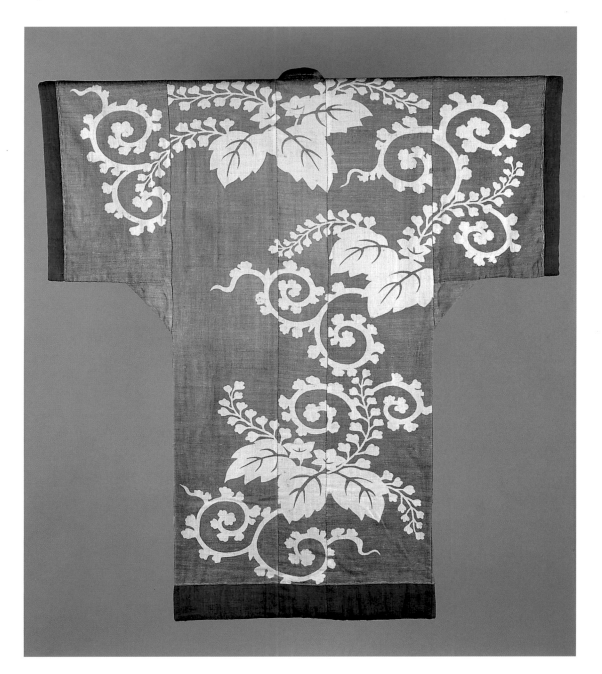

PLATE 57

Bridal Sleeping Cover (*Yogi*)
Western Japan
Nineteenth century
Rice-paste resist (*tsutsugaki*); plain
weave cotton and silk
64⅛ x 61¾" (163 x 157 cm.)

As seen in this example, many *yogi* are spaciously constructed with triangular gussets at the bottom of the sleeves and an extra central panel inserted at the back. Such a roomy design allows the sleeper to move freely under the *yogi* during the night. This cover is woven in silk and dyed moss green, unusual features for country *tsutsugaki* textiles. Its dynamic masculine image suggests that it was perhaps created, not for a wedding, but for some other ceremonial occasion. The cover is decorated with paulownia flowers and leaves of enormous size. The paulownia, or *kiri*, tree is cherished in Japan. In early summer its large bell-shaped flowers of pale lavender release a sweet fragrance into the air, and craftsmen prize its light, strong wood for

making *koto*, elegant boxes, or utilitarian objects such as clogs. On this green *yogi*, swirling tendrils extending from the flowers and leaves curl energetically into a familiar arabesque design, known as *karakusa*, or Chinese vine. *Karakusa* has been a popular textile motif since the Nara period (646–794). It is said to have been derived from both the lotus and palmetto shapes of ancient Egypt and the twisting bodies (minus heads and legs) of Chinese dragons. Simple stylized *karakusa* patterns such as these were especially well-liked in the nineteenth century and often decorated country textiles. Here paulownia and *karakusa* motifs are successfully combined in an expression of animated energy.

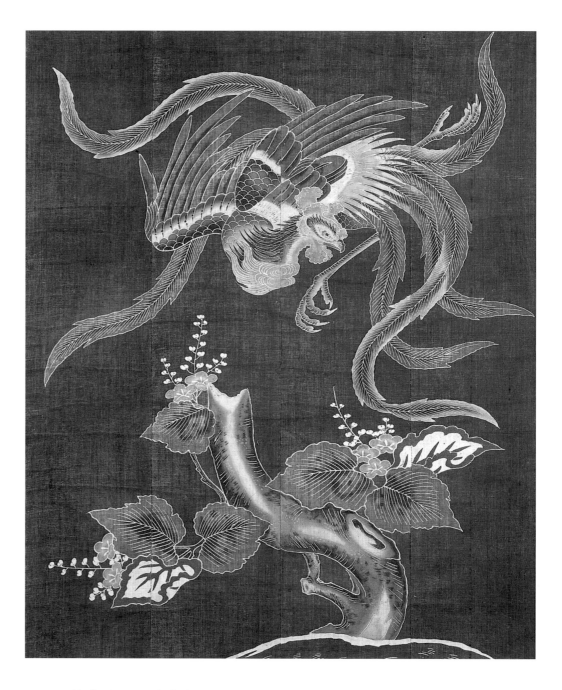

PLATE 58

Bridal Sleeping Cover (*Futonji*)
Kyushu Island, Japan
Nineteenth century
Rice-paste resist (*tsutsugaki*), painted
pigments; plain weave cotton
55⅛ x 51½" (140 x 131 cm.)

This classic rectangular bedding cover, or *futonji*,
that once covered the top of a stuffed bridal
futon, is made of four panels seamed together
lengthwise. The design brings together the
well-known imagery of the auspicious *hô-ô*
(phoenix) and *kiri* (paulownia tree), superbly
drawn to celebrate the happy occasion. The
phoenix and paulownia are intimately associ-
ated in Chinese legend, for the only place a
phoenix can alight is on a branch of paulownia.
Otherwise, this mythical bird flies with the clouds
and lives solely on holy sweet water and bam-
boo seeds. It is seen only on special occasions,
such as the appearance of a truly virtuous ruler.
The phoenix is a composite animal whose color-
ful trailing feathers represent the traditional

virtues – truthfulness, propriety, righteousness,
benevolence, and sincerity. So its image is quite
appropriate on a bridal gift such as this *futonji*.
The precise drawing of the slender phoenix, the
fine but sharp white *tsutsu* lines that articulate
scenic details, and the delicate shading of the
dye tones testify to the experienced hand of a
master artisan. The result is a bridal masterpiece
that exactly conveys a quiet, feminine delicacy,
and at the same time, brims with life.

PLATE 59
Bridal Bed Cover *(Futon)* or
Chest Cover (*Utan*)
Western Japan. Nineteenth century
Rice-paste resist (*tsutsugaki*),
painted pigments; plain weave cotton
76 x 61¼" (193 x 157 cm.)

An imaginative and rhythmic imagery cele-
brates this bridal textile. Six red lobsters with
long antenna play with a winding *shimenawa*,
or Shinto straw rope. The lobster is a popular
symbol of longevity because its bending body
suggests old age: bright red, cooked lobsters are
a necessary food at a wedding feast, and lob-
ster replicas frequently decorate offerings and
gifts as a symbolic connotation of happiness.
The *shimenawa*, or sacred rope, is an ancient
and distinctive Shinto decoration. A *shimenawa*
hung in the worship hall or at the *torii* gate of a
shrine delineates the sacred area of the gods.
In various shapes, it may be hung for the New
Year season at the entrance to a home, where it
will prevent the entry of evil. A *shimenawa* may
be decorated with fronds of fern known as
urajiro and with the leaves of the *yuzuriha* tree.
The *urajiro,* literally "white back," is tied to
show the white side of the leaves, thus symbol-
izing purity. Its fronds always grow in pairs,
which represents the happiness of marriage.
The *yuzuriha,* because its leaf remains green and
growing until it is replaced by a new leaf, con-
notes continuity. In this *futon* cover design, we
see celebratory fronds and leaves attached to
the rope at regular intervals. Straw tassels, too,
hang from the rope, following a regional style
of *shimenawa* design. The family crest of plum
blossoms, a symbol of wisdom and bravery,
appears at the top, reinforcing the family's wish
for protection for the newlywed couple.

PLATE 60

Ceremonial Textile

Western Japan. Early Twentieth century

Rice-paste resist (*tsutsugaki*),

painted pigments; plain weave silk

60 x 48' (152.5 x 122 cm.)

The popular motif, *karajishi botan*, Chinese dragon and peonies, majestically embellishes this exceptional textile. The *tsutsugaki* rice-paste resist technique and *tsutsugaki* patterns seen here are popularly used for country bridal *futon* covers, but the use of silk material dyed in mustard-yellow, place this piece in a special category. (It has been suggested that it may be a celebratory decorative hanging rather than a cover.) The paired motifs of a Chinese dragon and peonies are closely associated with the celebratory Nô drama, *Shakkyô* (Stone Bridge). The play dramatizes the legend of Jakushô, a Japanese monk traveling in China who stops at a stone bridge and is told the land beyond is ruled by Monju (Manjusuri), the Bodhisattva of wisdom. A lion then appears and dances energetically among peony blossoms to celebrate longevity and a felicitous life. Following yin-yang cosmology, a lion is a masculine manifestation of energy, while peonies are a feminine manifestation of beauty and sexuality. Lion-peony motifs are therefore appropriate for the sacred occasion of a marriage, when a man and a woman join together to begin a new life.

The design composition of this piece is bold yet well balanced. The swirling mane and tail of the rather humorous lion seem to sway in the same rhythm as the huge blossoms, while the rounded body of the lion provides a solid center. The delicate shading of blue, red, and brown vibrate pleasantly against the mustard-yellow background. In all, the coloring is reminiscent of Okinawan textile sensibility.

PLATE 62

Fisherman's Ceremonial Coat (*Maiwai*)
Boso Peninsula, Chiba Prefecture
Japan. Late Nineteenth or early
Twentieth century
Rice-paste resist *(tsutsugaki)* painted
pigments; plain weave cotton
64 x 50" (162.5 x 127 cm.)

Southeast of Tokyo, on the coast of the Boso
Peninsula, where the Pacific Ocean's strong
waves wash the shore, fishermen wore special
ceremonial outer kimonos called *maiwai* (abun-
dant celebration) to inaugurate the New Year,
and on other important festival occasions.
Usually dyed in indigo blue, the garment was
decorated with dynamic good-luck symbols.
The design of this *maiwai* incorporates a large
bundle of *noshi* – long strips of dried abalone, a
symbol of longevity – over which a gigantic
lobster moves, spreading its long antenna. Its
curling body, reminiscent of old age, symbolizes
long life and happiness. Chinese characters read-
ing *tai-ryô* (great catch) appear diagonally over
the motifs. At the top of the kimono, a crane
in flight towing a small banner printed with the
same characters, *tai-ryô*, is superimposed over
a red logo. When a ship's catch was especially
abundant, the ship's owner would present crew
members with specially ordered *maiwai*. Fisher-
men proudly wore the auspicious *maiwai* at
festival times to announce their good fortune
at sea and demonstrate their comradeship.

PLATE 61

Wrapping Cloth (*Uchukui*)
Shuri, Okinawa Islands
Japan. c. 1900
Rice-paste resist (*tsutsugaki*), painted
pigments; plain weave ramie
40½ x 40½" (103 x 103 cm.)

Called *furoshiki* on mainland Japan, and *uchukui*
in Okinawa, a Japanese wrapping cloth is a sim-
ple square of cloth that can be made of almost
any material and in any size. Flexible, light,
and easy to use, it can wrap, cover, or bind up
almost any object. In Okinawa, wrapping cloths
for ceremonial purposes were made of fine
ramie and cotton material using the *tsutsugaki*
(*nuibichi* in Okinawan) rice-paste resist dyeing
technique. This superb ramie wrapping cloth
depicts typical auspicious *uchukui* patterns: bloom-
ing plum trees and pine clusters intersecting
a circle of bamboo. The three auspicious trees,
known as "the three friends of the cold season,"
were especially popular on ceremonial occa-
sions for they symbolize longevity, fidelity, and
integrity, the three virtues required of a man
or woman facing the hardships of the "cold
season" of life. Originating in China, the joint
motif is called in Japan *shôchikubai* (pine-bam-
boo-plum) and is perhaps the most popular
decoration used at weddings. This *uchukui* prob-
ably wrapped or covered ceremonial gifts at
an important wedding. The warmly hued images
comprising the *shôchikubai* motif are lightly
juxtaposed against a deep indigo-blue back-
ground. At the center, an unusual family crest
in white is gently surrounded, and protected,
by the encircling auspicious trio of trees.

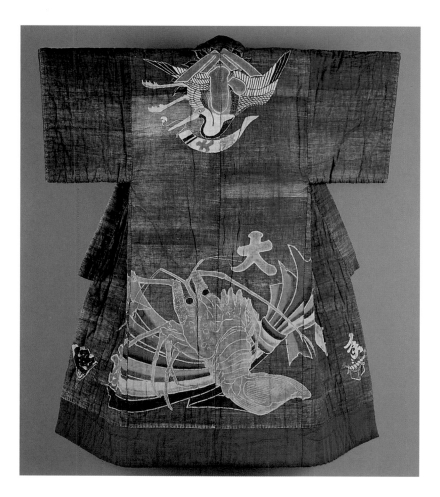

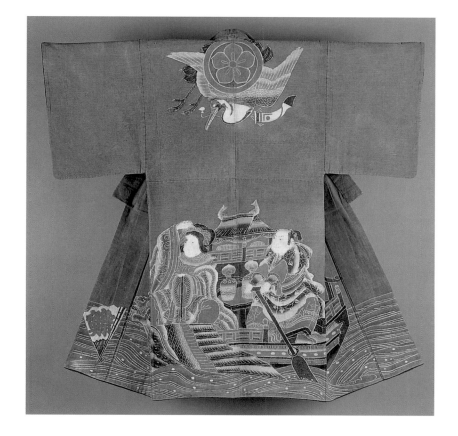

PLATE 63

Fisherman's Ceremonial Coat (*Maiwai*)
Boso Peninsula, Chiba Prefecture
Japan. Late Nineteenth century
Rice-paste resist (*tsutsugaki*), painted
pigments; plain weave cotton
64 x 50' (162.5 x 127 cm.)

This handsomely made *maiwai* is enlivened
with an image from the well-known folk tale
Urashima Tarô. One day, a young fisherman
from the Tango region, named Urashima,
saves the life of a turtle. The turtle, grateful for
Urashima's kindness, takes him to Dragon
Castle (*Ryûgûjô*) at the bottom of the sea. There
he meets a beautiful princess and spends 300
wonderful years together with her in this eter-
nal paradise – while imagining it was only three
days. When the time comes for him to leave,
the princess presents him with a *tamatebako*, a
treasure box, that he promises he will never
open. Returning home, Urashima finds that all
the people he knew are gone and all the familiar
things no longer exist. Deeply depressed, he
opens the box and, as white smoke billows forth,
he is transformed into an old man. This ancient
tale associated with the sea appropriately deco-
rates the lower half of the fisherman's *maiwai* –
the whimsically humorous image of Urashima
and the princess conveying the human wish for
longevity and everlasting happiness. At the
top center, the ship owner's plum crest is super-
imposed over a flying crane motif.

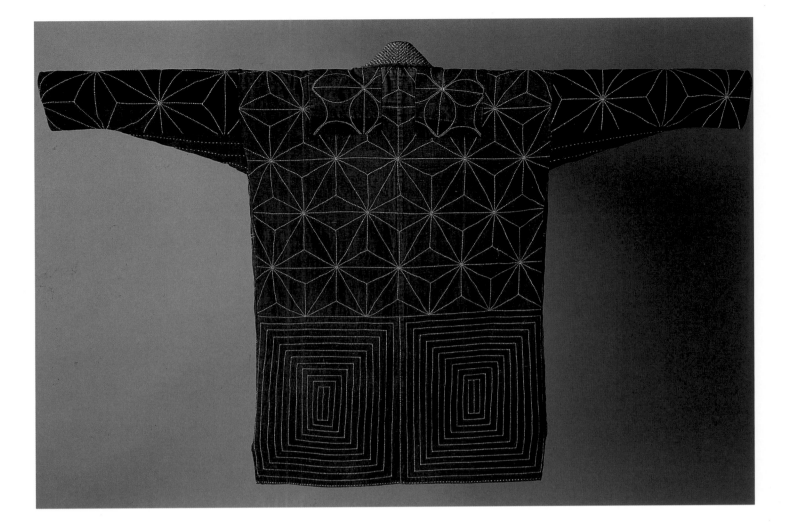

PLATE 64

Farmer's Jacket

Yamagata Prefecture

Japan. Early Twentieth century

Cotton quilting (*sashiko*) on

plain weave cotton

49 x 47¼" (124.5 x 120 cm.)

In modest households of farmers and fishermen in northern Japan, expensive cotton fabrics were continuously recycled. Often, several layers of used cotton cloth were quilted together to make a durable fabric. As seen in this *sashiko* jacket, the sleeves are narrow and tapered and the body is relatively slim and short, practical features for a work garment. Precise white cotton quilting stitches (*sashiko*) not only reinforce the strength of the cloth, they also produce wonderful "optical" designs on what is otherwise a somber and modest garment. This well-used jacket is particularly pleasing. Several different fabrics, probably salvaged from older *sashiko* garments, have been patched together. The lower half of the back quietly vibrates with closely-arranged, nesting squares, while the upper back comes alive in a three-dimensional *asa-no-ha* (hemp leaf) pattern composed of interlocking diamonds, triangles, and hexagons. Hemp stalks produced durable weaving threads from which most commoners' clothing was woven before cotton was introduced. Hemp,

which grows energetically in poor soil, represents health and endurance. Because of this association, the stylized, interconnected pattern of hemp leaves is perfectly suited to a farmer's working garment. A rectangular patch of different material reinforces the back of the neck. Its *sashiko* patterns of round leaves soften the sharp visual tone created by the straight lines of the hemp leaf motifs. Whether a particular assemblage of patches is intentional or not, the subtle beauty of the patterns makes this type of modest clothing very, very special.

PLATE 65

Coat

Northern Japan

Early Twentieth century

Cotton quilting (*sashiko*) on plain weave cotton

48½ x 48" (123 x 122 cm.)

This elegantly graphic kimono was made in the style of work clothes and was probably used as casual wear. However, it is obvious that the elaborate *sashiko* decorations were carefully designed and executed to achieve visually exciting effects – a tribute to the imaginative talent of its unknown domestic creator. The robe is densely decorated with highly precise stitches. The lines are so regularly stitched that many parts of the kimono appear to consist of woven patterns. For example, the upper half of this kimono is graced with parallel zigzag lines that are repeated so exactly they look like a woven herringbone twill.

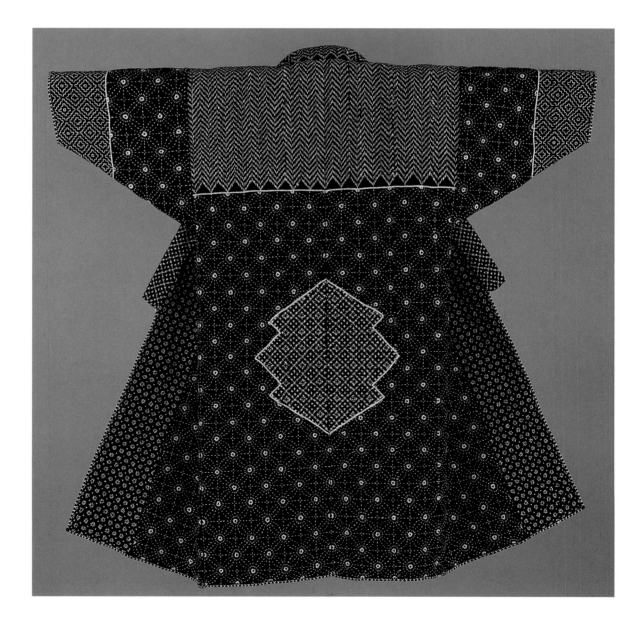

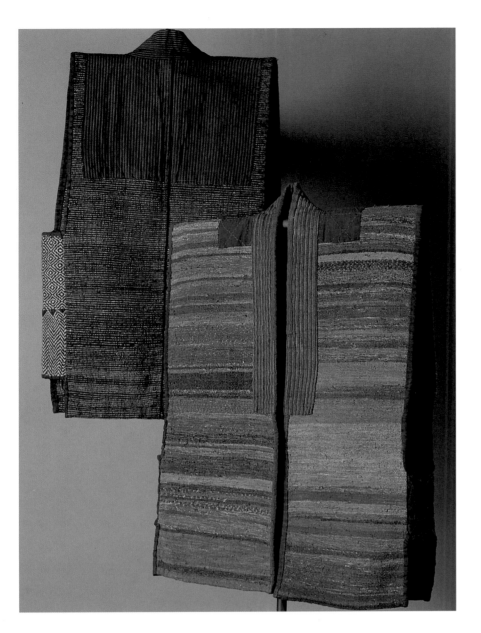

PLATE 66
Farmers' Vests
Japan Sea Coast. Early Twentieth century
Cotton quilting (*sashiko*) on plain weave
cotton strips (*sakiori*)
Right: 30 x 25" (76 x 63.5 cm.);
Left: 30 x 20⅞" (76 x 53 cm.)

The garment that covered the body of a hard-working villager in northern Japan underwent a long journey of transformation from the time it was first worn to its final days as cloth scraps. All Japanese clothing follows a unique straight-cut method construction in which front, back, and sleeves are made from rectangular pieces of cloth of the same width. Therefore, it is relatively easy to resew or recycle these cloth panels. When a kimono was washed it could be taken apart and the panels rearranged to disguise worn areas. Right and left panels of sleeves could be exchanged to replace frayed sleeve openings. Badly worn sections could be discarded in order to transform a full-length kimono into a short jacket or sleeveless vest. Discarded panels could be patched together to make cushions or bed covers. And finally, a worn-out country textile could be torn into narrow strips and the strips woven into a new fabric, a technique known as *sakiori* (tear and weave). Women in fishing and farming villages along the Japan Sea Coast were adept at producing wonderful *sakiori* garments. As these two vests attest, through the careful choice and variation of colors and textures, their makers were able to create quite charming and exceptionally durable clothing from reworked pieces and remnants. The shoulders and collars have been reinforced by pieces of striped fabric recycled from other garments. The side panels of the one vest are decorated with dense *sashiko* zigzag and diamond patterns. Unpretentious and extremely practical, these long-lasting *sakiori* vests exude a serene and homely beauty that is undiminished by their many seasons of hard use.

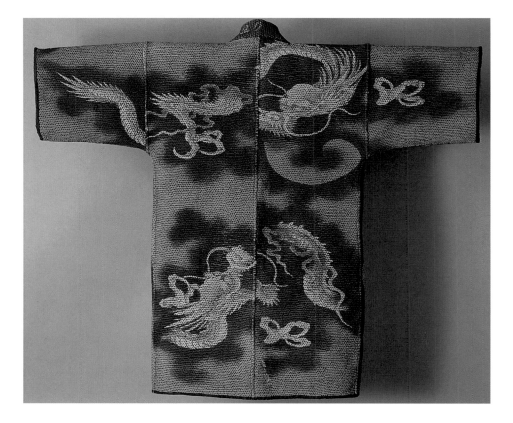

of a city. These professional firemen held mundane daily jobs as gardeners, carpenters, and construction workers, and on these jobs they also wore their coats to reflect a sense of pride and to claim credit for their hazardous, occasional occupation.

The inside of a fireman's coat, particularly one worn by a chief, is often decorated with dynamic pictorial images appropriate to his hazardous calling. Although the same subject matter is used repeatedly, these eye-catching images are usually one-of-a-kind, drawn individually for each garment. The inside of this coat (see plate 69) is adorned with fierce dragons whose twisting bodies and tails emerge from swirling black clouds. Their clenched claws viciously protrude from their bodies, and red flames blaze from their mouths like lightning bolts. This skillfully painted image of fearsome animals obviously symbolizes the tremendous force of the fire that challenged the firemen. At the same time, the mythical dragon's godly power embraces the fireman's body, offering him sacred protection. For the New Year and other special occasions – such as visiting fire victims to offer condolences after a fire had been put out – a fireman proudly wore his jacket inside out to display its prominent pictorial design.

PLATE 67 and PLATE 68 (outside of Plate 67)
Fireman's Coat (*Kaji Banten*)
Japan. Late Nineteenth century
Rice-paste resist (*tsutsugaki)*, painted
pigments, and cotton quilting
(*sashiko)* on plain weave cotton
42⅛ x 51" (107 x 129.5 cm.)

Firemen in Edo and other cities were famous for both the great pride they took in their profession and for their fantastic fire-fighting costumes. Their coats, tightly fitting trousers, and hats were made of several layers of cotton fabric painstakingly quilted together with *sashiko* stitching. The thick, padded garments, often soaked in water before they were worn, protected the men from the intense heat and falling embers that they had to endure while fighting the many fires that plagued Japan's large cities. Firemen's coats are decorated on the outside with simple, dynamic patterns. Here, a wide red band at the top and three white undulating bands in the midsection stand out against a deep indigo blue background. Customarily all the members of a fire-fighting company wore coats with the same basic design on the outside, like a uniform. The large stylized character juxtaposed over the red band at the back is the owner's first name, Kiyoshi (the owner's full name, Hashimoto Kiyoshi, appears on the front lapel). The unique construction and graphic design of the coat clearly identified the fireman and his company when occupied in their dangerous task of fighting fires. In the early days, firemen were resident volunteers, but soon professional fire companies were established in each section

PLATE 69
Fireman's Coat (*Kaji Banten*)
Japan. Late Nineteenth century
Rice-paste resist (*tsutsugaki*), painted
pigments, and cotton quilting
(*sashiko*) on plain weave cotton
50 x 48" (127 x 122 cm.)

A legendary battle scene, skillfully painted on the rough cloth surface, embellishes the inside layer of this fireman's coat. The painting depicts Minamoto no Yorimitsu, a warrior of the Genji clan of the eleventh century, well known for his martial art and for his bravery, in seeking out and killing the giant spider-demon, Tsuchigumo. This popular tale, included in the *Tale of Heike*, a chronicle of the downfall of the Heike clan (twelfth century), was first dramatized in the classic Nô theater and later adapted to the spectacular Kabuki stage. The painted image of the coat parallels the scene shown in Kabuki production as well as popular paintings of the time. A gigantic spider web stretches like a spreading fire, below which Yorimitsu, representing a brave fireman, slashes at the head of the demonic spider, symbolic of the fire, with his magic sword. This painting was probably drawn by a professional painter, or at least was based on his cartoon. It is said that vertically elongated compositions were chosen for the inside of firemen's coats so that the painted image would not be spoiled when the *sashiko* stitching and many washings caused vertical shrinking of the cotton material.

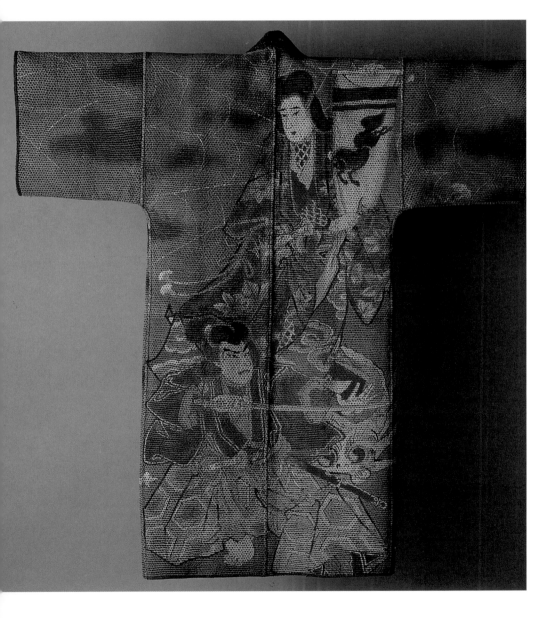

PLATE 69
Fireman's Coat (*Kaji Banten*)

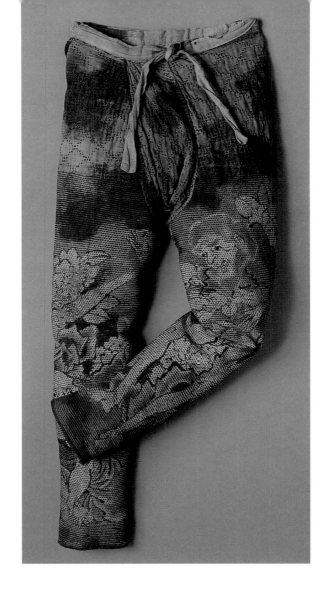

PLATE 70 and PLATE 71 (detail of Plate 70)
Trousers (*Momohiki*)
Japan. Nineteenth century
Painted pigments and cotton quilting
(sashiko) on plain weave cotton
35¾ x 35¾" (91 x 91 cm.) (waist circumference)

Japanese first encountered Westerners face-to-face when Portuguese ships began to appear in ports in Kyushu in the 1540s. These Portuguese trade ships brought pepper from Sumatra and Java, and silk from China to be bartered for Japanese silver; they also brought Jesuit missionaries who introduced Christianity to Japan. Christianity spread rapidly through Japan, protected by the paramount military ruler Oda Nobunaga (1534–1582) and tolerated by his successor, Toyotomi Hideyoshi (1537–1598), who saw political as well as economic advantage in these contacts with exotic Europe. The Tokugawa government (1603–1868), however, fearing the rising influence of Christianity, totally banned the foreign religion in 1614 and instigated a notorious persecution of believers thereafter. Except for one Dutch merchant ship that was allowed to bring trade goods into Nagasaki each year, Japan severed all ties with Western powers during the following 250 years. Japan's isolation ended in 1853 when Commodore Matthew Perry arrived in Tokyo Bay with a squadron of American "Black Ships" to demand that trade be opened with Western nations. In 1854, the Tokugawa government signed treaties with the United States, Britain, and Russia that inaugurated a flood of commerce and communication with the outside world. Once again, Japanese encountered Western sailors and merchants. From their first meeting with the Portuguese in the sixteenth century, Japanese have called Westerners *nambanjin*, "southern barbarians," and have portrayed them as strange-looking foreigners in scenes painted on numerous

screens and scrolls, and in decorations on furniture, utensils, and other objects. However, images of foreigners are quite rare on utilitarian fabrics. This pair of tightly fitting trousers was possibly worn by a fireman in the late Edo period. It is extremely unusual in depicting two Westerners, one on each leg. The faces have stereotypical *namban* features, round eyes, bright red hair and beards, and long noses. Clad only in simple jackets and short trousers, the two are portrayed with startled expressions on their faces. We can easily understand that Japanese living in the mid-nineteenth century who had only known a homogeneous society would feel tremendous curiosity and awe toward exotic Westerners, as well as fear of these unknown people.

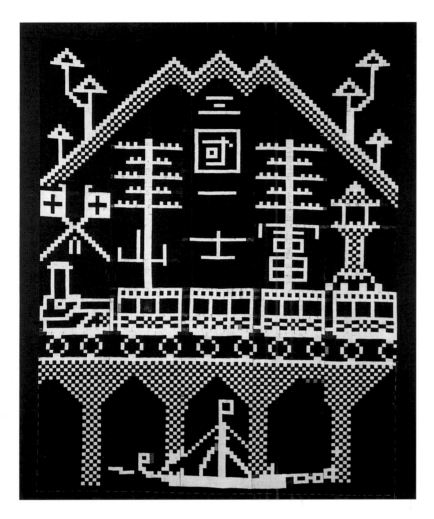

Ceremonial Rain Cape (*Kera*)
Akita Prefecture, Japan
Twentieth century
Twined and knotted; grass,
seaweed and cotton
39 x 18⅞" (99 x 48 cm.)

A cape made of rice straw was once an indispensable article of clothing for a Japanese villager: draped over the shoulders, it protected the wearer from rain or snow. Elaborately decorated rain capes were reserved for festive occasions such as the New Year or a wedding ceremony, as with this excellent example. This cape from Akita Prefecture in northern Japan, known as *kera*, is made with wild grass called *mige* and seaweed, special materials indigenous to the area. The neck yoke is meticulously twined with white and black cotton thread that create *yabane*, or arrow feather, designs. The body of the cape is made of bundles of grass knotted together that overlap, like roof shingles, from top to bottom. Long strands of black seaweed, known as *umikusa*, are added at the center of this cape as a design element. Previously, the seaweed strands were soaked in a muddy field so they could absorb natural iron from the earth to create a deep, shiny black color.

PLATE 72
Bed Cover (*Futonji*)
Kurume City, Kyushu Island, Japan
Late Nineteenth century
Weft ikat (*kasuri*); plain weave cotton
88½ x 70" (225 x 178 cm.)

The *kasuri*, or ikat, technique was introduced to Japan from the Ryukyu Islands (Okinawa) in the seventeenth century. After Okinawa was invaded and conquered in 1609 by Japanese warriors of the Satsuma clan (present Kagoshima Prefecture), Okinawa's famed ramie textiles were brought to Satsuma as tribute. Many of them were made in *kasuri* technique, thus planting the seeds of this intricate dyeing process in mainland Japan. *Kasuri* fabric making was well developed in the Satsuma region in the mid-eighteenth century, and by the beginning of the next century the technique had become widespread throughout the country. The Okinawan tradition of reserving delicate ramie *kasuri* cloth for elite consumers was continued on the mainland in the prestigious *kasuri* patterned ramie cloth produced in Niigata Prefecture near the Japan Sea. However, in general in Japan, *kasuri* technique was widely used to make everyday cotton clothing.

This skillfully made bed cover in weft *kasuri* comes from Kurume City, Fukuoka Prefecture, Kyushu Island. Kurume was an early, major *kasuri* center and its traditional *kasuri* technique has been recognized as an Important Intangible Cultural Asset since 1957. Their large pictorial *kasuri* designs are particularly well known. The intriguing images of a steam locomotive, iron bridge, and electric poles depicted on this piece reflect the first stage of Japan's industrialization in the Meiji period (1868–1912). This *kasuri* dyer was obviously inspired by the fascinating new inventions of the modern era. Her, or his, rather naive composition conveys the almost child-like curiosity and excitement of the early period of bringing elements of the Western world into Japan, set against the powerful backdrop of the sacred Mount Fuji. Below the peak of Mount Fuji, three vertical characters read: "Best in the Country" (*san-goku-ichi*, literally "first in three countries"). And three horizontal characters above the train, reading from right to left, say "Mount Fuji" (*fu-ji-san*).

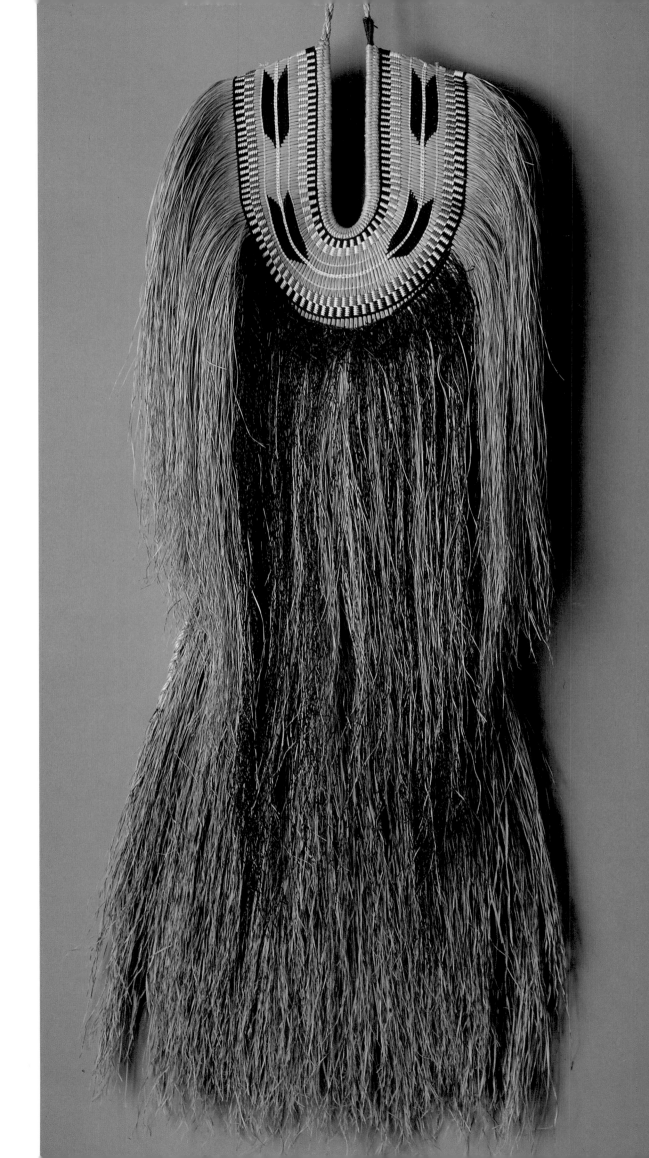

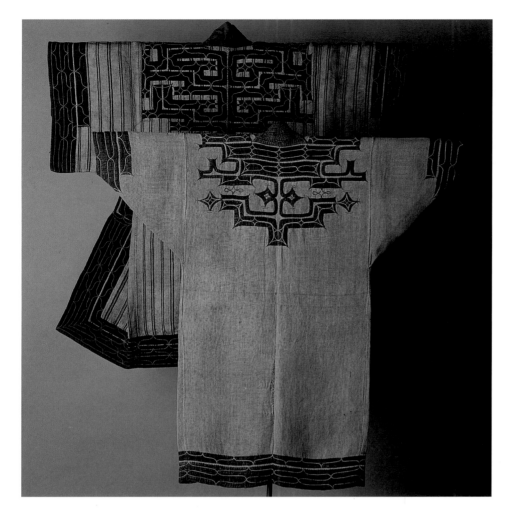

The large garment at the left with square sleeves, reminiscent of a standard kimono, was probably worn by a man. The elm-bark ground is decorated with fine stripes made with light and dark blue cotton, obtained in trading with the Japanese. The garment's prominent appliqué design creates an awesome impression of might. These curvilinear patterns created by indigo-dyed cotton appliqué and white chain stitch embroidery include the two basic motifs of Ainu design. The ovoid motif in the embroidery pattern is called by the Ainu *chik noka* (eye form). The second motif, a curling form called *moreu* (slight curve), is created here by narrow appliqué strips. Usually these two basic motifs are combined and interconnected to create marvelously vivacious net-like patterns on Ainu costumes. Highlighting this exquisite early robe are the large *moreu* motifs at the center, created by linking inverted arcs that form two eye-like diamond shapes. Below the neck are solid blue appliquéd rectangles on which delicate white embroidery *chik noka* patterns spread like a net with thorn-like points. Mesh-like designs on Ainu's textiles are said to derive from ancient images of tied ropes and fishing nets. On this *attush*, the composite pattern of net, thorns, and guarding eyes, concentrated at the most vulnerable area below the neck, seems to offer symbolic protection for the wearer.

PLATE 74

Right: Coat (*Attush*)
Ainu People
Hokkaido, Japan. c. 1850
Appliqué and embroidery on plain weave elm bark fiber and cotton
47½ x 51⅛" (120.5 x 130 cm.)

Left: Coat (*Attush*)
Ainu People
Hokkaido, Japan
Early Twentieth century
Appliqué and embroidery on plain weave elm bark fiber and cotton
45½ x 47" (115.5 x 119.5 cm.)

In their traditional society on the northern island of Hokkaido, the division of work was clearly determined by sex. Making clothes was the domain of women. They prepared fiber, spun thread, and wove cloth during the long winter. The most typical garments, known as *attush*, were made from the fibers of elm (*Ulmus laciniate*), trees native to Hokkaido. *Attush* garments were closely associated with the Ainu's animistic belief that spiritual beings reside within all parts of nature – mountains, water, trees, animals, and man-made objects such as clothing. The elaborate rituals of the Ainu were designed to regulate these many spirits: to please and cajole *kamui*, or beneficial spirits, while warding off evil demons. These striking costumes were worn at numerous ceremonies and rituals – weddings, child births, funerals, and the Bear Festival (dedicated to the powerful spirit that dwells in the black bear). The elm-fiber coat at the right is a superb example of an early *attush*. Delicate linear patterns exquisitely embellish small areas at the neck and sleeve openings, which the Ainu believe are vulnerable to the entry of evil spirits.

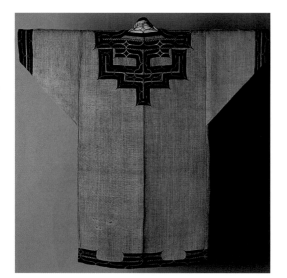

PLATE 75
Coat (*Attush*)
Ainu People
Hokkaido, Japan. c. 1850
Appliqué and embroidery on plain
weave elm bark fiber and cotton
52 x 52" (132 x 132 cm.)

Ainu designs are characteristically symmetrical,
yet because appliqué and embroidery are exe-
cuted freehand, living variations occur. On this
robe, flowing net-like patterns in light blue
chain stitching attenuate the sharp shapes of
the solid rectangular patches at the back,
sleeves, and hem. The collar of white cotton is
delicately embroidered with circular *moreu*
patterns in black cotton threads. Although the
sparkling white collar is small, it effectively
enlivens this otherwise serene Ainu costume.

PLATE 76
Coat (*Chikarkarpe*)
Ainu People
Hokkaido, Japan. Late Nineteenth century
Appliqué and embroidery on plain
weave cotton
48 x 50" (122 x 127 cm.)

Cotton fabrics and cotton garments had been
known to the Ainu through trade with the
mainland Japanese since the beginning of the
seventeenth century. But because cotton was
expensive it was only used to decorate the
surface of fabrics made of elm or linden bark.
Under the Tokugawa feudal system into which
the Ainu were incorporated, cotton fabrics were
brought to Hokkaido through maritime trade
under the aegis of the Matsumae clan, main-
land Japanese who had settled in southwestern
Hokkaido in the fifteenth century. It was a uni-
lateral trade wherein the Ainu were encouraged
to buy cotton, iron, and rice, while not being
allowed to trade freely on their own. In some
cases, Ainu working under Japanese were paid
in cotton fabrics and needles rather than wages.

Scarce cotton fabrics and needles, particularly
the latter, were greatly treasured. It was said that
if you heard an Ainu woman cry out you knew
either her loved one had died or she had lost a
needle. As a result of increased Japanese settle-
ment following the Meiji Restoration of 1868,
gradually greater quantities of cotton cloth
became available. Simple farmers' kimonos from
the mainland made of cotton soon supplanted
traditional elm bark garments for daily wear.
Ainu artisans often applied dramatic appliqué
and embroidery patterns over these mainland
garments, transforming simple outfits into unique
costumes of their own. The remarkable Meiji
period robe seen here was made by appliquéing
pure white cotton fabric over the entire surface
of a dark Japanese-made cotton kimono. Typical
symmetrical Ainu *moreu* motifs are greatly
enlarged and simplified. Stunningly rhythmic,
the swirling patterns are created by a thin line
of stitches paralleling wider lines where the white
appliqué has been cut out to reveal the black-
striped ground cloth beneath. A robe with white
appliqué designs, such as this, was worn at
funerals and other ritual occasions.

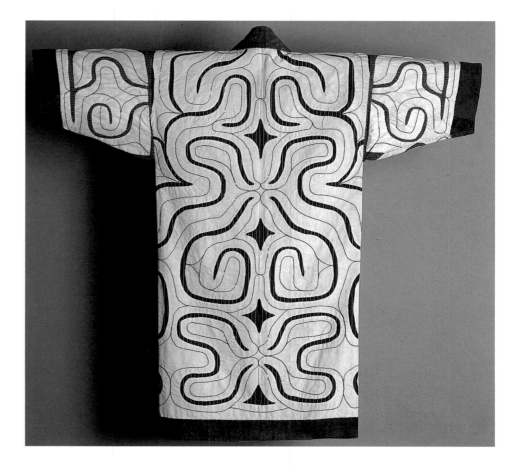

PLATE 77

Woman's Kimono

Shuri, Island of Okinawa, Japan.

Early Twentieth century

Rice-paste resist stenciled

(*bingata*); plain weave cotton

58½ x 54¾" (148.5 x 139 cm.)

Bingata, literally "red pattern," is a most appropriate term for the bright, vivacious textiles developed in the islands of Okinawa. *Bingata's* colorful patterns are created by pigments and dyes applied through rice-paste resist dyeing. The origin of these textiles is obscure, but some scholars see a link with rice-paste resisted Chinese *inkahu* (flower pattern cloth), which was believed to have been introduced to the Ryukyu Islands during the fifteenth century. Rice paste, the agent that resists penetration of dyes, can be applied in one of two ways to create a *bingata* fabric: through cut-paper stencils, or through a cone applicator (similar to mainland Japanese *tsutsugaki* technique). Colorful pigments or dyes are then handpainted on the open areas of the cloth with a brush, while the dried rice paste protects the other areas. On this kimono, a pleasant garden scene has been repeatedly stenciled until it covers the entire surface. Colorful dyes enliven the auspicious inhabitants of the garden – bamboo, plums, cranes, and small birds. These motifs show a close kinship with Japanese *yûzen* kimono designs. After the Kingdom of Okinawa had come under the domination of the

Japanese Satsuma clan in the eighteenth century, Japanese kimonos would have been known by Okinawan dyers, and perhaps Japanese textile pattern books were known as well. However, we can easily see that *bingata* fabrics are clearly distinguishable from Japanese delicate resist-dyed textiles in their dynamic incorporation of bright colors. *Bingata's* cheerful red, orange, and pink colors are generally created by applying repeated thin layers of mineral pigments. The intensely colored opaque patterns are set against a natural undyed white ground or a translucent dyed background in yellow, pink, or ocean blue, as if reminding us of the fabric's tropical origin. The production of *bingata* was traditionally associated with the Okinawan royal court. Dyers lived in the kingdom's capital of Shuri and were given the rank of lower gentry. The garments created by these selected artisans were exclusively worn by royalty and the elite. Certain colors and patterns were the prerogative of nobility: yellow, for example, was reserved for kings, while large motifs were limited to the upper nobility. This garment was probably worn by an elite woman on festive occasions.

PLATE 78

Women's Kimonos
Okinawa, Japan. Early Twentieth century
Warp ikat (*kasuri*); plain weave wild banana
cloth (*bashôfu*)
Back: 44 x 42½" (112 x 108 cm.)
Front: 47 x 46" (119.5 x 117 cm.)

Bashôfu, or *bashâ* in Okinawan, is a crisp, light, semi-transparent brown cloth made from the stalks of the wild banana. The threads taken from the inside layers of the stalk produce a fine quality of cloth which, in the days of the Kingdom of Okinawa, was made into special garments reserved for the elite class. Less refined threads were used to make everyday cloth for commoners. The rather brittle fiber of the wild banana tends to break in cold or dry climates, so that *bashôfu* was not valued as a trade textile for China or Satsuma. Rather, when most of Okinawa's delicate ramie fabric production was confiscated by Satsuma during the seventeenth and eigh-

teenth centuries as taxation, *bashôfu* provided staple clothing for Okinawa's own people. In front is a modest casual outfit from the turn of the century reminiscent of the classic shape of an Okinawan garment with narrow sleeves and a rather wide body. Its lustrous ground is patterned with simple vertical stripes made by *kasuri* (ikat) technique and using natural brown dye. The other kimono, constructed in the standard Japanese kimono style, is decorated with familiar Okinawan *kasuri* patterns, such as undulating cloud motifs, and three diagonally aligned circles created through stenciling.

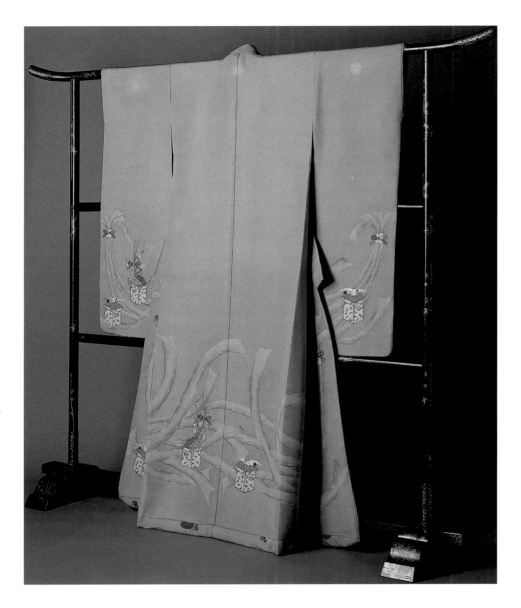

PLATE 79

Bridal Outer Robe (*Uchikake*)

Possibly Kyoto, Japan

First quarter of the Twentieth century

Yûzen-dyed, painted, stenciled, with silk
and gold-leaf-paper-wrapped thread
embroidery on warp face, plain weave silk

68⅞ x 50" (175 x 127 cm.)

Uchikake, literally "drape," is an outer robe that is worn over a woman's kimono. Open at the front, it "drapes" on the wearer, its padded hem trailing elegantly on the floor. Its long, sweeping profile provided an ideal canvas upon which textile artisans could create complex pictorial designs. *Uchikake* were particularly popular among high-ranking samurai ladies during the Edo period (1603–1868). They competed on festive occasions to be seen wearing their most luxurious outer robes. In contemporary Japan, the elegant *uchikake* is wholly impractical and survives primarily as a bridal costume. This excellent early-twentieth-century *uchikake* was probably worn by a bride at her wedding reception. The garment's wonderful design and superb craftsmanship demonstrate both the owner's wealth and the profound significance of the textile to the wedding occasion. Auspicious motifs – *noshi*, ribbon-like strips of ceremonial dried abalone, and *sanbô*, raised trays to hold gifts – decorate the outside of the robe. Because *noshi* also means "prolong," the dried strips symbolize a wish for long-lasting happiness. Animated *noshi* tied in bundles joyously curl and sway on the sweeping lower half of this robe. Scattered over the *noshi* are small *sanbô* holding auspicious gifts: the red lobster symbolizes longevity because its bending tail is reminiscent of old age, the bamboo stands for resilience because it does not break under heavy snow, the plum blossoming in winter represents bravery, the sacred pine allows the gods to descend to mankind, and the long-lived crane is a symbol of longevity. These popular symbols of good fortune appropriately bless this lovely robe, which was probably worn over the bride's pure white ceremonial kimono. At the time this robe was created, the arranged marriage was usual in Japan and we can imagine how anxious and hopeful a young woman would be at the beginning of her future life as a new bride. And we can imagine that when she wore this luxurious robe and was enveloped by its auspicious motifs, she felt it bestowed upon her the protection, the support, and the love of her family.

PLATE 80 (inside of bridal outer robe in Plate 79)

In an interesting contrast to the rather cool
tone of the outside design, the inside layer of
this robe is illuminated with a bright scene from
Shôjô, a celebratory play of the Nô theater, the
classic masked dance-drama. A *shôjô* is a small
mythical elf-like being from Chinese legend. It
has brilliant red hair, speaks in a childlike voice,
and adores rice wine. Several versions of the
play feature one or more of these mischievous
fun-loving creatures who are believed to bring
an abundance of blessings and happiness to the
audience. Here, five red-headed *shôjô* charac-
ters, dressed in Nô costumes, cheerfully drink
and dance around a huge pot of wine. Chrysan-
themums in full bloom surround the party, while
cranes of longevity fly in the pink-shaded sky.
A brilliant red hue effectively highlights the chry-
santhemums, the performers' *hakama* (trousers),
and the enormous wine cups. The whole scene
is skillfully painted, perhaps by a professional
painter or following his cartoon. Interestingly,
the tiny white *tabi* (socks) of the performers are
decorated in pure white silk embroidery. They
sparkle to draw attention, as if symbolizing the
importance of foot movements in Nô dancing.
It is fascinating that this elaborate decoration is
created on the lining of the robe, and most of it
is hidden when the robe is worn. Only the front
hem areas can be seen as the wearer walks and
kneels. Applying such luxurious decoration to
the nearly invisible kimono lining may be traced
to the spirit of resistance against edicts of the
government that banned expensive kimonos
during the Edo period. However, even before
this, according to Japanese aesthetics, concealed
beauty was considered more effective and attrac-
tive than extreme luxury. This delightful and
happy image, hidden within the robe, seems to
"privately" distinguish and celebrate the impor-
tant occasion.

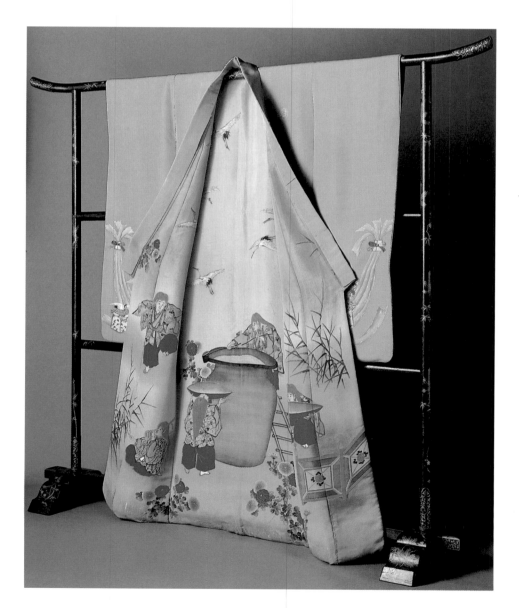

PLATE 81 (detail)
Woman's Summer Kimono (*Katabira*)
Japan. Early Nineteenth century
Yûzen dyed, painted, with silk and gold-wrapped
thread embroidery on plain weave ramie
60 x 48" (152.5 x 122 cm.)

Extremely long, fine ramie or *choma* threads
made from the *karamushi* plant of the nettle fam-
ily were widely used throughout the Edo period
to weave expensive summer garments, such
as this single layered kimono. The *yûzen*-dyed
design of colorful iris plants blooming alongside
wooden bridges and streams is a well-known
scene, repeatedly encountered in many types of
Japanese decorative arts. The image can be
traced to a poem in the Heian period *Tales of Ise
(Ise Monogatari)* by Ariwara Narihira (825–880)
and was made famous in the paintings of Ogata
Kôrin (1658–1716). The placement of iris flowers,
the flowing water, and zigzag wooden planks
on this kimono resembles Kôrin's work. The
kimono's beautiful pattern attests to the sophis-
ticated taste of the garment's upper-class owner,
while its rich, crisply cool image is perfectly
appropriate to the summer season.

PLATE 82

Man's Under Kimono (*Nagajuban*)
Japan. Possibly early Nineteenth century
Plain and crepe weave (*shijira*); silk
56 x 50⅜" (142 x 128 cm.)

In contrast to the colorful material and luxurious embellishment of Japanese women's costumes, since the Edo period kimonos for men were generally made in dark, somber colors with very small and inconspicuous patterns. This fashion most likely derives from the frugal life-style of samurai of the late Edo period, and from the conservative attitude of the Meiji nobility who followed them. At that time, it was considered chic for Japanese men of elite status to compensate for the plainness of their outer garments by wearing expensive and relatively colorful under kimonos. The full-length under kimono (*nagajuban*) illustrated here displays a sophisticated sense of combining contrasting colors. The handsome orange-brown silk on the upper body stands out from the finely striped beige *shijira* crepe.

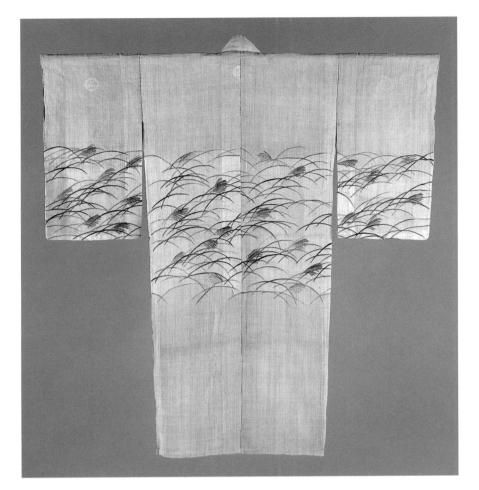

PLATE 84

Kyôgen Costumes (*Kataginu*)

Japan. Early Nineteenth century

Right:

Rice-paste resist stenciled (*katazome*); plain

weave hemp

28 x 25¼" (71 x 64 cm.)

Left:

Rice-paste resist (*tsutsugaki*), plain weave hemp

46 x 23" (116.8 x 58.5 cm.)

Kyôgen comedies are performed in the intervals between two Nô dance-dramas, providing a release from the tension of serious Nô through heartfelt laughter. Since the sixteenth century, Nô and Kyôgen performances have been intertwined like yin and yang. Although Kyôgen was developed for the same elite audience as classic Nô, the stories of Kyôgen were inspired by the open hearts of ordinary people, and its humor is rooted in the universal human condition. Among the most fascinating and expressive Kyôgen costumes are coarse hemp vests called *kataginu*. The small vest at the left was intended for a child actor, the son of a Kyôgen master, who appeared in small roles from the age of four or five years old as part of his training for the stage. A young child would be delighted to wear this costume decorated with large, freely drawn folk toys – a snapper on a wooden cart, a doll of a samurai's servant (*yakko*), a Daruma figure, a flute, and a tiny drum. The adult-size *kataginu* at the right is patterned with repeated waves and swirling *tomoe* medallions made by *katazome* stenciling. A single crest of the *nazuna* (shepherd's purse) plant decorates the back of each hemp vest: this is the designated crest that is shared by all Kyôgen performers and appears on their costumes.

PLATE 83

Child's Summer Kimono

Japan. Early Nineteenth century

Rice-paste resist and painted dyes;

plain weave ramie

44½ x 41½" (113 x 105.5 cm.)

This lovely child's kimono is unusually sophisticated. The mustard-yellow ground of fine ramie is highlighted with an exquisite painted image of delicate *susuki*, pampas grass, bending and curving under the autumn winds set against a light background. *Susuki* plants grow wild in the field where they bear long strings of flowers in the autumn. Tall and plain, unpretentious *susuki* commonly represent in Japanese decorative arts the melancholic feeling of this transitional season. This superb kimono was probably worn by a child of high status for very special occasions. Five family crests of oak leaves tastefully identify the child's family.

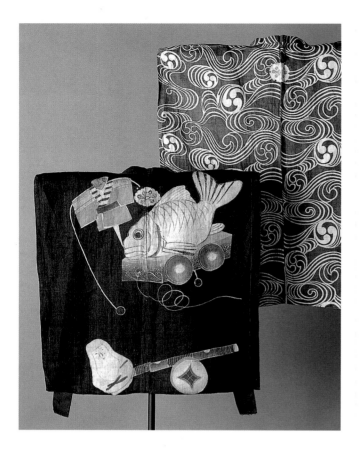

PLATE 85

Right: Child's Ceremonial Kimonos
Japan. Early Twentieth century
Rice-paste resist and *yûzen* dyed;
plain weave silk
Front: 42⅞ x 33½" (109 x 85 cm.)
Back: 41⅜ x 32¼" (105 x 82 cm.)

The same attention was given to the creation
of special children's costumes as that paid to
adults' garments. Children of wealthy families
were dressed in elaborate clothes for ceremo-
nial occasions such as New Years Day and
shichigosan (seven-five-three) on November 15.
At the latter festival, a boy three or five years
old and a girl three or seven years of age would
be taken to a local shrine to pray for health and
safety. The *yûzen*-dyed kimono in front proffers
a showcase of superbly depicted natural objects
against a sober colored ground, which may sug-
gest it was worn by a boy. The skillful hand of a
professional painter is evident in this dramatic
composition and in the utterly realistic render-
ing of the rabbits and the texture of wood
and leaves. The girl's kimono in back is dis-
creetly decorated with hand-painted motifs of
traditional cypress fans. Colorful streamers
fluttering from the tips of the fans represent
femininity. The fan, because it spreads outward,
is a popular symbol of unfolding good fortune
and is an appropriate embellishment for this
lovely garment intended for a growing girl.

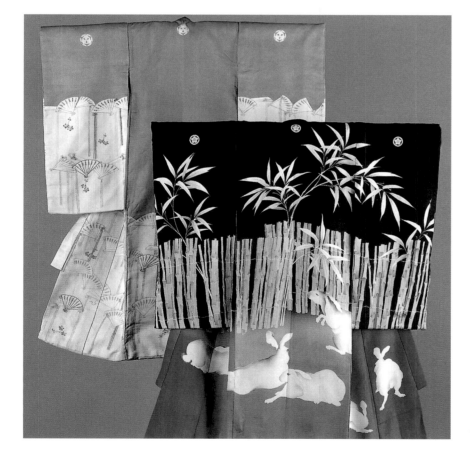

PLATE 86

Women's Kimonos

Kanto region, Japan. c. 1920–1950

Stencil-printed weft (*kasuri*); plain weave silk

Front: 62 x 49½" (157.5 x 126 cm.)

Back: 55⅞ x 46" (142 x 117 cm.)

The economically prosperous and culturally expansive Taisho period (1912–1927) was a unique era in Japanese history that was marked by strong Western influence. A genre of Japanese kimono of an unprecedented nature was invented during the Taisho period – massproduced silk kimonos made with bold and bright *kasuri* patterns that caught the fancy of middle-class and working women. In 1909, an innovative *kasuri* technique, originating in the city of Isezaki, one of the country's largest silk-weaving centers north of Tokyo, replaced traditional hand tying and dyeing with stencil printing. Dyes were printed through paper stencils directly on the stretched threads to create *kasuri* patterns, thus speeding up and simplifying the traditional hand *kasuri* process. When this technique was applied to low-cost mill-end silk, mass production of inexpensive silk *kasuri* kimonos became a reality. Stencil printing also helped artisans create complex designs with comparative ease. On these new Taisho kimonos, traditional small patterns were daringly exaggerated. Bold and dynamic new versions of *kasuri* motifs were created. Chemical dyes produced intense colors and brilliant tones. Western Art Nouveau and Art Deco motifs, which were introduced at this time, were added to the repertoire of Japanese kimono motifs. These two kimonos vividly reflect the daring, open, funseeking spirit of the Taisho era. Animated patterns on both kimonos vibrate and flow like musical compositions. Production of kimonos in the "Taisho mode" continued into the following Showa period (1927–1949), gradually ceasing after the Second World War.

PLATE 87

Warrior's Jacket

Japan. Late Eighteenth century

Lacquered and hand stitched; plain weave cotton, leather, and hemp lining

49¼ x 31¾" (125 x 81 cm.)

By the eighteenth century, the samurai class had lived for more than one hundred years under a peace imposed by the strict rule of the Tokugawa shoguns. Individual warriors had no chance to wear armor in a real war, so garments that had originally been created for protection in battle became mere decorative heirlooms standing as proof of honors earned in the past. Newly made warrior's garb turned more colorful and was often elaborately decorated. This unusually somber jacket seems to display the genuine protective function of a battle jacket. The indigo-dyed hemp ground is covered with tiny lacquered hexagon leather pieces designed to prevent the penetration of dangerous weapons. Uncovered areas allow flexibility and, at the same time, create interesting visual patterns on this otherwise austere garment.

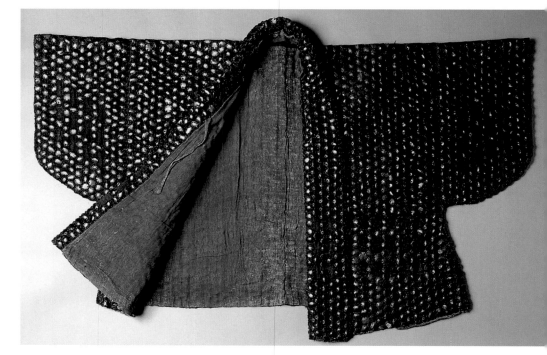

PLATE 88

Shop Signs (*Kanban*)
Tokyo, Japan. Twentieth century
Paint on wood
Top: 17½ x 20¼ x 1¾" (44.5 x 51.5 x 4.5 cm.);
Bottom: 26¼ x 14¼ x 1¾" (66.5 x 36 x 4.5 cm.)

Kanban are traditional Japanese shop signs. Simple and strongly visual, they are designed to advertise a shop and its wares. Displayed on the roof, or hung at the entrance under an eave, such a sign proudly announced the shop's location, inviting passersby to step in. Many *kanban* were made of wood, sharply sculpted into an exaggerated replica of the merchandise being sold. Huge clogs, umbrellas, wine cups, fans, pipes, and vegetables lined up along a shopping street, straightforwardly greeting customers. The direct, naive, powerful visual images of *kanban* can be recognized by anyone. In spite of the often deliberately humorous appearance of their shop signs, the *kanban* were extremely important to the store owners. A *kanban* was like a treasured trademark, and usually it was passed down from one generation of owner to the next. A loyal employee might be allowed to open his own shop using the same design of *kanban* as his former employer. This was considered a great honor. These two delightful shop signs feature a badger and radishes. The badger, or *tanuki*, is known in Japan as a mischievous, clever creature who loves to fool humans. This apprehensive-looking *tanuki* advertises a cake shop – the characters *o-kashi*, "honorable cakes," are written on his belly. The shop may have made rice crackers and pastries named *tanuki* or shaped like the animal. The *kanban* at the top is shaped like two long Japanese radishes, or *daikon*, humorously crossed like an insignia or family crest. The characters in red read *yaoya*, "green-grocer," identifying the business of the shop. Because the *daikon* is one of the most frequently used vegetables in Japanese cuisine, it may have been chosen to represent the owner's trade.

PLATE 89

Papier-Mâché Dog (*Inuhariko*)
Tokyo, Japan. Early Twentieth century
Paint on papier-mâché
16⅛ x 7 x 13½" (41.5 x 18 x 34.5 cm.)

Bell
Japan. Twentieth century
Paint on clay
5 x 4 x 3½" (13 x 10 x 9 cm.)

In Japan, folk toys have functions beyond being objects of play for children. Reflecting the strong undercurrent of Shinto animism in people's daily lives, folk toys, made mostly of natural materials, convey a rich symbolism and a wealth of ritual meaning. For centuries these delightful objects have been cherished and worshiped, serving as amulets, souvenirs, and good-luck charms. They are considered capable of granting wishes and averting evil. During the New Year and other seasonal festivals when good fortune is particularly sought after, these colorful good-luck toys are sold at vendors' stalls at shrines and temples, creating a bright and happy ambience. Here are two delightful toys: a papier-mâché dog and a painted clay bell fashioned in the shape of a rabbit. The charming *inuhariko*, literally "papier-mâché dog," is particularly intriguing. *Inuhariko* were first created in the late eighteenth century in the city of Edo (Tokyo), and they continue to be produced in downtown areas of Tokyo today. This stylized *inuhariko* is colorfully dressed and carries a traditional child's toy drum on its back. In Japanese lore, the dog is known as a watchful guardian of people, particularly children. Because dogs give birth easily, parents will present a dog amulet or charm to an expectant daughter, representing their wish for safe completion of her pregnancy and easy childbirth.

PLATE 90

Votive Tablets (*Ema*)
Japan. Mid-Twentieth century
Stenciled and hand painted; wood
Approx.: 4½ x 7" (11.4 x 17.8 cm.)

Ema, literally "horse picture," is a wooden votive
tablet sold at a Shinto shrine (or sometimes a
Buddhist temple). Petitioners write their wishes
on the tablet and hang it on a designated rack
to "communicate" with the gods, whom, they
hope, will generously grant their requests. The
ema developed from the ancient custom of
donating a live horse to a shrine when seeking
some personal favor from the gods. In the course
of time, this custom, which only the very wealthy
could afford, gradually shifted to offering a
wooden placard on which was painted a picture
of a horse. By the thirteenth century, *ema* were
widely used by commoners in Japan. Today
numerous subjects other than a horse appear
on the wooden votive tablets. *Jūnishi*, the twelve
Zodiac symbols, are very popular. Tablets deco-
rated with the animal of the year will be sold at
almost every shrine. The present collection cheer-
fully brings together five animals of the Zodiac:
snake, tiger, boar, dog, and chicken. Today, the
images on most *ema* are printed or stenciled,
but some of these mid-twentieth century *ema*
show genuine hand painting. Skillful brush strokes
enliven the boar under the cherry tree, person-
alize the coiling snake's alert expression, and
make the ferocious tiger delightful. Over a year,
a shrine will accumulate many thousands of
ema, each bearing a frail human's "message to
the gods." These tablets are eventually burned
and the people's wishes ascend to heaven.

PLATE 91

Sacred Straw Ornament (*Shimenawa*)
Yamaguchi Prefecture
Japan. Twentieth century
Plyed and knotted; rice straw
48 x 53 x 10" (121 x 134.5 x 25.5 cm.)

As the New Year approaches, throughout Japan
shimenawa makers become exceptionally busy.
Each region of Japan produces unique types of
shimenawa, sacred straw rope ornaments. From
almost every household, someone will go to the
local year-end market or a street vendor to buy
shimenawa during the last few days of December.
Following thousands of years of Shinto tradi-
tion, people will fasten a *shimenawa* at the gate
or over the entrance to the house or other loca-
tion to purify and mark the sacredness of the
area. The fresh smell of green straw that graces
people's homes during the New Year power-
fully connotes the promise of new beginnings.
Around January 7, *shimenawa* are taken down
and brought to a near-by shrine, where they
are burned along with other New Year offerings
and decorations. People believe the sacred power
residing in these objects should be returned to
the *kami*, or Shinto deities, so the gods can bring
good luck again the following year. The *shime-
nawa* that is illustrated here (and obviously
escaped burning) is made in an elaborate design.
The rope is knotted in the shape of the character,
kotobuki, meaning congratulations or felicitations.

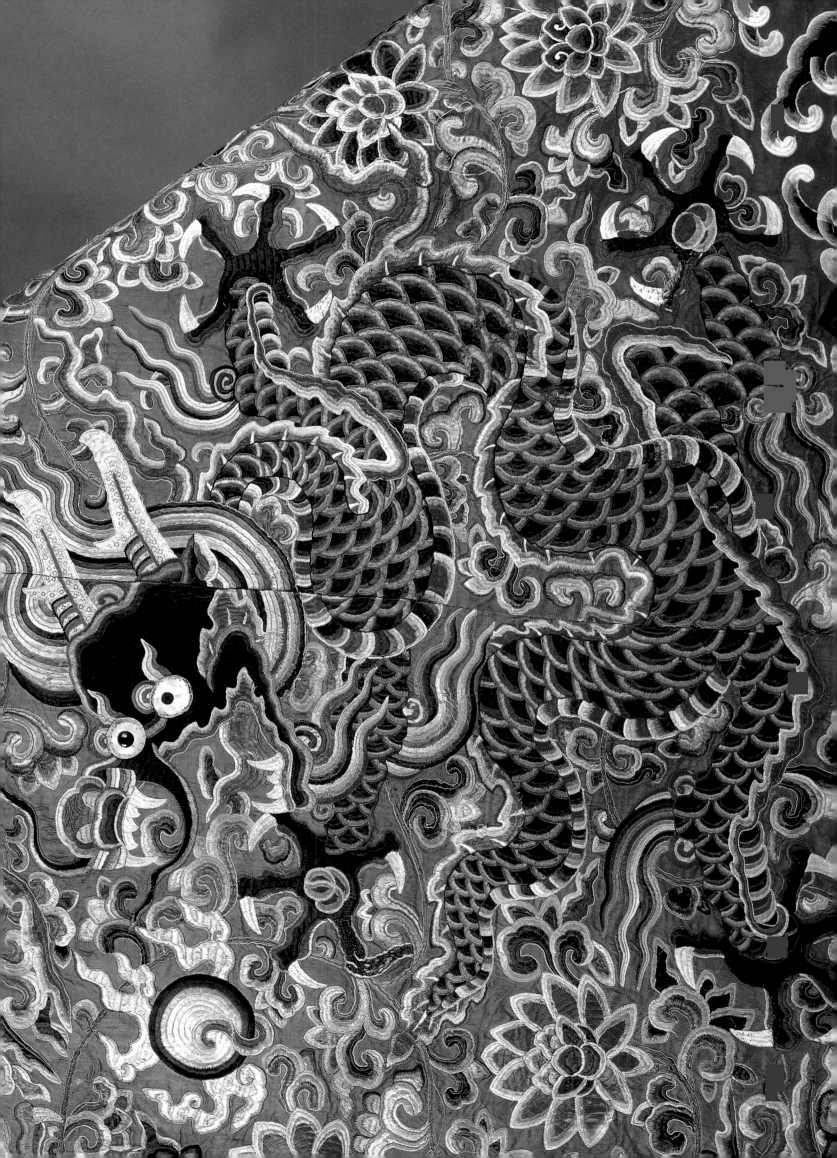

CHAPTER 4 # China

BY JOHN VOLLMER

The pre-eminence of silk in the economic and cultural development of China significantly affected Western perceptions of Chinese textiles. To the ancient Greeks and Romans, China was known as Seres, the Land of Silk. Sericulture, the cultivation of the *Bombyx mori* moth, appeared in China in the late fourth millennium B.C. The discoveries of how to hatch moth eggs all at one time and how to secure a supply of fresh mulberry tree leaves (the sole food of the larvae) set the stage for a state-controlled industry. Threads were formed by unwinding the cocoons in a process called reeling, in contrast to spinning.

Individual households had the resources to raise larvae to the cocoon stage. Because subsequent operations required specialized equipment and skill, they tended to be centralized. Silk production was associated with urban centers and became inextricably linked with the rulers of the powerful states on the North China Plains. Patterned silk weaving required high levels of capitalization, complex machinery, a highly trained specialized workforce, and sophisticated marketing systems. State control led to uniform production standards and contributed to the accomplishments of the Chinese weavers. Silk was a standard of value for taxes, as well as official wages. It was also the centerpiece of an elaborate state-controlled international trade monopoly.

For Chinese society clothing and textile furnishings were key indicators of status. They demonstrated a reverence for the past that was linked to the Confucian ideal of social harmony. The materials from which clothes were made differentiated the social classes – rulers wore silk, peasants used hemp. Workers' clothing was functional and cut short, in contrast to that of the elite, which was generously cut to display the luxury materials in keeping with their exalted station.

For the social elite textiles were vital to their identities. They were vehicles for expressing position, taste, and wealth publicly through a system of symbols and signs. In China color played both aesthetic and political roles. One of the basic concepts of the ancient Daoist philosophy was the notion that all nature was made up of varying combinations of five elements (wood, metal, fire, water, and earth). The Five Elements had a direct correspondence to the seasons, directions, and times of life. These correspondences were expressed in colors. For example, red clothing was used for celebration of major events within the family – birth of children, weddings, and significant anniversaries. Red symbolized the element fire; it expressed wishes for happiness, connoting the summer of life. Politically, at the start of each dynasty the official color was set in relationship to the colors used by previous dynasties. All court clothing was harmonized with the official color.

Imagery provided indications of rank and position. Textile decoration was an integral part of a symbolic language where objects reflected many layers of meaning. A tree peony (*paeonia arborea*), for example, might represent the late spring season when it blooms, or the male principle, since its name, *mutan*, is literally translated as "male vermilion," suggesting qualities attributed to the blossom. This meaning is frequently emphasized by pairing it with the phoenix (*fenghuang*), symbol of female beauty and the emblem of the empress (see plate 106). The peony also represents the ideal of great riches, since its poetic name, *fuguihua*, means "flower of riches and honor," a term reflecting the horticultural expertise the plant required and the fact that it was only found in the gardens of rich households that could support gardeners.

Punning is another feature of Chinese ornament. Since the language is monosyllabic, an object's name could be represented by other words sharing the same pronunciation, but written with different characters. By substituting these words for phrases that describe a design, a rebus is formed. For example, along the center seam of the embroidered red satin *jifu* (see plate 99) a motif features a bat with a chiming stone. The descriptive phrase: "red bats with chiming stone attaining Heaven" becomes a rebus meaning "may [your] happiness know no bounds."

Although status textiles were constantly being replaced with new, up-to-date goods, their value as symbols or as indicators of wealth did not diminish. Because silk served as a form of payment for taxes and the wages of court-appointed officials, garments and furnishings could be exchanged for cash. Fine textile reserves were valuable investments. In part this was determined by the fact that the imperial household traditionally controlled the monopoly on silk production. The emperor's appointed official oversaw silk production and collected taxes due at each step in its manufacture and insured a steady supply of superior-quality fabrics for the emperor's personal use. As the source of official trade, the imperial household needed silks to offer as diplomatic gifts in exchange for tribute paid to the Dragon Throne. This trade, particularly among the non-silk-producing cultures, was of singular significance to China's neighbors, who often adapted Chinese costume for official dress.

Courtly practice set the standard for domestic custom. Within the family, new textiles were offered as gifts for superiors and equals, while a supply of hand-me-downs served the needs of retainers. Hence, celebrated textiles were treasured possessions that were carefully stored and preserved for possible use as gifts and presentation offerings. Sentiment obviously played a role in the preservation of textiles among the upper classes. Wedding clothes, court attire, and grand furnishings survive in large quantities.

Confucius taught that art collecting and connoisseurship were among the attributes of *wenren* (literally, a man of culture). The emperors of China, as the most exalted *wenren* amassed spectacular art collections. In 1912 the imperial collections stored in the Forbidden City were nationalized by the Kuomingtang to serve as a public museum. Parts of this collection moved with the Nationalist forces to Taiwan in 1945. The Communist government has also supported public art museums. Much of the remaining imperial collections, including the Qing imperial wardrobe, are in the National History Museum and are housed in the Forbidden City. Among these treasures are tapestry-woven (*kesi*) and embroidered scrolls emulating the subtleties of ink painting. From the tenth century this specialized pictorial textile tradition was considered the epitome of refined aesthetic expression, and the names of master weavers and embroiderers are recorded with those of the great painters.

Another type of textile collecting coincided with the spread of Buddhism. During the fourth to the ninth centuries Buddhism flourished alongside Daoism and Confucianism. China was profoundly affected by the achievements of Indian culture that Buddhism introduced: metaphysics and science, a noble literature, a beautiful religious art, aesthetically satisfying ceremonials and the appeal of a peaceful monastic life, as well as the promise of personal salvation. As the faith moved north and east across the Asian landmass, the ascetic practices of its Indian subcontinent origins gave way to wider public access and spectacle. Central Asian and Chinese monasteries amassed reserves of fabrics for use in the liturgy. Secular luxury fabrics, because of their intrinsic value, were deemed worthy of donation by pious devotees. In turn these textiles, both yardages and garments, were transformed into other forms to decorate Buddhist worship halls and clothe celebrants of ritual. This act of recycling was encouraged as a means of gaining merit, but it also acknowledged one of the founding principles of the faith. Buddha taught renunciation and withdrawal from the world of attachment. As a demonstration of this tenet, he advocated a patched, unbleached robe (Skt. *kasaya*, literally, impure colored) as the standard monk's attire. By the second and third centuries A.D. in the non-cotton-producing regions of Asia, "impure colored" clothing was equally applied to silk textiles. Specifically commissioned vestments (see plate 96) and hangings for public and private worship were also collected by monasteries.

Throughout history, in both the East and the West, choices of which textiles to acquire were often idiosyncratic and highly personal. When we examine the social, religious, political, and personal circumstances (including those at work in public museums), we discover the same factors affecting the collecting of Chinese textiles. Patterned silk textiles were costly and exceptional. Ultimately their acquisition was based on availability. Chinese silk textiles have always existed in the marketplace, an arena influenced by commerce, trade, tribute, looting, exchange, investment, survival, and rarity. Acquisition of these luxury goods demonstrated conspicuous consumption and good taste. Their intrinsic value made them worthy as gifts to peers and retainers, as well as pious contributions to religious institutions, and continues to validate them as donations to public museums.

PLATE 92
Market at Qin Shihuangdi tomb in Shaanxi province. 1982. (Photo: Dorothy Kidd)

PLATE 93

Jar

Gansu Yangshao Neolithic, Machang
cultural phase

China, Gansu region. 2000–1500 B.C.

Painted buff earthenware

H 15½ x Diam 11½" (39.5 x 29.4 cm.)

Neolithic culture developed along the Yellow
River on the North Chinese Plains during the fifth
and fourth millennia B.C. It was called Yangshao
after the village site that yielded painted buff
and reddish ceramics found in the region in 1922
by the Swedish amateur archaeologist Johan
Gunnar Andersson (1874–1960). In further exca-
vations, Andersson discovered that by the third
millennium B.C. Yangshao culture had spread
northwestward to the Gansu region at the head-
waters of the Yellow River system. The ceramics
from this region are among the most distinctive
hallmarks of Chinese Neolithic culture. Large
storage vessels were built up from coils of clay
that were smoothed and polished, covered with
a buff slip and painted. Most of these large jars
are made in two sections and joined at the widest
part of the body; two lug handles are attached
at the joint. The elongated ovoid shape taper-
ing sharply to the base with a short flaring neck
is a form that continues to appear in Chinese
ceramic arts to the present. The placement of
boldly painted anthropomorphic forms with
cross-hatched circles emphasizes the swell of the
shoulder and the robust shape of the vessel.

Ceramics are synonymous with China. Even
during this early phase we witness the promi-
nence of ceramic traditions within a hierarchy
of the arts. In the descriptive, representational,
and abstract qualities of the Yangshao artisan's
brushstroke we see the beginnings of the sophis-
ticated Chinese aesthetic expression based on
calligraphy.

PLATE 94

Shadow Puppets.

Han People

Northern China, Hubei (?)
province. 1875–1925

Painted rawhide

Attendants: H 15¾" (40 cm.);

Cart and Horse: L 20⅝" (52.5 cm.)

The screened cart with attendants carrying lan-
terns on standards would have been immediately
recognizable to a Chinese audience as a wedding
procession. In form and trappings the elaborate
train bearing the bride to the groom's house-
hold imitated imperial processions, reflecting
the Confucian notion of the ruler as father of the
nation and his relationship to the family. Tradi-
tionally, a Han bride was referred to as "empress
for the day."

The shadow puppets in the Collection con-
sist of over 130 pieces, including figures, separate
heads, scenery, and props. They would have
enabled a small traveling troupe to perform a
large repertoire of puppet plays. On festival
evenings adults and children crowded into dark-
ened temple courtyards to view performances.
Behind a sheet stretched taut over a bamboo
frame, the master puppeteer manipulated as
many as four puppets at a time with the help of
one or more assistants. Other members of the
troupe sang the arias and recited the dialogue
that moved the story along. An assortment of
gongs, drums, and flutes punctuated the main
dramatic actions.

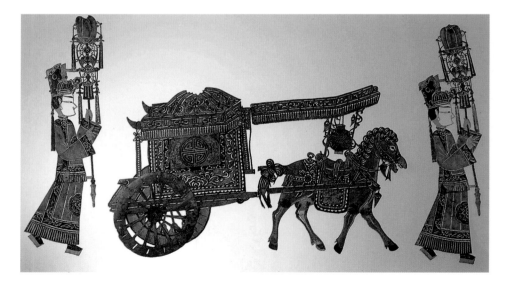

A hanging kerosene lantern illuminated the translucent, colorful puppets that were held tightly against the outward-leaning screen by a control stick of wire and reed. Two other controls – the "life sticks" – moved the hands and arms in graceful or forceful gestures. The cutout designs of the costumes and the lace-like faces, as well as the elaborate scenery, furniture, and stage props were the hallmarks of the shadow puppet theater associated with the North Chinese Luanzhou school. Shadow puppets entertained by their unearthly antics. Characters jumped incredible distances and flew through the air. Characters were transformed or assumed different guises simply by switching heads. These separate heads were inserted into a leather collar at the neck of the body that carried the main control rod. This accounts for the large number of supplemental heads in the Collection.

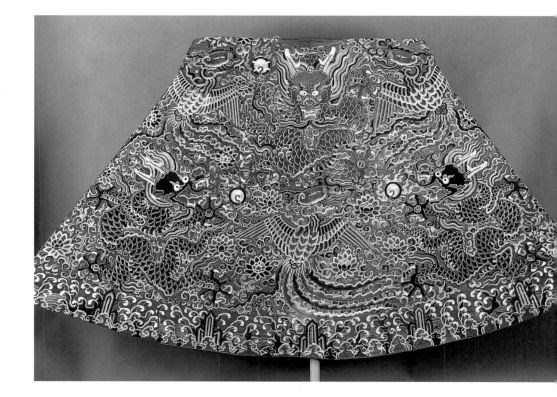

PLATE 95

Shadow Puppet Heads in Storage Cabinet
Museum of International Folk Art
Santa Fe, New Mexico. 1997

PLATE 96 and PLATE 97 (detail at beginning of chapter)
Fragmentary Cape for Buddhist Clergy
Han People
China. 1550–1625
Embroidered in multicolored silks in satin stitch with couched silk-wrapped cord; applied mother-of-pearl plaques; twill weave silk
54¼ x 26¾" (138 x 68 cm.)

The shape of this sumptuous ceremonial cape was based on Tibetan or Mongol prototypes. It is decorated with quintessential Chinese imperial imagery – five-clawed dragon (*long*) and phoenix (*fenghuang*), symbols for the emperor and empress. They represent male and female principles and are displayed amid five-colored clouds above a wave and mountain border, symbolizing the visible universe.

Such a garment type is rare among collections of Chinese costumes and is known to this writer in only two other examples, which are later in date (Victoria and Albert Museum, London, T183–1948, and Art Institute of Chicago 1937.186). Stylistically the embroidery, with its dramatic color contrasts and use of a vegetal filament under the edges of satin stitch to form crisp contours, can be linked to works dating from the Wan-li period (1572–1620). The mother-of-pearl plaques sewn over the dragon eyes are also unusual. They are obviously part of the original design, since the areas under them are not embroidered.

Buddhism rose in northern India during the late sixth century B.C. The faith was carried to Southeast Asia and Indonesia by Indian traders and missionaries. Five hundred years after its founding, Buddhism was brought to China via Central Asia by missionaries. The settings for worship were particularly sumptuous. In China, Buddhist temples were strongly influenced by palace architecture. Soaring columns supported elaborate wooden brackets which, in turn, carried heavy tiled roofs. Vast interiors were illuminated by sunlight from south-facing doors, as well as by candles and braziers. Walls were covered with colorful murals depicting paradise or the complex pantheon of deities. A raised platform at the center of the room held painted wood or gilt bronze images. Before them altar tables were set with censers, vases of flowers, and plates and bowls of offerings. Pillars might be draped in fabric and hung with banners to delineate the sacred space. Fine cloth also draped the altars; carpets and cushions designated the spaces for ritual. Vestments worn by the celebrants focused attention on the liturgy.

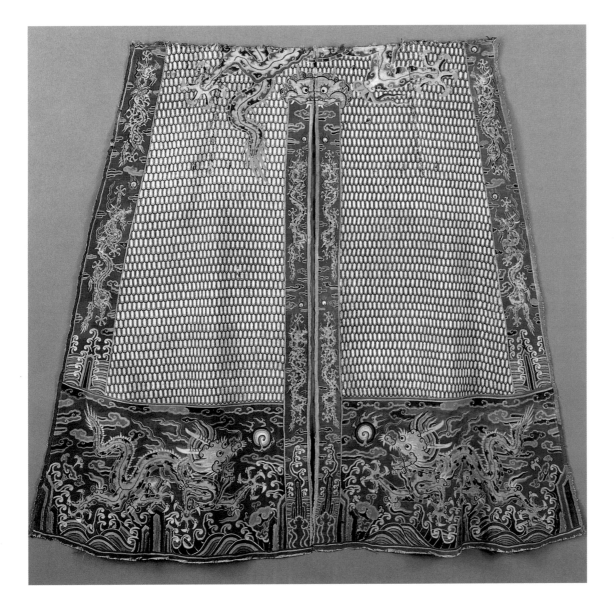

PLATE 98

Fragments from the Overskirt
of a Military Uniform
Han People
China. 1550–1600
Tapestry technique (*kesi*),
silk- and gold-wrapped threads
33⅞ x 39" (86 x 99 cm.)

These delicate silk tapestry-woven (*kesi*) frag-
ments of the chap-like overskirts that covered
the front and sides of a soldier's legs are a tour-
de-force of the weaver's art. They belie the
original purpose of the brigandine or plate
armor garment it represents. Overlapping metal
or leather plates are indicated by a repeating
scale pattern. Brigandine armor had been
developed for bow-and-arrow warfare, and in
China remained largely unchanged from the
third century B.C. At the time this garment was
made, the armor form was ceremonial.

Borders at the center front vent issue from
the jaws of a delicately drawn gold monster
(*taotieh*) mask, imitating an applied bas-relief
metal fitting. The five-toed dragons (*long*) with
curly patterned bodies are unusual and link this
piece to porcelains of the Wan-li period (1572–
1620). No documentation exists to substantiate
an imperial attribution for these pieces. However,

the incredibly fine workmanship and inclusion of
five-toed dragons (*long*) strongly suggest that these
unique fragments may have been ordered for the
ceremonial costume of an emperor in his role as
commander-in-chief of the army. A hand scroll
painting in the National Palace Museum, Taipei,
depicts the Ming dynasty Jiajing Emperor (r. 1522–
1566) leading an imperial inspection tour on
horseback wearing light-colored brigandine armor
very reminiscent of these fragments.

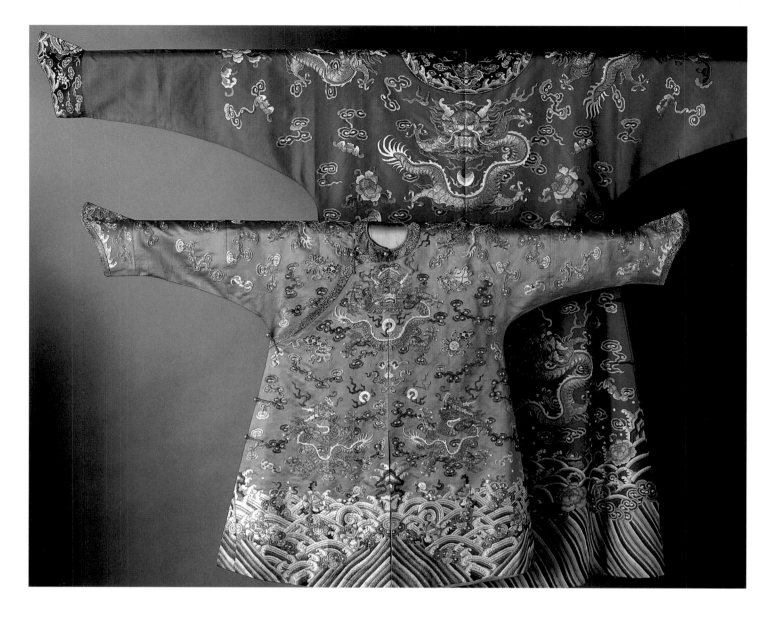

PLATE 99

Front: Boy's Court-Style Coat (*Jifu*)
Manchu or Han People
China. 1860–1890
Plied and silk floss threads in satin, stem, and
knot stitching, couched gold-wrapped threads
on plain weave silk with plied silk cords
34¼ x 54" (87 x 137 cm.)

Back: Man's Court-Style Coat (*Jifu*)
Manchu People
China. 1900–1920
Plied silk threads in satin stitch embroidery
and couched gold-wrapped threads on plain
weave silk
52⅛ x 80⅓" (132.9 x 204 cm.)

Dragon-patterned garments have been synonymous with Chinese imperial court attire since the Tang dynasty (618–907). At the time of the conquest of China in 1644, the Manchu were already wearing dragon-patterned coats adapted from Ming dynasty (1368–1644) coat yardages given to them as diplomatic gifts. The Manchu modified the *longpao* form to conform to their own regional dress, thus symbolizing their identity as horse-riding conquerors. The trapezoidal profile – long tight sleeves ending in a distinctive horse-hoof (*maxing*) cuff, front overlap held with loop-and-toggle fastenings, and vented skirts – had evolved for an active life out-of-doors.

The Manchu also reorganized and clarified *longpao* decoration to form a single composition. By the early eighteenth century the number of dragons for the court coat had been specified as nine, a number symbolizing man, and by extension, human control. Although these coats reflect official styles, neither is actually a Manchu court garment. Rather, they are formal garments intended for domestic use, since many aspects of private life mirrored official culture. Neither of these coats has a ninth dragon on the panel under the front overlap. The red coat was probably made for a young student to be worn at celebrations to symbolize the family's desire for success. The boy was encouraged to study hard, pass his civil service examinations, and attain an official government appointment, thereby guaranteeing his status and position in society. The blue coat may have been worn by a bridegroom symbolizing his role as emperor to his bride, customarily called "empress for the day."

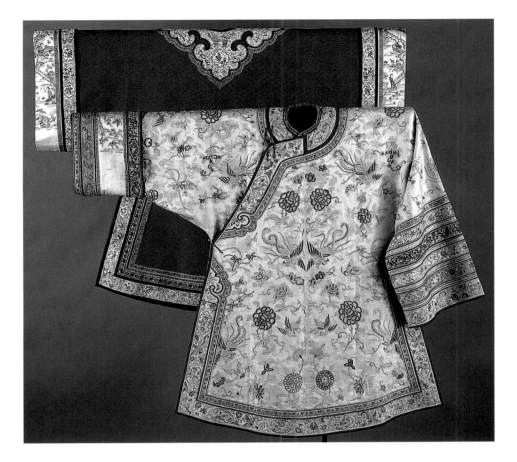

PLATE 100

Front: Woman's Coat
Straits Han People
Malaysia. 1875–1900
Knot stitch and silk floss embroidery
and couched gold-wrapped threads
on silk damask
44⅛ x 79⅛" (112 x 201 cm.)

Back: Woman's Coat
Han People
China. 1860–1880
Silk floss embroidery on silk damask
and couched gold-wrapped thread
43¼ x 55⅞" (110 x 142 cm.)

Although these coats come from widely sepa-
rated Han Chinese populations living in East Asia,
they reveal a consistent taste and style. Chinese
aesthetic in dress sought harmony through a
balance of contrasts: light against dark, ornament
against plain, borders against field. From the
Shang (1523–1028 B.C.) and Zhou dynasties (1028–
256 B.C.) garments were edged with contrasting
facings of expensive cloth applied to the outer
surface. Structurally this technique reinforced
the cut edges of cloth at the hem and reinforced
areas of wear such as sleeve ends and edges of
openings. Aesthetically it permitted the maxi-
mum display of valuable patterned fabrics. The
proliferation of bands, borders, and decorative
ribbons to trim the edges of garments is a char-
acteristic of Chinese costume dating from the
last half of the nineteenth century. The so-called
sleeve bands (actually a facing turned back into
a cuff) on the red coat are particularly handsome.
The scenes of women in gardens, which were
copied from woodcuts that illustrated Chinese
novels, are meant to be read as a unit when the
arms are brought together across the chest.

Bird and flower imagery were favored by
women for domestic wear. These motifs evoked

seasonal changes and promoted a notion of
affinity with nature, one of the underlying prin-
ciples of the ancient Chinese philosophy of
Daoism. This is particularly clear in the case of
the light blue coat with its polychrome knot stitch
embroidery of mixed flowers and phoenix. The
bands of contrasting satin used to trim these
coats also feature bird and flower motifs. In
addition to five decorative bands on the outside
of the sleeve of the blue coat, the inside of the
sleeve is finished with a wider facing and two
more bands, possibly offering its wearer two
different ways to arrange the sleeves.

These very pretty coats would have been
worn by upper-class women. Although such
women were confined to separate quarters in
a house, they maintained an active social life
with other members of the extended family.
When they received visitors or paid calls, fine
clothes demonstrated personal taste and style
and reflected one's status and position within
a minutely observed hierarchy. These occasions
were marked with animated conversation,
music-making, reading poetry, and drinking tea.

PLATE 101

Male (?) Undergarment

Han People

China. 1880–1910

Bamboo stems threaded on cotton netting;

edges bound with plain weave silk

26¾ x 69¼" (68 x 176 cm.)

The versatility of bamboo as a material has been exploited by Chinese craftsmen since the third millennium B.C. This undergarment demonstrates one of the more innovative uses of this material. Sections of hollow bamboo stems are strung on cotton cord as beads. The mesh is tied with great precision. An openwork design at the hem is formed of overlapping circular cash coins. This feature and the very fine finishing, which included edge bindings and closures made of silk fabric, are exceptional, distinguishing the quality of this object.

The ability of the stem to bend under pressure, rather than break, and its tendency to spring back to its upright position have been celebrated in Chinese poetry as qualities of the the Confucian *wenren* (man of culture) an ideal of Chinese society since the late Zhou dynasty (1028–256 B.C.). Loosely woven cuffs of split bamboo worn to keep the sleeves from sticking to the wrist, and mesh vests and coats that kept outer clothing from sticking or from being soaked with perspiration, contributed to the elegant decorum cultivated by the social and political elites.

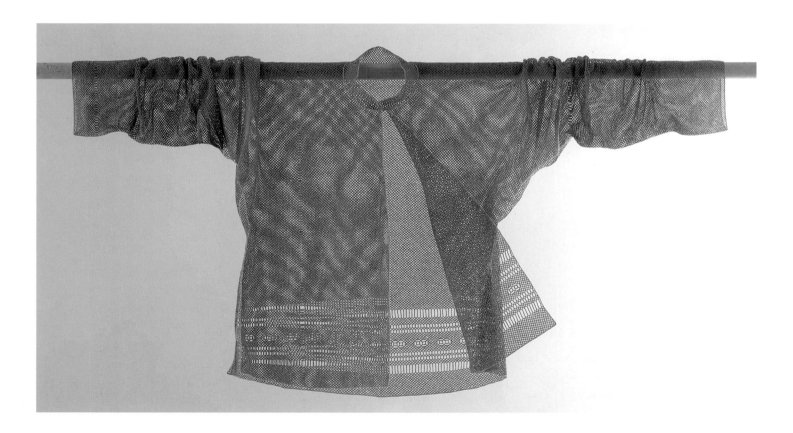

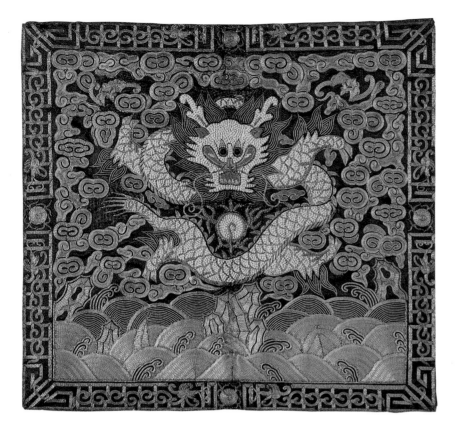

PLATE 103

Fragment of a Coat Border or Band

Han People

China. 1500–1600

Silk floss in satin, laid and couched embroidery stitches, plied silk thread in darned stitches, and couched gold-wrapped threads on silk gauze

6¼ x 13" (15.8 x 33 cm.)

This embroidery may once have adorned a garment from the trousseau of an upper-class woman. The charming garden scene features lotus rising dramatically from a pond on which a pair of Mandarin ducks swim. The half mountain form at the left suggests the piece comes from a border, possibly from the band of ornament that ran horizontally across the skirts of Ming dynasty-style coats. Within Buddhist symbolism the lotus is associated with purity as it rises clean and fresh from the muddy bottom of the pond. In this context with ducks, symbols of marital fidelity, the lotus also symbolizes the summer season in which it blooms. The Chinese believed the Mandarin duck mated for life, hence its association with wedding imagery.

The background is worked in a darned embroidery technique using the grid of the silk gauze ground to create a diagonal lozenge pattern that simulates a woven pattern. This technique was perfected during the sixteenth century. It is rarely seen in embroideries made after the mid-seventeenth century.

PLATE 102

Rank Badge (*Puzi*)

Manchu People

China. 1880–1900

Satin stitch silk embroidery and couched gold- and silver-wrapped threads, seed pearls, and coral beads on plain weave silk

11⅜ x 12" (29 x 30.5 cm.)

The system of signaling the status of individual courtiers by requiring them to wear badges emblazoned with birds or animals on the chest and back of their official attire was introduced to the Chinese imperial court during the Ming dynasty (1368–1644). Various dragons indicated noble ranks. Different birds identified the nine grades of civil officials, while nine animals were used for the grades of military officers. The Qing dynasty (1644–1911) adopted the Ming rank system with minor variations.

The size and composition, even the details of iconography for rank badges were prescribed by the Board of Rites. Yet within these strictures, individual workshops exercised their creativity and imagination. The effect of this badge is particularly sumptuous. Freshwater pearls mark the dragon's scales, the supernatural flames are tiny coral beads. The couched embroidery is particularly finely worked. Green, red, blue, and white silk couching threads that are used to hold silver- and gold-wrapped threads create a lively pattern that suggests more numerous materials. The border design features pairs of curly dragons within square frets confronting flaming pearls. The hoofed dragon is a rarely seen beast in Qing textiles. These features relate more to the taste and economic resources of the patron, rather than his status and rank.

PLATE 104 (for detail see Plate 32)
Banner
Manchu People
China. 1750–1800
Satin and stem stitch silk embroidery, couched
gold-wrapped threads on twill weave silk
47⅔ x 46½" (121 x 118 cm.)

Tigers with bat-like wings emblazoned military banners during the seventeenth and eighteenth centuries. Here amid five-colored clouds symbolizing the universe, the rampant beast's supernatural power is symbolized by the bat wings and shooting flames. The flame-shaped border with couched gold-wrapped threads further emphasizes this power. The banner shown here was probably meant to be carried in military parades, such as the gatherings of the Qing armies held every three years in the capital.

Throughout Asia the tiger is a potent symbol associated with strength and military prowess. In China the tiger was known as the king of all land animals – a complement to the dragon, the chief of aquatic animals. It was associated with *yang*, the active, life-giving, and masculine principle and was the animal guardian of the West. Together with the guardians of other quadrants – the red bird of the South, the black tortoise of the North, and the blue or green dragon of the East, it held sway over daily life and protected the tomb for the afterlife. It was even claimed that during the Zhou period (1028–256 B.C.) living soldiers, dressed in tiger skins, advanced into battle shouting loudly in the hope that their cries would strike as much terror in the hearts of their enemies as if they were being confronted with the actual roars of tigers.

PLATE 105

Fabric Length

Han People

China. 1550–1600

Damask technique; silk

42⅞ x 27⅛" (109 x 69 cm.)

The color of four horses with five good-luck symbols is inverted on alternate vertical repeats so that each unit is mirrored in the next. This weaver's strategy creates groups of eight horses and was probably intended by the designer to symbolize the eight steeds of Mu Wang. Mu was the fifth king of the Zhou dynasty (1028–256 B.C.) and was renowned as a wise and powerful ruler. According to legend, Mu Wang's eight horses (each bearing a distinguished name) pulled his chariot as he traveled throughout the empire. In popular culture, the horse was an emblem of speed and perseverance. It is one of the twelve animals of the zodiac. Good-luck symbols include a mixture of motifs connoting wealth and luck. Three symbolized wealth: the square cash coins (money), *ruyi* scepter (a ceremonial object whose name literally means: "as you wish, in accordance with your heart's desire") and a T-square shaped stone chime (one of the traditional court musical instruments whose name also meant felicity). Two motifs are part of the eight Buddhist symbols: the wheel of the law and the endless knot.

Three pattern units are created with colored warp threads – dark blue, blue-green, and red (now faded to tan). However, these pattern units do not quite match horizontally across the width, and the mirrored repeats suggest that the fabric was intended to be cut apart into small rectangles. Although there is no evidence to suggest an original use of this cloth, it is possible to imagine pockets or covers for small items.

PLATE 106

Fragment from Border

Han People

China. 1500–1550

Tapestry technique (*kesi*); silk

7½ x 15⅓" (19 x 39 cm.)

This border design features a flying phoenix flanking a peony above a pendant *ruyi* scepter headband. Both the phoenix, symbolizing the female principle as well as representing the empress, and the peony, as a symbol of wealth, are commonly found on objects made for women's use. The weaver has used distorted wefts to enhance the pattern of the leaves and feathers, creating a charmingly naïve design. This may suggest a provincial workshop. It contrasts sharply with the precise workmanship in which all weft elements are kept perpendicular to the warp that is typical of imperial silk tapestry (*kesi*) production.

The narrow blue band above and the wider pink band below are the edges of the weaving – shots of coarse silk remain outside these to indicate cutting lines. The fragment is probably half the original width and may have been made for curtain borders or garment trimming in China. However, four equidistant dirty vertical lines suggest the piece may have been pleated, possibly as a canopy valance for use in Tibet, where it was found.

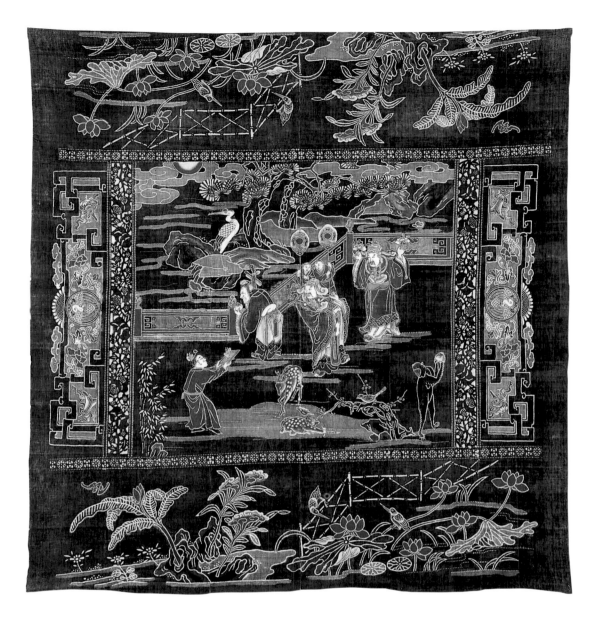

PLATE 107

Coverlet Top

Han People

China, probably Jiangxu province. 1890–1925

Resist-dyed with overpainted colors;

plain weave cotton

74⅞ x 71⅜" (190 x 182 cm.)

In traditional upper-class households, the bedroom was a major, if private, residential space. The bed furniture itself was often elaborate and richly embellished with silk curtains and coverlets. For the less privileged, beds remained a major focus of the house, even when they were little more than built-in benches that served dual function as daytime seating. In these households, bedding was often portable; it was rolled up or stored during the day and brought out at night. For such families, costs precluded silk furnishings.

Six lengths of handwoven cotton cloth have been seamed to form a large rectangle, which has been decorated with rice-paste resist using stenciled and freehand drawing, dyed indigo, and over painted in colors. Originally there would have been a plain backing to make an envelope for a thick, padded quilt. This professional workshop design is derived from the rich iconography of Daoism. It is directed toward wishes for a long life, probably intended for the use of a family patriarch. The deities called the "Three Stars," symbolizing happiness, wealth, and long life are shown with attendants standing on a heavenly palace terrace. Beyond it is a garden with pine, bamboo, and plum. These three plants, called the "Three Friends," symbolize the virtues of the scholar-gentleman: long life, flexibility, and perseverance. Because the pine remains green all year it came to symbolize long life. The bamboo bends under the weight of snow, then flexes back upright, unbroken. The plum blossom is the first to appear, often blooming in the late spring snows. The deer, *lingzhi* fungus, and crane further emphasize wishes for a long life. At the right is a monkey stealing the peaches of immortality from the garden of the Queen of the Western Paradise. This image evokes a popular sixteenth-century novel about the exploits of a mischievous monkey who must find redemption through a pilgrimage to India. Although the latter is primarily a Buddhist story, its inclusion here reflects the highly syncretic nature of the major Chinese religions and the liberal borrowing from one another.

CHAPTER 5 # South and Southeast Asia

BY MARY HUNT KAHLENBERG

A lingering image from Bali is the sight of a magnificent red
silk cloth lavishly embellished with gold threads being paraded
around its owner's waist in a temple procession. This resplen-
dent red moved in striking contrast to the lush green of the rice
paddies. As the sun emerged from beneath the soft cumulus
clouds there was a dazzling flash of gold. My previous perception
of such ostentatious dress was in the domain of the movie star.

To attract attention was the only reason to wear such glitter, I thought. Could this Balinese Brahman and the movie star have this common desire? One hoped to attract the paparazzi, and the other to be noticed by the deities who would honor his request to bring communal harmony. Textiles, both in the form of ceremonial dress and architectural embellishment, are an essential component of festivities throughout South and Southeast Asia. Their beauty, and in some cases, sheer opulence is not intended to glorify the owner but rather to reflect the reverence of the owners for their gods. Throughout this part of the world people utilize art to assert control over the conditions of their daily life and their environment. To bring order and reason to daily life, music, dance, ceremonies, and festivals are used to appease the gods and focus their attention on the needs of the community.

In discussing the South and Southeast Asian material in the Collection, we have brought together a broad geographical area, but one whose history and origins have been closely connected. The area covered stretches from Formosa to the Philippines across the chain of Indonesian islands to the mainland and north to Myanmar (formerly Burma) and the Indian Subcontinent. In this overview and the captions that follow, general concepts and facts mingle together to create the impression of an area. Several aspects are repeatedly revealed: how outside influences appeared and were absorbed one after another; how strong community traditions provided the continuity for a distinctive local style and symbolism; and, how everywhere textiles are a metaphor for life.

Several waves of migrations laid the foundations for the South and Southeast Asian populations. Traders from China, the Arab World, India, and Europe brought their goods to exchange for the agricultural and mineral wealth of the tropics. All of these people contributed to the layering of beliefs that define the peoples of Southeast Asia. The original inhabitants of Southeast Asia migrated from then mainland Southeast Asia to Australia over 40,000 years ago. These were hunters and gatherers using very simple stone tools and without the accoutrements of settled life, such as pottery and textiles. The first peoples had a reverence for their ancestors since the continuity of their line was ever in jeopardy, and this reverence was the beginning of a strong continuum. The shamans of these early peoples sought the assistance of the ancestor spirits through trances. They divided their deities into the two categories that continue today: male gods related to the sky, represented by birds, and female earth gods represented by snakes. The Australian Aborigines, the peoples of Papua New Guinea and the Indonesian islands of Irian Jaya and Papua New Guinea,

the "Orang Asli" or original people of Malaysia and southern Thailand, and small groups in the Philippines are the direct descendants of these peoples.

The second wave of migration of the Proto-Malays in approximately 5,000 B.C. from India and Myanmar brought the domestication of rice. This knowledge afforded the newcomers an immediate superiority. They have maintained their identity and are represented in this Collection by the spirit-filled ikat textile of the Dayaks of Sarawak (plate 117), the sublimely simple tie-dye banner of the Toraja of Sulawesi (plate 122), and the meticulously embroidered costumes of the Philippine Bagobo. The Deutero-Malays followed in another wave from southern China between 3000–1000 B.C. They traveled by sea along the Indochinese coast to Malaysia via the chain of islands that now comprises the Philippines and Indonesia. Sometimes the Proto-Malay and Deutero-Malay are grouped together and called Austronesians. Both groups settled throughout Southeast Asia; with their knowledge of pottery and slash-and-burn rice cultivation they too dominated their predecessors.

Throughout history, textiles in Southeast Asia were symbolically female; their male counterpart being metalwork; a complementary relationship that reflects the idea of unity as a combination of masculine and feminine elements. The process of weaving represents creation as a whole, and human birth in particular. Offerings are made to ensure the spirit's consent. In the Balinese village of Tenganan, a ritually prescribed purification sacrifice is made to spirits when someone is weaving a figurative textile. Blossoms, rolled betel leaves and lime, and two sets of eleven coins with holes in the center are tied to the ikating frame. Adherence to such mandated obligations literally threads together the life of the family, village, and tribe. Completed textiles are sanctified by these symbolic concepts. The textile as a metaphor for life is clearly expressed in the Indonesian concept that the crossing of the textile's warp and the weft symbolizes the structure of the cosmos: the warp threads fastened to each end of the loom represent the predestined elements of life; the weft threads passing over and under denote life's variables.

Southeast Asia changed substantially when the practice of irrigation was brought from India in the first century A.D. Surpluses of food provided the funds for a more elaborate religious structure, also imported from India. What developed then was a mosaic of ideas, a blending of the existing beliefs going back to the "Orang Asli," combined with a mix of Hinduism and Buddhism. This patchwork of religions permeated the rich river

valleys of Myanmar, Cambodia, Thailand, eastern Borneo, the Malay Peninsula, and the Indonesian islands of Sumatra, Java, Bali, and Lombok. In these new religions the king was at the apex of a pyramid that reached to the sky, and he became a god, or close to one. With the king's claim came the responsibility of ensuring the benevolence of nature and general good health among the population. Hindu and Buddhist beliefs reinforced royal rights and responsibilities and symbolic relationships with perceived animal ancestors such as crocodiles, elephants, and birds – the carriers of the spirits and souls that had dominated their mythologies for centuries. Today, the Balinese are the largest group of Hindus in Southeast Asia. Buddhism, however, thrives throughout Thailand, Cambodia, Laos, Myanmar, and among the overseas Chinese.

From these hierarchical systems two major factors influenced textile design. First, symbols of the spirit world, which identified the owner/wearer's social position, evolved from earlier shamanistic roles to representations of political power. The element of mysticism connected with animals may be one of association between an animal and a man, or the metamorphosis of man into animal or vice-versa. The bird, for example, was connected to heaven and a conveyer of its messages. In Hindu areas the bird was transformed into Garuda, the great deity of the sun. This mystical bird characterized by its invulnerability and creativity is today the symbol of Indonesia and even the name of its national airline. In Thailand, the Garuda is the personal emblem of the king. Second, there emerged a new form of presentation based on the Indian aesthetic of stylized patterns of flora and fauna. This sense of pattern evolved over the years with amazing continuity. Motifs carved on the costumes of the statues of the ninth-century Javanese Buddhist temple, Borobodur, remain today in batik patterns associated with the courts of Central Java. Another persistent legacy was the sumptuous Indian textile tradition of brightly colored brocades with gold and silver, which also added its brilliance, particularly in the fabrics of Malaysia, Thailand, Laos, Cambodia, and the Indonesian islands of Sumatra, Java, and Bali.

The techniques of ikat and batik may have been imported at the beginning of the first millennium. Both of these Malay-based words have now entered the English language, but it is not known if the development of these techniques began in India and spread to Southeast Asia or if they developed independently. Ikat has remained the decorative technique of choice for centuries because the required loom technology is simple, yet the patterns can be complex. The batik or resist-dyed technique is also most elementary in its technical requirements. In lieu of technology, both

techniques require endless hours, days, and even months for production. The investment of time makes the resulting ikats and batiks seem so astonishing to our efficiency-minded culture. What we would see as tedium they would define as a form of meditation. Intricate repetitive designs require a steady and continuous movement of the hand. A rhythm develops that becomes a mantra.

It was on the Malaysian peninsula that the first Islamic traders settled in the eleventh century. All sea trade between the east and the west traversed through the straits of Malacca, a narrow opening between Malaysia and the Indonesian Island of Sumatra. Islam served the trader well by teaching that all believers are peers in the eyes of Allah, thereby stimulating individual initiative. In the fourteenth century Islam began to spread not because of any democratic appeal, but because of the arrival of Sufi teachers.[1] The Sufis' learned and intellectual manner allowed them to settle comfortably within some of the Southeast Asian courts. They emphasized the spiritual and mystical aspects of Islam and made it possible to integrate the older beliefs and religious practices into the new religions. Islam spread over the next few hundred years to Malaysia, parts of Sumatra, Java, the coastal areas of Sulawesi, and the Maluccas. In the areas of conversion, ceremonies changed to emphasize rites of passage rather than the previously dominant mortuary rites. As the functions of some textiles were altered, aesthetics and composition were adapted to these new roles – animal and bird imagery lessened, and floral designs continued in a more abstracted form.

When the Portuguese, English, and Dutch came seeking spices, they brought brightly patterned textiles from India, continuing an already established exchange begun by Indian and Arab traders. An increased supply of imported goods must have taken its toll on the local production, but how extensive it was is now difficult to tell. Another lost thread in the lineage of textiles is which designs were brought east and influenced the aesthetic, and what adaptations were made in India specifically for the taste of the eastern markets. The continuity of small, ever-evolving geometric designs is evident over the centuries. The importance of honoring your ancestors was both an overriding force and a stabilizing factor that resulted in distinctive local styles with unique and varying symbolism. While migrations and trade constantly brought new ideas, they were adapted to and fit within a specific aesthetic perspective. A slow metamorphosis of designs was both allowed and constrained by the close ties between these complexly designed and labor-intensive textiles and religious beliefs.

Because the designs of these textiles are tacit rather than explicit or literal, they form an emblematic language that represents a well ordered and understood social hierarchy for those at the top of the social or religious hierarchy. Most of the symbols are parts of complex metaphors that separate the initiated from the remainder of the community and from the outsider. The basic system of metaphoric equivalents used in ceremonies and on textiles constitute their major visual emphasis. It is usually at this metaphoric point that we as outsiders begin our understanding of these textiles. For instance, a deer refers to royalty as in the Sumba textile (plate 126) or, in Borneo, a snake with the underworld (plate 116). We can also determine how a particular textile is used in the context of a ritual gift or donned for a particular ceremony, but it is more difficult to make these disparate elements form a whole story and to understand its place within the context of the mythology that forms the structure of the society. Throughout this area, textiles decorated in some manner incorporate an intellectually refined application of the structural principles of the society within which they are made. The designs are a manifestation of a societal or religious order and, therefore, become a code that distinguishes that particular group. This can be accomplished either through the luxurious profusion of gold and brilliant colors reflecting the heavenly world or a more restrained elegance that reflects the sobriety of nature. Either perspective reflects the view that every component of the natural world symbolizes a higher reality.

Both the image-laden cloth and the threads used to make them are widely believed to be replete with beneficial powers to ward off harm and serve as a protection against misfortune. From the earliest time of the mythical ancestors textiles have metaphorically represented the life of the individual within the society. The process of producing a complex design by binding the threads as in the ikat technique, the lengthy and repetitious dyeing procedure, the even placement of the weft between the taut warps, and the detail added to the finished textile all combine to form a statement that in itself becomes a binding force.

PLATE 108
Weaver from the village of Waidelousaua in East
Sumba. 1987. (Photo: Mary Hunt Kahlenberg)

PLATE 109
Kilt or cape (*Piupiu*)
Maori People
New Zealand. Late Nineteenth century
Plaited flax and maurea
30 x 36" (76 x 91.5 cm.)

Piupiu were worn over the shoulder, as well as around the waist. The bold triangular shapes of this piece indicate a date at the end of the nineteenth to early twentieth centuries, when decorated areas became more prominent. The design was made by scraping the strands of flax to remove the shiny outer skin. Then the porous interior section was dyed black with a vegetal dye. These strands called *hukahuka* were inserted folded in half, while the waist band was plaited.[1] The sound made by the *hukahuka* was more important than the design, and the swishing noise of the *hukahuka* was increased by the amount of *hukahuka* squeezed into the waistband.

PLATE 110
Man's (?) Garment
Island of Aoba, Vanuatu. Nineteenth century
Plaited and stenciled pandanus palm, made in two pieces and sewn together lengthwise
52 x 18" (132 x 45.5 cm.)

Decoration is added to the basic shape of this mat-like garment by folding the palm strips back and interlacing certain fibers twice. Both ends feature a spacing technique to form rows of small holes. Added to this textural design is a stenciled motif done by winding the garment around a cut tree trunk of the same width. Then a stencil is cut from a large banana stalk that is subsequently bound tightly to the mat. Together they are dyed in a large vat. The geometric designs of the two end panels are cut precisely to match the open spacing.[2]

The designs on the mats are related to tattoo designs that are essential decoration for both men and women. Men are entitled to certain designs according to their rank within the prescript of the *suque*. The principle of the *suque* is that a man achieves higher status through a series of donations of pigs, mats, and money. Thus he acquires a more favorable life force on earth and will carry his esteemed position to the next life. Through the tattoos on a man's body and the patterns on his garments, his status may be quickly identified.[3]

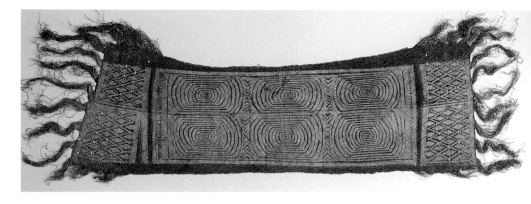

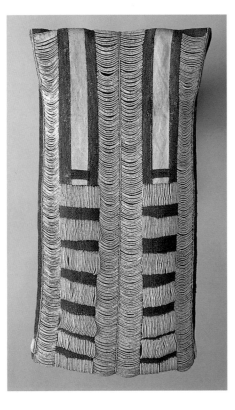

PLATE 111
Man's Coat
Atayal People. Northern Taiwan.
1850–1875
Supplemental warp and weft patterning in
raveled wool, cotton, and hemp, trimmed with
shell beads and natural hemp plaited band
38½ x 18" (98 x 46 cm.)

The conspicuous display of the countless hours of labor required to apply thousands of shell beads on strings to the back of this warrior coat confirmed his status and prestige. The rarity and costliness of materials would have been evident to members of Atayal society since the beads are made of seashell traded from the coast. The red and blue wool supplemental warp pattern threads were created by unraveling British woolen trade cloth and re-spinning the fiber into yarn.

Today the island of Taiwan is connected culturally and politically to the East Asian landmass. The aboriginal inhabitants encountered by these Chinese settlers were, in fact, linked to Southeast Asian and Melanesian cultures. Archaeologists suggest that the migration of these people traveling by boat from the mainland of Southeast Asia, Indonesia, and the Philippines, reached Taiwan in waves over a long period, possibly beginning as early as two thousand years B.C.

One of the most telling pieces of evidence for a South Asian origin of the Taiwanese aboriginal culture is to be found in textile production. All weaving technology used throughout Taiwan utilizes a specialized variant of the body-tension or back-strap loom where the weaver's feet brace the warp beam to create the tension necessary for weaving. Ethnographically, similar looms have been found among the Ángami Naga of the Assam Highlands, upland Mon-Khmer people of Vietnam, the Li people of Hainan Island, and among Melanesians off the north coast of West Irian (formerly New Guinea), and in the Saint Matthias Islands in the Bismarck Archipelago. Archaeological evidence for the loom has been found in Yunnan province in southern China and on the island of Flores in Indonesia. (John Vollmer)

PLATE 112
Ritual Mat
Atoni People. West Timor, Indonesia
Early Twentieth century
Plaited lontar palm leaves with machine
woven cotton
68½ x 20¾" (174 x 53 cm.)

On Timor the crocodile or lizard, sometimes with a stylized horned head as seen here, is known in many media: bone, bamboo, horn, wood, cotton weaving, and – as in this mat – in split element plaitwork. Here, the design of the crocodile is surrounded by serpents and anthropomorphic figures. The motif may possibly refer to an ancestor that is related to a lizard or crocodile totem. A lineage myth among the Tetum people in Central Timor recounts how one of seven brothers cuts an eel into seven parts. The eel speaks to the youngest brother and he is changed into an eel with a human head. While the transformation is taking place he speaks to his brothers and tells them that neither they nor any of their descendants must eat eel or bath in the spring where it is found. Later, the brothers went their separate ways and founded a clan called Tuna. It is likely that a related myth is the basis for the pattern on this mat.

Prior to Western contact in the late 1700s neither metal making nor weaving was known in the Pacific islands east of Indonesia, beginning with most of Micronesia to the north and most of New Guinea in the south. Houses were notched and bound together with cordage, people used plaited sails, and sat, slept, and in some places wore plaited mats. In Amarassi, West Timor, the dotting patterns on ikat textiles appear to have been borrowed from the alternating black-white structure of plaitwork. Therefore, it is not surprising to find cotton warp ikats from the village of Amanuban, West Timor, sharing the concentric crocodile or lizard motif (also known to the Tetum people in Central Timor), as the major element of this rare pictorial mat. (Garrett Solyom)

PLATE 113
Ritual Mat
Atoni People. West Timor, Indonesia
Early Twentieth century
Double and triple layer plaiting with
supplemental patterning; lontar palm leaves
46¾ x 17" (119 x 43 cm.)

While the designs of this mat may have been
obvious to the Atoni who owned and used it,
some explanation – while still tentative – is war-
ranted. A display of female ancestors with birds
on their shoulders, in the air above them, and
between their legs, is mirrored from the center.
These are bordered by crocodile-like lizards.
The areas of the body where there is an attach-
ment of birds seem to require a protective
presence. As late as the 1960s, but probably for
centuries before then, sitting with the feet raised
in the wrong context left an individual open to
entry by evil spirits.

The ancestral female's procreative power
is emphasized here by showing her in X-ray
view, with her vagina emphasized. She may con-
tain another small figure within her womb,
with another medium-sized figure between her
legs. She may even have very small figures
descending from her armpits. Her palms may
carry a central eye-like form. In Central Timor,
she is represented on spoon handles with birds
flanking her genitals, in or on her hands or
otherwise surrounding her in varying positions.
Through these birds, she is seemingly associ-
ated with a sky or spirit-realm element.

This Timor mat pattern has great graphic
power due to its size, the nature of its imagery,
and the scale of the diagonal plaiting that causes
the zigzag edges of all its forms to be promi-
nent. The pale reflective ground of the palm
embues the motifs with a stark clarity and the
whole pattern with a sense of visual vibration.
(Garrett Solyom)

PLATE 114
Interior House Door
Tetum People
Central Timor, Indonesia
Early Twentieth Century
Carved; wood
68 x 25½ x 1½" (173 x 65 x 3.2 cm.)

This door, which once divided the two sections
of a Tetum house, was more than a separator of
two spaces – it was the threshold between the
two halves of the Tetum cosmos. Tetum people
believe that the center of the earth is in the form
of a womb, an underground sacred source of
life from which their ancestors emerged to the
secular upperworld. A woman's womb symbol-
ized the womb of the earth mother and the
individual birth of humanity. A birth takes place
in the "womb" of the house – a room at the rear
of the building that is further associated with the
womb of the earth goddess. As part of the birth
ritual the father carries the baby through this
open door, also referred to as the "female door"
or "vagina" of the house. Thus the infant sym-
bolically leaves the womb, the underworld, and
enters the upperworld.[4]

The carved design on the door again refers
to its symbolic position. A man's ceremonial
ornament called a *kai bauk* sits atop a rectangle
form that may represent the head, and is said
by some to represent a half moon and by others
the horns of a buffalo.[5] The larger rectangular
shape below shows a quatrefoil formed by a con-
tinuous raised line. This repeated design may
be viewed as representing revered and deified
ancestors who have returned to the earth's
womb, but who continue to play an active role
in the lives of their descendants.[6]

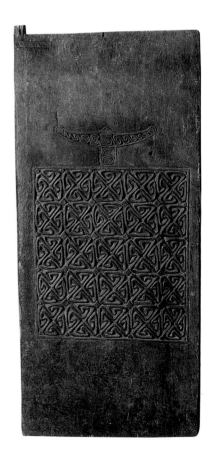

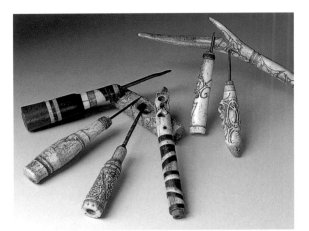

PLATE 115

Rattan Working Tools

Borneo, Indonesia, and Malaysia

Twentieth century

Incised, carved, and inlaid; ivory

and bone with rattan

4" to 8" length, ½" to 1" diameter

(10 to 20 cm. l.; 1.2 to 2.5 cm. d.)

That form follows function has been the credo
for more than half a century, and yet in earlier
times and other places the presence of design
on objects of everyday use was indicative of
reverence and status. Ornamentation can have
symbolic meaning, and it can have a sensual
and aesthetic value for the user.

 A group of tools for making mats and bas-
kets was collected from different areas of Borneo.
Wear patterns are left from the residue of hand
oils and the rubbing of the fingers.

PLATE 116

Ritual Mat

Ot Danum People

South Central Kalimantan (Borneo),

Indonesia. c. 1900

Plaited rattan

76 x 45½" (193 x 118 cm.)

A deceased man on his journey to the upper-
world is presumably represented by the large
orant figure sporting enormous earrings.
Dividing the mat are a pair of *etings*, snake-like
creatures that might be known as either the
rulers of the fish of the upperworld or as the
mystical snakes that move in the primordial
waters of the underworld.[7] The role of the ser-
pent is prominent throughout Southeast Asia.
As a fertility symbol it has been associated with
women from ancient times, symbolizing the
water that guards the life energy. Considering
the ritual context of the mat's function, it is
likely that the snakes represent a visual division
between the worlds, with the second "lower"
section with its array of fish, birds, and animals
denoting the soul's attainment of the abun-
dance of heaven.

 The materials of the mat add their contri-
bution to the aesthetics. The lustrous outer skin
of the rattan is perfect for conveying the sheen
of the serpents' scales. The diagonal plaiting
technique, like the grid of a weaving, allows for
the line of a design to be moved in increments.
The finer the elements the more the stepping
structure can resemble a curve. Nevertheless,
the geometrical aspect is a natural outcome of
these techniques and becomes, in time, an aes-
thetic preference. The placement of a human
figure or a snake into a composition is deter-
mined by the shape of the object, not by the
story line. The shape of the mat is determined
by the limitations of technique, which again
becomes codified into a cultural propensity.

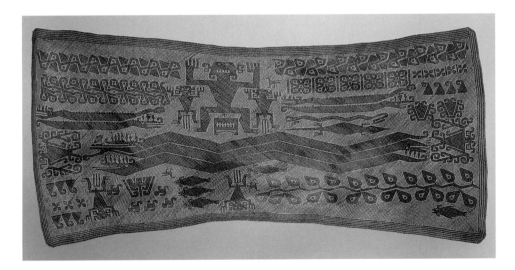

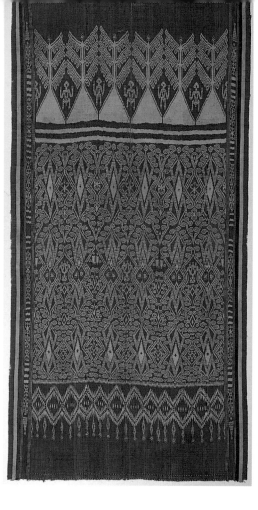

PLATE 117

Ceremonial Hanging (*Pua Kombu*)
Ibanic People
West Kalimantan, Indonesia. 1875–1900
Warp ikat technique; cotton
88½ x 44" (225 x 112 cm.)

Piercing eyes stare out from the center of this *pua* and command our attention. At first, this complex composition appears crowded but the precision and delicacy of the lines draw us in until we find small animals, insects, and birds hidden in a proliferation of scrolling tendrils. The origin of this "ornamental " design has been attributed to the bronze objects of the mainland Dong-son culture (600 B.C.–A.D. 100), though recent pottery finds in the Lapita Pacific island cultures (1500–500 B.C.) could be another source for this scrolling style found in many areas of the Indonesian Archipelago.[8]

The Iban people live in the dense jungle of Borneo where they are upland rice farmers. Upland farming exhausts the land and requires the periodic moving of the entire village to uncleared forest elsewhere. The expansive and aggressive qualities required to achieve this move have been developed through the male ceremonial activity of head-hunting. Connected as it is to the survival of the community, head-hunting is viewed as a fertility rite. Weaving is seen as the parallel female function and, in particular, the weaving of a *pua*. *Pua* have both protective and beneficial powers and serve as the covers of offerings and shrines, for newborn children, as well as the deceased. They function as canopies during ceremonies and were used to receive the heads when the men return home from a head-hunting expedition.

Potent designs of the spirit world give power to the *pua*. An established repertoire of patterns, copied from one generation to the next, exists for the weaving of the ikat *pua*. For a weaver to achieve the status of a warrior she must show her connection to the spiritual world by developing a new pattern. Only in a dream will the spirit reveal this new design. A medium to the ancestor spirits, therefore, becomes a metaphor for creativity.

PLATE 118

Jacket, (*Kalambi*)
Ibanic People
Borneo, Indonesia, and Malaysia
1930–1950
Supplementary weft (*pilih*), and tapestry techniques; cotton thread and machine-woven cotton
20 x 16" (50 x 40.5 cm.)

The forceful figures circling this jacket clearly say that its wearer was a person of importance. The row of male figures with arms encircling a trophy head (seen here reduced to a small dot), and a row of female figures sporting earrings dangling from extended earlobes, signify this status. The *pilih* technique makes the pattern reversible so that it can be seen in its opposite color on the inside. A background of small diamonds and zigzags, plus the alternation of a red and black background, totally fills the visual space.

The primeval jungle of the Iban world is pierced only by the rivers that flow from the arc of mountains that runs across the equatorial island. At certain points the jungle reaches from one side of the water to the other, blocking the rays of the sun. Vines swing down from the trees grown tall reaching for the light. The air carries the sounds of thousands of insects and birds that thrive on the wild vegetation. To be surrounded in this manner is normal for the Iban and may not be specifically noticed, but it is acknowledged as a form of security when it is extended as a design concept to garments and textiles of importance.

The addition of commercial threads to produce the bright solid stripes and the syncopated bands of triangular motifs brings another level of status. These yarns obtained only through trade were symbols of the wealth of the family and, therefore, were given prominence in the construction of the jacket.

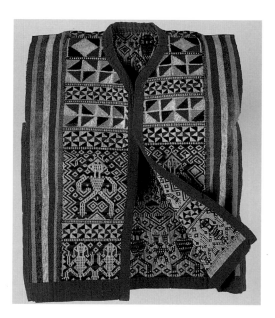

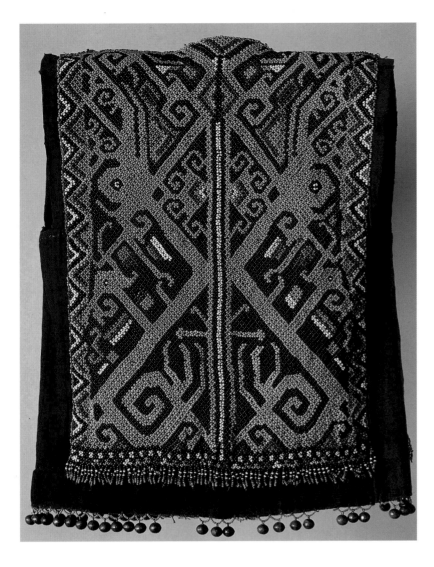

PLATE 120

Top: Shirt (*Ddgom*)

Kulaman People

Mindanao, Philippines. 1920–1940

Embroidery with cotton thread

and beads on machine-woven cotton

47 x 14¼" (119.4 x 36 cm.)

Bottom: Shirt (*Umbok*)

Bagobo People

Mindanao, Philippines. 1920–1940

Embroidery with cotton thread, handmade

sequins, and beads; machine-woven cotton

42 x 14¼" (106.5 x 36 cm.)

Wonderfully decorated shirts are worn by the different groups living on the island of Mindanao in the southern Philippines. While decorative styles vary, they use a related shirt shape that is worn by both men and women. Imported cloth brought down the coast and traded into the highlands has replaced the traditional abaca cloth, a type of wild banana that grows abundantly in many areas of Mindanao. Most abaca garments are dyed in brown tones, so the bright trade cloth was enthusiastically adopted, as were the lustrous white beads and the multicolored cotton embroidery threads.

The *Kulaman* shirt uses these beads to great advantage. Sewn densely into a triangular shape down the back they take on the look of a reptile, perhaps the crocodile. The crocodile is regarded with awe and adoration as the one animal capable of scaring away the spirits of disaster and disease.

The tie-dye sleeves of the Bagobo shirt also have their animal characteristics, although somewhat beyond recognition at this point. It too uses beads but in a more delicate fashion to outline very colorful embroidery that includes small bits of printed red and white trade cloth (an imitation of the cloth that has been tie-dyed for the sleeves).

PLATE 119

Beaded jacket (*Sape manik*)

Maloh People

West Kalimantan (Borneo), Indonesia

1890–1915

Beaded with glass beads, with a barkcloth lining, decorated with bronze bells; machine-woven cotton lining

21½ x 16" (54.5 x 40.5 cm.)

Beads, being a more mobile material than cloth, have been traded in the hinterland of Borneo for over two millennia. Imported and expensive, they are symbols of social status, becoming heirlooms passed down from mother to daughter. Thus, they enhance the ritual significance of a garment. Their hardness and durability are associated with strength and protection, qualities that are transferred to the wearer.[9] Here, the prestigious beads are combined with an image of power, that of the coiled serpent. Living underground, the serpent is viewed as a representative of the earth, and while living in the sea or the river, it is associated with the life-giving qualities of water. At the same time its shape and movement give it phallic qualities that – when taken together – make it a most powerful fertility symbol. The serpent is associated both with the eternal spirits of the ancestors and the underlying energy that inhabits all forms of life.

This concept of energy is conveyed by the brilliant yellow beads that form the coiled body of the serpent. The original power of the form has given way to the decorative spiral that forms both the tail and the headdress. The ritual association of this jacket is reinforced by the bark lining inside the jacket. Leaves and various unwoven fibers were used for garments until weaving technology was introduced through later migrations. The relationship of this older tradition with the ancestors accounts for its continued ceremonial function.

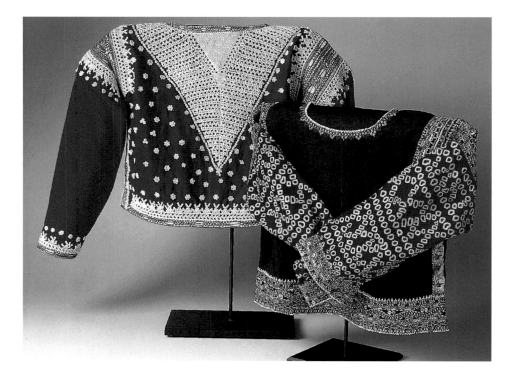

PLATE 121 (detail)
Woman's Bodice
Shan People
Myanmar. 1850–1900
Cotton plain weave with applied white
seeds, pulled wool plain weave, red cotton
twill embroidered with cotton threads
33⅔ x 29½" (85.5 x 75 cm.)

The Shan are a Thai-speaking minority living in
the highlands of northern Myanmar. They are
hunters and gathers, as well as rice farmers. Shan
tribes controlled commerce between the coast
and the highlands of south and west Yunnan in
China. The woman's tunic follows a traditional
form, but is made entirely of imported goods.
The red and blue cotton fabrics are commercial
goods made in India. The woolen fabric, which
has been cut into strips to form a decorative
lattice and fringe, is British-made. The complex
decorative program using appliqué and embroi-
dery with a variety of materials testifies to the
skills and accomplishments of the wearer/maker.
The garment reflects the local status of the
wearer, as well as the financial resources of her
family, who could acquire expensive and exotic
trade goods. (John Vollmer)

PLATE 122 (detail)
Banner (*Roto*)
Toraja People
Sulawesi, Indonesia. 1900–1920
Tie-dyed; plain weave cotton
168 x 23" (427.7 x 58.5 cm.)

Rainbow is the literal meaning of *pelangi*, the Malay word for tie-dye. Rainbows are thought to carry portents of important events and, for this reason, a textile that represents one is considered to bear a sacred function. Tie-dye is a simple coloration technique used throughout the world. Like the rainbow, it provides a graduated blending of colors. The *roto* was made by the Toraja people who populate the lush mountains of Southwestern Sulawesi, a large island in the Indonesian archipelago. It is kept with many other sacred heirloom cloths that are brought out from their storage in large baskets. High above the cooking fire, they keep the textiles dry and pest free. These textiles are considered so potent that they cannot be brought out into the light of day without sufficient reason. One of these occasions involves their sitting or being tied to the top of a seven-meter-high bamboo tower called a *pabalikan*. The *pabalikan*, with its ring of powerfully sacred cloths fluttering in the breeze like the large leaves of a tree, symbolizes the growth and renewal of the family and community.

PLATE 123
Ceremonial Hanging (*Sarita*)
Toraja People
South Sulawesi, Indonesia
Early Twentieth century (?)
Painted and dyed; plain weave cotton
189 ½ x 11 ¼" (481.5 x 193 cm.)

While we may not know the exact origin of this cloth, for the Toraja, sacred cloths such as this *sarita* were given to the *rapu*, or kin group, by their prominent ancestors who had descended with the cloths from heaven. This provenance gave these sacred cloths the power to bless the family, their animals, and their crops, ward off illness and, as long as the cloth remained in the possession of the family, prosperity. The safeguarding of these powerful objects is the responsibility of the women of the family. The matrilocal tendency of the Toraja means that the house is predominantly inhabited by a sequence of female descendants of the founder of the *rapu*.

Since they are so powerful, sacred textiles are only removed from storage when their power is required. Such occasions include ceremonies that honor the deities and ancestors. For these ceremonies sacred textiles are worn, hung as banners, or used to define a ceremonial boundary.[10] The power is an integral part of the textile regardless of its origin, design, age, or condition.

Two types of design are alternated on this long cloth that functioned as a symbolic wrapping. Some of the designs visible in this photograph include: spiral and curvilinear designs that may have their origins in Indian textiles, continuously imported over several hundred years; *buffalo ears* that refer to the sacred water buffalo; and, *the sun with rays*. Between these motifs are a series of genre scenes including a boy leading a buffalo, and a woman pounding rice.[11]

Sarong with Horse Design (*Lawo Jara*)
Ngadha People
Flores, Indonesia. 1900–1925
Warp ikat technique; cotton
72 x 29 ½" (182 x 75 cm.)

Despite the fact that this is called a horse sarong, there appears to be a question about whether the design is a horse or an elephant. Throughout the Ngadha Area of Flores these stick-like animals are interpreted differently, depending upon the village in which they are made or worn. As the exact origins of this sarong are now lost we must consider both options. The two animals are symbols of status. No entry date is known for the arrival of the horse to insular Indonesia. It is thought that they were brought by the Arab traders and given, along with opulent textiles, as royal gifts in exchange for trade concessions. Their exclusivity in the hands of the aristocracy led to their development as a rank symbol. In this association, horses became further identified with the male activities of hunting, ritual warfare, and rank-related transition ceremonies.

Horses were a reality among the Ngadha people of Flores, but elephants were not. Royal gifts of elephants were popular in Sumatra, where trade was more abundant, but even the fertile areas of Flores did not provide sufficient agricultural wealth for such a mighty present. Instead, representations of elephants came in the form of luxurious silk double ikat textiles from Gujarat, India. These textiles called *patola* featured pairs of magnificent caparisoned elephants. Even today, the sight of one of these textiles is thrilling.[12] In the context of the Ngadha people, where garments were limited to local cotton dyed in blue and reddish brown, the power associated with this magnificent silk with its large elephants can easily be conjectured.

But all this brilliance was not available with native dyes. Nor was the detailed drawing style suited to the expressive linear form of their ikat. So they took both the horse and the elephant and reduced them to an essential form, thereby eliminating the decorative element but retaining the power of the symbol. These simple motifs in white on blue, no matter which animal they represent, were immediately recognizable.

Plain garments dyed dark blue with indigo dye were worn by children. After puberty rites, garments with small simple ikat designs announced an individual's marriageability. The next important rite of passage was achieving mature status within the community. These new garments were decorated with bands of horse or elephant motifs. Status was continuously upgraded based on a couple's ability to host traditional feasts, and, as their status heightened, the amount of animals that paraded across their garments increased accordingly.[13]

PLATE 125 (detail)

Man's Ceremonial Garment (*Hinggi*)

East Sumba, Indonesia. 1890–1920

Warp ikat technique; machine-spun

cotton thread

114 x 68½" (289.5 x 174 cm.)

The woman who created the design for the warp of this *hinggi* had great skill and high status. Note the precision with which the complex design is rendered and the incorporation of a number of prestigious designs that her position entitled her to use. A motif that symbolizes growth and renewal fills the wide band that dominates the *hinggi*. After a victorious raid, enemy heads were placed on the upright branches of a stripped tree in front of the important households.[14] Royalty would then sponsor a grand ceremony, supplying large amounts of food for hundreds of guests. This display is essential to the renewal of life and the maintenance of order within the Sumbanese universe. Thus the design of this *hinggi* with its magnificent skull tree forms an equation in the viewer's mind between the garment itself and royalty.[15]

PLATE 126 (detail)

Man's Ceremonial Garment (*Hinggi*)
East Sumba, Indonesia. 1920–1940
Warp ikat technique; hand-spun cotton
114 x 68½" (289.5 x 174 cm.)

Deer with magnificent antlers stand facing each other. Their small heads and extended necks take on a serpent-like appearance that is kept in balance by the tree-like form of the raised tails. The overall curvaceous pattern of the two affronted animals is unusual. They establish their own graphic shapes and provide a sense of movement. This is contrary to the more rigid and detailed portrayal of many Sumbanese animal designs. The talent of the woman tying

the design is the essential key to its success, but there may be another reason why this piece is different. Compared to the previous *hinggi* it is rather coarsely worked. The threads are of a rougher handspun, and the design is not tied so precisely, nor is it so detailed in its display of filler motifs. It was probably made by an aristocrat as a gift and not for use by the family. Therefore, it would not be necessary to pay so much attention to these details.

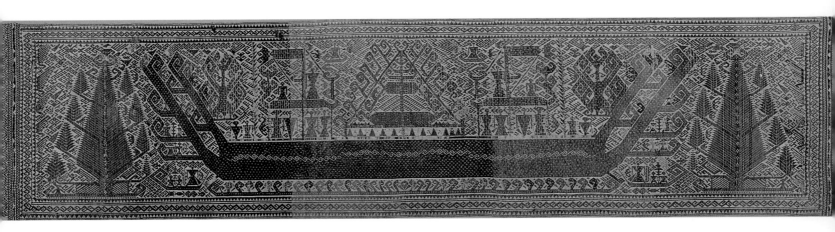

Pelapai are among the most famous textiles from Lampung, South Sumatra, indeed from all Indonesia. *Pelapai* were apparently displayed during the meetings of lineage heads, where they were hung hierarchically.[16] Each symbolized a lineage head that was present. During weddings they could be hung immediately behind the wedding seat of the bride and groom, representing the male line from which either bride or groom descended and they probably provided a symbolic vehicle of passage for bride and groom.

Lampung is veined by rivers, navigable to differing degrees by sail-bearing vessels. Ships were crucial for trade with Java less than twenty-five miles east across the Sunda Straits and with the royal port of Palembang, northeast some three hundred miles up the coast. Consequently, the ship was a primary symbol of conveyance from one place to another, one stage of life to another, a symbol of safety on the eternal waters,

and of power, for the fully laden ship represented great wealth and influence.

This *pelapai* belongs to a style group of at least seven examples of similar treatment and subject from Kalianda, part of the *Paminggir* southern coastal culture. Because the figural motifs of this cloth are fewer in number, more generalized in articulation, and thus less comprehensively descriptive of elements more finely and fully rendered in earlier examples, it is therefore somewhat late in this style tradition – perhaps late nineteenth century? The central motif on the ship stands out as unique. At the bottom of the radiant triangular structure with a central post lies its primary form: a large long bundle or container with hook-shaped finials that appear to have emanations of energy above it. Could this represent a corpse bundle or the coffin for a chief's funeral?[17] (Garrett Solyom)

PLATE 128

Ceremonial Garment (*Tapis*), End Panel
Lampung, Sumatra, Indonesia
Nineteenth century, possibly earlier
Weft brocade technique; cotton and silk
45 x 14¾" (114.5 x 38 cm.)

Outward growing branching energy reverberates from straight-line segments that pattern this important textile. The electric outlining with white and interlining with turmeric and red give the pattern an almost multi-phasic pulsing quality. In the *tapis* pattern band, each three side-by-side square contains a large hook-edged diamond with a smaller central diamond within it. Standing out from the inner diamond, each protruding into one of the corners of the hooked diamond, are four conventionalized angular human figures with legs wide apart. The two figures on the vertical axis with phallic trunks and arms at their sides are male (?). The two figures on the horizontal axis with triangular heads, arms akimbo, and two dots on their chests, are female (?).

This cloth is also notable because it shares its pattern with that found on at least one Sumatran large plaited conical food cover, *tudung*. The plaitwork versus weaving comparison is significant. In a number of places in Indonesia weaving has picked up and replicated plaited patterns. This repeating of the one-over-one-under interlacing structure of the long thin dark and light plaited strips makes it clear that weaving is borrowing from plaitwork. In Indonesia, more often than not, plaitwork appears to be a very conservative tradition, less susceptible to change than weaving. (Garrett Solyom)

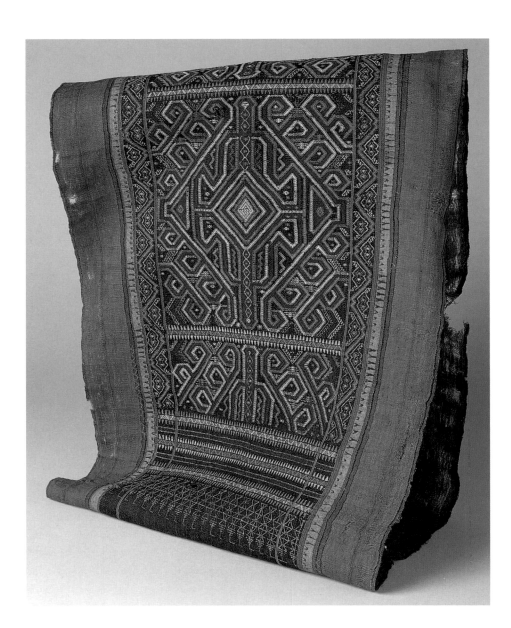

PLATE 129 and PLATE 130 (detail of Plate 129)
Ceremonial Garment (*Tapis*)
Lampung, Sumatra, Indonesia
Nineteenth century, possibly earlier
Supplementary weft and warp ikat techniques,
satin and running stitch embroidery;
cotton and silk, six panels joined side by side
50¼ x 49½" (128.5 x 126 cm.)

Both subtle and sumptuous, women's ritual tube-skirts, *tapis*, with broad silk embroidery panels stand as major forms of Lampung textile art. Their makers combined several techniques and juxtaposed several complex pattern types, still shaping skirt cloths with unit design integrity.

The suggestive mystery surrounding *tapis* patterns persists. We are unsure of the meaning of motifs and the long, narrow – possibly narra- tive – tableaux they fit into. They seem covered with ships bearing ancestors, portals of honor and power, wishing trees, banners of rank, fan- tastic creatures we think we see, all rendered in different combinations, scale, and varying details in different styles. The viewer realizes that mul- tiple levels of complexity are involved in these embroidered panels. Shapes are produced and juxtaposed in a suggestive manner. A structure appears to be a platform with posts – or is it a ship with oars – yet it sprouts tendrils and buds.

In certain areas, even a family that pre- served, remembered, and recorded much earlier traditional information and possessed a fine

tapis in perfect condition, nevertheless called it "old *tapis*," *tapis tuha*, knowing nothing about its pattern. This suggests some *tapis* were pre- nineteenth century in date. Within living memory, however, some were still used in the Liwa- Kenali area in North Central Lampung. During the wedding transaction they were folded and packaged in a formal manner, and taken to the potential bride's house as evidence of the seri- ousness of the boy's family's marriage offer. The *tapis* would have been accepted by the girl's family and returned after the wedding. In that context, *tapis* were not worn. (Garrett Solyom)

PLATE 131 (for detail see Plate 39)
Ceremonial Shoulder Cloth *(Kain Limar)*
Malay People
Bangka or Palembang, Sumatra,
Indonesia. Late Nineteenth century
Weft ikat and brocade techniques; silk
and metallic yarns
82½ x 32½" (209.5 x 82.5 cm.)

A sumptuous textile by any standard, this *kain limar* was part of the opulence of one of the courts of Sumatra in the latter half of the nineteenth century. For hundreds of years, great expense and time had been devoted to maintaining the power of this court in Sumatra. After the colonization by the Dutch, this warfare ended. The courts, powerless but with status, developed a new level of affluence. Time and money were now spent on furnishings and adornments.

Silk ikat textiles were probably made in this area for some time, since the tradition also exists on the mainland with similar textiles being produced in Malaysia, Thailand, and Cambodia.[18] The double ikat *patola* textile made in Gujarat, India, is the most likely progenitor of this style. The *patola* design most commonly exported to Southeast Asia was a stylized floral motif set in a repeated circular format. In many areas of Southeast Asia this design is still carried on with only small changes to accommodate the change of colors, the materials, and the more limiting warp or weft rather than double ikat technique. A design of the batik court textiles of Java, the mystical *garuda* bird with open wings – a symbol of royalty in many areas of Southeast Asia – was also a well-known design for these Sumatran ikats.

In Europe during the last half of the nineteenth century there was a revival of the floral motifs of the Baroque style. These European fashions were absorbed into what was becoming a court style in Sumatra. In this beautiful design, all of these influences appear to be layered, even the wings of the *garuda* can be seen in the green leaves and its head and body in the central diamond. More expansive in its drawing than usual, this ikat has a most unique technical feature: between every set of ikat wefts is a set of solid red wefts. This opens the design, making the lines more graceful and adding a vibrating shimmer.

NEXT PAGE
PLATE 132 (detail)
Head Cloth
(Iket Kapala Prada)
Malay People. Palembang, Sumatra,
Indonesia. 1890–1920
Batik and applied gold leaf; machine-woven cotton
35 x 35" (89 x 89 cm.)

The gilded saturate red and blue batik was made to sparkle as its wearer moved through the filtered light of an aristocratic Sumatran house. The prosperity of trade in Southeastern Sumatra, as well as the taste of the trading partners brought a predilection for the gilded. In contrast to the bright tropical light outside of nineteenth-century palaces, the inside is enveloped in gilded dark red lacquer. The aesthetic guiding the architectural setting governs the clothing worn inside.

This headcloth was most likely made in the town of Lasam on the north coast of Java. It would have been designed and made in a *Peranakan* workshop. *Peranakan* refers to a person of mixed race and most frequently to the mix of a Chinese man and a local woman. Headcloths in this coloration were made for the Muslim population throughout Sumatra, and only small differences give clues to their final destination. In this case, the running floral and leaf border locates its destination as Palembang. The cloth would arrive at the Sumatran port ungilded. This application of gold leaf was the specialty of Sumatra and would have been done in a workshop closer to its final destination.[19]

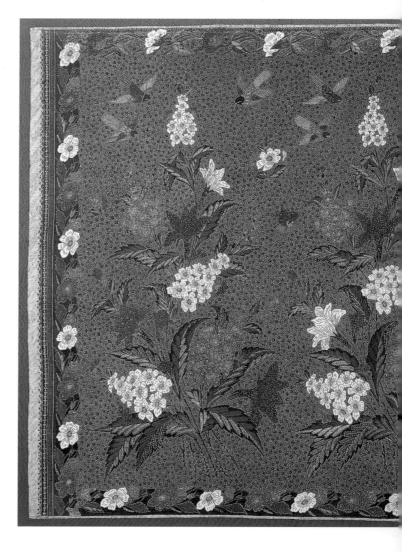

PLATE 133 (detail)
Woman's Skirt Cloth (*Kain Panjang*)
Artist: Boen
Koedus, Java, Indonesia. 1930–1940
Batik technique; machine-woven cotton
44¼ x 106" (112.5 x 269 cm.)

This batik is signed with the name Boen in Koedus. The batik has a very dense background of small flowers set on scrolling tendrils like fine lace. This provides a textural setting for a graceful bouquet of brilliant white flowers accompanied by more delicate colored blossoms and two-toned leaves. The fineness of the batik done with a pen-like tool, is amazing. The sensuous drawing of the flowers against the lush background appears to yield the rich floral scent of the tropics.

When we think of batik, it is this floral style that usually comes to mind. But this style of batik pattern was not worn by the Javanese or Sudanese population of Java, but rather was the creation of the community of mixed descent:

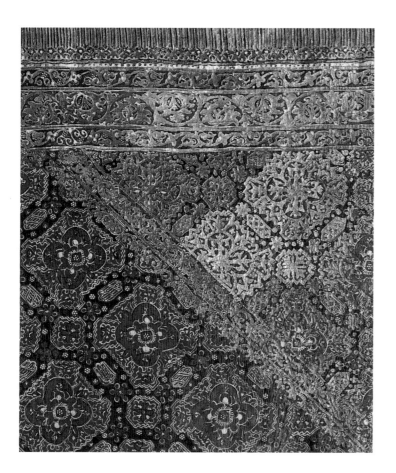

Javanese\European and Javanese\Chinese. In the nineteenth century, these groups – not being allowed to wear the traditional batik designs of the courts – began producing and establishing a style that was uniquely theirs. It was called *Batik Pasisir, Pasisir* meaning coastal, since the majority of these people of mixed descent lived along the Javanese east and northeast coast. Favorite designs included animals and flowers that reflected the European herbal traditions and Chinese designs, including the lotus and peony designs, as well as the then current European fashionable decorative styles, such as Art Nouveau. It became a garment of fashion, and versions of the latest designs by the couturier-level workshops were quickly copied by the less skilled designers and craftspeople.

PLATE 134 (detail shown in Plate 49)
Ceremonial Hanging
Western Indian, found in Timor,
Indonesia
Second half of the Eighteenth century
Resist and mordant dyed; plain weave cotton
32½ x 104" (82.5 x 264 cm.)

Hindu deities mingle with mortals on a very intriguing Western Indian textile that was traded to Indonesia in the eighteenth century. Floral borders typical of Western Indian workshops enclose an enigmatic group of figures. The closest textile parallels are the large theatrical painted scrolls employed as backdrops by the wandering troupes of Western India. Yet it is unlikely that this cloth could have functioned in that way, the figurative panel being only part of the overall design.

The subject matter is drawn from a Hindu cultural milieu beginning with the flute-playing figure performing for a maiden, Krishna Venugopala, with the herdswoman (*gopi*) and cow. Two other vignettes could be interpreted as illustrating scenes from the *Bhagavata Purana*, the Hindu epic that recounts the adventures of

the youthful Krishna: the male figure leading a protesting horse (upper left) could be Krishna killing the horse-demon Kesi and the combatants (lower center), Krishna killing the evil king Kamsa. An anthropomorphic representation of Garuda appears (left). Added to these scenes are cowherd farmers, courtiers, nobles, foot and equestrian soldiers, and a man being carried in a palanquin.

Masked and costumed theatrical characters occupy a stage in the upper register, reminiscent of troubadours in Gujarat and Madhya Pradesh. The style of the figures, and particularly the characterization of racial features, have affinities with the puppet theater tradition of Western India and the Deccan, and can also be linked to Gujarati paintings of the period.

How this cloth was employed in Eastern Indonesia remains unexplained. As a high-value exotic commodity, its role most likely was as a social status marker. In all probability, it was used by members of the Timorese elite as a ceremonial backdrop on state or ritual occasions. That the subject matter could be read as courtly entertainment must have only enhanced its desirability.[20] (John Guy)

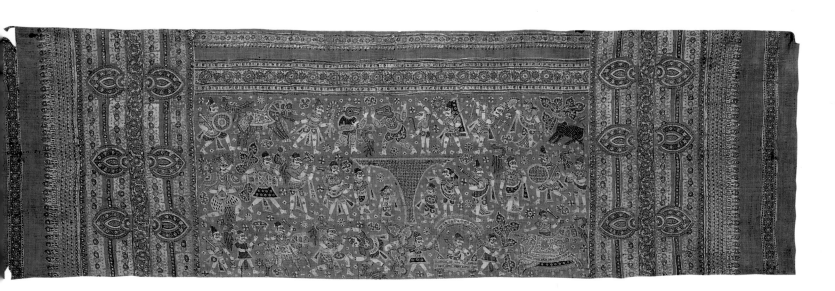

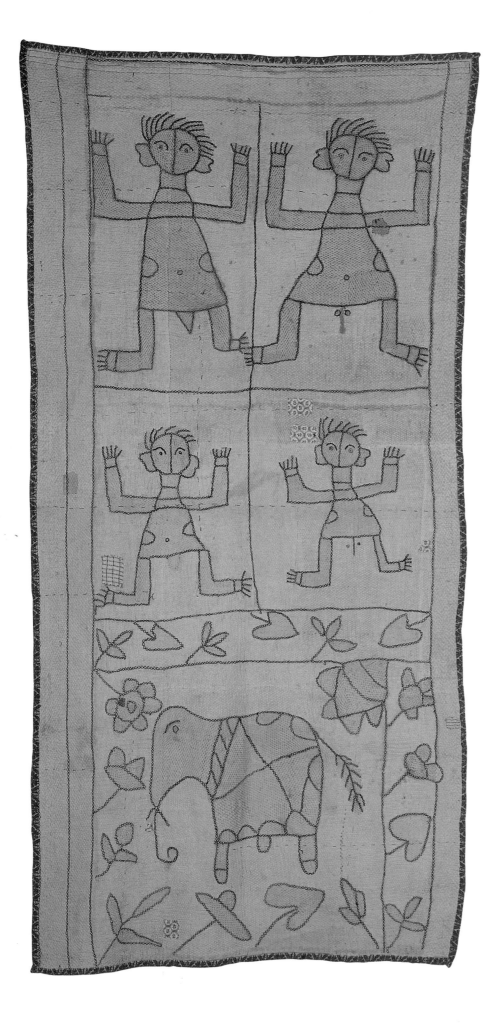

PLATE 135

Quilted Cover (*Sujani*)
Bihar, Madhubani region, India
Mid-Twentieth century
Cotton embroidery on plain weave cotton
102 x 50" (259 x 127 cm.)

The inhabitants of rural villages of the Madhubani region struggle with nature for survival. In the village of Mithila, on the north bank of the Ganges, people give visual voice to their hardships and joys by adorning their few possessions. Embroidered textiles of the region are made mostly by women for use in the home, although an increasing number are produced for direct sale. This embroidered quilt, or *sujani*, represents not only a symbolic dialogue between a woman and the traditions of her community, but is also an intimate and loving embrace created by a mother for her child, or a wife for her husband. As she sits down to outline the designs of her quilt, she is striving to capture the objects and ideas that are familiar to her or close to her heart: a cherished comb, a lotus blossom, a prosperous harvest. With such a quilt, a woman envelops her loved ones in the embroidered symbols of hope, wealth, and happiness.

These humble quilts are made by layering and stitching together remnants of old saris and *dhotis*, a white cloth worn as a lower garment by Hindu males. Preserved saris also provide the colored embroidery thread that is carefully drawn out of the fabric, strand by strand. *Sujani* are decorated in bold, simple strokes. The outline of each motif is usually worked in a dark-colored herringbone stitch and then it is filled in by creating large blocks of straight, parallel lines using a running stitch.

This simply rendered and charming quilt is divided spatially into three tiers. The naïve and uninhibited portrayal of the female and male figures may represent a bride and groom or, perhaps, a family. A garden of abstract floral designs surrounds the auspicious elephant, a symbol of prosperity. Although its creator is unknown to us, there is a certain sense of warmth, humor, and comfortable familiarity about this quilt that brings a smile to one's face. (Tamara J. Tjardes)

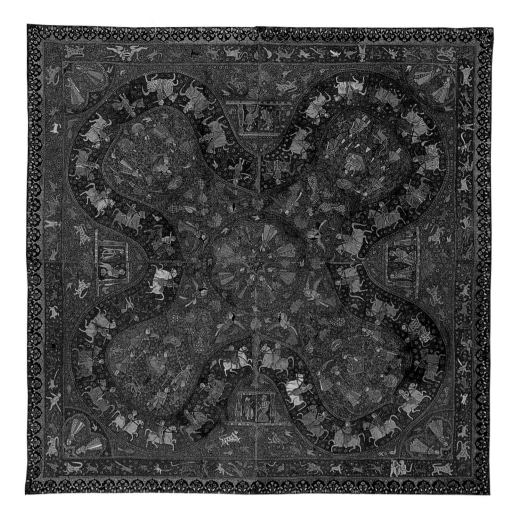

PLATE 136 and PLATE 137 (detail of Plate 136)
Embroidered Cover (*Rumal*)
Kashmir region, India
Late Nineteenth century
Chain, stem, and buttonhole stitch;
silk embroidery on cotton
65¾ x 66" (167 x 167.6 cm.)

The embroidery of Kashmir, a northern state of India bordered by Pakistan and the Tibetan Autonomous Region of China, reflects the diverse cultural influences of Hinduism, Islam, and Buddhism. Successive rule by the Mughals, the Afghans, and the Sikhs, as well as a flourishing European export trade in the coveted Kashmir shawl, have all contributed to the rich repertoire of color, design, and symbolism which imbue woven and embroidered textiles. This exquisite pictorial embroidery is reminiscent of *shikargh* (Persian for "hunting ground") textiles that became popular under Sikh rule (1819–1846). Resisting attempts to enforce an ideal Islamic prohibition against the depiction of humans and animals, the Sikhs brought a wider palette of color and figurative decorations to Kashmir textiles. As the shawl trade began to decline toward the end of the nineteenth century, artisans from Kashmir, neighboring Himachal Pradesh, and other areas of India began to make embroidered covers such as this for the European and Indian market. Here, lyrical vignettes of elegant ladies and gentlemen engaged in conversation, some in Western dress, emanate from a central lotus mandala. A large cloverleaf, shaped by a procession of dashing horsemen, composes the cover into four quarters, suggesting its possible use as a table cover. A menagerie of animals, birds, and anthropomorphic beasts romp and chase each other through a field of flowers as angels hover over the scene, possibly an allusion to the heavenly guardians of Islamic Paradise. (Tamara J. Tjardes)

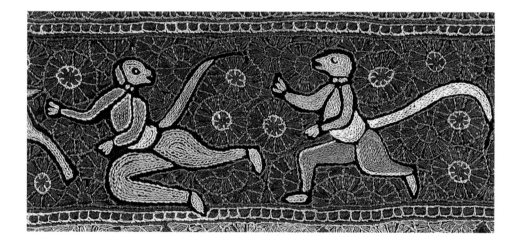

CHAPTER 6 # Western Asia

BY JOHN T. WERTIME

Western Asia has played a singular role in the evolution of the
fiber arts. It was the site of humankind's earliest domestication
of plants and animals, among them flax, the goat, and the
sheep. It was also the site of one of humankind's earliest weaving
cultures. Sheep in captivity in western Asia first developed a
woolly coat suitable for spinning and fabric production. Weft-
wrapping (or "sumak"), tapestry weave, cut-pile wrapping
("knotted-pile"), and felt-making first came into being in this
region and have remained characteristic of it ever since.

Later, the drawloom for weaving complex textiles of silk, a luxury fiber from China, was invented there. Accompanying the diversity of materials, structures, designs, and formats in western Asian fabrics was an amazing range and quality of color achieved by dyers that makes color one of the most outstanding attributes of this textile tradition. In view of the richness and substantial output of western Asia it is not surprising that a significant portion of the handmade rugs in European and American homes, as well as rugs in western collections and museums, comes from this area.

Geographically, the principal weaving cultures of western Asia are bounded by the Marmara, Aegean, and Mediterranean Seas in the west, the Hindu Kush, Pamir, Tien Shan, and Altai mountains in the east, the Persian Gulf and Gulf of Oman in the south, and the steppes above the Caspian and Aral Seas and Lake Balkhash in the north. This vast region encompasses a large part of the Near or Middle East and all of western Central Asia, also known as Western or Russian Turkestan. In the Near East, the locus of weaving and felt-making has been the Anatolian and Iranian plateaus. These are mountainous regions with interspersed and adjacent low-lying or elevated steppes and deserts that include Turkey, northern Syria, northern Iraq, Transcaucasia, Persia, and Afghanistan. In western Central Asia, weaving and felt-making take place in the margins of the massive mountain ranges, the oases of the large deserts, and the steppe lands. Viewed in contemporary political terms, western Central Asia is formed by Turkmenistan, Uzbekistan, Tajikistan, Kirgizstan, and Kazakhstan. Generally speaking, as one moves through the entire region from west to east toward the heart of Asia, mountains become higher, deserts become larger, and the population decreases.

Unlike the peoples of Europe and China, who use furniture to raise themselves off the ground, the inhabitants of western Asia, for the most part, have traditionally lived close to the ground. Wide fluctuations in temperature there make warm floor coverings and clothing essential items of life. Initially, animal pelts served this function to a great extent, while animal skins provided early hunter-gatherers with the means of transporting and storing essential items and foodstuffs. In time, plant fibers worked into string, nets, clothing, baskets, and mats became significant as well. Weaving plant fibers accompanied, or followed, the growth in human population that came with people becoming increasingly sedentary and the establishment of permanent settlements in the Near East by 10,500 B.C.

Some of the earliest textile remains, made of flax, come from archaeological sites in the Near East. These date from 7,000–6,000 B.C. Animal fibers have not been found in these early levels, and would not be expected until the early domesticated sheep developed a woolly coat about 4,000 B.C. This occurred around the same period that nomadic pastoralism, the seasonal nomadic migration of people and animals as a distinctive way of life and specialized mode of production involving substantial populations, came into being in the Near East. To maximize their herds, the keepers of sheep and goats took them to graze in mountain pastures in spring and summer, and to lower lying and warmer pastures in winter. All the nomads' possessions went with them on the backs of pack animals.

Once wool from the domesticated sheep became available in adequate quantities, it created a fiber revolution, largely supplanting flax as the mainstay of textile production. The elasticity, scaly surface, and insulating quality of this easily spun and felted fiber made new types of fabrics feasible. This was particularly true of the pile-rug, tapestry-woven kilim, and felt. The other principal fibers employed in western Asia, cotton and silk, were later additions to its textile repertoire. Domesticated in India, cotton probably came by way of Arabia and Egypt into the Middle East and the Mediterranean only in the mid-first millenium B.C. Silk, while known as a trade item probably from the same period, and abundant only from the first century B.C., was not produced in the Near East until the secret of sericulture (long closely guarded by the Chinese) was discovered by the Persians in the sixth century A.D.

From the earliest urban cultures of western Asia and their successors, which developed imperial traditions that led to the vast Persian Empire of the sixth to the fourth centuries B.C., we unfortunately have very few preserved textiles compared to less perishable types of objects. Our view of these civilizations is thus a skewed one due to our limited perspective on the fiber arts and weaving which, since their inception, have been one of humankind's most labor intensive and time-consuming activities. The dearth of fabric remains in western Asia also often limits our perspective on the evolution of this art form during subsequent centuries. For certain groups of objects, the earliest surviving examples date only to the nineteenth century.

The civilizations of western Asia were significantly affected at different times by intruders from the peripheries in the north, south, and east. Indo-Europeans from the steppes above the Black and Caspian Seas first entered the Middle East by the nineteenth century B.C. The most lasting consequence of the Indo-European

invasions was the occupation of the Plateau of Iran around 1200 B.C. by Iranian-speaking groups. Their descendants created the Achaemenian, Parthian, and Sasanian empires and made major contributions to the art and culture of Islamic civilization. Other Iranian-speaking groups, consummate horsemen leading a nomadic pastoralist lifestyle dating back no later than around 1000 B.C., dominated the Eurasian Steppe to the north for centuries and profoundly influenced the Turkic and Mongol groups who succeeded them. The felt covered tent and horse nomadism were characteristic of these groups.

Islam was spread from the Arabian Peninsula in the seventh century A.D. by conquering Arab armies who, a hundred years later, had gained control of most of western Asia. In time, the people of this region were melded into a new and distinctive Islamic culture and civilization. Islam emphasized the abstract and geometric in art and discouraged the depiction of the human figure, especially in religious contexts. This informed Islamic art in general, and textile art, in particular, but by no means eliminated the human form from them.

The last major invasion that indelibly stamped the character of life in western Asia came in the eleventh century A.D., when nomadic pastoralist Oghuz Turks, living on the fringes of the Islamic world in Central Asia, began to establish themselves permanently in Byzantine-held Anatolia, in northwest Persia, and in Transcaucasia. Subsequent invasions under the Mongols and Timur (Tamerlane) both depopulated the sedentary segment of society and increased its Turkic population. To their east were other Turkic tribes – the Uzbeks of Uzbekistan and northern Afghanistan, the Kirgiz of Kirgizstan, and the Kazakhs of Kazakhstan – all of whom were originally nomadic pastoralists, some of whom continue to be so today.

The Uzbeks came into prominence in the fifteenth and sixteenth centuries as conquerors of western Central Asian lands that bordered on Persia to the south. Three Uzbek khanates ruled over most of western Central Asia during the nineteenth century when the textile arts of Central Asia underwent a notable renaissance. These states were multi-ethnic and included large nomadic pastoral populations – Uzbek, Kirgiz, Kazakh, Arab, and Turkoman, as well as urban and village-based Uzbek and Tajik (ethnic Persian) peasants.

Fabric production is the one type of craft and artistic endeavor in which all socio-economic groups in western Asia participated. Except for agriculture, no other

activity could match the amount of time and labor that went into it. A student of the Persian textile industry writing about the period 1500–1925 has likened that country to one big weaving mill. The same could doubtless be said of other areas of the region. Among the nomadic pastoralist and village populations, this was almost exclusively women's work. In the towns and cities, men were the main participants, with some women and many children working as well, as was true since the beginnings of urban culture.

With the knowledge and skills of earlier generations acquired from their mothers, nomadic women undertook virtually all facets of textile production, from washing, carding or combing, and spinning to dyeing and weaving. The animal fibers they utilized came from their own herds. Cotton and silk were obtained from sedentary sources. Their designs were geometric ones that could be drawn from their memories and committed to woven or felted fabrics without the use of cartoons or other devices.

Some village women wove in a geometric style similar to that of the nomads. Others copied urban fashions and rendered their curvilinear designs in a geometrized form. Their materials were those they themselves prepared or purchased in local markets. Like nomadic women, they produced textiles for their families' needs and for sale in nearby markets. Other village-based women were less independent financially and wove under cottage industry arrangements with materials supplied and designs dictated by urban entrepreneurs or their agents.

Production in the cities was based on craft specialization. Professional designers, some of whom may have been court artists, produced designs that were woven by professional weavers. Different specialists prepared and dyed the fibers they utilized. Fashion was dictated by court and urban tastes. Its influences were eventually felt by all but the most remote and isolated segments of society.

Of the large variety of fabric types produced in western Asia, it is the pile rug that holds the place of honor for most natives and outsiders alike. More than any other, this textile typifies the region's cultural background and aesthetic predilections. Pile-rug weaving has principally been the work of the Indo-Europeans – Persians, Armenians, Kurds, Greeks, and so forth – and the Turks.

Our historical perspective on the pile rug is relatively short due to the lack of preservation. The oldest surviving example of a complete rug in extra-weft cut-pile wrapping, from a Pazyryk tomb in the Altai Mountains, dates only to the fifth to fourth centuries B.C. This is an accomplished piece of weaving with a closely cropped

pile and complex design that obviously came from a tradition with long antecedents. Pile-cutting knives excavated in northern Persia and Turkmenistan not far from the southeastern corner of the Caspian Sea indicate that cut-pile rugs were being produced there shortly before 2000 B.C. The origins of pile weaving, however, are possibly far older than the period of these implements, and may be related to the replication of animal pelts that humankind had used for so long.

Pile structures can be created in a number of ways, as we know from various ancient fragments and recent examples. Over time, those structures and construction methods that proved most versatile and efficient became most prevalent, a process which ostensibly was taking place by 2000 B.C. Others that have survived may have been part of a repertoire that was contemporaneous with, or earlier than, those that were most successful. Such may have been the case for the type represented by the fur-like rug woven in narrow strips that are sewn together in plate 148, a type which has survived only among isolated groups of weavers in Central Asia. Rugs of this kind and others woven to accentuate a long fur-like pile rather than a clearly delineated and sophisticated design have simple compositions, or no design other than solid stripes. These could be relics of the distant past when the woven-pile rug was possibly conceived more to resemble a pelt than the densely woven short-pile textile bearing a complex design that it later became.

The pile rug has traditionally enjoyed widespread use on important occasions. Kings and their guests sat on them. Rugs covered the ground and hung from the buildings and bridges of a town in honor of a ruler when he visited. They were deemed appropriate gifts for fellow rulers and important visitors. The floors of mosques were carpeted with them and people used them for individual as well as group prayer. Nomads held their best rugs in reserve for visitors and as a form of savings. Families used them outdoors as well as indoors to create a special space. Their quality often indicated a person's wealth and status, and they were admired and treated with respect. That this respect was not limited to the natives of the region is apparent from the history of the pile rug in the West, where it helped transform the interior decor of the European home during the Renaissance and has retained a special place for itself to the present.

PLATE 138
Ayse, Dudu, and Gülay Yilmaz weaving a carpet in Ahmetler, Çanakkale, Turkey. June 10, 1990. (Photo: Karen Duffy)

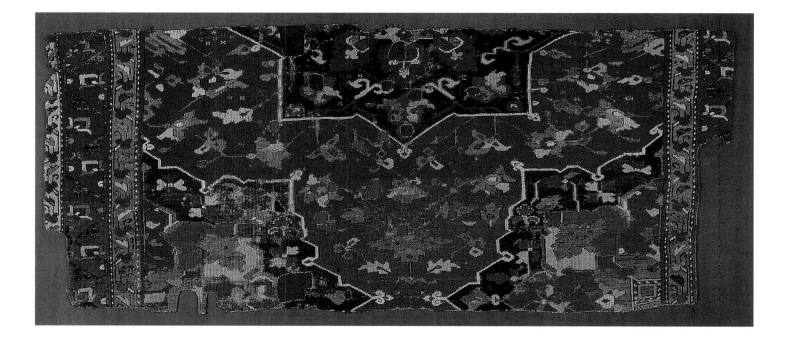

PLATE 139

Carpet Fragment

Urban craftsmen: Turks (Greeks? Armenians?)

Ushak, Turkey. 1550–1650

Knotted pile on plain weave wool

31½ x 75" (80 x 190.5 cm.)

Before Persian carpets came to dominate the rug trade with the west in the second half of the nineteenth century, oriental carpets were known generically to Europeans and Americans as "Turkey carpets." This appellation reflects the role that Turkey long played as an outlet for carpets from Persia and elsewhere and as the principal source of the rugs that went to Europe during the Renaissance.

The best known and most important center of the Turkish rug industry during most of the Ottoman period was Ushak, a small town in western Anatolia. Carpets that were revolutionary in their designs or of large dimensions were first woven there in the third quarter of the fifteenth century on orders from the court of Mehmet II, the conqueror of Constantinople. Later, these Medallion and Star Ushak carpets and their variants, all featuring repeated rows of large motifs in alternate alignment, were exported to Europe in considerable numbers. Both types are seen in European paintings of the

sixteenth century. By the time their production had become commercial, Ottoman court taste had changed and a new style of carpet design was favored in the capital, Istanbul.

The fragment seen here is from a variant Star Ushak carpet. This rarely encountered variant is based on the alternation of two main motifs, a straight-edged eight-pointed star and a foliated eight-pointed star, both dark blue and containing arabesque and plant ornament on the usual red ground with a floral design and red-ground border. Judging from a related example, it is possible that this carpet was originally over sixteen feet (five meters) in length. The straight-edged eight-pointed stars along the central vertical axis would have been "framed" by the laterally opposed halved foliated stars. While only an intimation of the original boldness of this rug is retained in its fragmentary form, the beautiful palette of strong primary colors that characterized the Star Ushaks is very much alive.

PLATE 140

Bedding Bag End Panel
Azeri Turks. Shirvan / Baku region,
Republic of Azerbaijan. 1875–1900
Sumak on a plain-weave ground;
wool warps, wool and cotton wefts
23 x 22" (58.5 x 56 cm.)

This bag is also part of a larger object. It comes
from nomadic pastoralist Turks living in the east-
ern part of Transcaucasia, the area south of
the main range of the Caucasus Mountains and
north of the Aras River and Persia in what is
now the Republic of Azerbaijan.

A favorite type of container among these
peoples was the box-shaped bedding bag, known
as *mafrash* or *farmash*. These consisted of two
side panels, two end panels, and a bottom panel
which was woven on the loom between the two
side panels and connected them in an assembled
bag. Such bags were utilized for the transpor-
tation and storage of mattresses, quilts, sheets,
and pillows. They were made in pairs, one for
each flank of a camel.

Most often the two side panels and two end
panels were woven in extra-weft wrapping, a
structure in which a weft is progressively wrapped
around the warp and is tightly compacted to
cover a ground weave and form the surface and
design of the fabric. The use of weft-wrapping
seems to be an old and honored one in Transcau-
casia, no doubt long antedating the coming
of the Oghuz. The skill and artistry with which
weavers in northwest Persia and Transcaucasia
employed it is unsurpassed in any other weaving
tradition known.

The bag no doubt had the same design
on all four sides – the wide horizontal panels
with "peacocks" flowing uninterrupted all the
way around. Peacocks in different renditions
are widely found in the *sumak* bags and covers
of the Turkic tribes of northwest Persia and
Transcaucasia. In the Shirvan/Baku region, from
which this comes, they usually alternate with the
smaller motif with two "crooked arms" found
here. The visual impact of this textile comes
from its limited but strong palette and the sim-
plicity and boldness of its repeating design, as
well as from its fine and regular weave.

PLATE 141

Transportation and Storage Sack
Qashqa'i Turks. Fars Province,
Southwest Persia. 1875–1900
Plain weave with weft substitution,
weft-faced reciprocal weft weave; wool
28 x 42" (71 x 107 cm.)

The tribes of the Qashqa'i confederacy have produced a wide range of pile and flat-woven textiles on their ground looms. In general, tribes that were fully nomadic probably produced fewer pile rugs and more flat-weaves, as they had less time to weave the more time-consuming pile products and probably preferred the lighter weight of the flat-weaves.

From well before the Islamic period, nomadic pastoralist tribes, semisedentary pastoralists and cultivators, and sedentary farmers have inhabited Fars province in southwest Persia, where Shiraz is its chief city and capital and two ancient Persian capitals are located. After the eleventh century A.D., these rural inhabitants – Persian, Lori, Laki, Kurdish, and Arabic speakers – were joined by Turkic speakers from the north, northeast. and northwest. Until perhaps as late as the late eighteenth century, no form of comprehensive political organization existed among them. Gradually, a polity with a centralized authority and hierarchical leadership, the Qashqa'i tribal confederacy ruled by the Turkic Shahilu dynasty, came to contain many of these groups in Fars. A Qashqa'i identity and sociocultural system also evolved, drawing from the Shahilu family (and its Turkic and probably tribal heritage) and the local, primarily Turkic yet still heterogeneous, population.

The principal structure of the bag seen here – weft-faced plain weave with weft substitution – is found most often among the Turkic tribes of southwestern and south central Persia, and among the neighboring Baluch tribes to their east. It is a very sturdy one and appropriate for a sizeable container.

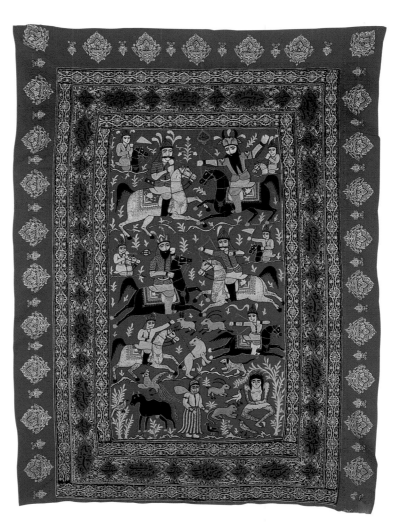

PLATE 142

Pictorial Panel
Rasht, Gilan Province, Persia. 1850–1875
Silk chain stitch embroidery on wool
84 x 65" (213.5 x 165.5 cm.)

In the upper right corner of this embroidered and inlaid pictorial panel, we see figures from the *Shahnameh* or "Book of Kings," the monumental national epic of Persia written in verse by Abo'l-Qasem Ferdowsi between A.D. 980 and 1010. A mounted Rostam, the great champion of Persia, is engaged in combat with an unidentified enemy, probably Afrasiyab, king of Turan, or Central Asia. Rostam is identified by an inscription, by his helmet made of the head of the White Demon, and by his split beard. The cartouches of the main inner border bear four repeated hemistiches from the *Shahnameh* separated by the expression, "may it be blessed!"

In the lower right corner are Leyli and Majnun, whose love story has been one of the most popular in the Middle East since it was put into verse by the great poet, Nezami of Ganjeh, in the late twelfth century A.D. Majnun, love-crazed and emaciated, sits in self-imposed exile in the desert surrounded by the birds and animals that have befriended him as he pines away for his beloved, but unattainable, Leyli (shown in the center). To her left is what may be the fabulous bird, the Simorgh, and the sacred Birmayeh. The other horsemen appear to be generalized figures of warriors and hunters. A favorite pastime for Persian kings, the hunt is a constant theme in the long tradition of Persian art and literature. Quintessentially Persian is the archer shooting at deer over the back of his horse (the "Parthian shot") and the mounted rider dispatching a lion with a lance.

For centuries, Gilan has been one of the chief silk producing regions of Persia. European observers in the second half of the nineteenth century were laudatory of Rasht's chainstitch embroideries in silk on woolen flannel cloth imported from Western Europe or Russia. The charming, naive style of this hanging or curtain indicates a nineteenth-century date, probably the third quarter.

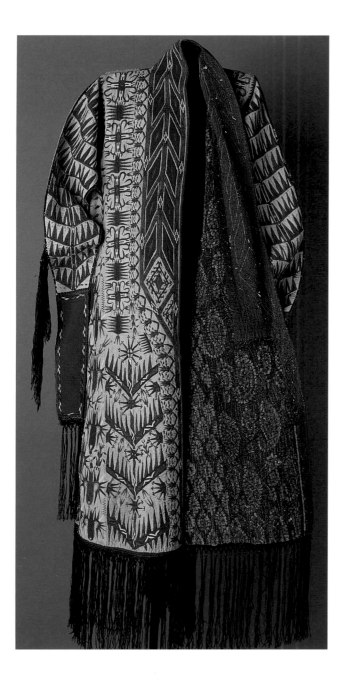

PLATE 143 and PLATE 144 (detail of back of Plate 143)

Woman's Mantle
Tekke Turkoman People. Turkmenistan.
1850–1875
Silk embroidery on silk plain weave cloth, woolen trade cloth on sleeves, backed with block-printed cotton cloth, silk tape with attached silk fringe sewn to sleeves and bottom
43 x 27" (109 x 68.5 cm.)

Few nomadic pastoralist groups have been as rich in the quantity, quality, and diversity of their fabrics as the Turkoman tribes to the east of the Caspian Sea in Central Asia's far west. As seen in this mantle, Turkoman women were as skilled with a needle and thread as they were at the loom. They used needlework to decorate clothing, cloth furnishings for the tent and camel trappings, and sundry felt articles. Silk and cotton were cultivated in both Turkmenistan and northeastern Persia. Wool came from their own sheep, and woolen flannel cloth through trade. Settled Turkoman women usually wove the silk and cotton cloth the nomads embroidered.

One of their remarkable garments is the richly embroidered mantle or *chirpi*. This was draped over a tall and elaborate headdress whenever a woman went outdoors, the left armhole placed over the crown. In keeping with this method of use, the shawl collar was quite tall at the back and the false sleeves, linked behind the garment by a piece of material, were reduced to vestigial, sharply tapering flaps at the ends. The needlework in one of these mantles reportedly occupied two women for three months.

A color code was strictly followed in the use of this garment. Young women wore a green or dark blue mantle, women over forty a yellow one such as that seen here, and women over sixty-three a white one. Those that are most appealing, in addition to their brilliant colors, show a restraint in covering the ground cloth and an exceptional sense of rhythm and spacing in the use of the traditional motifs. The drawing of these motifs, beautifully done in this example, distinguishes the best examples.

PLATE 145 (this detail – not illustrated here –
appears at beginning of chapter)
Hanging or Cover
Multi-ethnic urban craftsmen
Samarkand, Uzbekistan. 1850–1875
Warp ikat technique; silk warps, cotton
wefts, 5 panels (each 11" / 28 cm. wide),
1 panel (5½" / 14 cm. wide), silk tape,
printed cotton lining
71½ x 59½" (181.5 x 151 cm.)

Of the wide variety of woven, embroidered, and
felted objects produced in the Uzbek khanates
ruling most of western Central Asia in the nine-
teenth century, the greatest inventiveness in the
textile arts occurred in their brilliant warp-faced
silk ikats, of which this hanging or cover is an
example. Bokhara, the richest and most active
trading center of the region, played a vital role in
this silk textile industry; it or its emigrants are often
cited as the source of luxury fabric production in
other Central Asian cities. By the end of the
nineteenth century, silk seems to have engaged
most non-nomadic households in western Central
Asia through the raising of silkworms. Nearly
every mulberry tree was utilized to feed these
voracious worms, whose cocoons were sold to
professional silk reelers or unraveled for home use.

Most silk fabrics were produced through the
collaborative efforts of a number of highly spe-
cialized crafts that involved virtually every ethnic
and religious group of the urban population.
Unlike other textiles, the resist-dyed ikat warps
already carried a design when they were set up
on the weaver's loom. From this loom came a
long warp-faced strip, approximately 10 to 12
inches (26 to 30 cm.) wide in the first half of the
nineteenth century and usually around 19 to 20
inches (50 cm.) wide at the end of the nineteenth
and beginning of the twentieth century. The ear-
lier ikats were half silk, half cotton; that is, they
had silk warps and concealed cotton wefts. Some
all-silk ikats may date back to the mid-nineteenth
century, but most were made in the second half.
The strips were cut into matching or different
lengths and sewn together along their selvages
to make up a hanging, a bed cover, or a garment,
or to be used as a lining or for some other purpose.

Paramount in these ikat strips is the art of
the dyer and the designer, who created a myriad
of motifs and compositions to fit the textile's
narrow, vertical format. Some of these designs
are dense, wild, and exuberant. Others, like this
hanging from the ancient city of Samarkand,
are more restrained and restful.

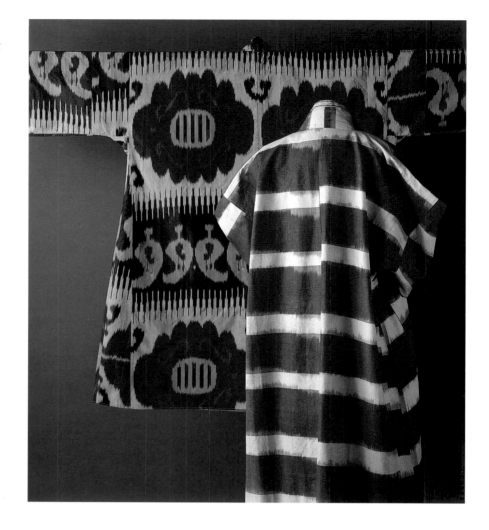

PLATE 146
Back: Woman's Dress
Multi-ethnic urban craftsmen
Bokhara, Uzbekistan. 1890–1910
Warp ikat technique; silk warps and wefts,
2 panels (each 17¼" / 44 cm. wide)
50 x 80" (127 x 203 cm.)

Front: Man's Robe
Multi-ethnic urban craftsmen
Samarkand, Uzbekistan. 1890–1910
Warp ikat technique; silk warps, cotton
wefts, 2 panels (each 15½" / 39.5 cm.
wide in front and 15¾" / 40 cm. in back)
56 x 76" (142 x 193 cm.)

Few societies have had a more spectacularly
attired citizenry than the Uzbek khanates in the
nineteenth and early twentieth centuries. Differ-
ent types of outer robes were the garments
most prominently seen in public. A person privy
to female circles would also have seen these
beautiful ikat dresses.

As is typical of most Oriental wearing apparel, robes and dresses were made so that the sleeves, when fully extended to the sides, formed a straight line across the shoulders. Girls' dresses had horizontally cut necklines, while those of married women had a deep vertical slit to facilitate breast-feeding. Dresses were cut straight and very wide. Sleeves fell far below the hands to cover them out of respect to others. A woman of means wore several silk dresses and a silk under-robe beneath her veil and a dark silk outer robe, with the brilliant silks of the layered dresses showing through.

As the nineteenth century drew to a close, mounting pressures from outside economic competition seem to have had an impact on the designs of the ikat strips produced in the khanates. The time-consuming and costly practices of using numerous colors and complex designs gradually gave way to fewer colors and simpler designs. Rather than do a detailed design badly, the makers opted to do a simple one very well.

A bold design silhouetted against an open, solid-colored background is characteristic of the trend of the second half of the nineteenth century. Design dissonance from the misalignment of motifs or from a change in direction on either side of a white jagged horizontal line creates unpredictable, dynamic combinations. Assembly in offset alignment injects an element of dynamism in the robe, while the jagged outlines of the stripes soften its starkness.

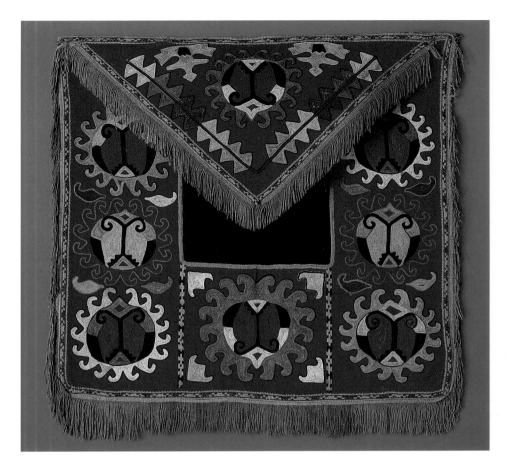

PLATE 147

Decorative Pouch-Shaped Hanging
Lakai Uzbek. Southern Tajikistan. 1875–1900
Blanket and chain-stitch silk embroidery on plain weave wool trade cloth, cotton cloth, warp-twining silk tape and silk fringe sewn to the edges, cotton trade cloth backing
24 x 26" (61 x 66 cm.)

Uzbek women, whether urban, rural, or nomadic pastoralists, were skillful needleworkers. An outstanding example of their work is the decorative pouch-shaped hanging. These small silk-embroidered objects with bold, dynamic designs were predominantly the work of a small Uzbek group located primarily in southern Tajikistan – the Lakai – who called their squarish and pentagonal shield-shaped wall hangings *ilgitsh.*

Designs for embroidery were traditionally drawn with chalk or outlined in simple stitches on wool flannel or plain-weave cotton trade cloth grounds by old women who worked as designers. Silk utilized in them came from Bokharan traders or was obtained in local markets. A Lakai bride of respectable means would have embroi-

dered several pairs of these hangings for her dowry, one or more being of this squarish type. These were done during the period of her seclusion, just before her wedding, and later hung on the lattice wall of a round felt-covered tent, one on each side of the traditional bedding pile.

Although *ilgitsh* means pouch or container, these delicate embroideries were used as decorative hangings only. In the present example, an envelope shape is suggested by an overhanging triangular flap at the top of the square, an arrangement reminiscent of the Turkoman bread bag used on ceremonial occasions. The motifs are powerful and carefully placed around an empty center, with plump ovate forms enveloped by a nimbus of curled arms. Two of these ovate forms have been given a more subtle nimbus, which has the effect of emphasizing the gorgeous ovate center and providing spaciousness and a change of rhythm to the entire composition. Clarity of drawing, brilliance, and harmony of color, and dynamism and boldness combined with an organic quality in its shapes make this a masterpiece of Lakai art.

PLATE 148 (detail)

Pile rug

Uzbek / Kirgiz / Kazakh Turks

Western Central Asia /

Northern Afghanistan. 1900–1925

Knotted pile on warp-faced plain-

weave wool, four strips sewn together

117 x 35" (297 x 89 cm.)

The pile rug seen here contrasts strikingly with that of plate 139. While much younger in age, it is probably far older in conception. Known in the rug literature by the Persian expression *jol-e khers* ("bear skin"), such rugs have a long pile that is reminiscent of the fur of animals, whose pelts served as the first ground covers, as well as clothing. The warps in these strips outnumber the wefts (both the interlacing ground and pile-forming wrapping wefts), thereby giving the fabric a warp-faced look on the back, whereas multiple ground wefts between rows of long pile-forming wrapping wefts give it a loose, shaggy appearance on the front. This is characteristic of certain pile rugs woven by closely related Turkic nomadic pastoralists of Central Asia – Uzbeks, Kirgiz, and Kazakhs – some of whom also live in northern Afghanistan and Chinese Turkistan. Besides sheep's wool, goat hair and yak hair are said to have been used in their rugs.

The earliest looms were probably band looms, and the earliest structures were probably warp-faced or warp-predominant. Before loom technology developed to permit weft-faced structures in wider widths (with their greater design possibilities), the construction method seen here was likely the norm. The earliest pile structures may have been similarly woven. Thus, with its warp-faced back, long pile with multiple ground wefts between each row of wrapping wefts, and narrow strips sewn together, this rug would appear to preserve a combination of traits that were very early in the evolution of weaving.

The Turkic nomads who made this rug had a shamanistic background, which certainly is consonant with the powerful impression it makes. How a rug like this might have figured in shamanistic culture is essentially a matter of speculation, given the lack of firsthand observations.

CHAPTER 7 # Mediterranean

BY IRENE A. BIERMAN

The Mediterranean Sea has linked the lands and peoples on its shores for millennia. Its currents and winds have moved ships eastward along its southern coast, returning them westward along the northern shores with their treacherous coastlines made rugged by peninsulas and waters dotted by islands. Natural forces, primarily topography and climate, as well as historical forces, empires that conquered its lands and religions adopted by the people and their governments, have worked in tandem, sometimes differentiating, and other times harmonizing the social and visual practices of the Mediterranean region.

Islands, especially in the Eastern Mediterranean linked only by this sea, developed their own visual traditions, often incorporating elements from nearby mainland cities. By creating a barrier, mountain ranges, such as those in Anatolia and in North Africa have served to foster visual and cultural traditions in the hinterland different from those in the coastal ports. The Mediterranean climate has supported agriculture and animal husbandry in generous measure, assuring a plenitude of fibers for textiles.

From antiquity to the pre-modern era, silk was the most sought after fabric in the Mediterranean region. The Mediterranean climate enabled sericulture to be practiced virtually everywhere, even in places such as Egypt where the climate was not really conducive to silk production. In Spain, Sicily, Syria, Palestine, and Anatolia, where the climate was most favorable to sericulture, silk production became a highly refined industry. In the medieval period, according to the commercial documents found in the *geniza* of the synagogue in Old Cairo, Sicily produced the widest variety of qualities of silk, while Egypt, which grew only the lowest priced varieties, rarely traded in the international market. Centers such as Gabes in Tunisia, where silk was grown on a small scale, participated in the silk industry by serving as the major processor of silk from Spain. Ships from every locale (but not from Byzantium), plied the Mediterranean Sea carrying raw materials, cocoons, and reeled silk, to centers of weaving and of textile and clothing production, from whence they departed laden with garments and finished products destined for still other ports. (Byzantine imperial policy restricted the export of raw silk, permitting only finished products to be traded.)

In the pre-modern and early modern periods, centers of the silk industry and transit points for luxury textile goods, such as Bursa and Damascus, were renowned from China to Europe for the variety and quality of their goods. Many cities specialized in types of silks, such as heavy brocades, or patterns with gold and silver thread. Alongside this international trade in silk supported by commercial silk growing and processing centers around the Mediterranean, many areas, such as the Aegean and Ionian Islands, supplied local demand for silk through local sericulture maintained on a modest scale. By the mid-nineteenth century, industrialized Europe and its machine-made goods, new materials, and new trade alliances changed sericulture in the Mediterranean forever. The esteem in which silk was held, and the ubiquitous presence of sericulture accounts for the fact that a significant proportion of the textiles, textile fragments, clothing, and household furnishings in the Mediterranean section of the Collection are either fabricated of silk or patterned with silk, and sometimes both.

In addition to silk, wool was produced in commercial quantities all around the Mediterranean. As with sericulture, the climate was more conducive to sheep raising in some areas rather than others, but undoubtedly certain food traditions, such as those relying on cheese as a food staple, served to encourage local sheep raising even in the most difficult circumstances. Despite its universal availability, wool was always traded. At various times, specific areas dominated the wool trade, or were known as a source of a special variety or quality. In the Roman period, for example, Asia Minor was the major source of commercial trade in wool, and in the late medieval period, wool from the Atlas mountain region was sought for its fine quality. Wool garments were produced in many weights. Lightweight garments, such as those represented by the Egyptian tunic fragment (plate 154) from the fifth-sixth century, could have been worn all year long in most of the Mediterranean climates. Wool was also used as a patterning thread. In the Roman period, for example, Egyptian weavers produced tunics with woolen *clavi* (stripes) woven into, sometimes sewn onto, them as decoration. The woolen stripes on this tunic fragment indicate that the tradition of weaving such decorations continued in Egypt from antiquity well into the medieval period. Wool was also used as thread for embroidery, for example, on the medieval hanging depicting the row of figures (plate 150).

Cotton, too, grew almost ubiquitously in the Mediterranean region, and was processed and used locally. In the medieval period, for instance, cotton goods in commercial quantity came from Tunisia, or were imported from India through the Red Sea, entering the Mediterranean from the port of Alexandria. Although Egypt is known for its fine cotton, it grew cotton only for local use, such as for funeral wrappings, until the late medieval and early modern periods, when it began to grow crops in commercial quantities. Cotton then became Egypt's dominant commercial product, outstripping and ultimately replacing flax as a basic economic staple. The thirteenth-century cotton tunic fragment (plate 155) is an indication of the increasing use of cotton, whereas clothing fragments in the Collection from earlier dates are either linen or wool.

Linen, the other basic fiber of the Mediterranean region, was woven into finished fabrics and garments at many sites in the medieval Mediterranean, especially Tunisia and Sicily. Several places, such as the Aegean and

Ionian Islands, grew flax for local use. However, throughout the medieval period, flax was a primary commercial crop only in Egypt, where it was grown in twenty-two varieties, and linen fibers in many more grades were processed. No other Mediterranean area competed in the flax trade. From the time when Egypt was the sole center producing linen garments for all the Roman armies until the thirteenth century, Egypt's fine linen garments and furnishings were highly prized both within the Mediterranean area, and beyond it, to the east and north, reaching as far as Ireland and China.

Metallic threads of silver and gold were used from the earliest periods to pattern cloth made from these fibers, and to add aesthetic as well as economic value. Over time the technology and techniques for using metallic materials were expanded, and both weavers and buyers had options for patterning fabrics and clothing. The Mediterranean textiles in the Collection display several of these materials. Flat silver or gold wire could not be pulled through these materials, since their sharp edges would cut the adjacent threads. But they were applied by couching on to the surface, as seen on the Tunisian wedding ensemble (plates 158 and 159). Other metallic threads were made by twisting the metal around the core of another thread, frequently silk. Sometimes, very thin strips of gold and silver were laid onto a gut or paper base. The weight, fineness, and quality of the metallic threads, of course, were directly related to the cost of the finished textile, but other considerations also pertained. Heavy metallic threads used for weaving or embroidery required fabric sturdy enough to support the weight of the metal. Being less pliable, they also required large-scale patterns. In the pre-modern period, both Venetian and Ottoman silks made for elaborate costumes used gold and silver threads of fairly moderate weight.

The second technique of metalworking displayed in the textiles of the Collection, metallic wrapping, is found on the cotton tunic fragment (plate 155) and on the twentieth-century cotton shawl. The technique was used for over a thousand years in the eastern Mediterranean. This technique calls for a thin, flat strip of metal, usually a silver alloy, to be clasped around the warp or weft threads, almost like a staple. Metallic wrapping most often was used to highlight or accent an area or decorative motif as on the cotton tunic fragment (plate 155), where it was used to form the smaller Coptic crosses. In the early twentieth century, throughout the eastern Mediterranean, a fashionable use for metallic wrapping was as a main patterning technique on an openwork cotton base to produce shawls (plate 152) or festive bed hangings.

Wrapped thread technology is also represented by the textiles in this Collection. Developed in the late Middle Ages, this technique involves thin, flattened sheets of silver or gold cut into strips which are then wrapped around and glued to a thread core. In the seventeenth-century silk fragment (plate 162), fine, flattened silver and gold strips are wrapped around a silk thread core, and then those wrapped threads are used as the pattern weft of the textile. In this fragment, the ground color is silver-wrapped thread, and the wings of the angels and the ogival lattice are woven from gold-wrapped thread.

In the medieval period, just as today, many fabrics were blends. The most popular blend, one that appears regularly in commercial records, is a fabric with a silk warp and a linen weft. Perhaps what is most surprising to the modern reader about these medieval commercial transactions is the high degree of fiber knowledge displayed by the men and women ordering fabrics. They ordered loom lengths by specifying the quality, weight, and fiber content of the warp and weft. They were acutely aware of the draping qualities of specific blends and weights of fabrics. Such attention to the fabric itself was no doubt due in part to the sameness of the shape of the garments, making the fabric and its qualities visually important in conveying the status of the individual. Acute awareness of fabric and its qualities was engendered by the role textiles and clothing played in medieval society. Loom lengths were bought and stored as family wealth. Clothing as well as household furnishings were handed down over the generations. In the tenth century, when one female member of the Fatimid ruling family in Egypt died, her treasury held over ten thousand separate loom lengths of fine linens, richly ornamented.

Knowledge of fabric in the Middle Ages also included a refined knowledge of color. Orders for loom lengths, clothing, and household furnishings included descriptions of such colors as "gazelle blood," and "musk colored," along with the more mundane descriptions, "intense yellow," and "pure violet." People along the Mediterranean in the Middle Ages wore much more colorful clothing than their counterparts in western Europe. Dye stuffs that produced these colors were grown locally throughout the whole region. Madder, for instance, which produced a deep red on cotton and linen was grown from Andalusia to Central Asia. Henna was also used for red, but was more fugitive. Plants, roots, and nut shells were used for dye materials for the threads of everyday life, especially for fabrics woven or embroidered in the household. The local nature of

the dye sources helps to explain how various local areas developed their characteristic color palettes. Until the second half of the nineteenth century, when coal-tar dyes became widely available, basically only three dye materials dominated the international dye trade, although others were traded in smaller quantities.

The most prized red, which became more common after the seventh century, was made from the insect *Coccus genus*. The Caucasus was the source closest to the Mediterranean, and it produced three species of the insect. This red was not only clearer and richer than that produced by madder, it was also easier to use, although higher in price and thus not usually used in rural weaving venues. Saffron produced the brightest yellow, its cost limiting its use primarily to expensive silks. Recognized and named for its dye source, "saffron," its distinctive color could never be achieved by the other local sources of yellow, namely turmeric, sumac, and pomegranate rind. Indigo was the third major dye source internationally traded. Grown in Yemen, Egypt, and Palestine, three varieties were traded on the international market. Indigo was not only used for blue, it was a basic ingredient for all of the shades of green. When combined with certain varieties of henna it produced a deep black without using a mordant.

In addition to the forces of nature, historical forces such as empire and religion also shaped the visual and cultural traditions of the Mediterranean area. From the Roman Empire to the modern nation state, the lands and peoples of the Mediterranean have been both linked and divided by the forces of government. Through policies of the central government, large empires, such as the Roman and Ottoman, supported textile and dye stuff specializations throughout their lands. As alluded to above, the Romans supported the flax industry in Egypt for use throughout the entire empire, and the Ottomans supported the silk industry in their Anatolian and Syrian provinces for similar reasons. In their turn, Greek, Roman, Byzantine, Umayyad, Fatimid, Ayyubid, Mamluk, Venetian, and Ottoman governments linked urban areas of the Mediterranean to their imperial capitals from which visual and social practices spread throughout their empires. In turn, certain regional practices were acknowledged and absorbed in the center.

Provincial elites participated in fashion at the imperial capital by bringing teachers from the capital to instruct their households. In the seventeenth century, for instance, governors in the European provinces of the Ottoman Empire brought embroideresses from Istanbul to teach the women of their households the techniques for executing fashionable patterns. In this

way, both embroidery patterns and costumes cut in the style worn at court were brought to provincial households. Many of the patterns and techniques, as well as the style of costume brought from the capital to fuel fashionable taste, were adopted and adapted into the local traditions. This movement of ideas is particularly evident on many of the embroideries from the Ionian and Aegean Islands.

The representation of nature, particularly of carnations, tulips, hyacinths, plum blossoms, and cypress trees in the embroideries of the Collection echoes the dominance of nature and its symbolism in the practices of the sixteenth-century Ottoman court. At that time the court poets – and even the Sultan and members of the court – extolled these elements of nature for their symbolic value related to Islam and Islamic cultural practice. The properties of the cypress, for instance, tall and straight, resonated with the *alif*, the first letter of the Arabic alphabet, and also the first letter of the word for God in Arabic, *Allah*. The ceramic revetments displaying such elements of nature on the monumental buildings sponsored by members of the court, such as the mosque the Grand Vizier Rustem Pasha built in Istanbul, resonated with this symbolism. Knowledge of such symbolism required knowledge of the poetry and the language of that poetry – Ottoman. Such knowledge was a basic requirement for participation in the life of the court.

Outside the court context, on the pottery, costumes, and household furnishings on which they were also popular, this symbolic association did not pertain. These representations traveling beyond the court both in time and place, were readily able to invoke regional associations. Thus while the historian can account for the almost ubiquitous presence of these representations of nature in the visual practices of the post-sixteenth-century Mediterranean culture by alluding to court practice and its dissemination, that is only one strand of the explanation. The beauty of the flower patterns themselves and their meaningfulness to local contexts account for their longevity. Local practices also account for the very great visual differences in the form, color, and scale of these representations of nature. Those on the bedcover from eighteenth-century Epirus (plate 165) differ in form and in material from those on the Tunisian wedding ensemble (plates 158 and 159) of the twentieth century. The symbolic values or understandings local communities ascribed to these representations undoubtedly also varied.

Religion and religious practices have also impacted textile traditions in the Mediterranean. Judaism, Islam, and Latin, Orthodox, Coptic, Armenian, and Syriac Christianity, among other religious expressions, each have left their mark either on the textiles themselves in terms of patterns, or on the making and use of the garments or furnishings. The thirteenth-century tunic fragment (plate 155) provides an example. What is depicted is the Madonna and Child flanked by two personages. In the Middle Ages, such an image was appropriate to all the Christian groups of the Mediterranean, but the form of the cross, with the horizontal arm crossing in the middle, identifies the image with Coptic practice.

This tunic fragment (plate 155), as well as the tunic fragment from an earlier period (plate 154), remind us of a burial practice common to Christians throughout the Mediterranean, namely burying the dead in the clothing of everyday life. Jews and Muslims do not bury their dead in clothing. Clothing, and clothing fragments from the Middle Ages and earlier are made known to us mainly through archaeological excavations in Egypt. As is well known, the dry sands of Egypt have preserved textiles better than any other Mediterranean region. Burial sites in Fustat and more recently at Qasr Ibrim in Upper Egypt revealed much information about the clothing of religious officials in the Coptic Church as well as those of the general Christian population. The cotton tunic fragment displaying the Madonna and Child (plate 155), most likely from this site, probably also was worn by a Coptic Church official, whereas the woolen tunic fragment (plate 154), with its secular imagery was most likely the burial garment of a member of the Christian population.

Religious ceremonies punctuated the successive stages of people's lives, and textiles played a role in those events. The Aegean and Ionian Island embroideries in the Collection relate directly to the Orthodox Christian bridal traditions maintained there in the seventeenth and eighteenth centuries. Young girls prepared for their wedding by embroidering linens for the bed and for general household use. In this endeavor they were aided by the women of their family. Similar traditions continued into the twentieth century in Hammamet (plates 158 and 159), where a combination of hand embroidery with workshop-produced panels were fashioned into a wedding dress and head covering. Handsomely embroidered textiles were used to decorate the circumcision bed for young Muslim males, and to imprint the sign of virginity on the wedding night in both Christian and Muslim traditions.

Just as empire succeeded empire, modern nation states now divide the lands of the Mediterranean. Textile practices of the past have become a part of national heritages. In many areas, attempts are being made to revive or continue embroidery practices of the past, often maintaining many of the traditional patterns and applying them to clothing and household furnishings appropriate to contemporary use. The tradition of valuing textiles still remains important and families often divide up older pieces and pass them on to succeeding generations. Collections such as those gathered here provide a kind of extended family context in which the artistry and visual traditions of those who went before remain as a memory device of the past.

PLATE 149

Weaver from Chauen in the Riff Mountains in Morocco. 1995. (Photo: Edward Stack)

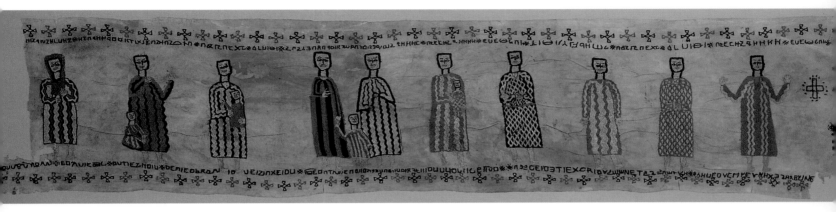

PLATE 150

Hanging

Egypt or Ethiopia

Fourteenth to Sixteenth Centuries (?)

Wool embroidery on plain weave cotton

20½ x 95" (52 x 239.4 cm.)

This handsome hanging with ten figures, some of children, provides an inviting puzzle. The evidence currently available suggests a late medieval to pre-modern date. That assessment is based on the fabric of the ground, the prominence of the cross motif, and the writing. Cotton plain weave fabric is more common after the thirteenth century when cotton began to be grown in the Mediterranean in commercial quantities. Of course, locally grown cotton provided fibers for cloth long before that date. The form of the prominent cross motif delimiting the design layout appears to relate to the form of Ethiopian pendant crosses. Pendant crosses became a more prominent visual sign within the Christian population in Ethiopia when, in the fifteenth century, the Emperor Zara Ya'gob imposed a law that all Christians must wear pendant crosses. The habit of wearing them and their form spread north-

ward, even as far as Upper Egypt. The prominence of the cross motif in the design suggests a religious context for the hanging.

The writing outlining the figures offers yet another puzzle. It appears to be Ethiopian and remains to be studied. Writing on textiles, whether embroidered or woven into the fabric, was a common motif on textiles for all of the communities in the greater Mediterranean area. Writing on textiles produced for use at the courts, or by wealthy members of society, was usually well executed with letter forms conforming to script styles. As such, the writing was highly legible. The writing on textiles produced away from the courts and urban influence is often less legible. It is also possible that the letters represented anagrams or abbreviations with referents that are unclear to the modern viewer.

PLATE 151

Hanging, Fragment
Egypt. Fifth to Sixth Centuries
Wool tapestry and paint on plain weave linen
27 x 15¼" (67.5 x 36.5 cm.)

This fragment of a wall hanging displays a danc-
ing *putto,* a popular motif connected to mytho-
logical tales of warriors and warrior games,
such as weight lifting and shot putting. Mytho-
logical subjects, more popular in the Late Antique
and early Middle Ages, gave way in the later
periods to depictions of nature, of animals, and
of fish. Until the Late Medieval period, woolen
tapestries were an important household fur-
nishing. They were used to cover doorways, to
cover cushions, and especially to hang on walls.
Those used on walls usually displayed large-scale
patterns, such as the one on this fragment.

The climate, especially of Lower Egypt, sup-
ported the use of such tapestries for the warmth
they provided. Dampness from the flooding
Nile characteristic of winter before the Aswan
Dam was built in the mid-twentieth century, and
winds bringing sand, cold air, and sometimes
rain combined to make the short winter season
a chilly one, especially indoors. Tapestries were
used as wall hangings not only in domestic archi-
tecture, but records from the later Middle Ages
indicate that they were used in churches, syna-
gogues, and mosques. Of course, the pattern of
the dancing *putto* displayed on this fragment
suggests a date in the early Middle Ages, and a
domestic venue for its use.

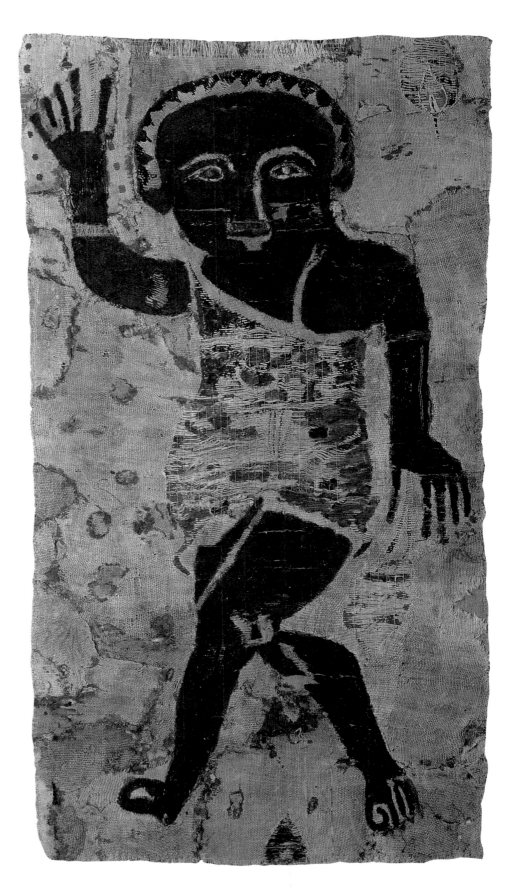

PLATE 152

Hanging or Shawl

Egypt, Turkey or Syria. 1910–1930

Open work cotton netting with

flat silver alloy strips

88 x 37" (223.5 x 93 cm.)

This type of lightweight, netted fabric, with a design entirely in metal wrapping, was popular in the early decades of the twentieth century. Although they were made in several areas in the eastern Mediterranean, the materials, i.e., the open work of the fabric and the metal wrapping, dictated the basic characteristics of all the patterning regardless of the site of fabrication. Patterns were geometric, following the grid of the warp and weft, and schematic, rendered in broad outline rather than small detail. This type of fabric was used both as an elegant hanging, and as a decorative shawl.

On this fabric, the pattern of highly stylized houses and elements of nature, such as trees and vines, responds directly to the landscape depictions that had been popular throughout the Ottoman Empire. In the late seventeenth and early eighteenth centuries, landscapes were painted on the walls in the rooms of the Topkapi Palace, and in the elegant houses along the Bosphorus. In the eighteenth century, the fashion for landscape painting made itself felt in the homes of wealthy merchants along the trade routes of the Ottoman Empire, from the Balkans and Crete to Yemen. By the closing years of the eighteenth century, landscape painting identifiably Ottoman in style was to be found in China. Ottoman landscape painting depicted a countryside with buildings, trees, flowers, and usually a stream or river. These elements were depicted within an oval space, and several such scenes were painted as a border along the upper portion of the walls, or on the soffits of the ceiling beams. It is not surprising, then, that from being painted directly on architectural elements, landscape scenes came to be embroidered on textiles used as valances, and as screens, and then embroidered on towels. Landscapes were painted as illustrations in books, and also block printed on paper. By the early years of the twentieth century, the landscape form was no longer popular, but individual elements of the landscape, such as houses, came to enjoy an independent existence as design motifs.

PLATE 153

Fragment

Arab, Muslim

Egypt. Eleventh century

Plain weave linen with silk tapestry bands

6½ x 4½" (16.5 x 11.4 cm.)

Decorated ends, known as *tiraz* textiles, form the largest category of cloth and clothing known from medieval Egypt. The term *tiraz* originally referred to an embroidered inscription in Arabic on textiles. From that specific use, *tiraz* has come to be applied to any band of writing on textiles regardless of the technique, i.e., on this fragment the writing is tapestry woven.

The urban population of medieval Cairo used such fine woven linen textiles with ornamental end bands displaying script and animal motifs for a number of functions. These kinds of textiles, of which this fragment is representative, draped easily and thus probably most often were used in daily life as turban cloths by the male population. The documents found in the *geniza* of the synagogue in Old Cairo suggested that Muslim, Christian, and Jewish males all wore turbans. These documents also suggest that turbans were wound in various different ways, each of which produced a different shape and "look," but almost all of which seemed to have tails that hung down and were ornamented with decorative bands. This fragment of banding displays an eleventh-century style. These same documents and the archaeological records tell us that such cloth was ordered by various groups within the wealthy urban population with writing in different alphabets and languages: Arabic in the Arabic alphabet, as on this fragment; Hebrew in the Arabic alphabet and also in the Hebrew alphabet; and Coptic in the Coptic alphabet. The messages ranged from general good wishes and dedicatory phrases, to pious phrases and specific selections from the *Qur'an*, the Hebrew Bible, and the New Testament.

Most fragments of this type of cloth displaying the Arabic language and alphabet have come down to us from an archaeological context, the burying grounds in Fustat, or Old Cairo, excavated in the early part of the twentieth century. As such, they represent the burial customs of the Muslim population. Muslim burial practice requires the deceased member of the community to be prepared for burial the day of death. Washed and wrapped in a shroud, the body is laid in the ground on its side facing Mecca. The evidence from medieval Egypt indicates that shrouds were loom lengths of finely woven linen with the decorated ends displaying writing in Arabic wound across the face and eyes. During most periods one shroud together with cotton batting was sufficient for burial. However, during the Fatimid period, A.D. 969–1171, Isma'ili Muslim practice appears to have required the use of three shrouds. Burials from that period which have recently been uncovered and studied suggest that the shrouds were layered, with the newest cloth used for the outer shroud.

PLATE 154
Tunic Fragment
Egypt. Fifth to Sixth centuries
Plain weave and wool tapestry techniques; wool
25 x 26½" (63.5 x 67.3 cm.)

The tunic has been a hallmark of Egyptian dress from the Pharonic period to the present day. It is still worn in rural areas and occasionally in urban settings. "Tunic" is a general term applied to a loose garment fabricated from a loom length of textile, and does not suggest the wide variety of methods of construction, materials, and ornamentation that have characterized the fabrication of tunics during their long history of use in Egypt. The tunic of Pharonic Egypt was fashioned from a loom length of linen, folded in half, stitched up the sides, with a slit left on each side for the arms. The neck hole was made in the fold. The warp direction of the fabric was the length, and the starting and finishing ends were the garment hem. This was a garment without sleeves, although the width of the fabric caused it to fall off the shoulders and thus covered the upper arms. Worn by both sexes, this tunic was work clothing during the Pharonic period.

In the Roman period, the tunic was fabricated with the fold in the opposite direction, i.e., the weft became the length. One selvage edge was at the neck-shoulder area, and the other at the hem. One more shift in construction took place during the early years of the Common Era, which has lasted until the present day. Woven wider than it is long, the weft is again the length of the garment and the patterning direction. This woolen tunic fragment is an excellent example. The layout of the patterning on the tunic, with shoulder stripes and decorative squares, as well as the figural and geometric motifs within them, demonstrate that patterning popular in late antiquity was still appropriate in the early Middle Ages.

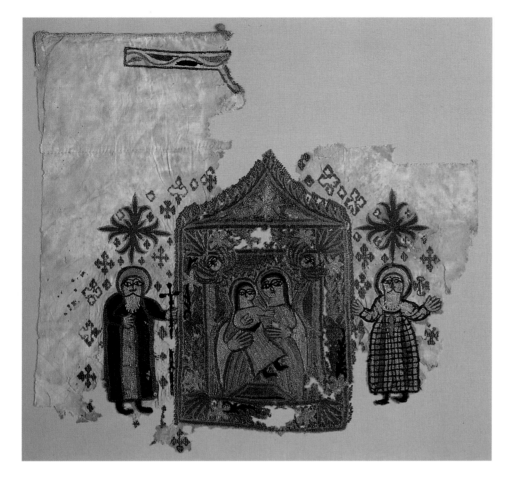

OPPOSITE
PLATE 156 (detail)
Fabric Length
Morocco. Eighteenth century
Compound weave; silk
3'9" x 22" (1.19 m. x 55.9 cm.)

Morocco was well known for its silk weaving industry. In the early modern period it produced a number of handsome striped fabrics, such as this, with symmetrical motifs that play with the geometries of the loom. The vertical direction is dominated by stripes of plain color, while the horizontal direction is dominated by the hand motif expressed in a number of patterns. In one horizontal band, pairs of "major" and "minor" hands separated by a white geometric design are arranged in a row, and in another, the hands are worked into a rotated four-sided motif flanked on either side by another pair of hands. Within the striping itself, yet another hand design appears.

Symbolic importance was attached to representations of the hand in the Muslim, as well as the Jewish, communities throughout the Mediterranean, but especially in North Africa and the Iberian Peninsula. Carrying different symbolic associations for each of these two sectarian communities, it also had different symbolic dimensions within each of these groups. The hand motif was especially appropriate for use at rites-of-passage, and thus is often embroidered on wedding attire, for example, as on the garment and headdress shown in plates 158 and 159. A hand imprint is often put on walls near the thresholds of houses to ward off evil. Today, in the Mediterranean area, especially in the eastern and all of the southern Mediterranean countries, the hand is largely understood to be an apotropaic device, i.e., one that wards off ill fortune, rather than attracting good fortune.

PLATE 155
Tunic Fragment
Coptic, Christian. Egypt
Twelfth to Thirteenth centuries
Silk and metallic embroidery
on plain weave cotton
19 x 19" (48.3 x 48.3 cm.)

Because this fragment of a tunic displays a scene with such an overtly Christian content – a Madonna and Child – it is most likely a fragment of an ecclesiastical tunic or *alb*. As such, this section would have been the front, possibly the back, panel of a long *alb* with long, wide sleeves, the whole fabricated from several pieces and panels. When excavated, garments of this type have been found gathered at the waist by a belt, which served to adjust the length to the height of the wearer, since the garments themselves were made to standard length.

One element of the image in particular relates it directly to painting traditions within Christian as well as Muslim practices throughout the late medieval Mediterranean. The human faces in the upper corners of the gazebo in which the Madonna and Child are framed both in their placement and form are a stylistic device found in representations in the ceiling paintings of the Palatine Chapel of the Normans in Palermo, Sicily. They are also found in Christian manuscript paintings. The rounded shape of these two faces, in contrast to those of the personages flanking the Madonna and Child, relates directly to depictive traditions at the courts of the Fatimids, and the military dynasties around the Mediterranean. Importantly, this embroidered depiction gives us ample indication today that many visual elements were shared by different Christian groups – the Coptic community in Egypt, and the Latin Christians in Sicily – and were present in the courtly arts of several Muslim rulers. Each group inflected the presentation according to its own needs and traditions.

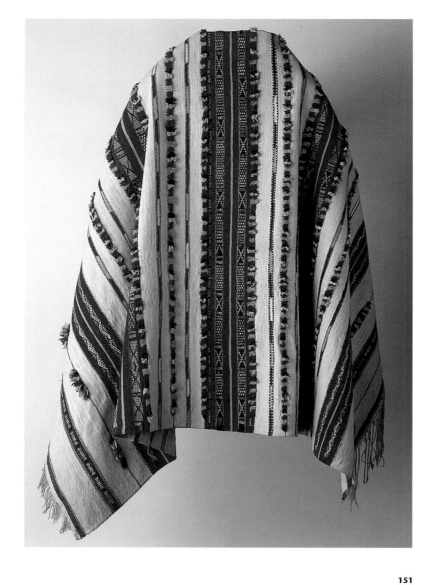

PLATE 157
Woman's Blanket or Wrap
Zemmour, Middle Atlas, Morocco
Early Twentieth century
Tapestry technique and knotting (tufts); wool
70 x 38" (1.78 m. x 96.5 cm.)

Wool is the basic fiber used for household fabrics and clothing by the Berber groups of the middle Atlas Mountain range. Wool was suitable to the climate and to the traditions of animal husbandry. Spun and woven within the household, it was also the fiber of choice for textiles destined for the market.

This handsome weaving, a showy piece with bold colors, was multi-functional. The woolen weft threads left hanging on the reverse side provided an extra layer of warmth when used either as a blanket or as a wrap. As a garment, like all women's garments in the Atlas Mountain region, it was designed to be wrapped and pinned. The basic outerwear garment was woven long enough to be wrapped around the waist, with one end brought over the shoulders to be fastened with ornamental pins. Shorter weavings, such as this one, could be worn as a shawl and pinned in the front at both shoulders, or worn draped and pinned on one shoulder. This style of wrapped garment, but not the specific patterning, is worn by the populations of the mountain regions of all of North Africa, from the western regions of Libya to Morocco.

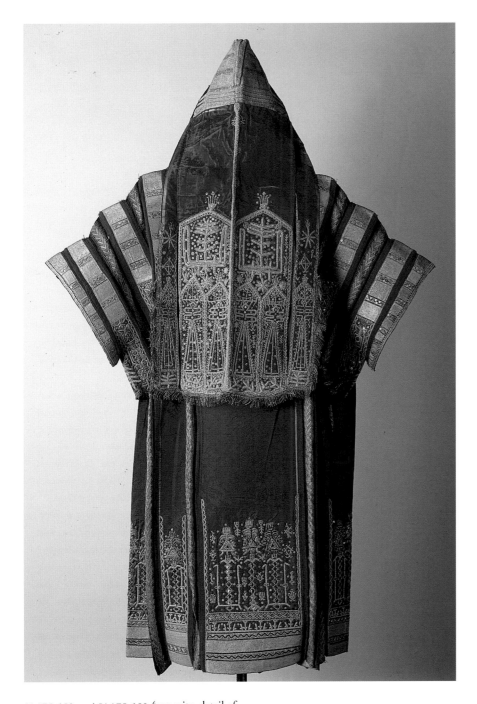

PLATE 158 and PLATE 159 (opposite, detail of
front of Plate 158)
Wedding Tunic and Cap
Hammamet, Tunisia. 1920–1950
Tunic: silk damask, silk ribbon, gold
and silver metallic thread embroidery,
sequins and coral beads
Tunic: 48¼ x 42½" (1.2 x 1 m.)
Cap: 36½ x 18" (92.7 x 45.7 cm.)

In Tunisia the seven days of nuptial celebrations
are intended to display the fine textile work that
the young bride has fashioned with her own
hands. This is the event in a woman's life during
which she is the center of attention among her
family and friends. The trousseau needed for such
celebrations includes a number of tunics, usu-
ally seven, worn one on top of the other which
are then revealed, one after another, over the
course of the nuptial celebrations. The last tunic,
revealed on the final day when she leaves for
the groom's home, is the most sumptuous. Brides
from wealthy families often wear many more
than seven tunics during the course of the nup-
tials. This lengthy ceremony of "unveiling" or
"*jeloua*" includes showing the trousseau to the
women friends of the bride, and ultimately,
unveiling the bride herself to the groom.

Wedding tunics, known as "*qmujja,*" are
loose-fitting garments intended not only to
accommodate layering, but also to ensure that
the bride is dressed modestly. Even the garment
worn on the final day is loose fitting. Made
with bands of silk ribbon, "*hwachy,*" this style
qmujja from Hammamet is known as "*souriya
bel lahwachi*" (silk with ribbons), for its distinc-
tive striping.

The pointed wedding cap, "*qoufiya,*" is
heavily embroidered in gold thread and sequins,
its ornamentation befitting the nuptial celebra-
tions. Red is the color of the fabric panels that
hang from the cap because it is the color for
brides and young matrons – which is why it is
also used in the wedding garment. In particular,
the hand motif, with either five, four, or three
fingers, is prominent in both the garment and
headdress.

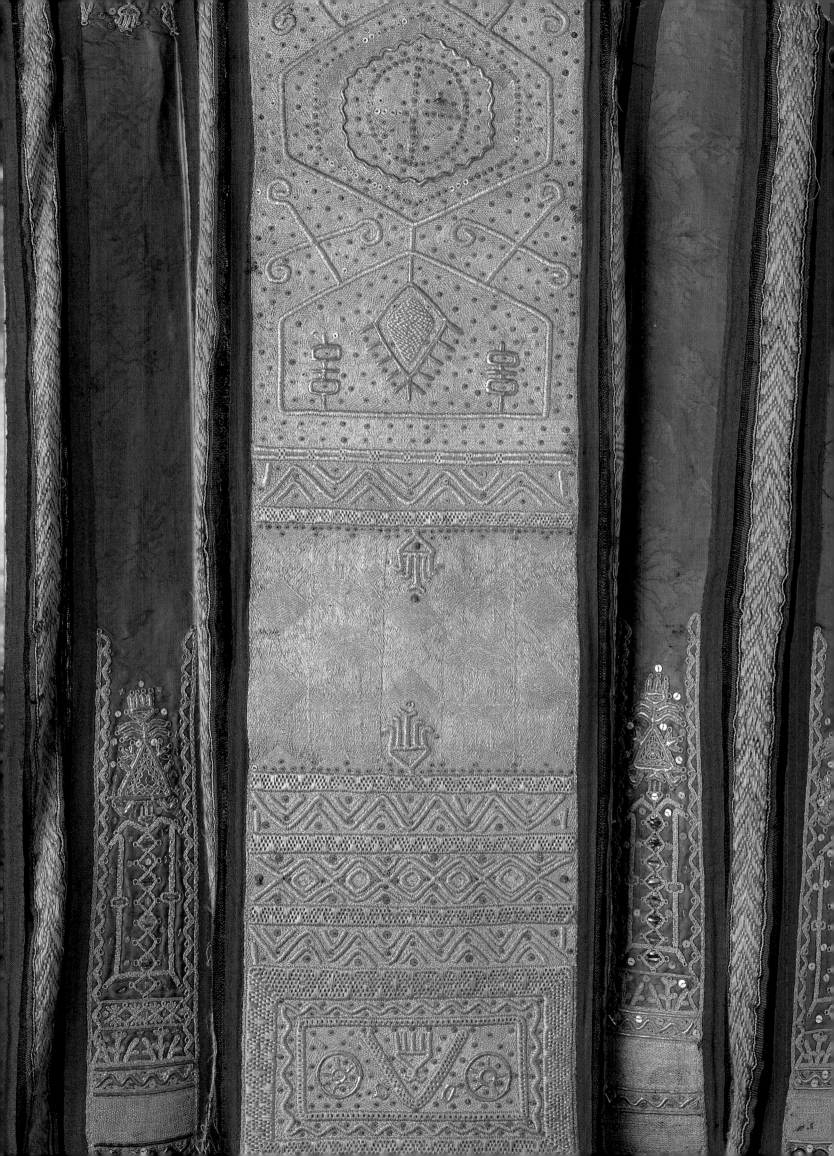

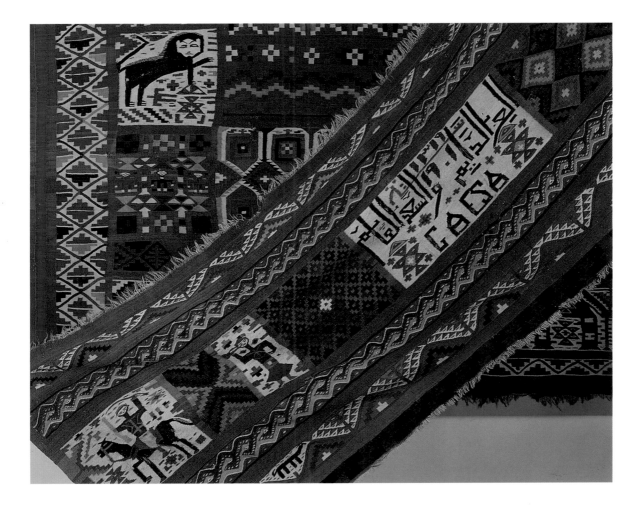

PLATE 160 (details)
Wall or floor coverings
Qafsah, Tunisia. 1880–1910
Tapestry technique; wool
Back: 62 x 94" (1.57 x 2.38 m.)
Front: 33' x 96" (83.8 cm. x 2.4 m.)

The color range and patterning used in both weavings suggest that they were produced in the same workshop. Each displays unique pattern elements, such as the mounted figure with gun and raised sword on the smaller weaving, and the lion with raised paw on the larger tapestry. Yet both share numerous designs in common, such as highly stylized human figures and lozenge shapes. Whether the designs on these textiles were fashioned to relate to specific events, either in the life of the weaver or in the region where they were made, may never be known, but rendering the date legible to at least two audiences appears to have been an important design element.

In the center of the inscribed panel on the front tapestry weaving the date is rendered in the *hegira* or Muslim era dating practice and in the Common Era dating system. The top numbers, 1319 rendered in Arabic numerals, are translated into the Common Era date of 1901 written in Latinized Arabic numbers used today around the world for business. In rendering the

Common Era date, the weaver used the sign for a dot (.), from the Arabic numeral system, rather than the sign, 0, as used in the Latinized numbering. The word for year in Arabic rendered in russet pink separates the two dates.

The weaver also named the town, Gafsa, or Qafsah in its contemporary spelling, in Latin letters. Gafsa is a town in the central part of Tunisia, important for the linkage it provided to the countryside and mountain regions. It is, of course, entirely possible that the writing in the central panel of the smaller weaving was intended not for a personal audience, but for a market audience, advertising a workshop and its production to the marketplace, where the users of the Latin alphabet were financially dominant. Regardless, the presence of both alphabets and dating systems is testimony to the change in the status of Tunisia, which became a French protectorate in 1881. With that change, French became the language of education, and the Common Era dating system was adopted for government offices.

The form of the main design on the back of this coat is directly related to designs found on precious metals and jewelry. This relationship is visually enhanced by the use of metallic threads in the design. The associations evoked by the design itself, and its fibers, linked the male child wearer and his family to the sumptuous display traditions of the area.

In societies where costly fabrics are purchased by loom length and then made into garments, clothing for children is often pieced together from those parts of garments originally fashioned for adults. This child's coat appears to follow such a tradition. However, the sleeves inset into, and filling only part of, the arm spaces provided in the coat are indications of yet another practice with a long history in the eastern and southern Mediterranean. The practice of making and selling sleeves independent of the garment, documented from the late medieval period, was fundamental to dressing adults in a world where status was displayed through textiles.

Before Euro-American costume was adopted by some segments of the urban populations, most clothing in these areas was fashioned either with sleeve openings, or with enough fabric to hang down onto the arm which obviated the need for sleeves, for example, in the Tunisian bridal garment (plate 158). For elaborate garments, especially elaborate outer garments, even for children, sleeves were added separately, and often purchased from sleeve makers who specialized in making only sleeves. Rank, financial ability, and family status were indicated by the design, pattern, and costliness of the fibers the purchaser could afford. In a system with such protocols of dressing, the options thus offered the wearer for expressing status were increased, as were the social subtleties conveyed by the mode of dressing. Undergarments with sleeves could be worn with a sleeveless coat. Sleeveless coats could be made to have serviceable sleeves through which arms could pass, as on this garment, or, alternately, to have ornamental sleeves that hung from the coat and functioned primarily as a means of conspicuous display. In addition, the very patterns and fibers of sleeves, each with its symbolic dimensions, offered a range of social choices for the customer. Such choices remained a part of the market offerings in some areas until the second half of the nineteenth century.

PLATE 161

Child's Coat

Syria. Nineteenth century

Tapestry technique; wool, silk, and metal threads lined with printed cotton

40 x 35¾" (101.6 x 90.8 cm.)

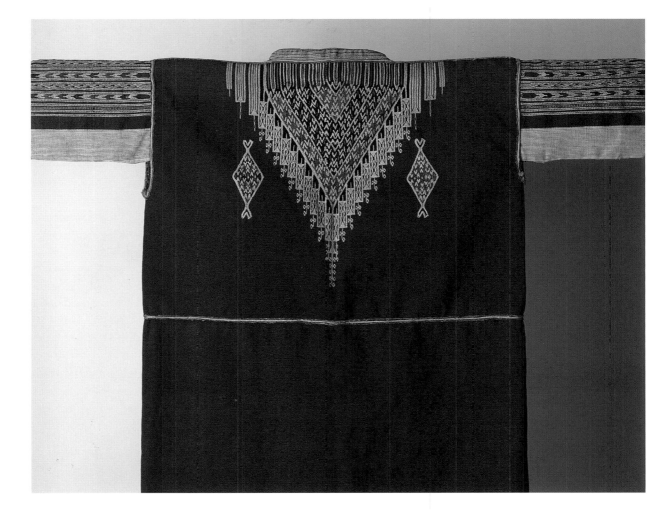

PLATE 162

Fragment of Vestment

Armenian. Ottoman Empire

Bursa (?) Seventeenth century

Silk brocade with gold and silver

metallic threads

8⅝ x 9⅝" (21.9 x 24.5 cm.)

This silk fragment represents a design used for Armenian ecclesiastical vestments. Although little is known about how patterns were developed, and who specifically designed them, designs were woven to order for specific customers in the private market both within the empire and outside its borders. The use of metal threads in this fragment, for example, where the ground color and part of the design are rendered in gold and silver, required expert knowledge to balance the weaving, and prevent the metal threads from sagging and pulling.

In the Ottoman Empire the silk industry was concentrated in Bursa. That city was the *entrepôt* of the international trade in raw silk. Court workshops and those owned by wealthy merchants were concentrated there. Skilled weavers from throughout the empire, and indentured laborers under contract to weave a specified amount of cloth, were employed at the looms. Master weavers taught apprentices and specialized in specific kinds of techniques, such as brocade, velvet, and taffeta. In the Mediterranean region, the silk industry of Bursa was rivaled only by that of Italy. Both silk industries supplied an international market, although the Ottoman court was a constant and dominant customer of the Bursa looms.

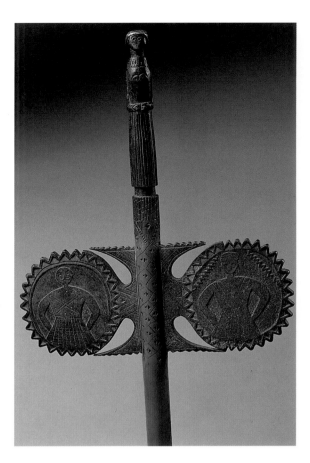

PLATE 163 (detail)

Distaff

Greece. c. 1900

Carved; wood

34 x 8" (87 x 21 cm.)

This all-important woman's tool holds clean prepared fiber that has been made ready for "drafting" into the spinning process. Using a distaff, either hand-held or secured into her belt, a woman's hands are freed to spin while walking, traveling, attending market, or doing chores. Used almost universally throughout Europe and the Mideast, even to the present day, the distaff is a relatively recent invention in the fifteen to twenty thousand-year-old history of spinning.[1] The earliest excavated distaff from Mesopotamia dates about 2250 B.C. The first depiction on a vessel from Hungary is dated about 1000 B.C. Greek vase paintings of the Archaic and Classic periods frequently depicted use of a distaff.

The distaff shares in the magic of spinning: the drawing out and twisting of a strong supple yarn from an amorphous mass of tangled fiber. As a creative process spinning is likened to the

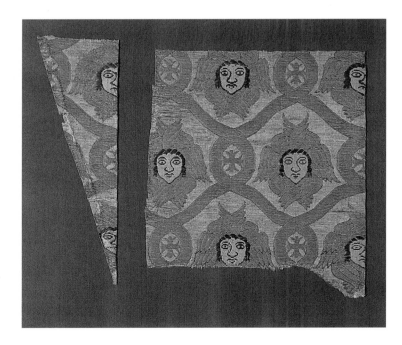

miracle of childbirth. Naturally, both spindles and distaffs are symbols of marriage. The Old Testament describes a virtuous woman: "She puts her hands to the spindle, and her hands hold the distaff."[2]

Even though distaffs may take the form of a bracelet or a simple forked stick, they have assumed ceremonial significance. They are often decorated with carving and decked with ribbons and bells after they have been "dressed" with fiber. Greek distaffs are usually carved, frequently with circular decorations. The two circles here depict a man and woman with leaf forms on the reverse – elements that resemble motifs embroidered on sacred textiles of Central and Eastern Europe. Surely this distaff is likely to have been a betrothal or marriage gift – a special blessing carefully crafted for the bride by her husband-to-be or her father. (Nora Fisher)

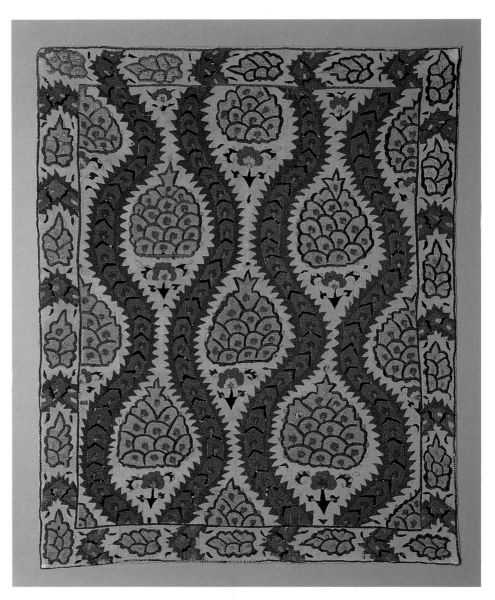

PLATE 164
Cushion Cover
Ottoman Empire, Anatolia (?)
c. 1700
Silk embroidery on plain weave linen
40 x 48" (101.6 x 121.9 cm.)

This embroidered cushion cover displays a design and color range characteristic of the seventeenth and early eighteen centuries. The design usually identified as a pomegranate was popular both in woven textiles and in embroideries. Often highly stylized, such as on this cushion cover, this pattern was appropriate for household furnishings as well as clothing.

Cushion covers of this type of needlework (*suzeni*) might have served both for daily use in a wealthy provincial metropolitan home, as

well as for special functions. Archival documents indicate numerous customs within the sectarian communities of the Ottoman Empire for which elaborate displays of household coverings were appropriate. In all communities, of course, weddings and the birth of a child were a major occasion for celebratory display. New mothers in their confinement with their babies received visits from female relatives. The birthing chamber, or the bed and alcove, was especially decorated to receive and entertain these visitors.

Within Muslim communities, circumcision of the male children was a time of celebration and commemoration. A bed was prepared and hung with elaborate hangings and covers. Because this was an occasion for visits and congratulations from family and friends, covers of these fashionable colors would have been appropriate to use.

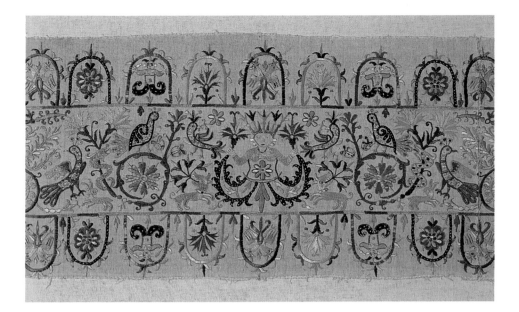

PLATE 165 (detail shown at beginning
of chapter)
Bed Cover
Epirus, Ionian Islands
Eighteenth century
Silk floss embroidery on plain weave linen
5'6" x 8' (1.68 m. x 2.44 m.)

The pattern of this bed cover indicates that it
was intended for a marital bed. On Epirus, cov-
ers used for the wedding bed displayed human
figures alternating with flower arrangements
inhabited by birds. The male figure is generally
understood as the father of the bride, or possibly
an attendant. The facial details of the figures
on this bed cover, like others of its age, were
stitched in black thread and have all but disap-
peared. Tulip sprays and hyacinths dominate
the embroideries, and are presented in vases of
differing shapes and sizes. Embroideries, such
as this covering for the marital bed, formed
part of a young girl's dowry and were meant to
display her needlework skills.

PLATE 166 (detail)
Fragment, Skirt Hem
Crete, Greece. Eighteenth century
Silk floss embroidery on plain weave linen
51½ x 11½" (130.81 x 29.21 cm.)

The quality of design, the specific motifs, and the
range of colors displayed on this fragment from
the hem of a skirt are fine examples of the visual
culture of daily life in the early modern Mediter-
ranean. The composition of the design is a hall-
mark of women's costume on Crete, the largest
of the Aegean Islands. In itself it expresses the
history of the island, linking its Venetian and
Ottoman heritages, with its Greek Orthodox
and local traditions. The elegant figure in the
central space, understood by some as the siren
with two fish tails, appears to have sprouting
flowers for legs. Fanciful as it is, figures ren-
dered in full face forward holding something in
either extended arm have enjoyed a long his-
tory in the Mediterranean. The medieval world
knows this form best as "the lion tamer," where
a central male figure is standing on two legs
holding a subdued lion in each upraised hand.
In the scalloped border, smaller but similar fig-
ures appear to be holding fish or some small
object, and are wearing horned or leafed caps
rather than a crown. Double-headed eagles
belong both to the Venetian and Ottoman reper-
toires, while the rabbits, and especially the
dogs, undoubtedly have a more local referent.

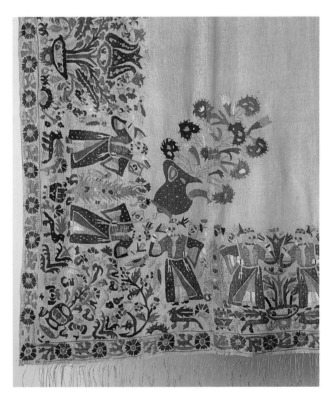

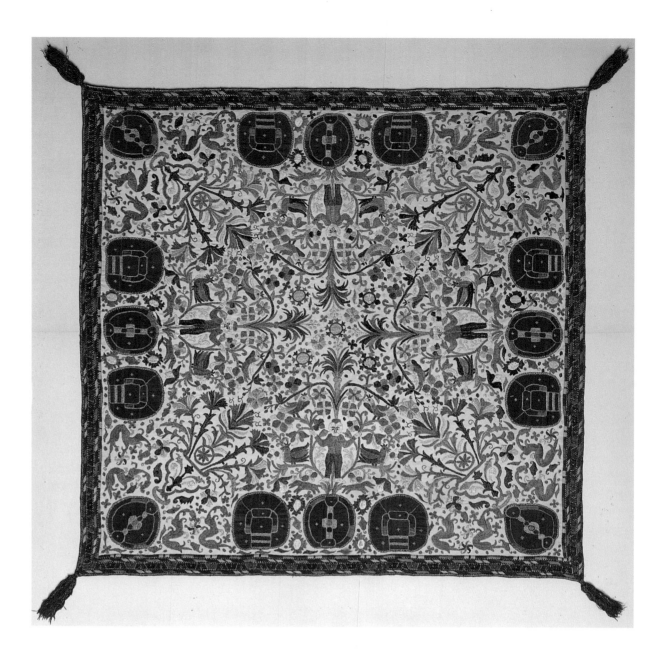

PLATE 167

Wrapper or Panel

Ionian Islands. Ninteenth century

Silk floss embroidery on plain weave linen

36 x 37⅜" (91.4 x 94.9 cm.)

This square embroidery could have served either as a decorative panel or as a wrapping. As a decorative panel, it would most likely have been placed on the wall of a house. In the islands of the Aegean and Ionian Seas the interior walls in all but the most elaborate houses were white-washed, and few windows punctuated the walls to bring in light and color. Such panels were used in daily life as ornamentation, and on special occasions were hung in even greater number.

Embroideries also served all manner of wrapping or covering functions. Before the nineteenth century when paper envelopes came into use, embroidered fabrics served as one means to wrap missives, such as personal letters and commercial payments. Goods, even fabric goods, that were stored in the house were wrapped. The wrapper served to protect the textiles, and

to offer ornamentation within the house because often household textiles wrapped in this manner were stacked against one of the walls when they were not in use. An embroidery of such a large squared size could have wrapped other textiles for storage, or gifts for presentation.

The pattern of this embroidered square is anchored on each side by a male figure. Balancing a plant on his head, and holding a vine in each of his raised hands, this figure serves as an example of how regional traditions adapted a motif shared over centuries in a broad cultural area such as the Mediterranean. The general pose of the figure links it with that displayed in plate 166, yet the specific qualities of its composition and the color range of its threads indicate its origins in the Ionian Islands.

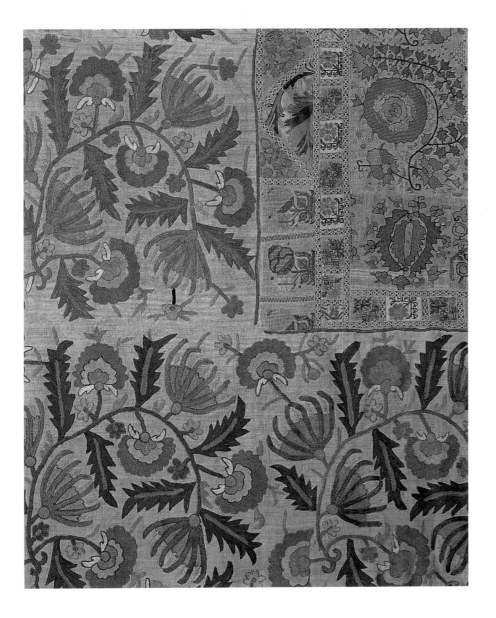

PLATE 168 (detail)

Bed Cover

Greece. Assembled in the Ninteenth century

Silk and metallic thread embroidery and lace

insets on plain weave linen

71 x 96½" (1.83 m. x 2.45 m.)

This handsome bed covering is a composite of
older pieces assembled in the mid-nineteenth
century. As such it is a sign of those changes in
social conditions throughout the eastern Med-
iterranean that diminished the importance of
embroideries for all segments of society. Greece
became a new nation state, and the economy
of the Aegean and Ionian Islands changed. New
materials and machine-made products, as well
as new venues for employment, edged out the
taste for embroideries, the time to make them,
and the lifestyle to enjoy them. From being
used at every social level as a ubiquitous design
technique for household furnishings, embroi-
deries came to be in short supply. Families began
to divide up embroidered linens so that each
new generation could have a piece of the family
traditions. This environment also fostered the
making of "new" embroideries for household use
by piecing together those parts of older embroi-
deries that remained in excellent condition.

In this manner, fine old embroideries were
preserved and later generations could display
them, at least on special occasions. In this bed
covering, the center panel displays the virtuosity
and control of an embroidery originally from
an urban environment. The fine drawing of the
vine pattern, and the texture and shading accom-
plished through the variety of stitches and
different colored threads indicates the reason
why this exquisite older piece, which probably
dates to the late eighteenth century, was pre-
served. The border is made up of fragments
from embroidered hangings of several regions
that are pieced together with lace inserts. The
skill of the person assembling this bed covering
is apparent in the meticulous way the design
of the border is a visual complement to the cen-
tral panel. To attain such visual harmony, each
design in the border has been chosen so that it
is complete within the shape of the individual
patch, and patch sizes have been matched and
proportions maintained by the use of lace inserts.

PLATE 169
Gondola Prow (*Ferro*)
Venice, Italy
Twentieth century
Iron
54 x 41" (137 x 104 cm.)

This *ferro*, an ornamental iron piece, once fit onto the up-curving prow of a Venetian gondola. The *ferro* is one of the few decorative features that has not been altered since the gondola's probable origin in the eleventh century. It is believed that the *ferro's* design is a symbolic combination of several shapes: the Doge's hat, the long gentle curve symbolizing the Grand Canal, and the six "teeth" (horizontal bars) that represent the six quarters of Venice.[3] The weight of the iron *ferro* acts as the forward counterbalance to the gondolier's weight at the back, thus becoming a stabilizing feature on the boat. The ancient design of the *ferro* provides a reference for the historical view as the passengers glide through the labyrinth of Venice's canals.

The gondola has long been the primary mode of transportation through the 118 islands and 180 canals that comprise the city of Venice. During the fifteenth and early sixteenth centuries the gondola, a prominent symbol of the owner's wealth, became so elaborate and ostentatious that in 1562, the Venetian Senate banned this display of public extravagance and decreed that gondolas should be painted black without elaborate gold decoration and lavish draperies. (Judy Chiba Smith)

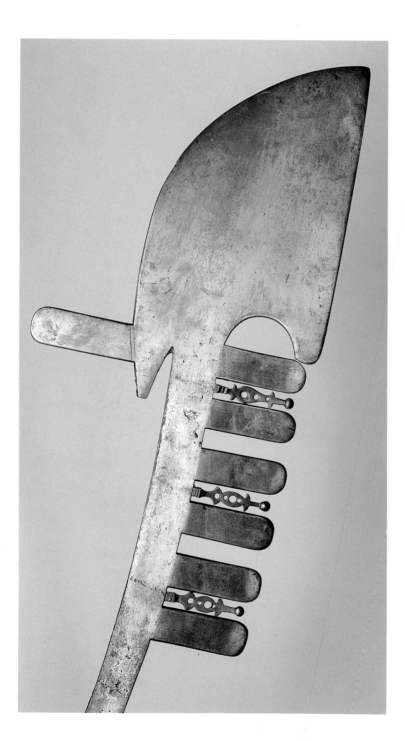

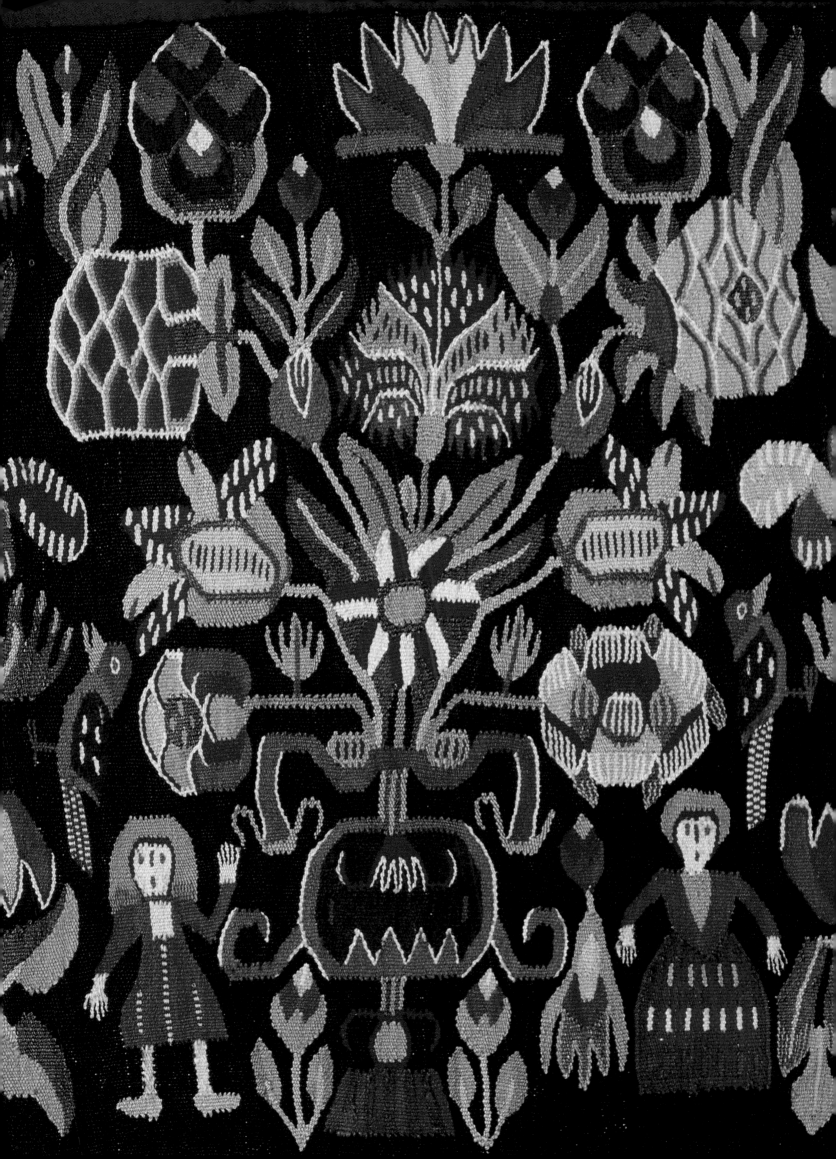

CHAPTER 8 Europe

BY MARY HUNT KAHLENBERG

A popular theme of European textiles, be they of the most fashionable types made by professionals or the labors of home production, is that of flowers. Artists have chosen flowers as designs for textiles out of interest and affection for plants, as well as for their adaptability as a decorative motif. Plants and flowers are frequently portrayed naturalistically, although this, of course, is a relative concept, since what is produced is an illusion of a three-dimensional form and amplified further by a change of scale.

The idea of presenting a realistic image also has a cultural bias. In the illustrations of flowers, the European tradition brings a more scientific and analytical perspective, which differs from the East Asian portrayal where the idea is to convey the sense of a living plant – or the western Asian textiles (particularly India and Persia) where flowers are always presented with a sense of pleasure and a feeling for their full decorative potential. Regardless of the perspective, floral art always carries with it a sense of joy. Delight in plants for their own sake is considered to be a characteristic of stable and advanced urban civilizations, beginning with the Minoans and followed by the Classic Greeks. The current vogue for gardening, therefore, speaks well of our historical place.

Despite this Greek interest in Naturalism it took a hiatus between the fall of the Roman Empire and the eleventh century to foster a revival of botanical interest. This renewed portrayal came partially out of the study of nature associated with the contemplative life of the monastery. Plants emerge as symbols relating to their unique qualities: the vine a symbol of life, or the rose with its thorns as an image of the Passion of Christ. Gardens to provide food and medicines were common fixtures associated with all early monastic houses. It was this medicinal use that brought about the serious revival of interest in the observation and illustration of plant species. It started in Southern Italy, under the influence of Islamic culture that followed the Arab invasions of the Mediterranean, but the scientific methods and knowledge were Greek. Greek botanical writing and theories based on observation had been preserved in the Greek centers of the Near East.[1]

The study of medicinal plants dates back to the *De Materia Medica* of Dioscorides (c. A.D. 40–90), which was continuously copied with ever-degenerating illustrations during the Byzantine Empire, and particularly in Arabic centers of learning.[2] With a revived interest in personal observations, artists returned to nature to again begin making accurate illustrations. These were compiled into books, originally as drawings and miniature paintings which, in turn, were copied widely as the desire for information spread. When books began to be printed, plant illustrations were reproduced by using wood blocks. These early books remained scarce, but they were not without influence in the textile arts. Late medieval tapestries used these drawing as the basis for the flowers sprinkled across their foregrounds. This is a style of presentation that continues to be revived.

Such tapestries also reflected a common theme in late medieval art, the small enclosed garden where the pleasures were both mystical and sensuous. Such gardens based on formal geometry were also very much a part of the Islamic world, but their development in Europe was based on the conscious acknowledgment of the beauty of flowers. This move away from the priority of plants for economical or medical value was a move from the fear of nature to its contemplation, then to an appreciation of its diversity, and finally to an enjoyment of its pleasures for their own sake. It was a major transformation in Western thought – it was as if a garden had been discovered where before there was only a hostile wilderness.

As this concept permeated Europe so did the proliferation of books with botanical illustrations. Increasingly, these illustrations were borrowed for tapestry and for embroidery. While many of these delicate embroideries were the work of well-trained ladies, the drawing of the patterns onto the ground cloth remained a professional skill. It was not until the seventeenth century that pattern books came into existence. One such example was Richard Shorleyker's *A Schole-house for the Needle* published in 1624, which included "Flowers, Birds and Fishes . . . to compose many faire workes."[3] These books combined the local flora and fauna, but also a liberal sprinkling of exotica. Plants from the Americas, the Near East, and the Orient were becoming the rage for the sophisticated gardener, just as the curiosity cabinet was for the collector.

In fact, garden design and embroidery design showed a remarkable commonality. Emphasis on individual plants as specimens expanded to geometric layouts of floral beds edged with evergreen borders. Inside the house the floral textile echoed the visual – if not the aromatic – delight of the garden viewed as from a window. This textile expression had the added benefit of being bright and cheerful even on a gray winter's day when the garden lay dormant.

The study of plants has always been connected to the study of design. During the past three centuries, the desire to improve on nature and help it to conform to the space requirements of a piece of furniture, or a repeat on fabric yardage became a priority. This brought about a change of emphasis from floral motifs to ornament. This modus operandi lingers on, following the curves or angles that reflect the current fashion. While in many cultures plant motifs became abstracted and highly symbolic, in Western cultures they remain popular for the pleasure they provide in beholding them.

PLATE 171
Sampler
Spain. 1654 (?)
Cotton thread embroidery on plain weave linen
25½ x 11½" (64.8 x 29.3 cm.)

This seventeenth-century sampler is signed *Lo hizo Carman Fernandez, ano 16(?)54. Beaterio del Santisimo Sacramento.* In Spain and in other European countries, women would sometimes join a *beaterio,* or community, where they would withdraw from daily life but without joining a specific Catholic order.[1] Ecclesiastical embroidery was usually undertaken in convents and communities of this kind, and young women were often initially instructed in embroidery skills through the creation of samplers.

Samplers probably made their first appearance in the sixteenth century as examples of patterns and stitches used in the everyday embroidery of clothing and household goods. From that time to the beginning of the twentieth century, the creation of samplers was an important part of the schooling of many young women. Young girls were taught needleworking skills starting at age six or seven and were expected to become accomplished by their late teens. In addition to teaching different techniques of sewing, samplers were often a forum for practicing the alphabet, numerals, and verses of moral virtue. The figure, animal, and plant motifs were most likely copied from pattern books of the time. (Judy Chiba Smith)

PLATE 170
Woman dyeing yarn at Marjaru spinning mill in Sweden. 1986. (Photo: Neil Goldstein)

PLATE 172
Miniature Drop-Front Cabinet with Drawers
Artist: Anna Maria McIlvain
England (?) Eighteenth century
Colored straw and paper appliqué on wood
5⅜ x 7¼ x 4½" (13.7 x 18.5 x 11.5 cm.)

The awe and delight one feels as the front lid
of this small box is opened and the series of
small drawers are revealed engenders a deep
fondness for the creator, Anna Maria McIlvain.
The combination of cut-paper details, such as
the figures' faces and the whimsical nature of
the animals gives this cabinet the sense that a
younger, less experienced hand created this
work. Small personal cabinets or boxes were
popular keepsake items for holding cherished
possessions.

Straw appliqué probably originated in
Southern Europe in the sixteenth century and
was a popular substitute for expensive ivory
and gold. Wheat and oat straw or corn husks
were cut, flattened with a knife, and glued to
the wood surface. During the eighteenth and
nineteenth centuries, this medium became
popular in England and France. The motifs on
this straw appliqué cabinet were probably de-
rived from popular pattern books of the period.
(Judy Chiba Smith)

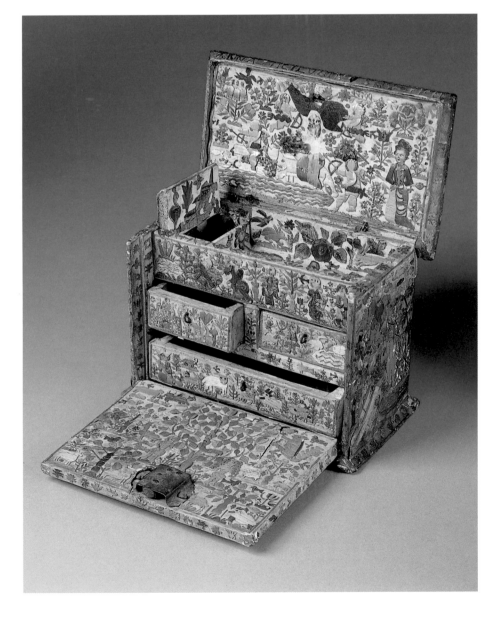

PLATE 173

Mirror Frame

England. c. 1660s

"Stumpwork" silk embroidery on

plain weave silk, tortoise shell frame

34 x 25" (86.5 x 63.5 cm.)

Embroidered works such as that displayed on
this mirror frame were probably created as
memorials to the Restoration of the Monarchy.
The two figures depicted on the side panels
may possibly be representations of Charles II
and his wife Catherine of Braganza.[2] The frame
has a thin gilt layer, covered with tortoise shell
and lacquer to give it a shimmering luxurious
appearance. This mirror frame illustrates how
the austere furnishings of the early seventeenth
century gave way to a more opulent style, thus
creating a desire to decorate homes in a more
affluent manner. In late seventeenth-century
England, it became fashionable for young women
learning needle-working skills to embroider dec-
orative panels for small boxes and mirror frames.
Raised work, later known as stumpwork, became
a popular embroidery technique. Shapes were
cut, padded, and then stitched to a background
material to create a three-dimensional effect.
An abundance of fine needle-working materials,
such as silk and metallic threads and seed pearls,
became readily available. as a result of the pros-
perous English trade routes around the world.
Print sellers, such as Peter Stent and his successor
John Overton, published embroidery pattern
books full of animal and floral motifs, as well as
images of popular persons.[3] (Judy Chiba Smith)

PLATE 174

Crewel Cushion Cover

England. c. 1650

Wool embroidery on plain weave linen

20 x 40" (50.8 x 101.5 cm.)

The term "crewel" has a variety of meanings: a style of embroidery, a two-ply yarn, and a stitch, also known as a "stem" stitch. Crewel embroidery usually refers to the use of wool yarn on a linen ground.[4] Needle looped and buttonhole stitches are incorporated in this fanciful cushion cover depicting whimsical animals, flowering plants, and smiling figures.

The influence for the style of this work was most probably chintz from India. The striped elongated tree and floral motifs, as well as the spotted background, are reminiscent of the cotton fabrics with floral designs, known as chintz. Trade routes between England and India flourished in the seventeenth century, and merchants were returning with exciting textiles and tales of distant cultures. After the austere period dur-

ing the reign of Oliver Cromwell (1653–1658), Charles II's reign reflected his preference for the exotic and extravagant items that were becoming accessible as a result of England's global trade.[5]

Two other events contributed to the rising popularity of crewel embroidery. During the sixteenth century, the steel needle began to be manufactured in England and became a popular and inexpensive replacement for needles made of bone, wood, or ivory. Crewel embroidery was also popular because it was easy to learn, as well as because the yarns were colorful and affordable. This atmosphere encouraged prosperous middle-class families to decorate their households with embroidered items, such as bed linens, tablecloths, wallhangings, and cushion covers. (Judy Chiba Smith)

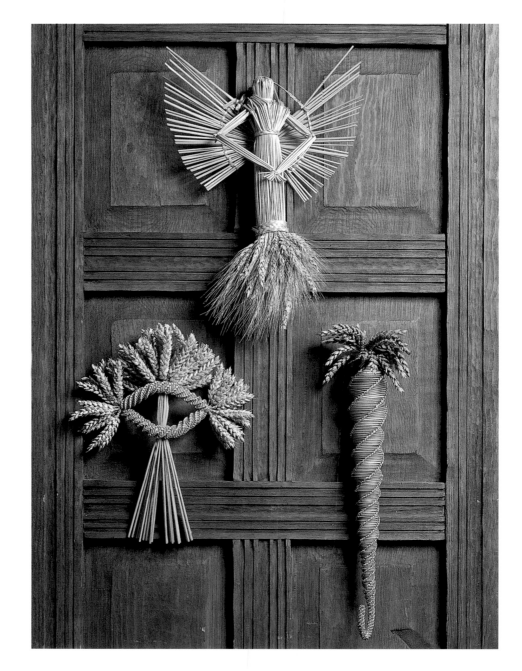

PLATE 175
Corn Dollies
England. 1970s
Plaited wheat
Approx: 18¼ x 5½ x 4"
(46.4 x 13.9 x 10.2 cm.)

These corn dollies from England are three of over fifty examples in the Collection from Europe, Russia, Sweden, India, and Mexico. In England the term "corn" is a general term meaning wheat, barley, oats, and rye. It does not include corn as known in the Americas. Human dependence on a successful harvest led naturally to the conception of a spirit upon whom people could call for aid. Corn dollies were harvest emblems made as offerings to ensure the continuity of agricultural abundance.

All European countries have had a special custom attached to the cutting of the last handful of grain, although there were differing approaches. Some destroyed the last sheaves by throwing their scythes until nothing was left, or trampled on the evil spirit hiding within. In other areas, these last sheaves were treated with honor for it was believed that the corn spirit had retreated into them as a refuge when the rest of the crop was cut. There, the corn spirit would sleep throughout the winter and in the spring would be taken to the fields when seed was being sown, so that the spirit could awaken to the newly-sown seed.

Sometimes these last sheaves of such grains were decorated with wild flowers or sprays of green leaves and made into figures, and it is from this form that the name "dolly" originated and became associated with an evolving variety of crosses, stars, diamonds, and triangles. Though many of these shapes were linked to specific places, they have been borrowed back and forth as our relationship to the corn spirit diminished, and the corn dollies became a decoration.[6]

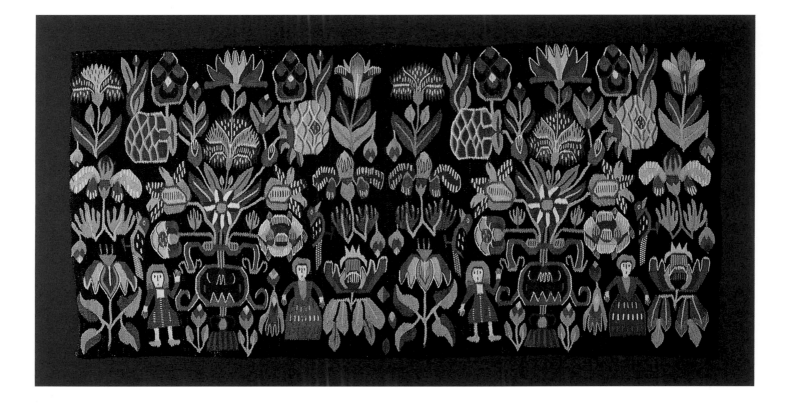

PLATE 176 (detail shown at beginning
of chapter)
Carriage Cushion Cover
Torna, Skåne, Sweden. Late Eighteenth century
Dove-tail tapestry technique (*flamskväv*);
linen warp, wool weft
18½ x 38" (47 x 96.5 cm.)

This carriage cushion cover with the figures and
vase motif is very typical of Flemish weavings
from Torna, Sweden. Flemish weave or *flamskväv*
is a dove-tail tapestry technique woven with a
paper pattern placed behind the warp for guid-
ance. In the tapestry technique the different
colored wefts completely cover the warp. They
do not pass from selvage to selvage but are
used only in the areas required by the pattern.
Dove-tail tapestry further delineates this tech-
nique by having the wefts from adjoining colors
wrap around the same warp. This creates small
points of color.

Much of the popularity of Flemish weavings
in Sweden can be traced to the 1530s, when
King Gustav Vasa brought tapestry weavers from
Flanders to weave for the royal court and teach
Swedish weavers their art form. Copying the
fashions of the royal court, Flemish weaving

styles spread from castles to manors and, even-
tually, to the rural farming class.

In southern Sweden, the province of Skåne
became a center for producing Flemish-style
weavings. In part, this occurred as a result of
land reform laws and the increased economic
well-being in the area. As farmers were able to
improve their financial status, and their wives
and daughters were released from farming
chores, more time was available to spend on
weaving decorative items for the home. Bench
covers, bed linens, and carriage cushions were
all signs of economic prosperity and status within
the local community. According to a report in
1797, "The goodness of a wife is measured by
the number of beautiful bed covers, cushions
and carriage cushions that she makes," and a
full chest chamber therefore provided economic
security.[7] (Judy Chiba Smith)

PLATE 177

Apron

Moscow region, Russian Federation

Nineteenth century

Supplementary weft and silk, cotton, and
metallic thread embroidery and sequins
on plain weave cotton

39 x 28" (99 x 71 cm.)

In the Moscow region of Russia, aprons and
headdresses were lavishly decorated with silk,
metallic threads, sequins, and seed pearls.
This full-length apron would have been worn
over a shirt with oversized sleeves. Large
embroidered segments, covering most of the
upper portion of the sleeve, would reflect the
colors and embroidery patterns of the apron.
Under the apron would be worn a skirt with a
decorated band around the hemline.[8]

Until the twentieth century, most tradi-
tional folk clothing gave evidence of the wearer's
place in society. Alison Hilton wrote in *Russian
Folk Art*: "The festive garments worn by peasant
women might be compared with the decor of
the peasant house. Made up of many elements,
each employing special techniques, with varia-
tions depending on occasion, region, age, status,
and taste of the wearer, the peasant costume
like the house, was a complete ensemble."[9]
Everyone, from the youngest to the oldest, had
special outfits for festive occasions – weddings
and funerals, as well as ceremonial and commu-
nity events. (Judy Chiba Smith)

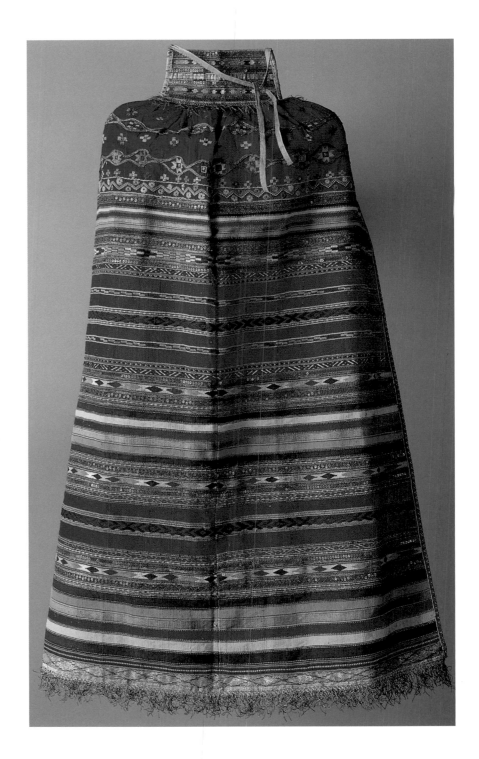

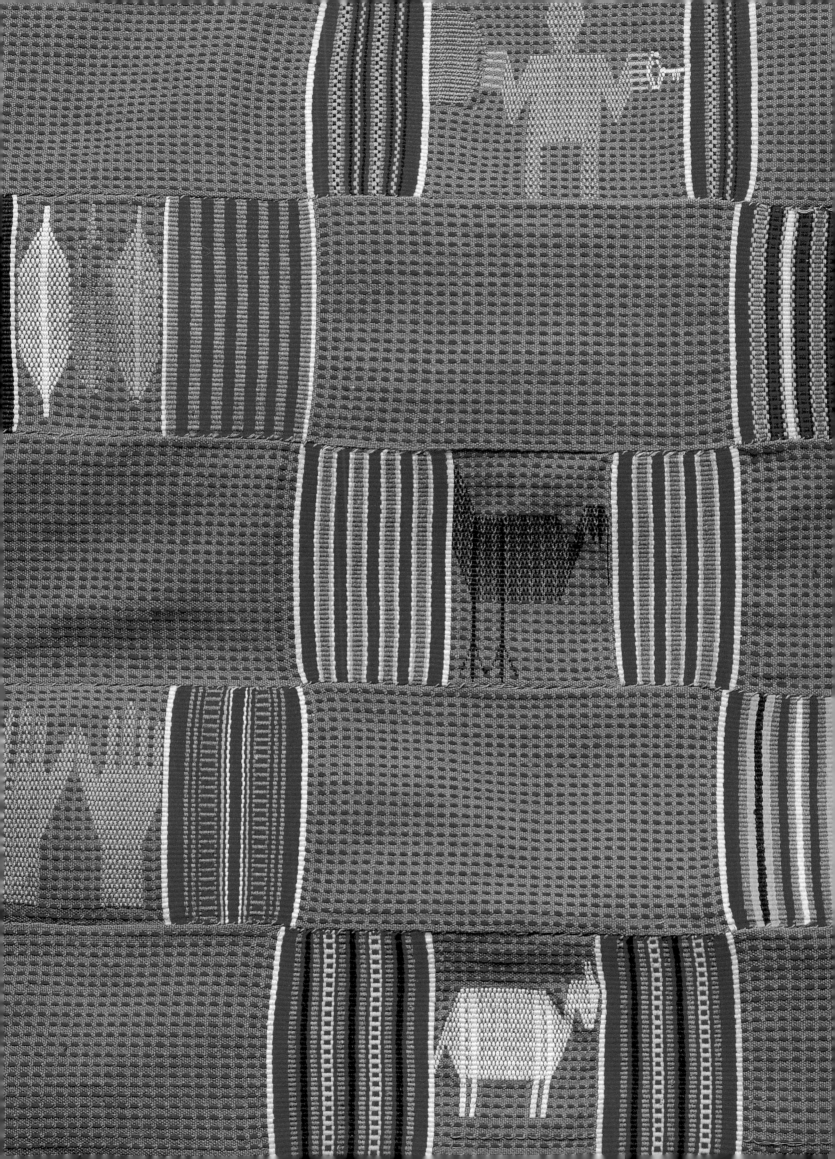

CHAPTER 9 # Africa
Sub-Sahara

BY ENID SCHILDKROUT

There are many ways to approach African art and it is no surprise
that countless observers have debated the primacy of aesthetics
over context, form over function. As this debate simmers, muse-
ums continue to mount exhibitions that draw together art from
the entire continent; critics debate the validity of these juxtaposi-
tions and groupings; and African art continues to delight and
amaze those who try to understand it, as well as those who sim-
ply love to look at it.

When African art first gained widespread public attention in Europe at the end of the nineteenth century, sceptics doubted that the beautiful bronzes of Benin were African. Only a few years later, however, with an exhibition of Kuba art at the British Museum, Africa began to receive credit for the invention of great art. As knowledge about Africa seeped into the West, the diversity and quality of African art – from Asante to Zimbabwe – were recognized and admired. Inevitably, there were calls for an understanding of context, for insight into what African art meant to Africans. Even to the most superficial observers, the power of African masks and figures suggested that these were much more than decorative objects.

We now have a fairly extensive literature on African art that does two things: first, it describes the variations in styles and traditions found throughout this vast continent, sometimes attempting to link variations to different kinds of parameters, from climate to political organization. Then, it catalogues the contexts within which Africans create and use art. They wear it, worship with it, exchange it, celebrate it, transform and create themselves with it, heal and protect with it. Through apprehending these contexts of use, Westerners get a glimpse of how art expresses Africans' attitudes toward the past, toward their environment, toward social life, and toward the spiritual powers that affect peoples' lives. Understanding these societal meanings may be irrelevant to aesthetic appreciation, but for some people this knowledge amplifies the experience of the art by bridging cultural gaps.

It has been argued that there is no justification for making general statements about African art or even about Africa for that matter.[1] On one level this is surely true, because Africa contains tremendous variations in hundreds of separate languages and cultures. Yet Africa does not consist of thousands of isolated ethnic groups. Throughout African history, boundaries between neighboring peoples were fluid, migration was an intrinsic part of African history, and objects and knowledge transcended any boundaries that might have temporarily existed. It is possible to map stylistic regions where techniques and traditions were shared and borrowed. The narrow strip loom, for example, was not the product of a single West African people, but rather a technology that was invented (we don't know where) and then borrowed, shared, and elaborated upon with stunning particularity from place to place. Africans valued fine objects both for their intrinsic beauty and for their functional utility, and they traded, exchanged, and purchased such things across cultural and even regional boundaries. The study of African art is, then, partly the study of the tension between local expressions and meanings and the way these reach backward and forward in time and across spatial boundaries. All of this movement did not homogenize African art by any means, but rather fostered local elaboration and creativity, enabling people to continually refashion the material world according to their needs and tastes. Today, for good reason, the field of African art includes the African Diaspora as much as it includes the history of ancient Egypt.

One reason that African art has such universal appeal may be that it is deeply personal. This quality transcends both form and function. It is perhaps something that those who are drawn to African art intuitively grasp. In Africa, art connects the individual to the community, to the dead, to the living, and to the not yet born. It connects the individual to the physical environment – to the alternation of the seasons, to plants and animals as they interface with human needs. It is made to be worn, lived with, loved, and feared, in everyday life and on special occasions. It does not wait for people to go and see it, hung in abstract spaces like museums. It is a ubiquitous part of life, although not always meant to be seen by everyone and at all times. Even when access is restricted, everyone knows that the individuals who have contact with art can be transformed by it. We recognize these powerful resonances in African art objects, even if we do not understand the specific contexts in which they are used. When Mr. Cotsen decided that African art was efficacious in the workplace, that it had the power to help people share ideas and tap into each others' creativity, he must have recognized this quality. It is something that, to a great extent, has dropped out of the definition of Western art in a secular age.

Whether in African sculpture, masks and masquerade costumes, musical instruments, tools, household utensils, even clothing and jewelry, this sense of a connection between people and art is evident. The simplest household object is often signed with some mark that identifies both the creator and the owner. The wooden stools carved by men for Mangbetu women in the Democratic Republic of Congo (formerly Zaire; hereinafter referred to as Congo) usually bear a mark identifying the artist, attesting to a personal bond between carver and client. Mangbetu women carry small pieces of bark cloth painted with abstract designs applied with the juice of the gardenia plant and soot from their cooking fires. Like their body painting designs, no two compositions are identical, even though the same motif may be used over and over in different combinations. The cloth, like the body, is a canvas for the creation of a work of art.

Similarly, every West African hand-woven or pattern-dyed textile is different, bearing some sort of signature of the weaver, the dyer, or the person who commissioned it. In the past, these variations were often interpreted by Westerners as "mistakes," but they are far from that. Besides acknowledging the artist who wove or dyed or embroidered the cloth, or the desires of the wearer, these variations are deliberate demonstrations of creativity. This is not simply a matter of claiming authorship; as Monni Adams has shown, it is an intrinsic part of the design aesthetic.² Sometimes these particularities express family and village identities; at other times they encode local histories. Among the Kuba in Congo, *lukasa* or "memory boards" are small wooden rectangles onto which beads are placed in a pattern recording important events. These boards, used in divination, are "maps of the mind," which only coincidentally become art objects for Westerners.

Masks and the costumes worn with them usually represent spirits, but each has an individual personality that is filtered through the masquerade performance. After a long period of training to gain the knowledge and be accorded the privilege of performing a specific masquerade, a dancer – almost always male – assumes the personality and power of a spirit. The masquerade filters and interprets the message of the spirit, but it is usually a personal message, directed at a specific person. The masquerade localizes the spirit, reinforcing the link between people and destiny.

In Africa, sculpture frequently helps the living maintain a connection with the dead, with ancestors who serve as guardians of tradition, health, social harmony, and creativity. The dead can often influence the day-to-day affairs of the living. If a family is torn by conflict, if a woman fails to bear children, then ancestors, embodied in or contacted through art objects, can intervene to restore order. Art helps create this link between the living and the dead; it serves as a memorial and as an altar. It is where the living and the dead are connected through sacrifice.

The most personal African art is what people wear and use every day: cloth, beadwork, jewelry, body painting, and hairstyles. In Africa, clothing, jewelry, body painting and scarification, hats and hair, define people, their age, marital status, gender, even their occupational roles and political status. Tremendous care and attention is given to color, pattern, material, and texture because these elements combine to create statements about identity. The Congo cap (plate 194) is a masterpiece of craftsmanship but also a sacred object that denotes a ruler's authority. Since much of what people wear is commissioned by the wearer or constrained by ritual, weavers, dyers, leather workers, metal workers, and jew-elers are linked with their patrons in the fabrication of statements of identity, as well as in the creation of beauty. In many African societies, a specific relationship is created by making and giving objects that are worn: a mother making a protective amulet for her child; an Ndebele woman making a special beaded apron for her daughter as she finishes her initiation rites; a husband giving his wife a special cloth when their first child is born.

Cloth, a particular focus of this Collection, can be imbued with endless meanings, expressed in tangible explosions of color and texture. It takes on great significance during ceremonies of initiation, when a person is moving between identities. Initiates cannot wear cloth, only unwoven and unadorned raffia fiber. To seal a marriage contract, among certain Yoruba-speaking people in Nigeria, *oparo* cloth (plate 180) must be worn by both bride and groom for a specified time period. Particular combinations of warp-striped patterns are required as part of the marriage contract. In many places, widows cannot wash their bodies or change their clothes. They must wear their oldest torn rags, or their normal clothes turned inside out. Death, like initiation, can mean the loss of identity. For Muslims in West Africa, only the simplest white burial cloth can be used for a shroud, for here death is not a time for marking anything but loss. Yet among the Merina in Malagasy, the most elaborate woven *lambas* are used for the reburial of the corpse, signifying the end of mourning and the beginning of the afterlife.

The most ornate and elaborate clothing celebrates life, or the afterlife, as in the example above. Layers of fine weaving and embroidery, as on the *agbada* (plate 181), demonstrate an elder's status. But cloth is more than wealth and ostentation; it is laden with ritual importance, not only mediating relationships between people and between groups, but also between human beings and spiritual forces. Certain kinds of cloth must be offered to the water spirits before they can descend from their canoes and appear in masquerades among the Ijo people in the Eastern Niger Delta region of Nigeria.³ Cloth known as *aso olona* is crucial to the rituals of the Oshugbo society – a society of initiates who perform many judicial functions among the Ijebu Yoruba. It not only demonstrates a participant's status as a leader or an initiate, but it also serves the spirits that are honored in Oshugbo shrines. The abstract representations of animals woven into the cloth in supplementary weft designs refer to crocodiles, mudfish, and tortoises; here these animals are symbols of power, but even more important, they appear as water spirits and intervene in the lives of human beings.

As the arbiters of fashion the world over can tell us, cloth expresses status as well as singularity. It is no accident that the finest materials and most intricate patterns are often reserved for royalty. Only certain patterns of weaving can be worn by the Asantehene, the paramount chief of the Asante people in Ghana. Certain woven or stamped patterns on cloth, certain carved patterns on stools, and certain gold leaf ornaments are associated with proverbs that encode messages about power and status. In Cameroon, only chiefs could wear clothes with embroidered or dyed representations of lions or leopards. The cloths displayed in the men's Ekpe society meeting house in eastern Nigeria (plate 187) proclaim powerful messages about the activities of this association. Understanding the embedded symbolism inherent in materials and clothing, Mobutu Sese Seko of Congo continued to wear his leopard skin hat as an assertion of power long after his power was questioned.

It would seem that the introduction of factory-made cloth could destroy the potential for cloth to serve as an expression of local and personal identity in Africa. But as soon as machine-made textiles were introduced, Africans found ways to transform the mass-produced into something uniquely African. Red woolen army blankets were teased apart and the yarn was rewoven on African looms. Ndebele women applied layers of imported glass beads to multicolored store-bought blankets. To celebrate the end of Ramadan, Muslims in Ghana select particular patterns to signify their group identity. And motifs on machine-made cloth, like handwoven textiles, celebrate leaders and events with realistic pictures, while abstract designs are given distinctive names that encode proverbial meanings.

West African narrow strip weaving, many examples of which are featured in this Collection, integrates color and pattern through rhythmic juxtaposition – using syncopation, not symmetry. This cloth has an obvious kinship with the patchwork quilts that African-American women make using a totally different quilting technique. Like European quilts, African-American examples are made from scraps of ordinary printed cotton, but in composing these quilts, the makers employ principles widely used in West Africa. These quilts are thus instantly recognizable as coming from an African tradition, rather than a European one. In a similar vein, African music, rich with polyrhythms and improvisation, is recognizable no matter how much it has been incorporated into Western forms. As diverse and varied as African traditions are, there are elements that are as recognizable as they are difficult to describe. They transcend Africa's internal and external boundries and they account for the broad appeal of African art.

PLATE 178

Hausa man embroidering a man's gown in
Kano, Nigeria. 1980. (Photo: Enid Schildkrout)

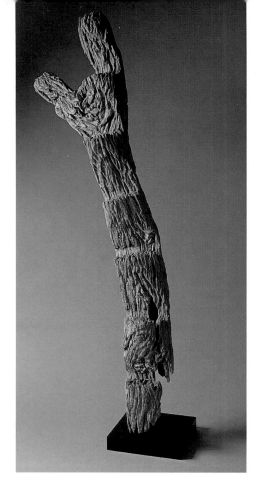

PLATE 179
Ladder
Dogon People. Mali
Nineteenth or early Twentieth century
Carved; wood
5'9" x 26" x 7 ½" (175 x 66 x 19 cm.)

A wooden ladder, carved out of a single piece of wood, was made to lean against the outside wall of a granary or house in the savanna regions of West Africa. With only a single annual rainy season, grain must be stored for many months in vermin-proof enclosures. In Mali, the Dogon build their granaries, like their houses, out of mud brick. The granaries are entered through small windows placed high above the ground so that livestock cannot enter. Among the Dogon, the window shutters are elaborately carved with human and animal figures that refer to myths about the society's origins.

Nestled in the sandstone Bandiagara cliffs where they settled in the fifteenth century, ostensibly to preserve their independence in an era of state consolidation and slave raiding, the Dogon still build their compact mud brick villages on hillside terraces. Each family lives in a cluster of single rooms surrounding one or more courtyards, and a number of granaries. Most dwellings have flat roofs and the Dogon use ladders to climb up to them. When it is hot, many people climb up to the roofs to sleep.

PLATE 180
Oparo Cloth
Yoruba People
Nigeria. Twentieth century
Strip-woven warp ikat technique; cotton
74 x 57" (188 x 145 cm.)

Although Yoruba women engage in a great deal of weaving, generally on a stationary vertical loom, *oparo* cloth is made on a man's narrow strip loom. *Oparo* cloth is a sub-category of cloth known as *aso alaro*, characterized by a plain weave made from handspun cotton dyed with indigo. Warp stripes of white, light blue, and red, as well as ikat designs, are common on *aso alaro* cloth. It is used on many different kinds of ritual occasions, especially in the series of gift exchanges that accompany a marriage ceremony. According to an account given by one weaver in the town of Ilorin, Nigeria, a groom and his family are required to give a prospective bride at least three *oparo* cloths, each one made up of a selection of strips woven in known patterns. At least five specific patterns, each with its own name and significance, should be offered to the bride's family. When strips of these patterns are sewn together in a particular order they make up the cloth known as *oparo eleto*. During the wedding, the groom also wears a garment of *oparo* cloth.

Descriptions dating back to the eleventh-century Arab traveler, el-Bekri, as well as archaeological examples of cloth found in burials and caves from Nigeria and Mali, show technical and design similarities to modern examples. The most valuable cloths still in use today, and those with the most important ritual significance, are handspun and handwoven cloths that resemble the ancient examples, sometimes even showing the same striped and checkered patterns.[1]

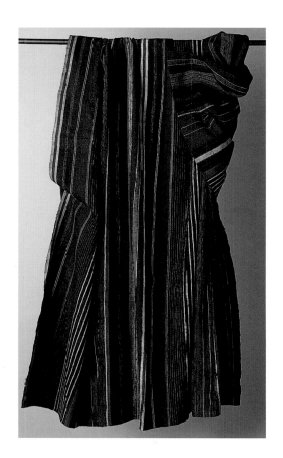

PLATE 181 (detail)
Man's Robe (*Agbada*)
Yoruba People
Nigeria. Nineteenth century
Strip-woven silk embroidery on
plain weave cotton
50 x 98" (127 x 249 cm.)

This Nigerian man's cotton and silk robe, *agbada*, dates from the nineteenth century, an early date for African textiles in museum collections. It is made of very finely woven narrow strips only 3/4 " wide on the main gown and 1 3/4 " wide on the sleeves. This type of robe was most likely produced by Nupe artisans whose workshops were centered in the town of Bida, north of the Yoruba heartland. Many of the finest gowns found in the north of Nigeria among the Hausa and in the west among the Yoruba were commissioned from specialist craftsmen in Bida.

Throughout West Africa, funerals are occasions for mourning and consolation, as well as for the display and circulation of wealth. Because of its dark blue color, this robe was suitable for wearing at funerals, although it was not reserved solely for those occasions. Here, a type of weave known as *etu* has been used for the body of the robe. The small checked pattern of light blue on a dark indigo background is known as "guinea-fowl," named because of its resemblance to the bird's small white-flecked feathers.

While indigo dyeing is women's work in many parts of West Africa, including the Yoruba in western Nigeria, in the northern part of the country among the Hausa and Nupe people, men operate the dye pits. There, weaving and embroidery are also men's work. Thus several different specialists – dyers, weavers, embroiderers – would have been involved in the fabrication of a single garment like this one.

The embroidered design panels on the front and back of this gown are made separately and then sewn into the gown. The embroidery patterns are derived from Islamic sources: the spiral pattern symbolizes the path of revelation, inward toward the divine center; while the five knives motif contain invocations to the Prophet.[2] The use of these designs suggest that the robes had a protective and talismanic function.

PLATE 182 (detail)
Ceremonial Cloth
Ijebu Ode or Ijo People
Nigeria. c. 1800–1850
Strip-woven, supplementary weft
technique; wool and cotton
98 x 82" (249 x 208 cm.)

This is a ritual cloth of a type used in ceremonies of the Oshugbo society among the Ijebu Yoruba. A large cloth such as this one would have been used on the walls of an Oshugbo shrine in Ijebu Ode. Clothes with similar designs were worn by initiates and chiefs and indicated the ritual and political status of the wearer. The cloths were also used in funerary contexts associated with the shrine. The dominant design on this cloth represents a mudfish, but the *oni*, or crocodile motif, is also important in this type of cloth. Linking spirits of the water and those of the land, the crocodile functions as an intermediary between spiritual realms.

Weaving has practically died out in Ijebu Ode today, but ritual cloths such as this were transferred throughout the Delta region of eastern Nigeria with the spread of certain masks and masquerades. Ijebu motifs like the mudfish and the crocodile have been adopted in masquerades for water spirits in the Kalabari Ijo region some 250 miles to the East, but the abstracted design has become identified not with a crocodile or mudfish but, as among the Ijo, with a tortoise. Among the Ijo, from whom this cloth may have been obtained, the dominant design is known as *ikaibiti*, or tortoise.[3] Like the crocodile and mudfish, as an animal that crosses the boundary between earth and water, the tortoise is an important part of the water spirit pantheon. In Ijo masquerades, water spirits are induced to appear with the payment of valuable goods including cloth.

Throughout southern and eastern Nigeria, women weave on a stationary vertical loom, producing cloth that is considerably wider than that produced on the man's narrow strip loom. However, certain ritual cloths – in Benin, for example – are woven by men,[4] and this example may be of that type. Here, handspun cotton provides the background for a large ceremonial cloth, constructed of four separate pieces. The red weft float threads were made from unraveled European army blankets, highly valued because they provided a color that was not easily obtained from local dyes. Nigerian weavers have been combining imported and handspun yarns for decades, and cloths can often be dated by the type of yarns used in the supplementary weft patterns.

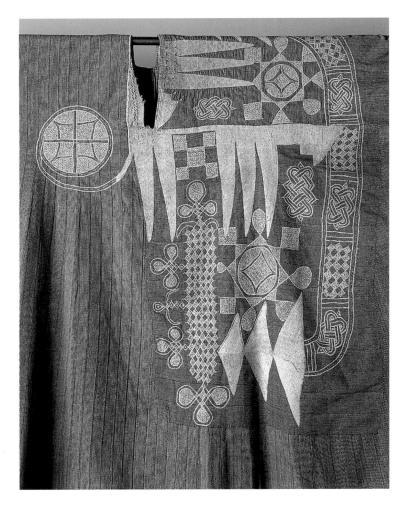

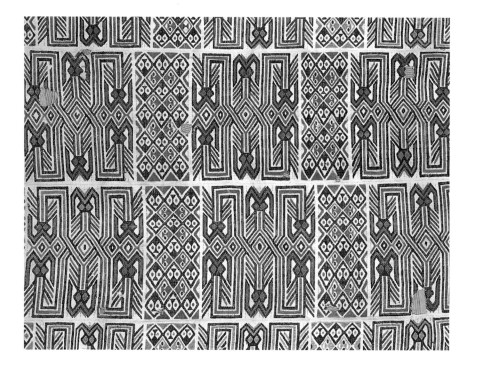

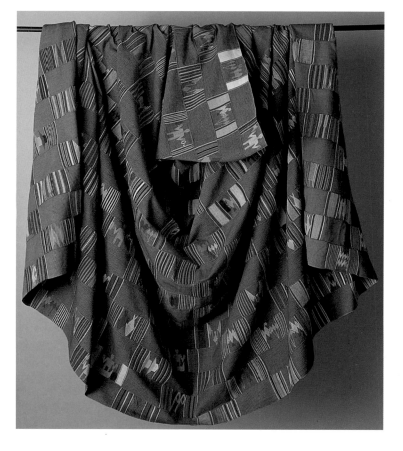

PLATE 183 (detail shown at beginning of chapter)
Man's Cloth
Ewe People. Eastern Ghana. c. 1940
Strip-woven supplementary weft technique; cotton
118 x 69" (299.7 x 175.3 cm.)

This full man's cloth is made from twenty-two strips. Each strip has eleven blocks of weft-faced patterns, some with hand picked tapestry woven designs and others of stripes. There are two hundred and forty-two of these motifs altogether and the vast majority represents flora, fauna, people and things drawn from the Ewe environment and culture. Although many of the motifs are repeated five or more times, this cloth is remarkable for the quantity and diversity of its imagery. A number of motifs represent royal regalia – stools, state swords, keys, and fans. The pair of hands and the scissors are both said to represent the weaver's work.

The menagerie of animal forms includes snakes, frogs, lizards, bats, fish crabs, and an assortment of birds (some on bushes). There are several unidentifiable quadrupeds, but most curious are the several images of the two-humped bactrian camel indigenous to Asia, not Africa. This was probably borrowed from a printed illustration and is just one of a series of motifs influenced by the British colonial presence in the area. There are a large number of human figures on this cloth, all posed in the same highly conventionalized posture but with different implements or regalia in their hands. One stands in a canoe holding a paddle, another has a pith helmet in one hand and a sword in another, a third has a key and briefcase (?), and a fourth has a cane and what may be interpreted as a microphone attached by cord to a speaker. Given that many of these motifs depict proverbs, this *tour de force* of Ewe weaving is also a splendid essay on the Ewe view of the world. (Doran H. Ross)

PLATE 184 (detail)

Hammock (?)

Ewe People. Eastern Ghana. c. 1930

Strip-woven, supplementary weft
technique; cotton

102 x 44" (259.08 x 111.76 cm.)

The use of highly conventionalized representational motifs and the English inscription place this cloth within the Ewe realm. One can see an assortment of keys, stools, hands, birds, fish, and unidentified quadrupeds that inhabit many of the finer and older Ewe weavings. Most Ewe imagery is derived from an impressive body of verbal forms. Since a single image, however, may elicit several maxims (in addition to those intended by the artists) one must be cautious in restricting the meaning of a motif to a single saying. *Adjasoo,* for example, associates the human hand with the expression "It is with the hand we work," but there are numerous Ewe proverbs dealing with the hand, any one of which could be applied to this image.

If the function of this piece as a hammock is quite rare, its role as a specially commissioned presentation piece, made clear from its inscription, is much more common. Yet the inscription is curious and reads:

W.J.A. JONES PROVINCIAL COMMISSIONER
GILLIAN FROM DADOY.

An inscription on any work of art, of course, may be an entrée into its meaning, context, and authorship. The colonial context for this piece should be obvious. Although Ghana was divided into "regions" after the 1957 independence, for most of the colonial period prior to that, the Gold Coast Colony was divided into three provinces (western, central, and eastern) headed by "Provincial Commissioners" working under the Governor of the Colony. We do know that W. J. A. Jones was Commissioner of the Central Province in 1928 and later became Sir Andrew. The second part of the inscription poses a few more problems. "Gillian" is a relatively common English female name, but what is the meaning of "DADOY"? Two possibilities come to mind i.e., that DADOY is the *place* from which Gillian comes, or DADOY is the *person* who gave the piece to Gillian. Unfortunately, DADOY is neither a name for a place or person of which I've heard. It could possibly be a nickname, a corruption of "daddy" (Is Gillian the daughter or wife of Jones?). If the latter were true then rather than the typical retirement gift for a colonial official, this would be a gift from that official to a close female relative. (Doran H. Ross)

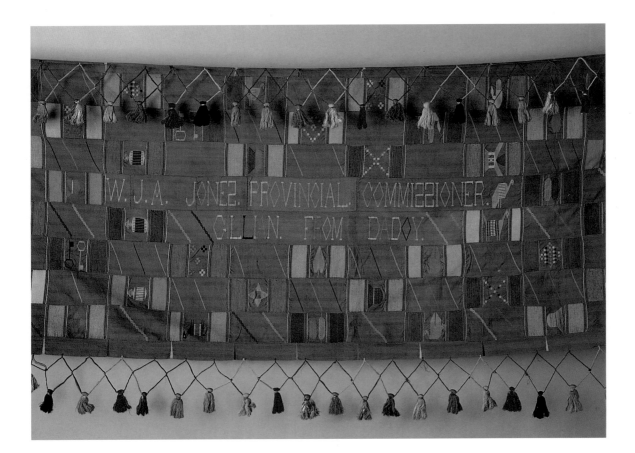

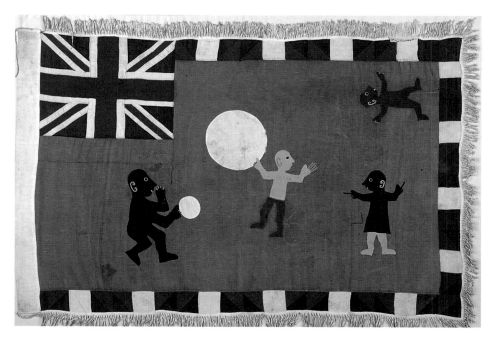

PLATE 186

Warrior's Flag *(Asafo Frankaa)*
Artist: Nana Manso
Fante People. Kormantine/Saltpond area,
Southern Ghana. c. 1945
Appliqué and embroidery on plain weave cotton
42 x 67" (106.68 x 170.18 cm.)

This flag once belonged to one of the traditional
warrior groups (*Asafo*) of the Fante peoples of
southern Ghana. Defense of the state was the
primary function of these groups, however, under
pressure from both colonial and national govern-
ments *Asafo* activities in this century have moved
away from military roles to more civic-oriented
activities. Depending on the area, today *Asafo*
companies may be involved in the maintenance
of local infrastructures, the care and feeding
of certain deities, and even the selection of the
town's chief.

Individual Fante states may have from
two to fourteen highly competitive *Asafo* com-
panies. Each company has designated colors and
emblems which are jealously guarded as exclu-
sive prerogatives. Violations of these prerogatives
are still seen as cause for often violent confronta-
tions. *Asafo* plastic arts are elaborately developed
in two media – cement sculpture adorning two-
and three-story concrete block shrines, and appli-
qué flags that share much of the same imagery
as the sculpture. This imagery springs from

the sophisticated corpus of oral literature that
characterizes the subject matter of all Akan arts.
Typically this orature, as it is increasingly called,
has been specified as proverbs or folktales, but
in fact it embraces a much wider range of ver-
bal forms including boasts, insults, riddles, and
jokes with a strong mix of irony and satire run-
ning throughout.

In an April 20, 1997 interview, flagmaker
Kobina Badowah (b. 1910) of Upper Kormantine,
identified the artist of this flag as his mentor
Nana Manso and placed its date as shortly
after the Second World War. The presence of
the Union Jack in the canton of this flag clearly
dates it before Ghanaian independence from
British colonial rule in 1957.

The subject matter of many flags pits the
leader of the flag's owner against that of a rival
company. Badowah identified the smaller *Asafo*
"captain" who confidently holds the large sphere
aloft, as representing the flag's company. The
larger figure struggling with the smaller sphere
is his rival. In this conflated verbal and visual
narrative the rival is asking if his competitor can
handle the moon. The flag's owner responds
by saying, "The sun is not heavy, how much of a
problem can the moon be?" The black figure
on the right pointing his finger is the narrator or
storyteller. Unfortunately, Badowah did not
have an explanation for the horizontal red fig-
ure in the upper right. (Doran H. Ross)

PLATE 185

Fante *asafo* flag dancer from Number 1
Company, Legu, performing during the annual
path clearing festival *(Akwambo)*. 1975. (Photo:
Doran H. Ross)

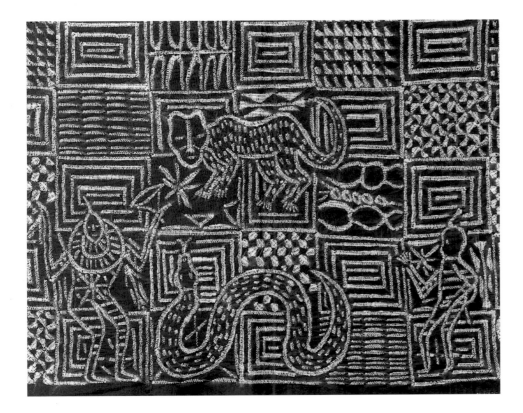

OPPOSITE

PLATE 188

Dance costume

Northwestern Igbo People

Nigeria. Twentieth century

Embroidery and cotton and felt appliqué

on plain weave cotton

57 x 55" (145 x 140 cm.)

The Igbo peoples of southeastern Nigeria have rich and diverse artistic traditions including sculpture, house painting, body decoration, textiles, and masking. Masquerades represent and honor the dead, who return as spirits to superintend the living. They remind people about the proper kinds of behavior necessary to ensure abundant harvests, large families, and prosperity.

Men make their own masquerade costumes, often using fabrics made by women, and they go through long periods of training before they can participate in masquerades. Women witness masquerades and are depicted in them – often in the form of female spirits. This costume was made for the "Fame of Maidens" or *Ude Agbogho* masquerade, a series of performances that are meant to entertain people, but that also serve serious social and ritual purposes. Through songs, dance, gestures, costumes, and masks, the dancers reiterate accepted social values and shame people who do not follow them.

The maiden masquerade costumes are appliquéd body suits worn with carved wooden face masks that represent the ideal of female beauty. The masks are surmounted by headdresses with elaborate crests representing women's hairstyles, as well as birds, antelopes, and groups of people. The white faces of the masks signify purity, while the appliquéd stripes on the costume refer to Igbo women's body painting.

Dancers with protruding breasts represent marriageable and fertile young women; other dancers represent older women who have fulfilled the ideal of having children. Sacrifices are made to ancestors and to the earth, conceived as female, during these festivities. Through their masks, costumes, and performance, the masqueraders reiterate the idea that physical beauty is inseparable from moral virtue. The *agbogho mmuo*, or young women, are pure, dignified, beautiful, and fertile, an honor to their ancestors and a tribute to their families.

PLATE 187 (detail)

Leopard Society Cloth

Igbo People, Cross River

Nigeria. Twentieth century

Resist dyed; machine-woven cotton

86 x 70" (218 x 178 cm.)

Known as *ukara* cloth, this ceremonial cloth is used in the rituals of the men's Ekpe (Leopard) society of the Igbo people in the Cross River Region of eastern Nigeria. Members who have reached the seventh – the highest – grade of the Ekpe society commission these cloths for wearing. Large Ekpe cloths are also hung in the society's meeting house and are used as a backdrop behind the thrones of certain chiefs. *Ukara* cloths are also used during a member's funeral, where they are sometimes draped around shrines or worn in funerary masquerades.

Ekpe cloths are produced on commission by artisans from the north of the area where they are used. On lengths of plain cotton factory-made cloth, the artists draw designs, which they then stitch, drawing the thread so that the design resists absorbing the indigo dye. In addition to geometric designs, human and animal motifs, the cloths contain *nsibidi* symbols, passwords that can be interpreted in a secret language used by members of the society. The cloths generally contain motifs and signs that refer specifically to the identity of the person for whom the cloth was made. Depictions of leopards, crocodiles, and pythons evoke the mystical as well as the earthly power of these threatening animals, together with the similarly awesome power of the Ekpe members. As is true of most secret societies in the area, the Ekpe society serves judicial as well as ritual purposes and is complementary to the power of chiefs.

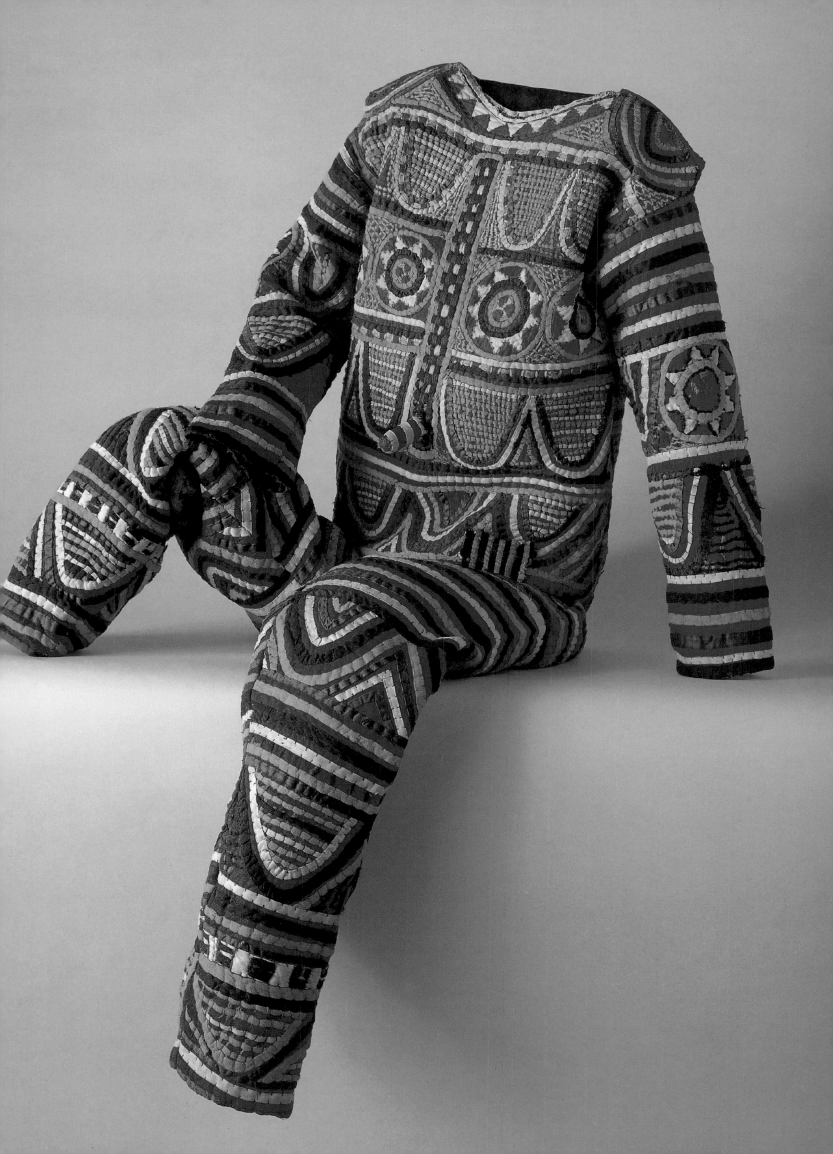

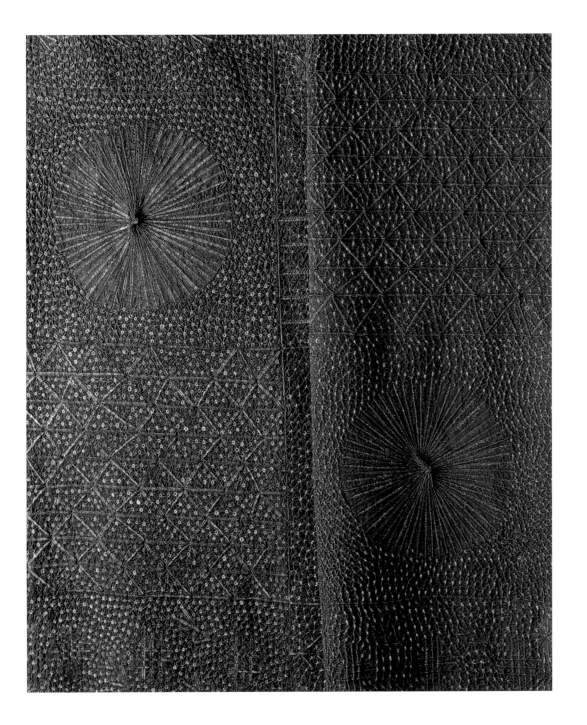

PLATE 189 (detail)
Adire Cloth
Yoruba People
Nigeria. Twentieth century
Tie-dyed; plain weave cotton
66 x 57½" (168 x 146 cm.)

In Western Nigeria, Yoruba women excel in the art of tie-dyeing. This cloth, saturated with indigo dye, still reveals the dyeing process, since the raffia threads used to tie and stitch the cloth have not been removed. This lends texture to the cloth, although it minimizes the color contrast that would emerge if the raffia knots were gone. The dyer has divided each half of the cloth into a mirror-image grid, a layout often used on both tie-dyed and resist-dyed *adire* cloth. Each square is filled with a different geometric pattern.

This cloth was purchased in the early 1970s at Abeokuta, the principal dyeing center of the Yoruba today. In the past, this time-consuming work was done by women artisans from specialized houses, particularly in the towns of Ibadan and Abeokuta. Today this laborious hand stitching and tying is rare and dyers frequently use sewing machines to achieve the resist designs.

PLATE 190 (detail)
Adire Cloth
Yoruba People
Nigeria. Twentieth century (before 1970)
Cut-thread work and tie-dye;
machine-woven cotton
73 x 63" (185 x 160 cm.)

This rare and unusual cloth invites speculation as to its origins, since it is quite unlike any other cloth known from Nigeria. It combines techniques from at least three different areas: cut-thread work similar to that found in the east among the Kalabari; men's embroidery similar to the work of Hausa and Nupe men in the north; and indigo tie-dyeing with its concomitant grid patterning common among the Yoruba in the west.

This cloth began as factory-made imported cotton broadcloth. It was then worked with a technique known as drawn work, or cut-thread work. This was a common technique of European women's needlework in the nineteenth century and may have been taught by Europeans in mission schools. The cut-thread embroidered patterns form a mirror pattern when the two sides of the cloth are sewn together. As in Yoruba *adire* patterning, squares – in this case twelve on a side – are filled with repeated geometric designs.

After the cut-thread work was completed the cloth was tie-dyed in a large and very fine spiral pattern. This example, collected in the early 1970s in Ibadan, shows signs of wear and use and probably dates from the early part of the twentieth century.

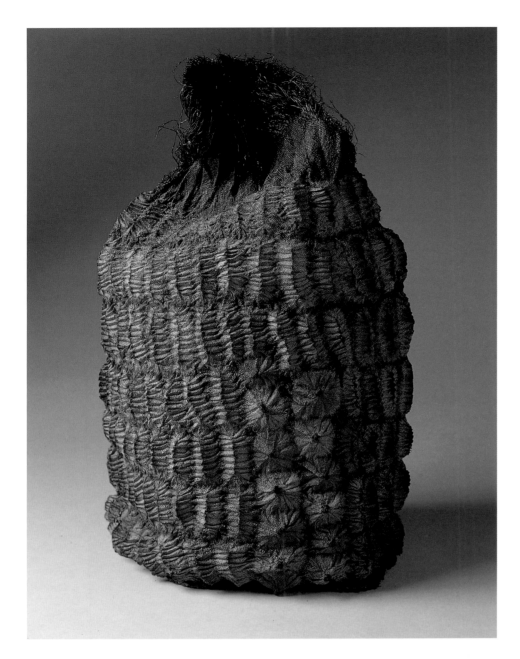

PLATE 192

Men's Hats

Tikar, Bekom, Bamenda Peoples

Cameroon. Twentieth century

Knitted and crocheted; cotton,

grass fibers, and wool felt

7½ x 10" (19 x 25 cm.) dia., 6 x 9" (15 x 23 cm.)

dia, 8 x 7½" (20 x 19 cm.) dia.

Men in the Grassfields region of Cameroon in West Africa display their status and wealth in their elaborate knitted and crocheted hats, which are masterpieces of inventive design. In recent times, these caps have become emblems of national dress, although there are recognizable variations that distinguish local identities.

The techniques used in making the caps are quite old and some observers have suggested that the modern versions, constructed of cotton and felt, are based on the older models made of raffia, elephant tail, and porcupine quills. The protruding burls and spikes on these hats also may imitate hair styles, as they are depicted on wooden sculpture.

The hats, *ashetu,* made and worn exclusively by men, can be purchased even today in local markets. Besides being a traditional way for men to show their status and wealth, these hats serve as a contemporary fashion statement, as new materials and new designs are often worked into the repertoire.

PLATE 191

Skirt, Loin cloth, Wrapper, or Shawl

Dida People. Côte d'Ivoire.

Twentieth century

Plaited and tie-dyed raffia

22 x 14½" (56 x 37 x 6 cm.)

The Dida people of southern Côte d'Ivoire produce a unique type of tubular handwoven garment that was formerly used as a woman's loin cloth. The cloth is also worn by men as a shawl and by men and women as a wrapper around the waist. Scholars have speculated that this combination of plaiting, the use of raffia fiber, and the use of mineral dyes rather than indigo, represent ancient techniques, possibly preceding the introduction of indigo and the narrow strip loom into West Africa.[5]

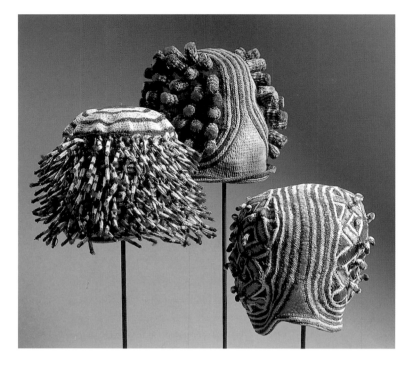

PLATE 193
Raffia Bag
Bemessing, Cameroon. 1950–1975
Supplementary warp technique,
plaited handles; raffia palm
30 x 20" (76.5 x 51 cm.)

This raffia bag represents the northern exten-
sion of a tradition of raffia weaving that extends
throughout central Africa. Raffia weaving is
usually done by men and takes many forms. As
explained in Chapter Ten, raffia cloth was so
important in the pre-colonial period that it
served as currency and also had many ritual uses
in marriage ceremonies, funerals, and as signs of
wealth and status. The distribution of the verti-
cal raffia loom extends northwards from central
Africa into Cameroon, and there it was used
primarily to weave shoulder bags of this kind.

Raffia bags have a long and complicated
history and turn-of-the-century photographs
show many different bags being carried by men
and women.[6] The bag forms and their associ-
ated design elements indicated a person's
ethnic and geographic origin, as well as ranks
and titles, membership in secret societies,
wealth, and even the purpose for which they
were carried.

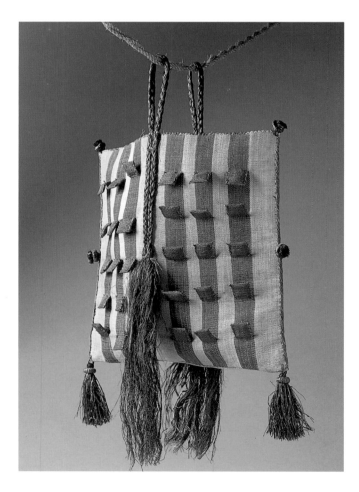

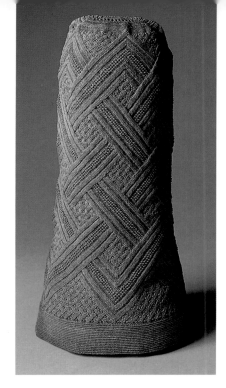

PLATE 194
Hat
Vili-Yombe People
Congo. Eighteenth century
Knotted raffia palm
14 x 6½" (36 x 16.5 cm.)

Descriptions of these high status raffia head
coverings extend back over five centuries, to the
earliest accounts of the Portuguese along the
coast. Raffia caps were part of the regalia that
distinguished rulers in central Africa, particularly
among the Kongo and Mbundu peoples in north-
west Angola and the western side of the Congo
River basin in what is now the Democratic
Republic of Congo, the Central African Republic,
and the Republic of Congo. Villages were known
as *mfumu a mpu,* which means "chief of the cap."
The caps demonstrated the high status of those
men who were privileged to wear them and
also partook of the sacred and magical power
of their owners. The hat was believed to protect
the wearer from harm.

When a ruler died, an effigy was created
and buried with him. Before the completion of
memorial services, the ruler's grave was marked
by placing his cap over the grave. The actual cap
was eventually passed on to a successor in the
appropriate rituals for transferring regalia.

The construction of a cap such as this one
is based on using single strands of raffia fiber
and twisting, looping, and knotting the strand
starting from a central spiral. The technique
seems to be indigenous to the region and is very
ancient, with many local variations in style and
in the specific stitches and types of knots used.

PLATE 195
Beaded Belts
Kuba People. Congo. Late Nineteenth
or Early Twentieth century
Plaited raffia palm with cowrie shells
and glass beads
57½ x 3¾" (146 x 10 cm.), 46 x 3"
(117 x 8 cm.), 54 x 3" (137 x 8 cm.)

Kuba beadwork, like the cut-pile raffia clothes
(see Chapter Ten), are thickly covered with
pattern. In these men's belts, color, texture, and
designs are created with glass beads and cowrie
shells applied to a woven raffia textile base.
The Kuba King, as described at the end of the
nineteenth century by Dr. William H. Sheppard,
was totally enveloped in beaded garments.
The belt was one part of a royal ensemble that
included beaded hats, gloves, and long raffia
skirts. The Kuba, Sheppard wrote, "have a
decided taste for the beautiful. They decorate
everything."

Cowrie shells, traded from the Indian
Ocean across the continent, were used as cur-
rency in many parts of Africa and as signs of
wealth. The glass beads were imported from
Europe as early as the sixteenth century, when
they were used in the slave trade. The blue
beads that were, and still are, popular among
the Kuba came from Venice.

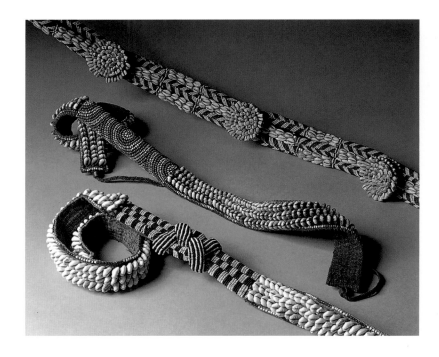

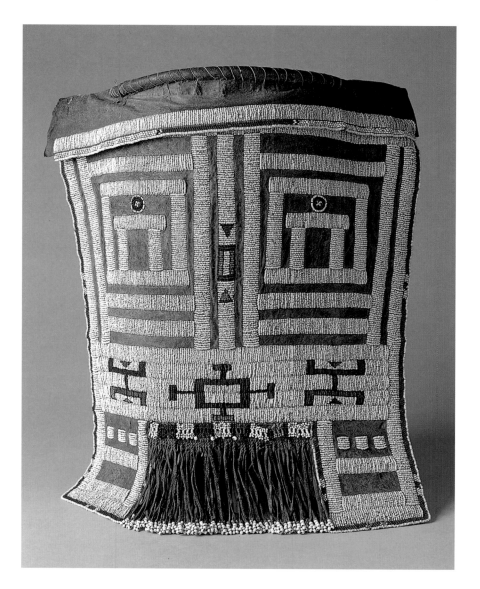

PLATE 196
Woman's Beaded Apron
Ndebele People
South Africa. c. 1950–1975
Glass beads on goatskin
21½ x 25½" (54 x 65 cm.)

Ndebele women in South Africa have been mak-
ing ceremonial beadwork to demonstrate a
woman's passage through life since at least the
mid-nineteenth century when glass beads began
to be imported to Africa in large quantities.
Although the elaboration of beadwork designs
and patterns and the importance of beads in
ceremonial life suggests that the tradition may
be much older, there is little documentary
evidence of the use of beads in earlier times.
Some scholars have speculated that this may
be because older beadwork was buried with
women when they died. This is based on infor-
mants' accounts, but substantial archaeological
evidence, linking ancient beadwork to present
styles and uses, has not been found.

Beadwork from the nineteenth century,
usually sewn onto a leather base, is often based
on a simple white beaded background. Designs
and symbols are created in these early pieces
by leaving open space on the leather base or by
the use of colored beads. From the 1920s to the

1960s, designs representing houses, courtyards,
and other aspects of domestic space, became
more prevalent and more naturalistic. Even the
abstracted designs, however, usually refer to a
woman's home, cattle corral, or the surround-
ing environment.

The type of beaded object, from a variety
of aprons, jewelry, and blankets, indicates at
what stage a woman is in the typical female life
cycle. On ceremonial occasions, a woman wears
beadwork to indicate whether she has been ini-
tiated, is married, or has children. Young girls
wear a small and simple beaded apron, while
an older unmarried girl wears a larger apron
called an *isiphephetu*, made by her mother with
motifs expressing the desire for a home and
family. Just before marriage, during a period of
seclusion, the bride herself makes an apron like
this one, known as *liphotu*, characterized by the
two side flaps representing the married couple
and beaded tassels representing the couple's
expected children.

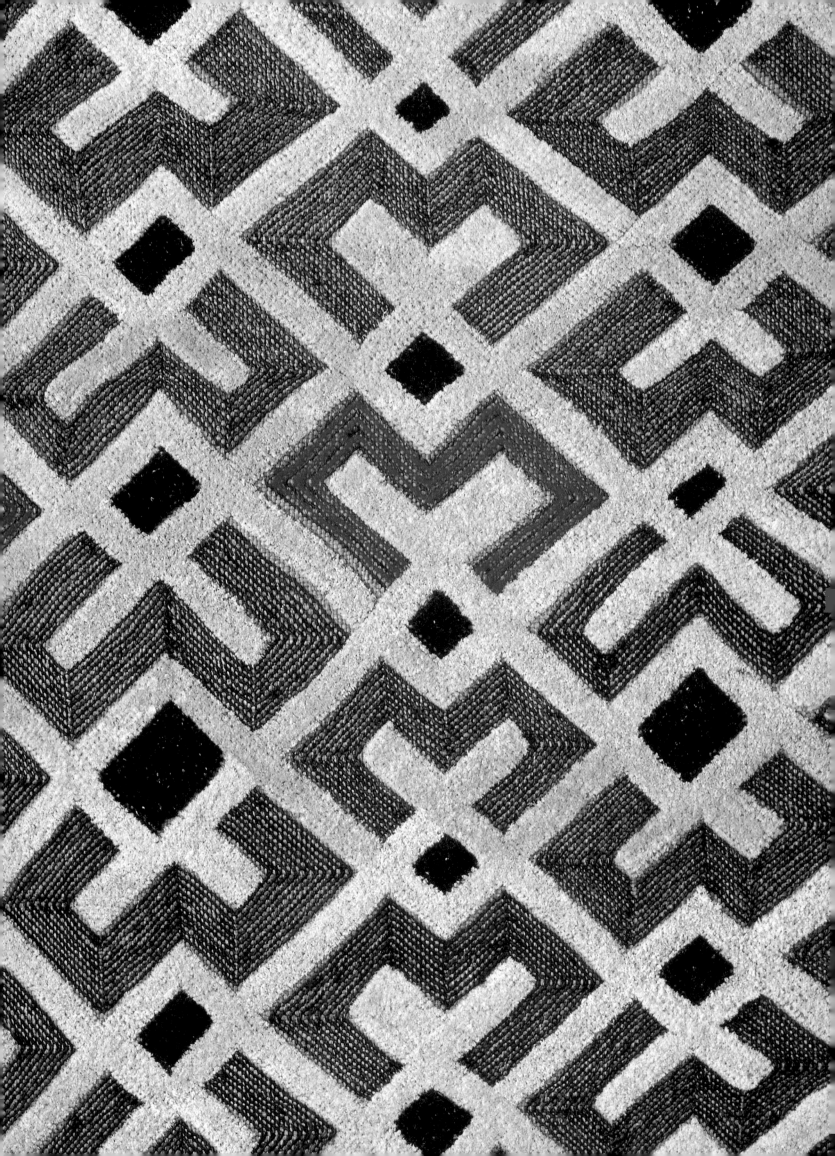

CHAPTER 10 # Africa

Congo

BY MONNI ADAMS

Kuba society seems to have been a stable and prosperous one in which values emphasizing work and wealth stimulated the development of a material culture of richness and diversity not found among the surrounding peoples of the Democratic Republic of Congo (formerly Zaire; hereinafter referred to as Congo). The Bushoong, who form the majority population, developed a constellation of art objects of exceptional quality: wood sculpture, ceremonial textiles, and decorated architecture.

The name *Kuba* first appears on late-nineteenth-century maps. It has become a way of referring to the kingdom of the Bushoong and their associated neighboring groups, who share many social practices and cultural values. The Bushoong kingdom was established probably in the seventeenth century in a well-watered fertile region between the Kasai and Sankuru Rivers within the present-day Western Kasai province of the Congo.

Its development seems to fit the pattern of a number of other, larger "empires" in central Africa, in which a conqueror organizes a number of agricultural villages into a state having at its center a sacred ruler and a royal court with supporting aristocracy. In the late nineteenth century, when Europeans first penetrated this region, the hereditary chief of the Bushoong was the acknowledged sovereign, or Nyimi, over the chiefs of the other ethnic groups such as the Bulaang, the Pyaang, and the Ngeende. From time to time, the Nyimi collected tribute from the neighboring Shoowa and Ngongo peoples.[1] The royal capital, Mushenge, had a planned court layout, and a population of several thousand, consisting of the king with his numerous wives, relatives, officials, and nobility, along with a number of specialized craftsmen, such as sculptors and tailors.[2]

After the Kuba region became a part of the Belgian Congo colony in 1910, accounts of the organized Bushoong court encouraged the colonial authorities to support the local authority of the Bushoong Nyimi. This status of indirect rule meant that much of traditional culture, including costume use and textile traditions, could be maintained. The Nyimi continued to stand at the apex of an intricate and elaborate system of title-holders, to whom he delegated his powers.[3] In contrast to some neighboring peoples whose members acquired prestige by passing into older age sets, the Kuba associated prestige with economic benefit. Elaborate costume became an important element in gaining status.

Photographs of officials in the Bushoong court during the twentieth century show the great attention paid to regalia such as hats, headdresses, belts, ornamentation with feathers, beads, and cowries; these items were graded as signs of royal descent or other political ranking. Many of these elements were expensive or difficult to obtain. Even after political independence in 1960, officials in the Bushoong court continued to give an account of rules concerning which rank could wear which textiles or ornaments.[4] Outside the capital, however, one finds a great variability of practice, especially with the textile garments that are woven of an accessible local material and made through widely known skills.

Early travelers who saw or obtained Kuba cloths described them with wonder as being as supple as silk. All the cloths, in fact, were woven of thin strands cut from raffia palm leaves, a skill practiced widely in central Africa. Throughout the region, men wove raffia cloth, its size limited by the length of the palm leaf strand. The cloth came off the upright loom as a flat panel usually just under a yard long – a weaving task of about a six-hour duration. Women spent a good deal of time, after cultivating and household duties, working on embroideries, dyeing and other decorative techniques.[5]

The basic item of clothing for men and women was a long cloth composed of several flat panels woven of raffia, gathered or wrapped around the hips and hanging down to knee-length. The Kuba took special pride in devising elaborate dress for ceremonies. On such occasions, a man's skirt (*mapel*) could reach over nine yards or more in length. Men's and women's style of wearing the skirt diverged. A man gathers the skirt and folds the upper part over a belt to form a thick flounce at the waist, while a woman winds her skirt (*ntshak*), somewhat shorter than a man's, in an upward spiral around the lower body and bunches it below the waist, securing it with a hide belt. Over this bulky hipcloth, a woman in the royal court (or elite women elsewhere) would add a shorter overskirt (five to six feet in length), decorated in various techniques; less frequently male officials also added an overskirt. Both men and women decorated their skirts principally by angular designs, through a range of interesting techniques. These included several kinds of embroidery, appliqué, patchwork, and resist-dyeing. Decorating a long ceremonial skirt could take the combined and intermittent efforts of several women, or men, over a period of months and even years.[6]

In producing textiles, the Kuba surpass neighboring peoples in the variety of decorative methods and the abundance of designs. Over two hundred names of designs have been noted. Most of these designs are angular and geometric in character.[7] The sensitivity to surface design is evident in an anecdote from the late nineteen-twenties about the reigning king's reaction when the first motorcycle rode into the capital. What caught his attention most of all was the pattern left by the imprint of the tires. He called an aide to have it copied and named after him, "Kwete's design."[8] In this way, a new design, attached to the king's name, entered the repertoire. On textiles, women embroiderers have combined these many designs in remarkably diverse ways.[9] A mathematician, Donald Crowe, found that Kuba artists developed all the geometric possibilities of repetitive compositions of border patterns, and of the seventeen ways that a design can be repetitively composed on a central surface, the Kuba had exploited twelve – and he did not include the myriad design permutations, embroidered by the Shoowa, a northern Kuba people.[10]

In the mid-nineteenth century, when long-distance ivory traders began to open caravan routes from the border of the Kuba area to the western seacoast, the prosperity of the kingdom was greatly increased, encouraging the Kuba people to enrich their textiles. Imported beads and shells replaced some painstaking methods of decorating costumes. Wealth was poured into prestigous activities. By the eighteen-nineties, the population of the capital at Mushenge, made up largely of aristocratic clans and appointed or hereditary officials, had the leisure and wealth to create a court of great ceremonial activity. There were recurring religious rites, masked dramas, festivals legitimatizing the status of royal relatives, funeral and commemorative celebrations for deceased court members, investitures for officials, and pleasurable dances.

The capital at Mushenge provided a vibrant cultural model for smaller regional centers. Outside of the capital, chiefs were likely to imitate Bushoong regalia, but occasions to don dance costume were less formal than at the royal capital. In the non-farm part of the year, one portion of the village would often invite inhabitants of the other part to come over in the afternoon for a dance, and upon such occasions the people turned out bent upon enjoyment, attired in their best skirts.[11] These public gatherings helped to maintain the keen interest in and elaboration of ceremonial costumes.

In addition to daily and ceremonial wear, Kuba cloths were used in a variety of ways, such as payment of annual tribute to the king, as valuable gifts in diverse political and social negotiations, and in the payment of fines. Decorated cloths played a significant part in spiritual relationships with the dead. Because people believed that textiles given to a deceased family member or friend would help maintain the deceased's identity and family status in the afterlife, funerals were occasions for a rich display of cloth, not only as clothing for the deceased but also as gifts for the grave. On these occasions, to satisfy the honor of the deceased and assure the prestige of the survivors, the quality of the textile gifts was a key concern.[12]

Although the Kuba give pride of place to the variously decorated ceremonial skirts, most foreign interest focuses on small panels with an unusual texture resembling velvet, achieved by a special technique of embroidery called "cut-pile" or more commonly "plush." The equipment is simple: a needle and a narrow knife, the same type men use for shaving and women for cutting scarification patterns on skin. The procedure for achieving the plush effect on a woven panel is simple but requires dexterity.[13] Plush is usually combined with another kind of embroidery, stem stitching in flat, linear patterns, a combination embroiderers developed to create contrasts of color and texture.

Within the past fifteen years, cut-pile cloth from the Shoowa people has become the most popular form among collectors and museums because of its astonishing variety of designs and patterns. The Shoowa are a small population on the northern fringe of the kingdom. Shoowa men weave the foundation cloth as part of their daily routine, while women add the embroidered designs. Shoowa plush cloth (*buiin*; pl. *winu*) is usually a small woven panel (24 x 26") first dyed red and then completely covered with geometrical figures formed by a combination of plush effects and tight embroidered lines. Most of the figures are angular: triangles, rectangles, hooks, and lozenges, placed in such lively compositions that visual interest does not flag. An outstanding embroiderer may plan to introduce as many small designs as possible within the principal pattern in order to show off her knowledge and skill.[14]

In early twentieth-century collections, there are numerous Shoowa cloths in the form of a woman's overskirt, combining two panels with distinctive border designs, similar to the example selected from the Collection (plate 200). Currently, for their own use, the Shoowa emphasize the destiny of these plush panels as funerary gifts rather than as costumes for the living. A rare photographic record from the early seventies, however, shows a Shoowa elder at a gathering of local officials performing in a costume consisting of plush panels sewn together to form a voluminous skirt and a shoulder wrap.[15] In recent decades, Shoowa panels have appeared also as part of costumes for masked figures and as furnishing cloths, which are laid on stools or placed like a mat in front of important persons, or worn by regional officials as a scarf or shoulder cloth, the small dotted designs perhaps suggesting prestigious leopard skin.

Like the multi-ethnic kingdom itself, textiles from the various ethnic groups share common features yet maintain certain regional differences.[16] As Torday said of plush cloths, no one acquainted with the art of the region could mistake Bushoong cloth for Shoowa or either of these for Ngongo or Ngeende, although, he added, to distinguish between these last two would require a native expert.[17] There remain, nevertheless, a number of unresolved questions as to regional practices, which makes confident assignment of origin to each and every cloth an unattainable goal.

While the political structure of the Kuba region has changed over the past century, and social and economic practices have been transformed, many individuals continue to treasure decorated cloths as garments for their family dead and as shrouds for their own burial. To be buried without these traditional cloths is said to be equivalent to being buried nude, repugnant to a people who have for so long devoted their skills to creating beautiful clothing.[18]

PLATE 198
Ceremonial panel
Bushoong People, Kuba group. Western
Kasai province, Congo. 1875–1900
Linear embroidery on plain weave raffia palm
15½ x 49" (39.37 x 124.46 cm.)

This old panel, likely to date from a hundred years ago, is composed of two woven pieces that are entirely covered by linear embroidery in square and circular motifs aligned diagonally across the panel. Following Bushoong practice, it was dyed red after the stitched decoration was completed. The closely packed designs are produced in a simple and a more complex stem stitch; additional variety of effect is created by twisting the fibers or tightening the stitch. Emil Torday, who was collecting for the British Museum in the Kuba region in 1908, provided a sketch of the more complex stem stitch and noted that examples of cloths fully covered by these embroidery stitches were extremely rare.[1] Making this kind of surface embellishment was limited to Bushoong women, and use of the cloths was restricted to members of the royal family. This panel could serve as a border on a ceremonial skirt or as an honorary gift to the grave of friends or family.

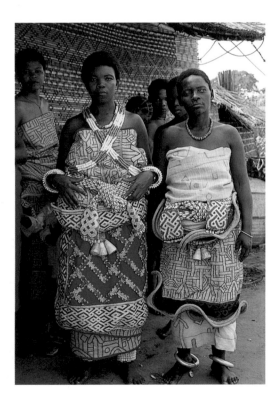

PLATE 197
Royal Bushoong women in ceremonial costume
in the Congo. 1978. (Photo: Monni Adams)

PLATE 199

Ceremonial Panel
Shoowa People, Kuba group. Western
Kasai province, Congo. 1885–1910
Cut-pile and linear embroidery on
plain weave raffia palm
25½ x 48" (64.8 x 121.9 cm.)

Age is indicated by the darkened raffia founda-
tion cloth and by the large spotted X-cross
designs. The surface is densely covered with
linear stitching and cut-pile embroidery. This
composition illustrates recurring principles,
whether followed consciously or not by Kuba
women embroiderers, principles which are
realized most fully in Shoowa cloths. Several of
these features give the composition its visual
complexity. Most notably, we see a constant
alternation of color in small units of light beige
and dark brown or black. Note also the con-
stant shift in size of design and design elements,
as in the fine lines and blocky squares or trian-
gles. In addition, there is a constant contrast
of texture from firm, tightly twisted lines of
embroidery to amorphous soft plush.[2] All these
variations fill the eye with sensation. Another
element to note is the long strip of designs mark-
ing one border only; this asymmetry is made
supportable by the way the border motifs share
these basic principles, which visually allow the
border to merge with the central pattern.

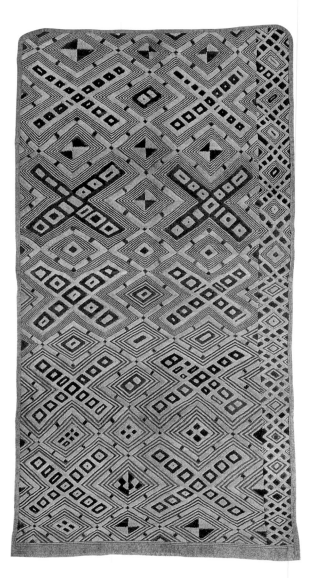

PLATE 200 (detail)
Ceremonial Panel
Shoowa People, Kuba group. Western
Kasai province, Congo. 1885–1910
Cut-pile and linear embroidery on
plain weave raffia palm
17 x 59" (41.9 x 149.9 cm.)

The Shoowa people are a small population
on the northwestern fringe of the Bushoong
kingdom. In spite of maintaining a different
language and loose political ties, the Shoowa
share many cultural practices with the people
of the Bushoong kingdom. This ancient cloth
is composed of two pieces and bordered by
pompoms, a technique reported for textiles
on the Kongo coast in the seventeenth century.
The basic weave is typical for Shoowa with
close warps and weft of similar thickness and
even distribution. The designs are shaped by
two embroidery techniques: lines of stem stitch-
ing and cut-pile. To create the plush effect, an
embroiderer twists a strand of raffia into an iron
needle which she inserts between the warp and
weft, leaving a short tuft. After pulling the fiber
strand through to about two millimeters in
height, she cuts it with a narrow knife held ver-
tically in the same hand and brushes both ends.
Repeating these motions creates lines of plush.

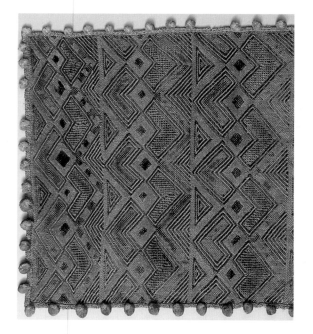

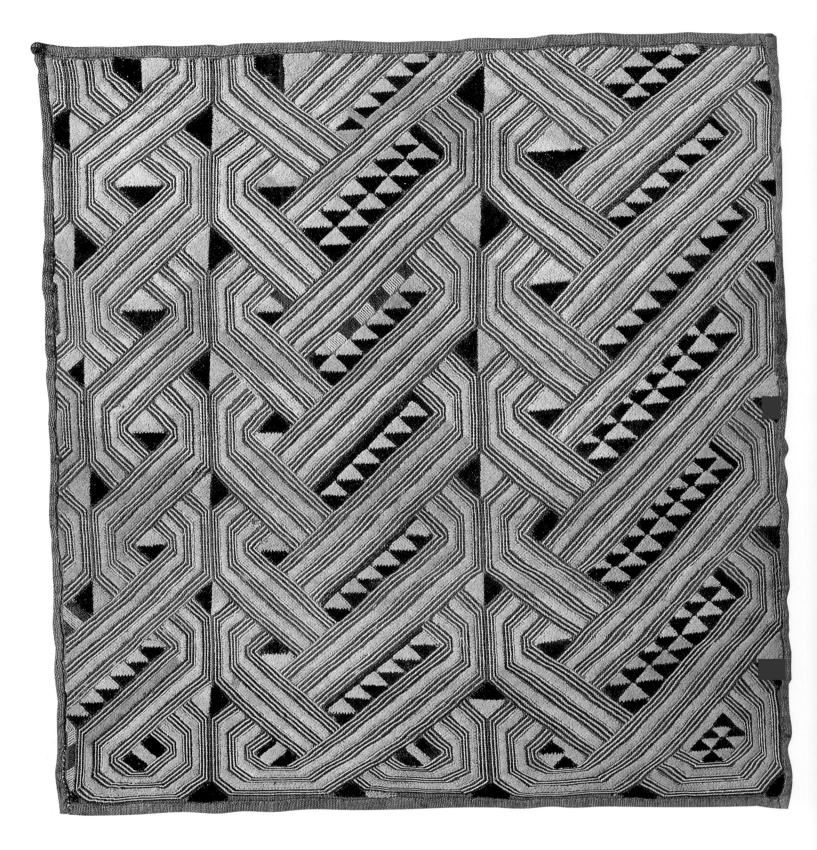

PLATE 201

Ceremonial Panel

Shoowa People, Kuba group. Western
Kasai province, Congo. 1910–1930
Cut-pile and linear embroidery on
plain weave raffia palm
23 x 24" (58.2 x 59.69 cm.)

This panel can be called a classic, that is, a model
of quality, for a mid-century Shoowa cloth. It
retains the major features of the late nineteenth-
century style and fine workmanship. Unlike the
Bushoong, the Shoowa typically, as here, dye
the foundation cloth red before embroidery
and execute their designs in natural beige and
dark brown. The pattern of two wide columns
of interlacing is a long-standing favorite Shoowa
theme. The manner in which the broad colum-
nar outlines are formed by multiple dark and
light rows of stem stitching, interspersed with
tiny light and dark plush motifs, called *tunjoko*, is
another characteristic of Shoowa style. Because
of the subtle distribution of light and dark across
the surface, there is a convincing sense of bal-
ance despite the asymmetry.[3]

Shoowa women have given two differ-
ent names to the interlace motif seen in this
panel, either *weshonkanda* (no translation) or
ikatankaang, serpent's coils.[4] The names given
by the embroiderers, as a means of identifying
and remembering designs, are obviously drawn
from their thoughts, experiences, and visual
surroundings. The names seem to fall into four
categories. The first comprises the names of
persons or items identified with these persons,
such as the cultural hero Woot, or a king's drum.
The second includes names of parts of objects,
either natural, organic, or man-made things.
The third category, most interestingly, points to
activities, such as flashing lightning, a swim-
ming insect, or the movements of a snake. A
fourth category is different in character; these
are aptly named general descriptors, such as
idiakele (or *ishashale*) and *topolo*, which indicate
spottiness. These two terms crop up when a
design is not readily recognized, either because
of its age, different origin, or deviation from
recognizable structure.[5]

PLATE 202

Ceremonial Panels

Shoowa People, Kuba group. Western
Kasai province, Congo. 1945–1970
Cut-pile and linear embroidery on
plain weave raffia palm
Right: 22 x 24" (54.61 x 60.96 cm.)
Left: 20 x 24" (49.53 x 60.32 cm.)

These two cloths probably date from the revival
of markets after the end of the Second World
War. Several points justify the late dating. The
plush tufts are very short but not of the exquisite
thickness of earlier technique. The weave lacks
the precise regularity of classic Shoowa work,
and the foundation cloths are not dyed red.
Both illustrate, nevertheless, the intriguing sub-
tleties of Shoowa design. Learning how Shoowa
embroiderers look at their work can clarify our
perception of their compositions. Laying the
foundation cloth in her lap, a Shoowa woman
embroiderer usually begins stitching on one
side with lines forming small triangles along the
edge nearest her.[6] By forming lozenge shapes
upon the slanting lines of the triangles, she
often creates diagonally oriented compositions.

The embroiderer of these types of cloth
began normally with a set of triangular lines
along one edge and filled the intervening slanted
spaces with a row of three lozenge shapes with
a small white cross in each center. By continuing
the vertical line between two lozenge shapes
to outline another lozenge, she created an opti-
cal effect of depth in space.

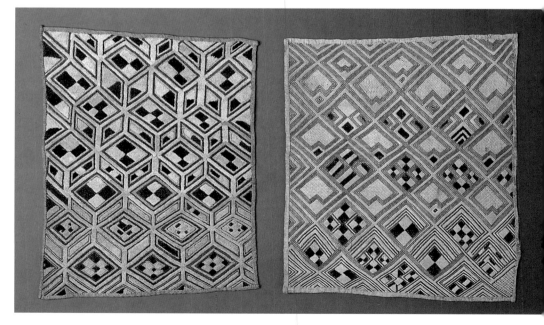

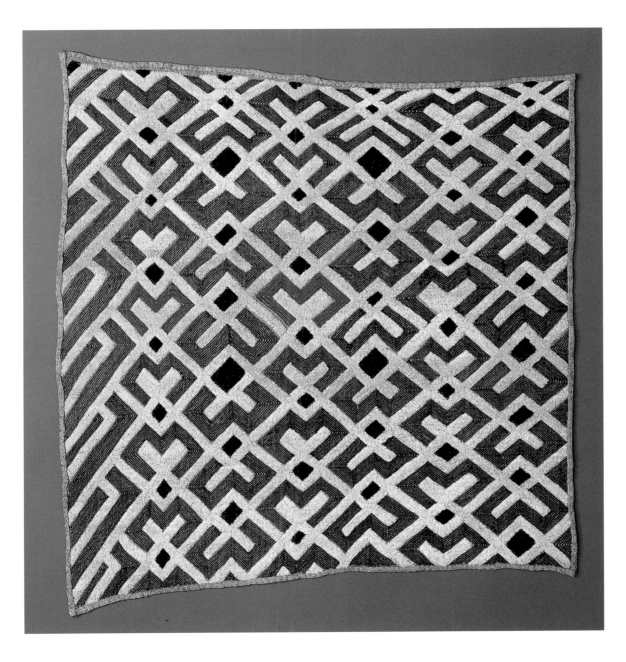

PLATE 203 (detail shown at beginning
of chapter)
Ceremonial Panel
Shoowa People. Western Kasai
province, Congo. 1955–1980
Cut-pile and linear embroidery on
plain weave raffia palm
23 x 25" (57.2 x 64.2 cm.)

The rhythmic movement up, down, and across
the surface of this cloth creates a strikingly
beautiful pattern. In one column the row of
repeated designs in light plush rises vertically,
only to descend reversed in the next. Bright
red accents mark two M-shapes in the center
field. The imaginative red touches, which come
from industrial color, provide a vivid contrast-
ing accent. The light tone of the plush may
result from leeching by an old method using
clay solutions or by new products.

During this period, ethnic style boundar-
ies become blurred and there is a tantalizing
sense of doubt about the identity of even this

exceptional cloth. The clarity and the restraint
of simple contrasts of color and texture suggest
Bushoong style. When Shoowa cloth became
popular in the seventies, their style influenced
the other Kuba women's work. A few photo-
graphs in the early eighties show Bushoong
women in the process of copying Shoowa cloth
designs.[7] This cloth may represent a Bushoong
effort to meet the rising demand for Shoowa
cloth panels by combining stitching and plush.
The principal motif of crossing lines appears in
plaiting on the walls of royal houses as *mikok-
woon mikwey* "leopard on a branch."[8]

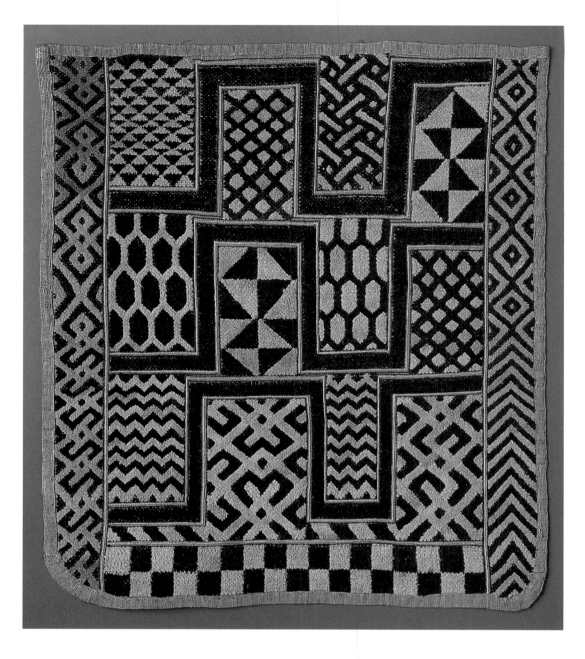

PLATE 204

Ceremonial Panel
Kuba group. Western Kasai province,
Congo. 1950–1975
Cut-pile and linear embroidery on
plain weave raffia palm
23 x 25½" (58.4 x 64.8 cm.)

The intense blackness of the plush designs and
strong dividing lines of this panel create a pow-
erfully bold impression. Even more striking is
that the thick black angular lines, which inter-
rupt the balanced distribution of light and dark
across the surface, are themselves unbalanced
from left to right. The way the black color bleeds
ever so slightly shows that it is not an industrial
dye. It is difficult to assign this cloth to a spe-
cific Kuba group because of the combination of
distinct regional features: the overall thick plush
typical of the Bushoong in a composition favored
among the small, northern Kuba groups along
the Sankuru River.

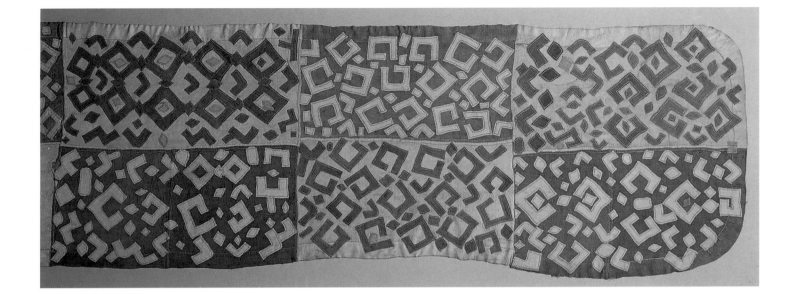

PLATE 205 (detail)
Woman's Ceremonial Skirt
Eastern Kuba (Ngeende or Ngongo People)
Western Kasai province, Zaire. 1930–1955
Appliquéd on plain weave raffia palm
28 x 160" (71.1 x 406.4 cm.)

In this outermost portion of a woman's wrap-around skirt decorated by appliqué technique, the light and dark angular figures are applied with verve in the form of tumbling open squares and small dots careening over beige and brown backgrounds. Like most women's ceremonial skirts, this one is constructed of sixteen rectangular pieces. When this long cloth is wrapped around a woman's body, the section illustrated forms the outer layer that will be seen by the public.

Appliqué skirts appear as ceremonial wear for women, less frequently for men, among most Kuba groups. The use of beige and dyed brown cloth with angular motifs in appliqué technique arranged in a scattered composition, with some seams in purple thread, indicates an origin among the eastern Ngeende or Ngongo.

Because natural raffia fiber is scratchy, men scrape the leaves for use in weaving and sewing. If the weaving is destined for wearing, it is soaked in water and pounded in a trough by women. Holes induced by this pounding are covered by stitching small cloth patches. To make the raffia fiber strands pliable for stitching, women rub and roll them between their hands. Skirts collected at the turn of the twentieth century show few appliqués. If, in fact, the elaborate and dense use of appliqués seen in later skirts is a development of the twentieth century, that surely represents a remarkable burst of Kuba creativity.

PLATE 206

Woman's Ceremonial Overskirt
Bushoong People, Kuba group
Western Kasai province, Congo. 1900–1925
Weft pattern technique, appliquéd, and
eyelet embroidery on plain weave raffia palm
29 x 68" (73.7 x 172.7 cm.)

The most striking and unusual decorative effect
created by the Kuba – and unique to them – is
the undulating edge on women's ceremonial
overskirts. This feature places the skirt in the
category of *ntshak a kot* (said to refer to Kot, a
king's name). The edge is made of a bunch of
raffia fibers bound tightly with cording, attached
to a band which, in turn, is sewn to the edge
of the wide border band. This is a particularly
fine old example of a Bushoong skirt for danc-
ing in court.

The patterning is a typical Bushoong kind
of appliqué grid of repeatedly crossing horizon-
tal and vertical lines. They convey a pleasing
impression of a stable network. More than the
other ethnic groups, the Bushoong favor regu-
larity and symmetry in their decorative work,
but they still take many opportunities, especially
in the women's long skirts, to interrupt the
rhythm and to add intrusive accents.

Combining techniques on one skirt is a
favored procedure. The dyed black border cloth
shows tiny raised designs in patterned weaving;
at intervals a group of circular eyelet holes sewn
in beige relieve the dark tone of the border.
Patterned weaving, here a warp float technique,
is not often encountered in collections although
it was reported among the Ngongo since the
early twentieth century.[9] To form the eyelets,
the cloth is not cut; instead the strands of the
weave are pulled aside and bound by a form of
buttonhole stitch.

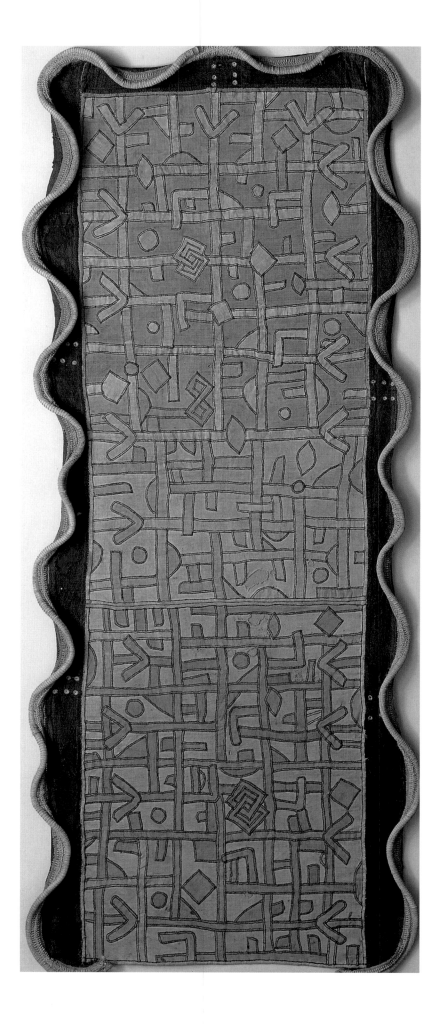

PLATE 207

Woman's Ceremonial Overskirt

Bushoong People, Kuba group

Western Kasai province, Congo. 1885–1910

Cut-pile and openwork embroidery on
plain weave raffia palm

20 x 56" (50.8 x 142.2 cm.)

One of the most elegant types of overskirts for
women is dyed a deep black relieved by embroi-
dery in beige. The black triangles have a plush
surface created by the cut-pile technique. The
light-colored triangles on the black ground
fabric are formed by tight stem stitching that
resembles braiding. Broad lines of plush, *buiin,*
in the form of black bars and X's ornament the
borders. Pale eyelet dots are sprinkled amid
the plush and they fill the space at one end of
the central panel. These borders illustrate that
although Bushoong designers favor complex
stitching, they also include plain areas of woven
cloth to introduce variety in texture.

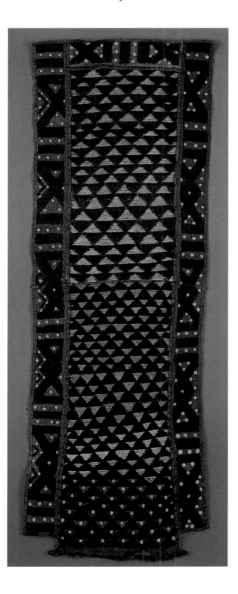

PLATE 208 (detail)

Woman's Ceremonial Skirt

Kuba group. Western Kasai province,
Congo. c. 1860–1885

Resist-dyed and eyelet embroidery
on plain weave raffia palm

21½ x 132" (54.61 x 335.28 cm.)

One encounters another kind of beauty in this
very old textile, a lyrically free arrangement dif-
ferent from the tightly structured patterning
familiar in twentieth-century Kuba cloths. Beige
eyelet circles are strewn in clusters, as on a
starry night, across the dark cloth. Narrow rect-
angles of open space partly filled with thick
embroidered stitching in undulating lines ripple
here and there amid the circlets. On plain areas,
thin strands of raffia thread trace designs in lin-
ear embroidery and in this delicate manner
present miniature grids and angular crossing
bars. This cloth harbors yet another kind of mark-
ing. Narrow bands of red color rise and fall
across the length of the cloth, some forming
faint lozenges around embroidered designs.
The red lines are a result of reserving those parts
(probably by stitch resist) before the original red
cloth was dipped in brown dye. Obviously, there-
fore, the use of brown was a deliberate choice.

PLATE 209 (detail)
Ceremonial Skirt
Kuba group. Western Kasai province,
Congo. 1885–1910
Resist-dyed, patchwork, linear, and eyelet
embroidery on plain weave raffia palm
22 x 132" (55.9 x 335.3 cm.)

The somber splendor of this old, worn skirt-
cloth is rarely encountered in Kuba textile
collections, therefore it is difficult to establish
the origin of this work. No cloth like it has been
identified in Bushoong royal costumes within
the past generation. Checkered patterns are
favored in all regions, but few old skirts have
shown these narrow rectangles of patchwork
covering the central panel. Usually the check-
ered pattern for skirts employs large squares in
red and white sewn together to form the cen-
tral panels or small dark and light patches in
rows assembled as borders.

 The regularity of the patchwork composi-
tion is blurred by the pursuit of variation in
decorative effects. Some rectangular patches
are marked by three rows of narrow slits. In the
Bushoong court, men's skirts dominated by
openwork were restricted to the sons and suc-
cessors of the king (his sisters' children), but
here the openwork in zigzag and circular stitch-
ing is only one of a number of techniques,
including linear embroidery, patchwork, and
stitch-resist dyeing. It is surely an elite cloth.
Because of its narrowness, variety of embroi-
dery techniques, and designs in delicate linear
embroidery, it is likely to have been a skirt for
a woman, but identification remains elusive.
With this beautifully conceived ancient cloth,
we come to a limit in our current historical and
regional knowledge of Kuba textiles.

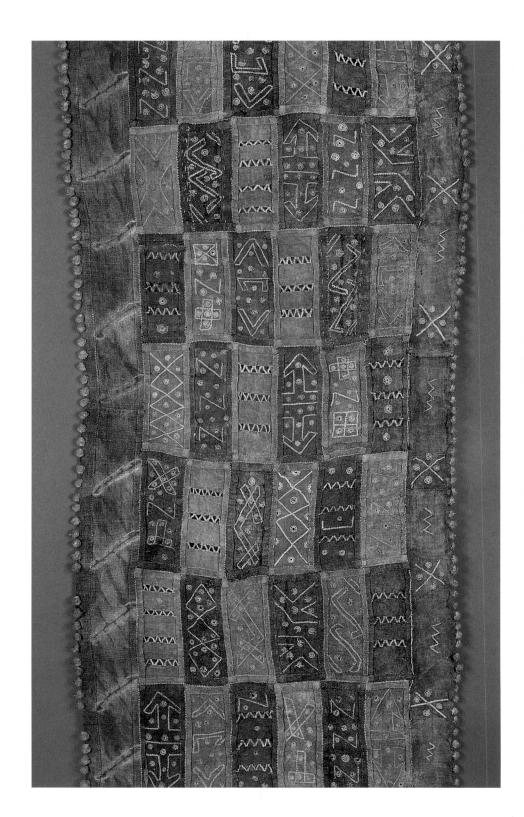

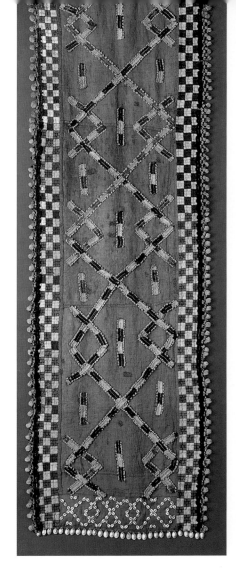

PLATE 210 (detail)

Man's Ceremonial Skirt

Ngeende People, Kuba group. Western
Kasai province, Congo. 1965–1980
Appliquéd on plain weave raffia palm with
cotton patchwork border
34 x 178" (86.4 x 452.1 cm.)

Throughout the Kuba region men ordinarily
wear knee-length skirts, called *mapel*, gathered
at the hips with the upper edge drawn under
and then over a belt. For ceremonial occasions,
their skirts are composed of numerous panels
of cloth so that when gathered they form a
bulky mass. The upper border jutting out over
the belt appears as a thick flounce, further
aggrandizing the body image. The men's volu-
minous gathered skirts, topped by multiple
rows of pompoms or other eye-catching deco-
rative borders, flare out into space as the men
stride about or dance in public.

Ceremonial skirts for men may include
twelve to eighteen panels, ranging to over thirty
feet. This *mapel*, consisting of six panels (three
shown) of woven raffia rectangles, may repre-
sent only half of the original number. Ideally
the panels on men's cloths are square. The red-
trimmed border is marked by small rectangles
made of dark blue and white cotton cloth. Just
as if it were raffia cloth, each small cotton rect-
angular patch is hemmed all around and joined
to other pieces. This strong patterning on the
borders creates a dramatic effect of contrast to
the soft tones of the central panels.

Skirts are named after the more worked
portion either in the middle field or the borders.[10]
Here, the patchwork border gives the skirt its
specific name, *mapel kotilaam*. Decorated tex-
tiles have an important role as costume in
burials. Just as the distinctive *mapel kotilaam* is
popular as a fine costume in life, men favor it
for dressing the male corpse, after first wrap-
ping the body with a plain red dyed cloth.[11]

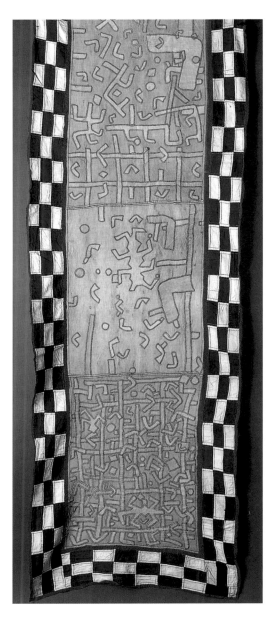

PLATE 211

Woman's or Man's Ceremonial Overskirt
Bushoong People, Kuba group
Western Kasai province, Congo. 1885–1905
(refurbished c. 1950s)
Appliquéd, patchwork, and embroidery
on plain weave raffia palm with cowrie shells
81.5 x 26½" (207 x 67.3 cm.)

On court occasions, both men and women may
don this kind of decorated skirt over their more
voluminous hip cloth. Several features mark
the overskirt as an elite garment. First, the pres-
ence of the cowrie shells sewn onto the wide,
terminal border (called *nkol*) was by rule reserved
to the royals and other members of the elite,
although more widely used in practice. The cen-
tral section (*mbom*), now a much faded red, is
crisscrossed with bands resembling other elite
overskirts, both men's and women's, as if form-
ing a kind of protective barrier for the wearer.
This central decorative feature gives its name
to the skirt (*kweemi ntshwey*).[12] The fringe area
(called *kwey*, leopard) is elaborate, and each
bobble is attached to a small piece of hemmed,
red raffia cloth. The decorative detail here is
remarkable, for the black band around the three
sides of the skirt is covered with a kind of plush
effect, created by laying a row of thin fibers of
raffia across the band and sewing them down
the middle.

Even without the testimony of Kuba indi-
viduals, one sees in this cloth a fondness for
assembling diverse elements. The lateral borders
(called *ntshwey*) show the checkerboard pattern
(*kotilaam*), made of small pieces of hemmed
patches, the beige ones in raffia cloth, the dark
blue, in cotton. The central crisscrossing bands
offer combinations of minute, mixed elements
to create a desired effect. Each band consists of
a decorative strip of raffia cloth upon which
one sees the painstaking plush effect noted on
the lateral borders, further embellished with
tiny pompoms giving a barbed effect to the
edges. These bands, called *kweemi ntshwey*, are
made in great lengths with infinite patience and
cut in pieces to form desired designs. On their
surface, some short sections are stained bright
blue next to others in faded greenish blue.
By the mid-twentieth century, blue dye was
obtained from decoctions of mimeograph ink
or other industrial products. The Kuba them-
selves reuse parts of older garments in compos-
ing new ones; the addition of bright blue may
be an effort to refurbish an old overskirt.

PLATE 212 (detail)
Man's Ceremonial Skirt
Ngongo People, Kuba group. Western Kasai
province, Congo. 1925–1950
Stitch- and tie-dyed; plain weave raffia palm
31 x 267" (78.7 x 678.2 cm.)

Adventurous color and design are far more likely
to be seen in the textiles of the eastern Kuba,
particularly among the Ngongo people, outside
the border of the kingdom. Their capital at
Misumba imitated the Bushoong royal court, but
their ceremonial activities were much less con-
strained by formal rank. In both official dress
and dance skirts, colors and techniques abound.

This cloth, made up of nine panels proba-
bly half the original length, was first dyed red
and then stitched and tied before dipping in
black dye, a technique the Ngongo call *elamba*.
Tailors added strips of more tightly woven plain
cloth to the borders on both long sides; the

added fringe of small pompoms indicates the
use of the skirt on ceremonial occasions. A spe-
cific feature helps identify this cloth as a man's
skirt, *mapel*. Frequently, as here, one border is
sewn so that the front surface is reversed. In
this way, the front side would be seen correctly
after the upper edge of the hip cloth was
folded over the man's belt.

Ngongo resist-dyed skirts are usually limited
to two colors selected from red, white, yellow,
and black, but in designs they display a degree
of panache that is strikingly different from all
other Kuba design. We are far from the minute
precision of the embroiderers' patient fingers
advancing into geometric forms. In this cloth
one feels contradictory currents. The restraint
of somber colors and gently curving outlines
are belied by the boldness of scale, registered
in the width of the horizontal and vertical stripes
and bands of color and the large single and
double rings.

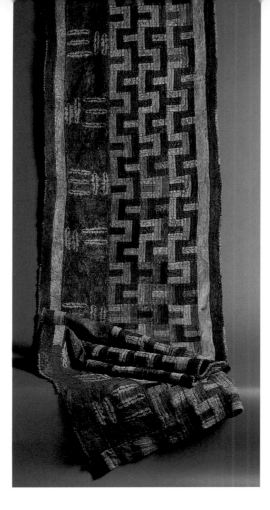

PLATE 213 (detail)
Man's Ceremonial Skirt
Ngongo People, Kuba sub-group. Western
Kasai province, Congo. 1885–1910
Patchwork and stitch-resist; plain
weave raffia palm
41 x 201" (104.1 x 510.3 cm.)

A truly remarkable textile in conception, techniques, and execution! The firm angular lines of dark and light meanders that fill three-quarters of the width are powerfully declarative; these thick horizontal and vertical bands continue the entire length of the cloth. Above the continuous meander, resist-dyed motifs offer another set of horizontal and vertical lines, but in contrast, their wavering forms appear as widely spaced, discontinuous elements.

The painstaking part of the execution is notable in that the angular lines of the meanders, whether beige, red, black, or brown, are made up of short pieces, each hemmed and attached edge-to-edge. Red pieces appear irregularly to relieve the black or brown patches. One also sees the careful attention the Kuba always give to edges, first in the straight alignment of the bottom row of angular motifs and secondly in the added red and black or brown borders with tiny pompoms.

PLATE 214 (detail)
Man's Ceremonial Overskirt
Kuba group. Western Kasai province,
Congo. 1880–1905
Patchwork and stitch-resist;
plain weave raffia palm
29½ x 171" (74.9 x 434.3 cm.)

This bold and complex composition produces a magnificent effect. Like a leopard's spots, the black and white squares in the center startle the eye with their sharp contrast, but their regularity declares order created by human hands. Along one side, larger square patches introduce red-colored sections and soft blurry outlines of dyed designs in straight and curving patterns. On the central part of men's skirts one often sees a thinner band of decoration, evidently meant to fit under the belt.

On the surface, one notes the thick hems around the small and large squares. Displaying these thick hems on the front surface indicates the appreciation of the investment of labor in patchwork cloth and accords with the preference for bulk and textured surfaces noted in other features of Kuba costume. The checkered

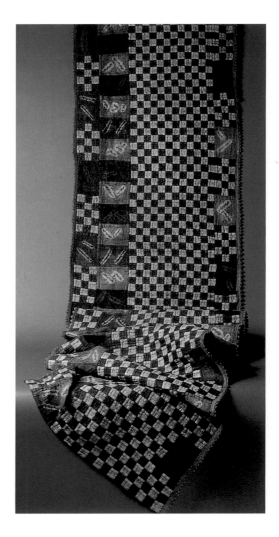

patchwork alternating with other decorated squares resembles the Bushoong pattern *ndwoong a kwey,* which refers to the leopard, an animal closely linked to notions of power and values of leadership. [13]

This particular composition of the central checkerboard patchwork squares bordered by stitch-resist patterns is not found among royal Bushoong garments worn during the past generation. It may represent an earlier style or a provincial origin. Currently, the Bushoong court officials name the dye technique *kumi-ndwoong* after the Ngongo people to the east, who are noted for their cloths decorated by special dyeing effects. [14]

PLATE 215 (detail)
Man's Ceremonial Skirt
Ngongo People. Kuba group. Western
Kasai province, Congo. 1925–1950
Patchwork; plain weave raffia palm
35½ x 207" (90.2 x 527.1 cm.)

A spectacular array of motifs on an imposing scale illustrates the range of styles Kuba designers dare to display. Although some of the appliquéd designs have familiar angular shapes, they are aggrandized and seem to flow over the surface of the square panels, constrained only by the boundaries of the cloth. Other motifs are coiled or labyrinthine. In each of the eight sections the designs are appliquéd in one color: red, black, pale green, brown, or brownish red. This creates a dazzling variety of effects. In spite of these seeming departures from the familiar Shoowa or Bushoong preferences, one notes how well this arrangement of designs respects the constant shift of light and dark that seems fundamental to Kuba aesthetic. Elaborately decorated long skirts were hung around the inside walls of the large walk-in, plaited coffin constructed and displayed at the funeral ceremonies for important members of the elite. This cloth may have been destined for such a display purpose, because the seams of the borders are both facing the same way, rather than one being reversed as would have been more usual for a man's dance skirt.

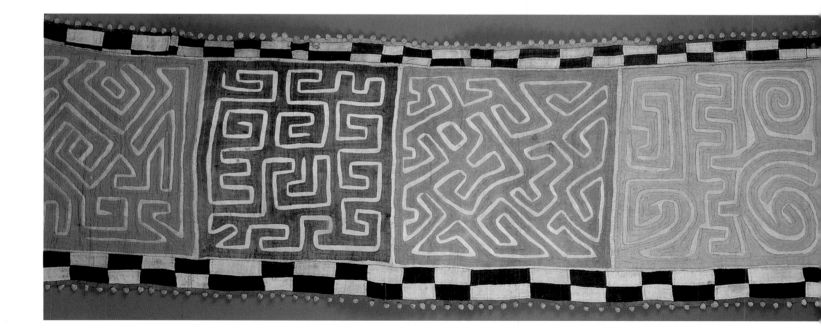

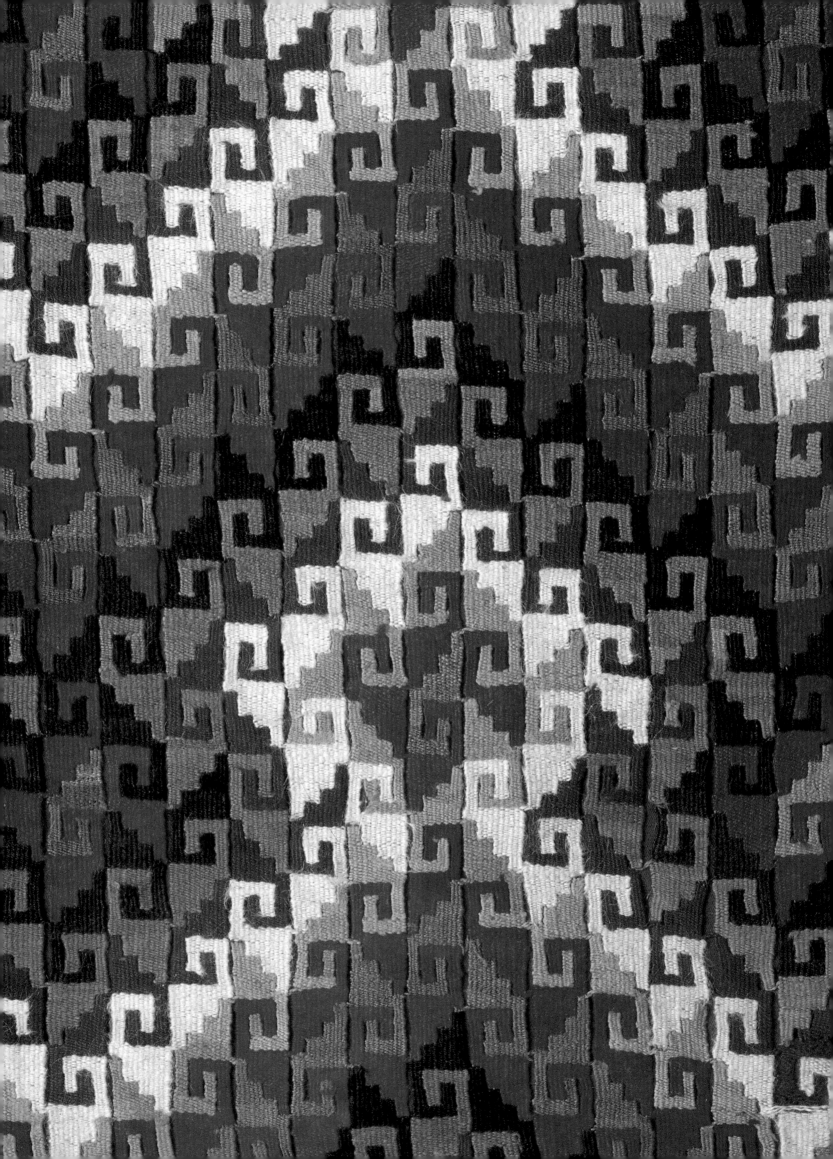

CHAPTER 11 # Andes

BY WILLIAM J CONKLIN

Understanding and appreciating Andean textiles is one of the best possible ways to develop a resonance between our own practical world with its rapidly turning century and the careful, artful pace of our predecessor Americans. Their four thousand years of Andean history neatly precedes America's soon-to-be four hundred. Understanding their world, and to some degree making it our own, extends our history and provides depth and width to our common concept of multiculturalism. It was an era that can quite accurately be called "The Great Age of Textiles." We should feel privileged to be able to view and to study the portions of that remarkable heritage that have survived.

A textile in that Age had an importance that is difficult for us now to understand. Not only were textiles the major form of art and the conveyors of religious ideas, but they were themselves generally considered to be sacred objects. The chroniclers of the Incas (and present-day ethno-historians) agree entirely on the essential nature of textiles in the Andes. "In one way or another, what is clear is that weaving had a profound ritual meaning and all liturgical ceremonies utilized textiles in large quantities."[1] But this kind of interpretation is possible only from the final phase of the Textile Age — the time of the Inca. Though many Andean textiles from the millennia before have survived, we can only attempt to decipher their significance. The evidence for the evolution of this form of art from such a unique world was hidden from the West for many millennia, but is now gradually being revealed. We can review the parade of "cultures," which archaeologists have identified as the major components of Andean history.

Among the earliest textiles of the Pre-Columbian world now recorded are those used as mummy wrappings in the Chinchorro burials along the north Chilean coast.[2] The wrappings were a form of twined mat made of vegetable fibers, but traces of grass skirts, and some red and black painting of the vegetable fibers, as well as strings for fishing lines, have also been found. Not auspicious perhaps, until we consider their dates–5000 B.C., some 7,000 years ago, and long before the Egyptians mummified their dead. The dates for early textiles in the Americas seem to be continuously receding with each new discovery. It now seems possible that the American settlers who came across from Asia may have brought some traces of weaving technology with them.

The early textiles found along the coast of Peru were pure structures with designs created only by manipulating useful elements of the weaving. The first textiles that have their "art" added on, are those associated with the Chavin religion of ancient Peru.[3] They are made of cotton and date to about 700 B.C. Textiles portraying the fanged, animalistic images of their cult deities were created in many forms. Painted images on cotton abound, and terrifying images were formed by wrapping warp threads with pink and yellow colored fibers. The Chavin weavers also invented tapestry weave in order to convey their images and ideas more effectively. The Chavin religion was the important founding religion for the Andes, and their representative textiles have been found in several coastal sites.

One area of Peru in which Chavin textiles apparently left a deep impression was along the South Coast. Settlements near the Paracas Peninsula, and later in the adjacent Nasca Valley, developed some of the most complex textiles ever created, clearly under Chavin inspiration. Paracas textiles have representational embroidered images of mythical beings that make modern horror movies seem tame by comparison. These images portray the transformation of humans into animal deities and vice-versa, but they do it with exquisite taste and marvelous coloration. Though far from the mountains, the natural habitat of the native camelid family, these South Coast weavers nevertheless had access to excellent alpaca for their weaving. Feathers from colorful jungle birds were strung together by Nasca weavers and attached to cloth to create feathered textiles. Nasca textile imagery became gradually more secular as plants and animals of the real world became part of the weaver's vocabulary. The most amazing of the South Coast textiles were the Nasca three-dimensional figurative constructions using a technique that resembles modern knitting.[4] The Nasca weavers proved to be highly inventive and used a wide variety of weaving structures. In Andean weaving, the structure of the weaving, as well as the image, often carried meaning.[5]

Another area whose weaving was inspired by the Chavin inventions was the Peruvian North Coast. The early Moche culture developed many forms of weaving with iconography that spoke of its Chavin origins. Early Moche weaving was mostly cotton with tiny amounts of alpaca, but over time they were able to obtain more highland alpaca.[6] By the end of Moche times, some textiles were tapestry with slits between vertical color divisions and with all alpaca weft. Moche warps, however, were always of cotton. Their imagery was of their own deities, who performed amazing feats such as riding giant snails. They used autumnal colors like the colors on their pottery. Very few Moche textiles have survived however, apparently because of torrential rains from an *El Niño* that soaked into graves and may have been a factor in the demise of the whole culture.

The Chimu Empire was a successor to the Moche and occupied some of the same territory. Its capital was at Chan-Chan, the great adobe ruin in the Moche Valley. The Chimu seemed to have worshiped some of the same mountains and pyramids, but their art, though obviously derived from the Moche, is not as mythological. Chimu textiles have images of figures in royal costumes and an array of coastal images that include birds and fish, as well as stylized and animated waves of the Pacific Ocean. Chimu textiles use cotton as a basic

material, some have painted images, some are of slit tapestry using colored alpaca like their Moche predecessors, but many of the garments have surface images formed of loosely attached colored threads.[7] Chimu textiles sometimes have gold or silver discs attached in patterns, which must have glittered in the bright coastal sunlight. The textiles of the Chimu Empire were very influential though, extending far down into the Peruvian Central Coast to areas slightly south of present-day Lima. Chancay was such a Central Coast settlement – one which has many surviving textiles. Though under strong Chimu influence, Chancay nevertheless developed its own style, primarily using slit tapestry in black and muted colors.

The highland cultures of ancient Peru seem almost to be in another world – especially the cultures of the mountaintops of the Andean cordillera. Highland textile evolution was largely independent of Peruvian coastal textile evolution. Textile influences over the eons usually traveled north/south along the mountains, just as coastal textile ideas traveled north/south along the coast. Highlanders occasionally conquered the coastal areas below or influenced them, but interestingly enough, the reverse seems never to have been true. The coastal people were never able to climb up and conquer the Kings of the Mountain.

These desert coastal areas obtained their water from the snow-topped mountains with their seaward-flowing streams. The Pacific provided rich maritime food resources and quite properly, both the mountains and the sea were worshiped. The two symbolic sources of water for highland people, however, were the cloud-capped mountains and Lake Titicaca. Lake Titicaca, cradled by mountains at an elevation of about 12,000 feet, seems like an ocean in the sky and utterly otherworldly. Its islands were revered as an Andean "Garden of Eden" by the surrounding highland cultures.[8] The earliest recorded highland weaving comes from north of the lake – from the Pucara Culture of the first millennium B.C. It seems likely that the Pucara Culture also received inspiration in the matter of weaving from Chavin, but this has yet to be demonstrated. This earliest known highland interlocked tapestry is highly complex and obviously the result of a long evolution not yet deciphered.

But the art, religion, and weaving technology of the Lake Titicaca area was also clearly the inspiration for the ultimately truly impressive culture of Tiwanaku. The capital site of Tiwanaku is not far from Lake Titicaca,

and it was there that the greatest monuments to Andean textiles were created. Stone pyramids and the ritual doorways of the architecture were supplemented by a series of carved stone stele of shaman who wore elaborate costumes.[9] Amazingly, the artist/sculptors did not choose to carve the folds of the clothing as in Greek and Roman figures, but instead flattened the images so that the exact designs of the textiles could be accurately portrayed. More eloquent by far than the textile traditions recorded by Spanish conquistadors, these sculptures tell the remarkable story of the value and importance of textiles in the Andes. Tiwanaku weavers also developed knotted four-corner hats, pile, and complex forms of textile dyeing.[10] Green-blue backgrounds seem to be a characteristic color for their fine interlocked tapestry with its multicolored religious imagery, repeats, and reversals.

Tiwanaku textiles met with a deep cultural resonance in the central Peruvian highland city of Wari. Wari was not geographically or religiously a part of the Titicaca-centered world, but its textile art is in part, astonishingly like that of Tiwanaku. As a culture though, Wari differed in some fundamental ways from Tiwanaku: it was apparently more militaristic, and it avoided the use of the complex psychoactive drugs that were characteristic of the Titicaca region. But most important for these considerations, Wari was far more adventuresome in art than the mother culture. Wari tunics with their amazing geometry, luminous color, many forms of symmetry, and their familiar-but-always-new iconography are to the history of weaving, what Bach's fugues are to the history of music.[11] Wari textile types included pile hats and tie-dyed cloth, but it was the tunics that influenced the weaving in much of Peru north of Lake Titicaca – especially the South and Central Coastal areas of Peru. In some places, Wari weaving even merged with Moche forms, resulting in a combination style at coastal settlements such as Huarmey.

The fall of the Wari is not understood, for it was not followed immediately by any powerful highland culture in Peru. Amazingly, the Tiwanaku in Bolivia lasted much longer and although the capital was abandoned about A.D. 900, the long shadows of those Tiwanaku stone giants extended over many centuries that followed.

But the most important proof of the esteem of Tiwanaku in the ancient Andes is to be found in the claims of the Inca culture. The Inca arose in the beginning of the sixteenth century in the highland Cusco Valley. The Inca's assertions that they were the "chosen people" of the Andes and the "sons of the sun" rested

largely upon their claim to having a spiritual origin in Lake Titicaca. They also declared that they were the true heirs of Tiwanaku, and their textiles provide a certain proof. Their elite textiles utilized interlocked tapestry – the age-old, elite highland technique – and their male garment form, the tunic, mimicked that established by Tiwanaku.[12] The Inca, though geographically much closer to the Wari than to the Tiwanaku, never mentioned the Wari.

The Inca were a brilliant and powerful clan – perhaps something of a cross between the Hapsburgs and the Mafia – and quickly captured all of the territories once occupied by the cultures mentioned thus far. They were eclectic in some ways, absorbing local cultures and shrines, but they were not eclectic in their official garments. Both men's and women's garments were precisely defined, and many Andean textile traditions were abandoned. There are no painted Inca textiles, no Inca embroidery, and no Inca pile. They did make use of captured Chimu weavers to make garments – but those garments remained Chimu in style, although now found in Inca graves.

Of great significance though, was the Inca attitude toward representational art in textiles. Ever since the ancient days of Chavin, complex mythical deities had been represented in textile form. For all of their glorious abstraction, the actual subject matter of Wari and Tiwanaku textiles consists of representations of staff-bearing deities. The Inca rejected all such representational imagery and chose instead highly geometric forms called *tocapu,* only a few of which we can understand. They also created a form of textile, with plied and knotted strings, called *khipus,* to record and communicate data. *Khipus* remain one of the few languages of the world still not deciphered.

Most of the Andean cultures mentioned, prior to the Inca, had life spans of some five hundred or more years, but the Inca, amazingly, conquered their known world, invented a very complex culture and art style, and were then conquered themselves – all in little more than a century. So there are no "early" or "late" Inca textiles.

The Inca presence in the Andes during their brief reign was so powerful that many pre-Inca textile traditions were obliterated or submerged. The Cusco-style Colonial weaving, which existed for a few centuries after the conquest, was derived exclusively from Inca tapestry traditions. There are no Colonial painted textiles, no Colonial embroidery, no Colonial pile.

Today, the weaving of the Quechua- and Aymara-speaking peoples of the highland Andes is definitely a continuation of the cultural aspects of Pre-Columbian

weaving traditions, but it is not a continuation of the technical inventions of the ancients.[13] Weaving in the Andes today is not created for rich rulers and royal ceremonies, but for daily use. The rich colors and complex symbolic patterns in contemporary Andean weaving are accomplished with warp-faced weaving that requires stronger and bigger threads than the weft-faced weaving used in the color patterning of interlocked tapestry, and the once rich coastal weaving traditions of ancient Peru have disappeared.

We can appreciate Pre-Columbian Andean weaving as pure art, and as art it holds its own secure place among the world's treasures. However, Pre-Columbian Andean weaving is also more than art. Because weaving was so enormously important as a conveyor of meaning for these early American cultures, it is also of great value today in the analysis and recording of the history of these great, lost civilizations.[14] An increased understanding of the original context and a perceptive analysis of potential meanings through textile scholarship can only enhance our appreciation of the unique art created by these early Americans.

PLATE 216
Carved stone stele (24'4" high) found at the site of Tiwanaku in Bolivia showing representations of a layered cosmos. (Photo: William J Conklin)

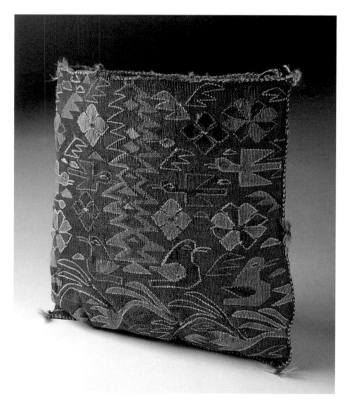 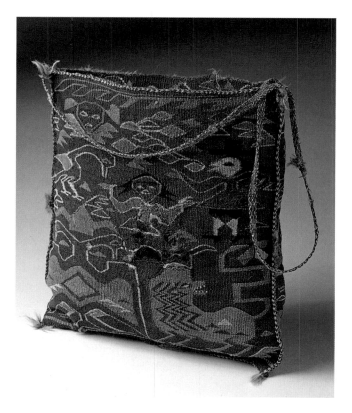

PLATE 217 and PLATE 218

Bag (*Chuspa*)

Early Colonial Peru. Seventeenth century

Interlocked tapestry technique; alpaca
weft, cotton warp

17½ x 19½" (44.5 x 49.5 cm.)

Out of the ashes of the Spanish holocaust of 1532 in Peru, there arose vigorous new art forms in both painting and in textiles. The Cusco school of painting of the sixteenth to eighteenth centuries is perhaps better known than the Cusco textiles created during the same time period, but the textiles demonstrate the same cultural mixture and speak even more eloquently of Andean art traditions. This *chuspa*, or bag, probably part of a male costume, is one of the greatest of small Cusco textiles, with its joyful mixture of European and Andean images. It is constructed of interlocked tapestry, a technique traditionally reserved for the elite textiles of the Andean mountainous altiplano empires. The white outlining of the figures with eccentric weft adds sparkle to the muted colors of the natural dyes.

The vertical zigzag design is a motif used for millennia in the Andes – a cross-section through weaving with the zigzag lines representing over-and-under weft and the interspersed spots, cross sections through warp.[1] This motif is used vertically on male bags such as this one. The birds with their long beaks fly toward this weaving motif and were no doubt thought of as weaverbirds. They perform their flying and weaving amongst an array of joyous four- and eight-petal flowers that may well represent cotton flowers.

The reverse side of the bag shows male and female figures in European dress with an image of the double-headed Hapsburg eagle below. Next to the eagle, and seemingly juxtaposed with it, is an Andean mythical animal. Both the eagle and the mythical animal also occur on *chacanas*, the Aymara feathered shoulder bands created during later colonial times.[2] The eagle and the mythical animal help to establish the continuity of the tradition created during the merger of Andean and European cultures.

One of the mysteries of the artifact though, is its intended use. Its form is clearly that of the Pre-Columbian coca bag used by Andeanists for carrying coca leaves – a form virtually unchanged over the millennia of Andean cultures. However, we tend to think of such elegant Cusco-style weavings as having been created for the Spanish overlords by the Andean weavers who worked for them. This explanation would then suggest that the Spaniards used coca, which they apparently never did. So, though its intended use remains something of a mystery, its excellent workmanship and its imaginative merger of the two cultures makes the *chuspa* a masterpiece of its time.

The design of this textile, probably half of a mantle or tunic, with no hint of imagery or iconography is an eloquent essay in the beauty of geometry. It illustrates in an extraordinary way, that when art becomes abstract, it also becomes universal – for although the textile is indeed from the ancient Andes, its pattern could be mistaken for one from the early twentieth century. A simple color bar is moved over and down three times, and then the movement is reversed to complete the design motif that is repeated in four colors.

Its technique, however, is strictly ancient and represents one of the highest achievements of Andean weaving. Each individual color section of the design consists of an entire, but tiny, textile – each complete with its own warp and weft. Probably the red and yellow sections were woven first, but were then held in place by an elaborate system of scaffold threads. The moss green and blue sections were then woven in place, interlocking with their neighbors, in a technique somewhat like darning.

This textile was probably found on the South Coast of Peru, but similar textiles have been found in the Chilean Atacama Desert, which was within the Tiwanaku sphere of influence. The geometry of this textile seems to resonate with the geometric carvings found at the site of Tiwanaku itself. The mantle is a very lightweight, in fact sheer, fabric, not one that could possibly be considered to have a utilitarian function for warmth or weather protection. It is like a flag worn for the world to see. In Andean weaving, art always seems to come before function. The effort involved in creating this textile would be difficult to estimate, but it is a convincing demonstration of the way in which art and design were the be-all and end-all of Andean weaving.

PLATE 219 and PLATE 220 (detail of Plate 219)
Mantle
South Coast of Peru/Tiwanaku
Sixth to Ninth centuries
Plain weave with interlocked warps
and wefts; alpaca
54 x 33" (137 x 83.8 cm.)

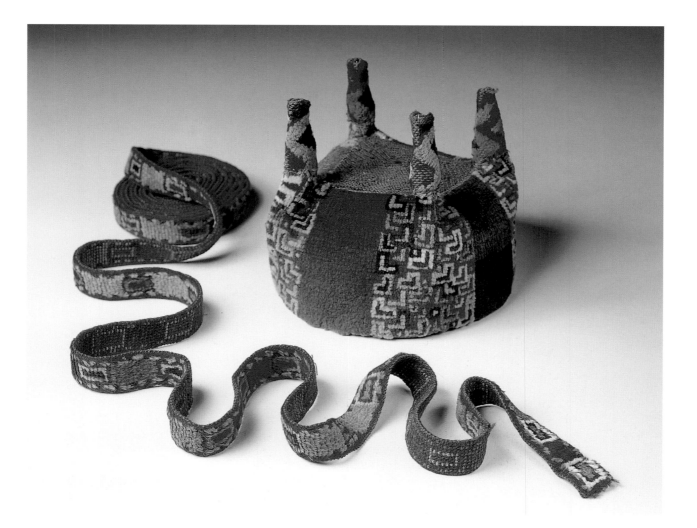

PLATE 221

Pile Band and Pile Hat
Wari culture
Peru. Sixth to Ninth centuries
Pile construction on a
knotted foundation; alpaca
Band ¾ x 121" (1.9 x 307.3 cm.),
Hat 5" high (12.7 cm.)

Headgear in Andean society was a conveyor of status, station, and cultural identity. The four-cornered hat, whose form was derived from the four-cornered hats of Tiwanaku, seems to have been the highest status headgear in the Wari culture. The pile band was probably a form of headgear also – perhaps wound around the head like a turban. Although the pile band has no design or iconography that would identify it specifically with the Wari culture, its technique, materials, and coloration are similar to Wari four-cornered hats. Such hats were presumably secured with a little chin cord, but only a few existing hats actually still have such cords and this one does not. The square form is designed to convey meaning, rather than to fit the head – so the hat is a sign more than it is a garment. The significance of the upright four corners has been the subject of much consideration – perhaps they stand for feathers, but another theory is that the sculpted headgear of the carved stone figures at Tiwanaku, were used as lamps during ceremonies and had skyward flames.[3]

The designs on the corners of this hat have wavy vertical signs that could indeed stand for flames. Perhaps this four-cornered hat was worn by a Wari shaman and recalled the flame-lit ceremonies at ancient Tiwanaku.

Pile creates a richly surfaced textile that has been considered a luxury finish by many cultures. Pile is the surface of Middle Eastern rugs where it forms a functional as well as an aesthetic base, but its use in the Andean world is purely aesthetic. Its construction in the Andes is also unique. Wari pile is created not by looped threads pulled through a base textile, but by looped threads that are formed simultaneously with a knotted base textile. After construction, the loops are then cut to form the individual little brushes that together create pile.

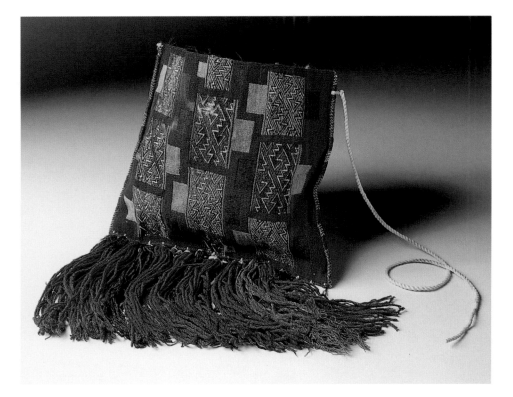

This very unusual coca bag was created during the reign of the Incas that lasted from the beginning of the fifteenth century to 1532. The Incas created an astonishing Roman-like empire by war and conquest but also by other means, and this bag speaks eloquently of their powers of persuasion and their diplomacy. Cieza de'Leon, one of the early Spaniards who wrote about what he observed, reports that the Inca himself visited settlements and "with his great skill won them over" by attiring himself in each village in the garb used by the natives.[4] Cieza wasn't a textile expert, and we don't know whether the Inca used borrowed clothes or made their own, but this textile provides us with a clue.

The basic red background of the bag, together with the yellow and blue rectangles, were created by interlocked tapestry – a characteristic Inca textile structure used for many forms of male garments. The ten highly animated insets though, with their colorful zigzag patterns, were created by an entirely different utterly non-Inca technique! These insets are created by weft substitution and use entirely different colored yarns from those used in the basic tapestry of the bag. Weft substitution, and the zigzag patterns as well, were characteristic of weaving done by the local people in the South Coast region of Peru.

The workmanship is excellent, like other Inca weaving, so it seems likely that the bag was woven in an Inca workshop specifically for its purpose. We can imagine the bag as a remarkable gift from the Inca to a local chieftain whom he wished to persuade, probably as a small part of a complete garment set made to serve the extraordinary political ambitions of the Inca. The bag quite graphically illustrates how a local cultural group could be nicely incorporated into the Inca Empire, and also speaks to us of the power of textiles in the Andes.

The attachments to the bag are of interest as well. *Khipu* is the name given to the knotted cords used by the Inca to record history and other data. The white cord attached to the left side of the bag is entirely unlike normal coca bag straps. It is made of cotton and constructed exactly like the cords used by the Inca in their *khipus*. The attached fringe, judging by the articulated face, was thought of as a row of suspended little string figures. Probably both of these unusual attachments, the white cord, and the little string figures, added important meaning, which we cannot decipher, to this highly diplomatic Inca pouch.

PLATE 223 and **PLATE 224** (detail of Plate 223)
Band
Tiwanaku. Probable highland construction,
coastal burial. Sixth to Ninth centuries
Interlocked tapestry technique; alpaca
weft and warp
92 x 2½" (233.7 x 6.4 cm.)

The design motif on this remarkable band is a
stylized multi-headed fish – a motif found on
Tiwanaku stone sculpture. The linear body of the
fish has fins as well as heads and is repeated in
rotational symmetry. The figure has four-color
variations and two design variations. Tiwanaku
artists spent centuries evolving the complex
abstracted forms of the fish used in the band and
in the associated stone sculpture at Tiwanaku.
No doubt the motif originally had some form of
symbolic meaning at which we can now only
guess. Perhaps the motif speaks of the inherent
dualism found in all of nature, but the weaver/
artist's interest clearly was as much in color as
in religion.

But understanding the iconography is not
a prerequisite for appreciating the effect of
the colors. The luminous quality of the band is
formed not so much by the brilliance of the
dyes but by their complementary juxtaposition.
Pink, for instance, is used as a boundary line
between the green body of the fish and its blue
background, making all of the colors jump out
with their luminance. The sharpness of the
color divisions was clearly of great interest to
the weaver. The interlocked tapestry technique
inherently produces sharp color divisions, but
along diagonals, small steps must actually form
the divisions between the colors. In this textile
though, the weaver used paired warps as a base
for the weft, which permitted the stepping at
the diagonals to be half-size and thus twice as
sharp. This special enhancement to the struc-
ture of interlocked tapestry has not heretofore
been detected in Andean textile construction.

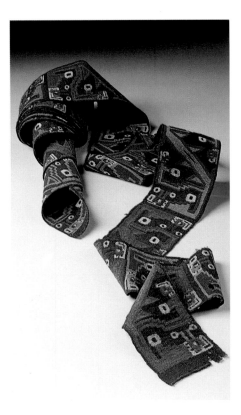

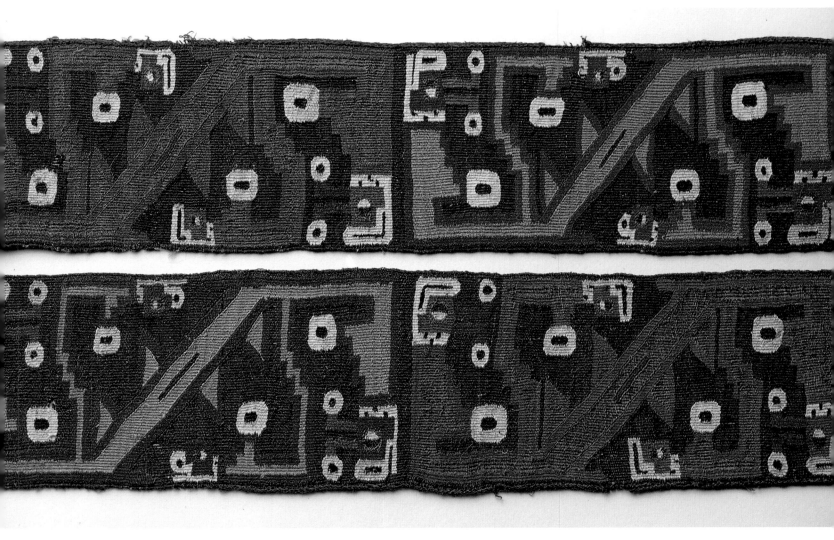

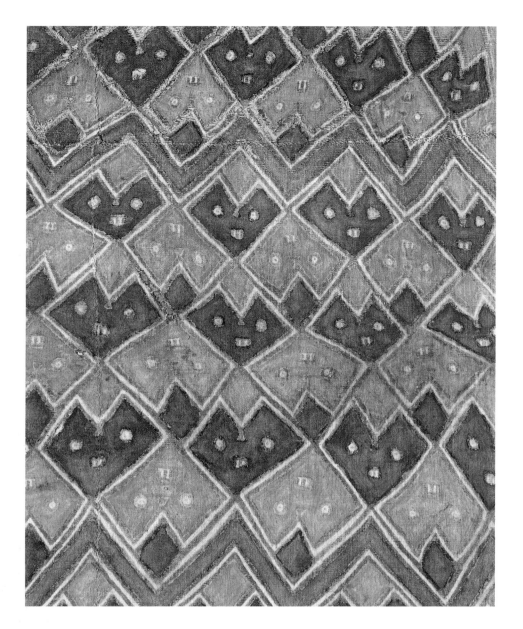

The art and technique of painting images of deities on textiles began early in Andean history, with the textiles of Chavin, about 700 B.C. Those early images were of complex and sometimes terrifying deities, but this textile from a later Peruvian coastal culture shows a happy and peaceful image of the highly animated, but nevertheless broad and gentle, waves of the Pacific Ocean.

The Andeans did not separate their world into two parts as we do; the animate world to which we belong and the inanimate world of earthly things. They believed that everything was living and everything was related and more or less equal in the eyes of their gods. So they worshiped mountains as heavenly beings, noting that mountaintops seemed to control clouds, lightning, thunder, and rain – and they understood very well that water is the essential ingredient for all forms of life.

In this textile painting, which adds to that understanding, we can see that they believed the ocean was animated as well, for the sparkling waves of this Pacific image are made up entirely of thousands of cheerful little beings. The beings come in two types, brown and tan alternately right side up and upside down. Together they interdigitate to form the imagery of the waves, which are stated more explicitly by the horizontal, blue zigzag lines. The fact that the little deities come in pairs, one dark, one light, one right side up, one upside down, is not accidental and probably represents the Andean understanding that all forms of life come in relating and interacting pairs.

PLATE 226

Half of a Tunic (?)

Wari culture

Peru. A.D. 600–900

Plain weave sections tie-dyed and
re-combined; alpaca

77 x 31" (195.6 x 78.7 cm.)

The bold circus-like color energy of the Peru-
vian Wari tie-dye tunics makes it difficult
for us to imagine their being created by the
same people who wove such color coordi-
nated textiles as the Wari interlocked tapestry
tunics. Tie-dye design has none of the reli-
gious iconography, which characterizes the
Wari culture, but it nevertheless was obvi-
ously a very important alternate textile form
for the culture. The technique seems unique
in the world of textiles and no doubt has its
own special history and meaning, upon which
we can only speculate.

Noting that each stepped triangular
color section was woven using only a single
thread for both warp and weft. and noting
that there are four colors and patterns used,
the amazing construction process for the
textile might have been something like the
following:

- First, four textile sections were created, each
 one-quarter the ultimate size of the textile and
 each consisting of a fitted set of the stepped
 triangles. The stepped triangles were held in
 place by temporary scaffold threads.
- Second, each textile section then had its pat-
 tern of ties and resist applied. The ties form
 tight little tents in the cloth that resist the
 absorption of the dye and ultimately formed
 the white spots in the present textile.
- Third, each of the four sections was dyed a
 color and in some cases a second color was
 added to undyed areas.
- Fourth, the sections were then disassembled
 and reassembled together to form the pre-
 sent textile configuration.

Tie-dye textiles were also created by the
Tiwanaku culture whose center was in Bolivia,
and by the Aguada culture whose center
was in Argentina. They all seem to date from
approximately the same time period, the
sixth to the ninth centuries, and so we may
be witnessing an ancient international fash-
ion, whose exact significance we cannot
understand, but whose existence we can at
least heartily applaud.

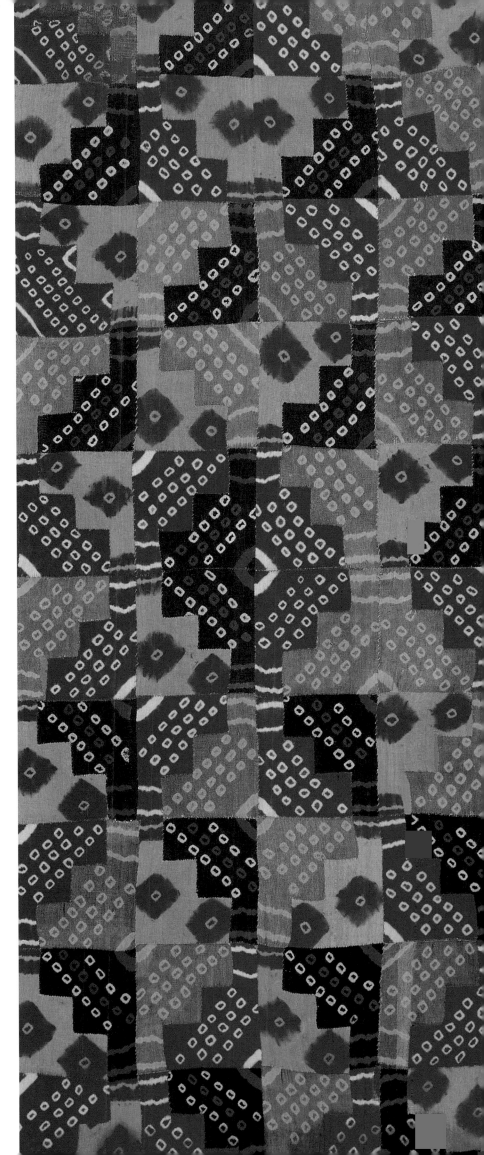

PLATE 227

Panel

Ancient Andeans. Peru. A.D. 900–1400 (?)

Slit tapestry technique (hand interlaced); alpaca weft; cotton bi-chrome warp

44¼ x 16½" (112.4 x 41.9 cm.)

This almost unprecedented textile panel causes us to rethink some of our presumptions concerning ancient Peruvian weaving, such as the presumption that the textiles of ancient Peru always represent essentially cultural products and not personal products, and that individuality is expressed in quality standards and not in design ideas. If we knew only the art of ancient Peru and had never seen the art of the twentieth century, it might be difficult for us to believe that this panel is indeed the work of a dedicated artist. However, knowledge of our own art makes it easier to accept such individualism in the ancients.

The time period to which it might be attributed, after the fall of the Wari empire, is a time when the great organized cultures of Peru were being rebuilt and reorganized. The impact of Wari and its amazing textiles had permeated the art of many local cultures. Some textiles were created during this time period that have only random echoes of Wari iconography and color-ation in a free-for-all organization. But this textile has no discernible remnant of iconography, only the vibrant color contrasts of the successive waving outlines, one surrounding another.

Although we can call the weaving of the panel by the technical term "slit tapestry," that term normally implies production on a loom. The construction of this textile consists of colored wefts which go over and under a varying number of warps, sometimes two, three, four, or five, suggesting that each interlacing action was actually handmade. This analysis indicates that the panel was woven by hand on tensioned warps without the discipline of sheds and heddles. We don't think of weavers as able to sketch, but that term suggests the nature of this textile. The warp construction itself is of two plies, one brown and one tan, which are plied together to form what is called a bi-chrome warp – a technique also found in Wari textiles, suggesting but not proving a highland origin for the textile.

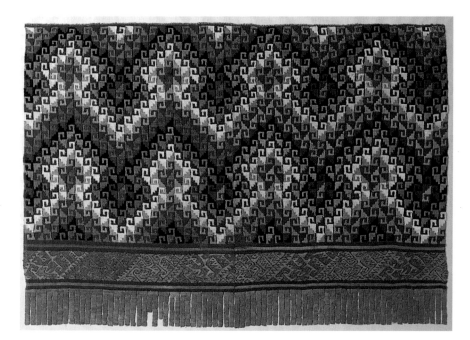

PLATE 229 (detail)
Fabric Sculptural Fauna and Flora
Early Nasca. Peru
First to Third centuries
Cross knit loop stitched figures of
alpaca on cotton armatures
49½ x 3" (125.7 x 7.6 cm.)

Most of the world's textiles were created on
looms that are, by their nature, Pythagorean and
two-dimensional with "X" and "Y" axes. The art
that is produced on such "machines," no matter
how patterned or layered, is of necessity two-
dimensional. When however, the mind and
hands of the weaver let go of the loom, letting
the fingers and the mind create like a sculptor,
then we have a new form of fabric art to which
the term "textile" does not quite apply. The
early Nasca weavers who created these three-
dimensional images had as a cultural background,
earlier weavers who created the magical and
mythological beings of Paracas. These ances-
tors had defined the coloration standards, the
quality standards, and the necessary levels of
devotion. But these early Nasca weavers' inter-
est differed from that of their ancestors: it was
in the real world that surrounded them, in the
plants and animals of the Nasca Valley. In order
to portray their vision of that world the artists/
weavers had to break out of the confines of
their looms. In one case, the figurative elements
are a child's row of imaginative trees laden with
flowers and fruit from a fairyland. In the other,
humming birds aligned along a knitted rail alter-
nate with the imaginative flowers that they
succor. Today, the Nasca Valley is almost treeless,
but the image conveyed of the Valley in these
textiles from the first centuries A.D., is that of
a paradise.

These bands were designed to be used as
edging for flat woven textiles such as tunics and
mantles. They consist of a linear structure that
unites them with a lower row of tabs formed of
bean images or bird tails and an upper row of
figurative elements. Technically, the figures have
a core of either twisted cotton thread or a small
flat textile. Upon this armature, the sculpture
was embroidered using a technique called cross-
knit looping that permits the maker to build up
a structure in any color in any direction. The
consistency and the quality of the work suggests
that it was a quick process, creating with fingers,
cactus needles, and alpaca thread whatever the
eyes saw or the mind imagined.

PLATE 228 (detail shown at beginning
of chapter)
Tunic Panel
Chancay Culture. Central Coast of Peru
Late Intermediate Period, A.D. 1100–1400
Slit tapestry technique; alpaca weft, cotton warp
32 x 44" (81.3 x 111.7 cm.)

This textile panel from a tunic was created in
the slit tapestry technique with textile bands
that are each twelve warps wide. Warp-wise
slits occur between each of these sets of twelve
warps with attachments to the adjacent band.
It is difficult for us to believe that this highly
aerated textile was actually created to be worn
as a garment and not simply as a work of art,
but the distinction between the two is our dis-
tinction and obviously not theirs.

The overall pattern is an organized maze
of identical geometric figures. The motif is a
stepped triangle with an attached hook – a motif
almost universal in Pre-Columbian art, occur-
ring in both coastal art, and in the highland
textiles of Wari and Tiwanaku. Its meaning or
the reason for its universality is unknown. Specu-
lations include the idea that it represents moun-
tains and ocean with the steps representing the
mountains and the hook form representing a
wave and hence the ocean – a two-part world
of mountains and water, which is indeed a close
representation of the Andean world. Perhaps
the large-scale undulating forms created by the
pattern of white motifs (and other colors) are
intended to represent waves that are a charac-
teristic presence in much of the textile art of
the Peruvian coast.

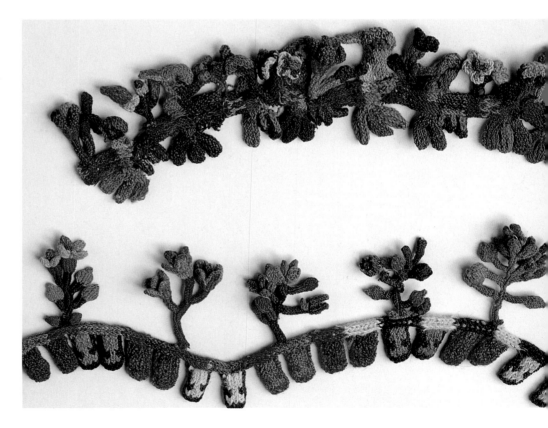

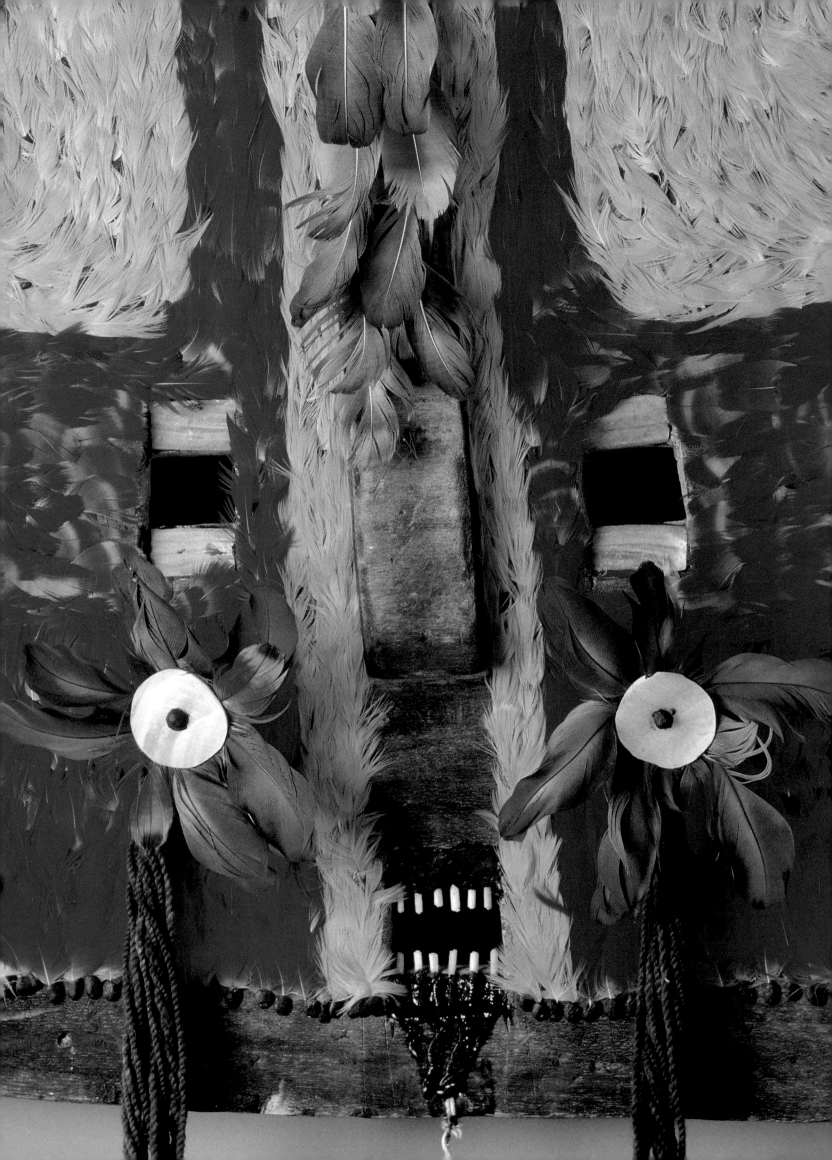

CHAPTER 12 # Latin America

BY BARBARA MAULDIN

The first morning light begins to illuminate the rugged, treeless landscape as my bus slowly makes its way down the winding road from the small mining town of Llallagua to the city of Oruro in the Bolivian altiplano. Off in the distance the light catches a colorful form and as we get closer we see two young Quechua women waiting to board the bus. They have walked several miles from their village to get a ride to Oruro for the Thursday market.

Proudly wearing the typical woman's costume for this region, their clothing consists of a simple blouse, full skirt decorated with embroidery, banded mantle around the shoulders, and a derby-style hat. In addition, each is carrying a large bundle wrapped in a striped cloth. The basic form of dress comes from pre-Hispanic traditions, but European influences can be seen in the style of hat and aspects of the tailoring and commercial fabric of the skirt and blouse. The mantle around the shoulders and the carrying cloths were woven by the women themselves using colors and patterns distinctive to their community. This weekly trip to the market is an ancient custom of exchanging goods between one region and another, and their colorful bundles are full of three varieties of potatoes grown in their family plots. The modern bus transportation allows them to travel a greater distance than in the past and they will trade for modern items such as kerosene, packaged foods, and synthetic pre-dyed yarns. These Quechua women exemplify many ethnic peoples throughout Latin America who preserve much of their ancient lifestyle, while incorporating changes that enhance the cultural expression and survival of their group.

Folk art production in Latin America continues to be passed down through families, one generation learning from another, mostly through gender lines. In pre-Hispanic times techniques were slow to change and even after the Europeans introduced new methods of production in the sixteenth and seventeenth centuries, artists in communities all over Latin America stubbornly retained many of their traditional practices. An example of this can be found in the pre-Hispanic hand-built pottery-making techniques still used by Indian women throughout the vast region today. Another example is the continued use of the back strap or heddle looms by native women to produce specific styles of fabric identified with the clothing of their village.

When Europeans arrived in Latin America, they set up workshops and trained Indian artisans, primarily men, to produce objects for the colonists' use and for commercial sale to other regions. Along with this came new technology, such as throwing pottery on a wheel or creating figural shapes pressed into molds. Europeans also introduced the foot pedal loom, which facilitated weaving quantities of wide yardage at a faster pace. When the colonial system collapsed in the nineteenth century many men continued to produce these types of items as a cottage industry, passing the knowledge down from father to son or to other members of the community. Although today some of their work is sold to a broader market, much of the production is designed to meet the needs and tastes of local consumers.

Materials used by the folk artists have been slow to change as well, but one thing that has drawn them to new resources is color. In pre-Hispanic times weavers utilized plant and animal fibers and a range of natural dyes. Although many of these elements produced subdued tones, the brighter colors of red and pink from cochineal and blue from indigo were highly desired. Tropical bird feathers in brilliant reds, blues, golds, and greens were also considered valuable commodities for ornamenting fabrics and other costume accessories. It wasn't until the late nineteenth and early twentieth centuries that a broad range of bright colors in commercial dyes, yarns, and fabrics became widely available in Latin America, and weavers and costume makers quickly began incorporating these materials into their work.

Patterns, motifs, and images have always been key elements in Latin American folk art, reflecting not only the aesthetic concerns of the various groups, but serving as a visual language to convey ideas about religion, social status, and the local environment. In pre-Hispanic art work, such as weaving, feather work, painted ceramics, and relief carving on wood and stone, much of this was purely geometric in form, but abstracted figural motifs often symbolized plants, animals, people, and other forms from the natural and supernatural world. In some instances more realistic images were portrayed, as seen in narrative depictions in wall paintings and codices. Representational sculpture was also produced by pre-Hispanic societies throughout Latin America for ceremonial use, as well as for utilitarian and decorative purposes.

The Spanish and Portuguese introduced their own patterns, motifs, and images into the New World, much of which was presented in complex Baroque-style compositions that appealed to the native eye. Narrative pictorial imagery was common in European art, conveying Catholic religious concepts as well as themes and stories from history and everyday life. All of these were depicted on painted canvases, in prints, and in a range of figural sculpture. An important graphic feature brought by the Europeans was the written or scripted word, particularly in the form of people's names and titles. They also introduced a variety of ceramic, wooden, and papier-mâché toys.

All of this was observed by the Latin American folk artists and, although they did not relinquish their own designs and images for those of the Europeans, some features were gradually incorporated into the Indian compositions, particularly a stronger emphasis on representational imagery. In the cottage industries that

grew out of the European workshops, Indian and mestizo artists often combined pre-Hispanic and European traditions to create new expressions.

By the twentieth century another phenomenon started to occur in the Indian communities, leading to further changes in some of the folk art. This was the development of an outside interest in indigenous culture by Latin American intellectuals, as well as anthropologists and tourists from other countries. These people began visiting the villages and wanted to take home examples of the local art work. They encouraged the production of both smaller, more portable items and also elaborate larger pieces for the serious collectors.

With the evolution of this new market, the outsiders wanted to know the names of the artists and, ideally, to have their signatures on the objects. Traditionally, folk artists throughout Latin America did not sign their work. In fact, most Indian ethnic groups did not have a written form of their language. Even after the younger generations were taught to write in Spanish, the occasional inscription or name worked into a weaving or applied to an object was generally of the person who commissioned the piece rather than the artist who made it.

In most indigenous societies, emphasis is not placed on individual artists or the uniqueness of an object. The makers' role is to create things for themselves or their community that fit the norm of what is considered correct. This is not to say that all folk art is anonymous, because many people in a village could recognize a particular person's work based on the level of technical skill, as well as subtle personal styles of combining patterns and colors. In the case of cottage industries, where families specialize in making products for the community, everyone knows the makers' names and there is no reason to attach specific labels.

When the market for these pieces moves beyond the immediate community into the hands of outside tourists and collectors, however, a new value system comes into play. In Western European culture great emphasis is placed on individual artists, allowing for appreciation of their distinct styles and providing a basis for comparison and assignment of perceived artistic and monetary worth. As this standard began to be applied to Latin American folk artists, some individuals rose above the others and their names and work became known to national and international audiences. Rather than compromising their creativity, many of these recognized folk artists have taken advantage of the situation to create works that convey strong messages about their cultural heritage.

Whether made for personal or family use, for broader distribution within the community, or for the growing tourist/collector market, most of the folk art being produced in Latin America continues to reflect the traditions of the various ethnic groups. Influences from the outside world have gradually been incorporated into much of the work, but there is still an underlying sense of cultural integrity and pride. Each piece tells a story, providing a small window into the lives of today's Latin American people.

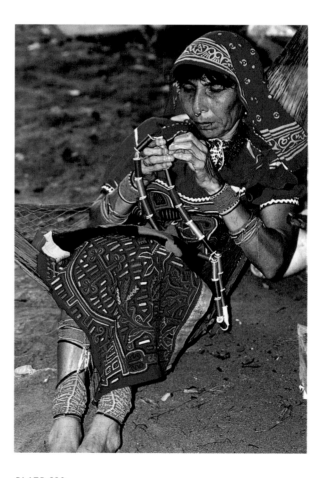

PLATE 230
Kuna woman, Gladys Iglesias, working on her mola in Wichubuala, San Blas Islands, Panama. c. 1990. (Photo: Max Heffron)

PLATE 231

Carrying Bag
Guaymí People. Chiriquí region,
Panama. c. 1910
Netted; plant fibers, natural dyes
7½ x 8" (H without strap) (19 x 20.3 cm.)

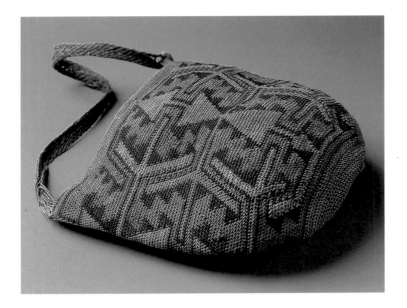

An extremely skilled Guaymí woman carefully
planned and executed this complex, multicolored
pattern that gives the illusion of a three-dimen-
sional surface on the bag. It was constructed
in a hand looping or netting technique, one of
the oldest forms of fabric production known to
man. Evolving in pre-ceramic times throughout
the Americas, netting has persisted to the pre-
sent day among some groups who make expand-
able utilitarian items, including carrying bags.[1]

Since the early twentieth century anthro-
pologists have considered the bags made by
Guaymí women, living in the interior highland
region of Panama, as exceptionally beautiful
examples of this art form.[2] Although very few
other types of arts and crafts are produced by
the Guaymí people today, they take great pride
in carrying on the ancient tradition of netting.
Young girls are taught the basic techniques dur-
ing their puberty initiation when they make a
sling to carry their first-born child.[3] From then
on they use this skill to make variously sized
bags for themselves and other family members
to carry during their constant hikes through the
Chiriquí mountains where they live. In recent
times these bags, called *kra* by the Guaymí and
chacara by the Spanish, have also been made to
sell to outsiders who appreciate their beauty
and the high quality of workmanship.[4]

Traditionally the cordage is made from
plant fibers colored with natural dyes, but since
the early twentieth century commercial cotton
and nylon threads have also been used along
with brightly colored synthetic dyes. The larger,
looser bags receive a minimal decoration of
horizontal stripes, while the smaller pouches
are more tightly woven and ornamented with a
range of geometric forms. Many of the motifs
and compositions have been handed down
through generations of weavers. In other cases,
the women use their creative talents to experi-
ment with new designs and layouts.[5]

PLATE 232

Shoulder Band
Aymara People. Lake Titicaca region,
Bolivia. Early Twentieth century
Glued mosaic feather work; tropical
bird feathers, wooden slats
12 x 36" (30.5 x 91.3 cm.)

Colorful shoulder panels such as the one shown
here are worn by dancers in the region of Lake
Titicaca, Bolivia. Feathers from the parrot, macaw,
and hummingbird have been carefully pasted
to wood, creating a mosaic of pictorial themes
portraying a blend of pre-Hispanic symbols, heral-
dic emblems of European viceroyalty, and scenes
from twentieth-century Bolivian village life. This
art form can be traced to the great Andean cul-
ture known as Tiwanaku (A.D. 1–1200), which
developed in the altiplano region of Lake Titicaca
and spread north into Peru. Extraordinary exam-
ples of mosaic feather work produced by Ti-

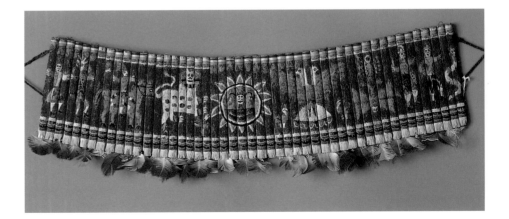

wanakan artists as early as A.D. 600 display a rich array of abstracted figural images such as monkeys, pumas, and other symbolic animals. In the early twentieth century a handful of Aymara artists living in northern Bolivia were still carrying on this tradition.

The primary focus for this work in recent times has been the ornamentation of costume pieces worn in ceremonial dances of the *Quena-Quena*. These dancers represent mythological warrior-musicians who wear breastplates made of jaguar skin and play out aggressive acts of war. In some villages around Lake Titicaca, their costumes also include colorful headpieces, pectorals, and shoulder panels decorated in mosaic feather work. In particular, the shoulder bands, known as *chacanas*, are revered for their exquisite beauty.[6]

In this example the imagery in the center of the band is dominated by a distinctive Andean sun god motif, flanked on the right by a Hapsburg double-headed eagle and on the left by a rampant lion found on many Spanish coat-of-arms. The butterfly, insect, and snake figures to the right derive from ancient Andean symbols, while the domesticated chickens portray animals of modern life. Aspects of contemporary festival activities are also shown to the left with the man on horseback wearing a feathered headdress and the pair of masqueraders next to him. On the right is another dancing couple wearing the regional *cholo* and *chola* costumes influenced by European dress. An Aymara man's name – Pasifico Hualcuasanani – has been carefully spelled out across the top, probably referring to the dancer who proudly took on the role of a *Quena-Quena*.[7]

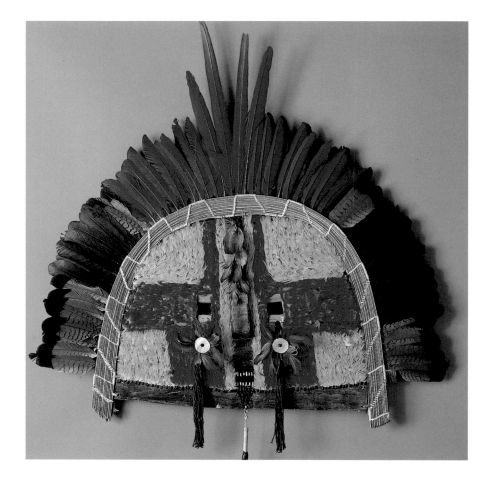

PLATE 233 (detail shown at beginning of chapter)
Mask *(Upé)*
Tapirapé People. Mato Grosso, Brazil. c. 1970
Glued and tied feather work; tropical bird feathers, mother-of-pearl, wood
40½ x 42" (102.9 x 108.7 cm.)

Giant masks such as this example are worn by Tapirapé masqueraders who usually appear in pairs and run through their village shouting and causing a commotion. Their actions lead to a mock battle between the maskers and other men of the community, who are eventually proclaimed the victors.[8] These Amazonian people live in the tropical rain forest of Mato Grosso, Brazil, hunting and fishing local game and farming in clearings created in the forest. Although they established their own territory in this region long ago, the Tapirapé have always been in competition for the resources with their distant neighbors, the Karajá and Kayapó. In fact, the rivalry among these groups has sometimes culminated in fierce battles. As a result, they take extra precautions to avoid these groups and perform ceremonies to help win the battles when they are confronted.[9]

The Tapirapé believe in a large variety of spirits, called *anchunga*, who come to reside in the village at different times of the year. Most of these are spirits of aquatic and terrestrial animals, while others are from specific Kayapó and Karajá enemies killed in past confrontations. While the *anchunga* are in the village they reside in the men's society house, occasionally appearing in public wearing masks with the distinctive features of different spirits. Those representing the Kayapó and Karajá warriors, as seen here, are the largest and most elaborate. The mask's headdress mimics the style worn in Kayapó and Karajá ceremonies, and is made from two layers of tail feathers, traditionally black from the hawk and red from the macaw.[10]

These colorful, large masks have drawn attention from all outsiders who have ventured into this isolated tropical area and eventually they were given the Portuguese name *Cara Grande* (Big Face). Since the 1950s, many *upé* masks have been made for this outside market. Due to an increasing shortage of red macaw tail feathers, however, the Tapirapé artists have substituted those from the blue macaw, as seen in this example.[11]

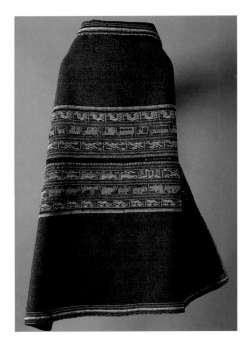

PLATE 234

Woman's Mantle

Aymara/Quechua People

Bolivar region, Bolivia. c. 1970

Complementary warp and plain
weave; synthetic pre-dyed yarns

40.4 x 41" (103 x 104 cm.)

This mantle was woven and used by a Bolivian woman carrying on an ancient custom of her people. Throughout Pre-Columbian Latin America, garments generally consisted of square or rectangular fabrics worn in a draped fashion. In the Andean region of South America men and women wore tunics to cover the main part of the body and mantles that wrapped around the back and shoulders. Under European influence clothing styles changed but some forms of the traditional garments were retained, particularly among the women. The mantle was one of

these and it has continued to be an important article of clothing for Aymara and Quechua women throughout Bolivia where it is known as *ahuayo* or *lliclla*. Sometimes this piece of fabric is also used as a carrying cloth for babies, produce, or other market items.[12] During Carnival celebrations young girls in some regions of Bolivia drape several folded mantles across their backs as a form of festival costuming, which displays their weaving talents to the young men.[13]

The woman wove this mantle on a heddle loom in two identical pieces that were later sewn together across the center. Following the traditional layout for mantle designs of the Bolivar region of south central Bolivia, she created two wide monochrome fields in a warp-faced plain weave and framed these in three groups of patterned bands or stripes. For these areas it was necessary to warp two and three different colored sets of yarns that were pulled forward or back as needed. This technique, known as complementary-warp weave, is a slow and tedious process, but the results are quite effective.[14]

Here we see a sampler of motifs, many of which are geometric and abstracted zoomorphic forms passed down through generations of weavers. The birds, snakes, and vizcacha have been important fauna in this area with symbolic meaning in Andean culture. The weaver has also included pictorial images of cows and roosters, domesticated animals that are now part of daily life. The figures of cars and trucks speak of contemporary technology and transportation in Bolivia today. The modern images show the woman's acceptance of the changing world, as well as demonstrating her skills in being able to conceive of and produce new designs using old techniques.[15]

PLATE 235

Hair ribbon

Quiche People. Zunil Region,
Guatemala. c. 1940

Tapestry technique; machine-woven
cotton and Mylar thread

(Tassel – commercial wool yarn)

Band: 11'8" x 1¼" (337.8 x 3 cm.)

This is a beautiful example of the type of hair ribbon worn by the women in Zunil, Guatemala, and the neighboring villages of Rabinal and Almolonga. It is characterized by varied sections of intricate multicolored designs and large banded tassels that are proudly displayed projecting out of the ribbon coiled around the head. A striking feature of women's dress in Guatemala is the hair ornamentation created by interweaving ribbons, or *cintas*, in a variety of ways. As with the rest of the traditional outfit, each region and village has its own headdress style, distinguished by the width, pattern, and colors of the woven ribbons, as well as the way they are worn.[16]

Although traditionally woven by women on back-strap looms, the production of these hair ribbons has been largely transferred to small foot-pedaled looms where men use tapestry techniques to create similar kinds of patterns and motifs. In the large community of Totonicapán, near Zunil, this type of cottage industry has been turned into a thriving commercial business where men weave *cintas* for many other Guatemalan villages, using the colors and patterns specific to each one, as seen in this example.[17]

The maker of this ribbon performed the complicated task of weaving a female's name into the ribbon – Francisca Quejtumaca – which suggests it was a specially commissioned piece, perhaps given as a gift by a mother or godmother. The relatively short length of the ribbon – compared to others measuring from twenty to thirty feet – indicates that it was made for a child, or even a baby, who are sometimes dressed up in the same style of clothes as the older women, including the *cinta* with large tassels sticking up over the top of the head.[18]

PLATE 236
Blouse
Kuna People. San Blas Islands,
Panama. c. 1965
Reverse-appliqué; machine-woven
cotton and rayon
23 x 29" (58.5 x 73.7 cm.)

This Kuna woman's blouse features a pictorial scene of a large fish eating an octopus surrounded by fishermen using both fishing lines and spears. The Kuna live on a chain of islands off the Atlantic coast of Panama, known as the Archipelago of San Blas. As might be expected, boats are the major form of inter-island transportation and fishing is one of the primary activities. Due to the warm climate and island life style, the Kuna people traditionally wore very little clothing, but their skin was painted with brightly colored abstract patterns and figural motifs portraying plants, birds, and humans. As they came into greater contact with Europeans they were encouraged to cover up their bodies, and by the nineteenth century Kuna women had adopted a wrap-around skirt and blouse and the painted decoration was transferred to the cloth of the garments.

As greater quantities of manufactured fabric, along with metal sewing needles and scissors, were introduced into this region, Kuna women began to experiment with new ways to decorate their body clothing. They were attracted to the brightly colored cloth in reds, yellows, and blues and they devised a way to combine the fabrics by cutting a decorative design out of one color and sewing it onto another color below. This reverse-appliqué decoration was primarily concentrated on the blouse and by the 1930s the style of this garment, known as a *mola*, was fairly well established. The hand work was done on two panels, that were then sewn together with the commercial fabric of the yoke and puffed sleeves.

Every Kuna woman learns to make her own *molas*, usually having three or four for everyday use and one or two fancier examples for special occasions. When she gets tired of wearing them they are sold to outside collectors. As seen here, the more complex patterns are constructed from three to four layers of different colored fabric. These usually have a central pictorial motif with subordinate images and designs around it and the remaining space is filled in with small repeated patterns.[19]

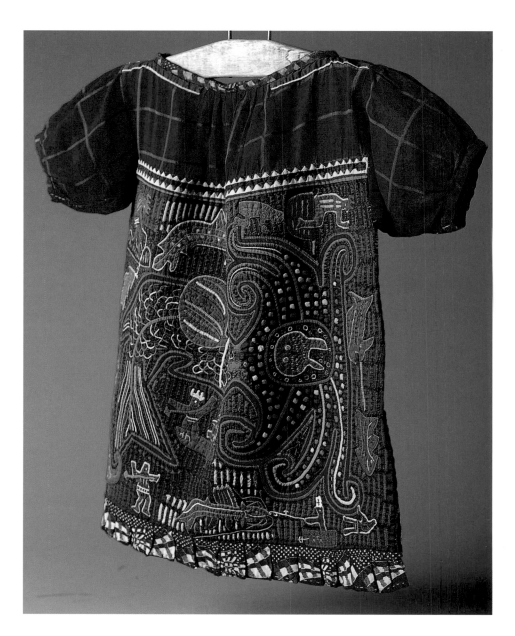

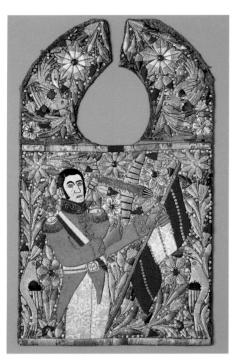

PLATE 237
Neck Panel for Dance Costume
Quechua/Mestizo People
Junin Department, Peru. c. 1960
Silk and cotton thread embroidery with
sequins on machine-woven cotton
30 x 18" (76.2 x 45.7 cm.)

The Junin region in the central highlands of
Peru was the site of a decisive victory for the
revolutionary war generals, Bolivar and Sucre,
in their fight for Peruvian independence from
Spain in the early nineteenth century. These
famous men, and others who fought for Peru's
freedom, are now portrayed on embroidered
capes and jackets such as the piece shown here,
worn by male dancers for fiestas celebrated in
several towns and villages throughout this area.

The costumes are made by men and their
families as a cottage industry and rented to
dancers from the different villages. The embroi-
dery technique, known as stumpwork, involves
wrapping the thread around wooden forms or
other stuffed shapes to create a three-dimen-
sional surface texture. This type of ornate embroi-
dery was used in Europe to decorate church
vestments and other fine goods and was intro-
duced into the Andes by missionaries and
Spanish colonists, who probably set up small
workshops and trained local men to adorn fab-
rics for use in churches and private homes.

The subject matter portrayed in the embroi-
dered dance costumes has evolved over time.
Nineteenth-century examples show a predomi-
nance of floral patterns interspersed with images
of birds and animals. Nativity scenes were also
very popular. However, since the early to mid-
twentieth century, the themes of the embroider-
ies have become increasingly focused on war,
liberty, and independence, in response to the
interests of dancers who rent the costumes.
Many of these images have a direct relationship
to Andean history, such as this example with
the portrait of General Bolivar. There is also a
fascination with modern technology, and air-
planes and automobiles are often worked into
the compositions, even though not in keeping
with the historical subject matter.[20]

PLATE 238
Candelabra
Artists: Aurelio and Francisco Flores
Izucar de Matamoros, Puebla, Mexico. c. 1980
Hand-molded, fired, painted; clay, paint, wire
42 x 26 x 8¼" (106.7 x 66 x 21 cm.)

This large multi-tiered ceramic piece is a won-
derful example of Mexican folk sculpture that
grew out of a traditional craft form. Introduced
by the Europeans, candlesticks and candelabras
were used throughout colonial Mexico to pro-
vide light and offer reverence to images of the
saints. The sculpted lighting devices were also
used for Catholic religious ceremonies, such as
weddings and funerals when they were placed
on special altars or carried in processions.

By the late nineteenth century, the area
around the town of Izucar de Matamoros, in
the state of Puebla, Mexico, had become known
for its production of brightly painted ceramic
candelabras and incense burners. These were
constructed in clay, featuring two or three tiers

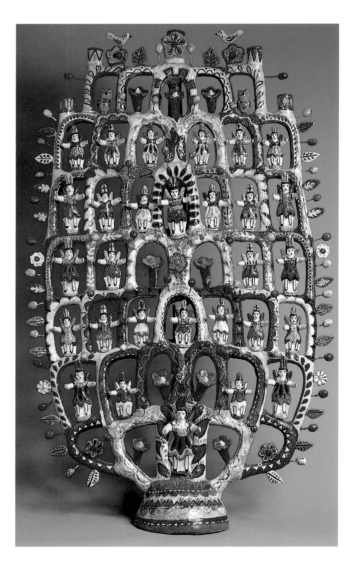

of arms ornamented with doll-like images of archangels, saints, and virgins as well as an array of sculpted flowers, fruits, birds, and other decorative motifs. Once the clay object was fired, the entire surface was painted in polychrome colors and coated in varnish and gum to give a shiny effect.

In the mid-twentieth century, two families in Izucar de Matamoros, Castillo and Flores, were still making ceramic pieces in this style. Aurelio Flores learned this craft in his father's workshop where a large part of their production was medium-sized candelabras used by families when they announced the engagement of a young couple. This ceremony was held in front of an altar adorned with the beautiful candleholder of polychromed clay. The central figure on the front stem of the piece was the archangel San Raphael, and other images of angels, flowers, and birds were dispersed on the projecting arms.

Through the encouragement of art dealers and collectors, Aurelio and his son Francisco began making extremely large and complex candelabras to serve as sculptures in museums, restaurants, and wealthy homes.[21] In this example, they have retained the traditional iconography of the engagement ceremony pieces, but the candle holders themselves have been reduced to small projections at the top.

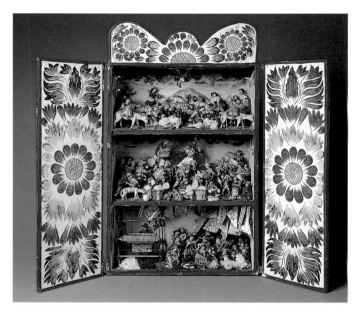

PLATE 239 and PLATE 240 (detail of Plate 239)
Portable Shrine
Artist: Nicario Jimenez. Lima, Peru. c. 1985
Sculpted and painted; wood, potato paste/gypsum clay, paint
28¼ x 17¼ x 7" (71.7 x 44 x 17.7 cm.)

This multi-tiered box with brightly painted doors provides an intimate setting for presenting scenes of Peruvian Indian life, such as the sheepherders, shearers, and weavers shown here. The form was developed in Europe during the Middle Ages when Christian pilgrims began using small, box-like altars with closing doors to carry sacred images while traveling to important religious sites. These portable shrines were later brought to the New World by missionaries and European colonists. As the native peoples were converted to Catholicism, they syncretized the new religion with traditional Indian beliefs and practices and the small altars, called *retablos*, were adopted as part of their religious paraphernalia to be set up in homes or to be carried when out herding their animals. Sometimes the Indians placed their own amulets inside the boxes to strengthen the magical power. A small cot-

tage industry developed in different regions of Latin America to produce portable shrines for local use.

This tradition continued into the twentieth century and one of the most notable artists to carry on this work in Peru was Joaquin Lopez Antay, who lived in the Quechua Indian region of Ayacucho. By the 1950s his *retablos* were being collected by outside artists and art dealers and he began portraying scenes from Quechua rural life, such as harvesting cactus fruit, herding sheep, participating in festivals, and selling merchandise in markets and shops. The figures were primarily sculpted in a potato paste/gypsum clay, which was allowed to harden and then painted.

A Quechua Indian man, Florentino Jimenez, and his family assisted Antay in producing the *retablos* and eventually they opened their own workshop. In 1981 the eldest son, Nicario Jimenez, moved to Lima and began working directly with art galleries, selling *retablos* made by his family in Ayacucho as well as producing his own pieces, such as the one seen here. Many of Nicario's *retablos* are now one-of-a-kind, with three or four tiers depicting scenes from Andean Indian life and their experience in the changing world.[22]

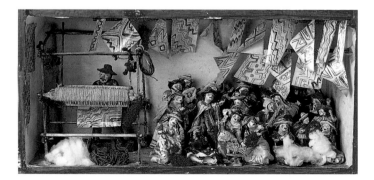

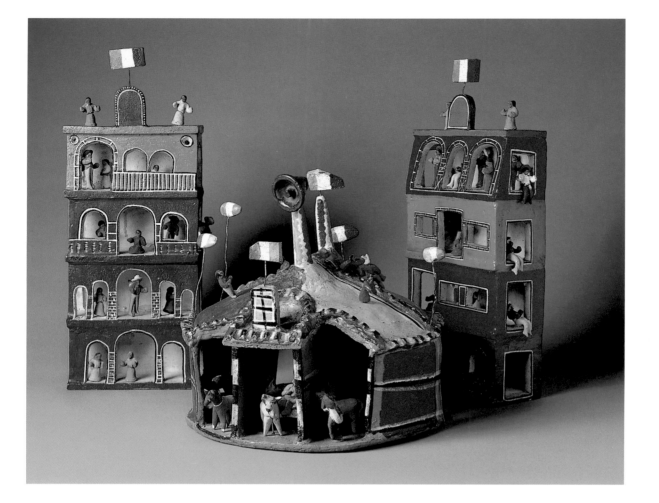

PLATE 241

Village Scene

Artist: Candelario Medrano. Santa Cruz de las Huertas, Jalisco, Mexico. c. 1970

Hand-molded and painted; clay, tempera paint, wire

Left: 23 x 9½ x 4" (58.5 x 24.1 x 10.1 cm.)

Center: 15 x 16 x 16" (28.1 x 40.6 x 40.6 cm.)

Right: 23 x 9¼ x 4¾" (58.4 x 23.5 x 12 cm.)

This colorful scene portrays a circus that has come to town, with townspeople watching the activities from their windows, balconies, and roofs. The small village of Santa Cruz de las Huertas is located on the outskirts of Guadalajara in Jalisco, Mexico. Since the nineteenth century it has been an important toy-making center, focusing on the production of painted mold-made ceramic banks and whistles often in the form of humorous animals, birds, reptiles, and mermaids.

One of the most famous toy-makers from this village was Julio Acero, who developed a unique style of caricature and decoration in his pieces. Acero produced these in his workshop with the assistance of a young boy named Candelario Medrano. As he grew up, Medrano learned the techniques of working with clay, either forming the images by hand or using the figural molds handed down from Acero's

father. Once the clay pieces were fired, they were decorated with commercial paints and then varnished.

After Acero's death, Medrano continued making ceramic toys, particularly animal whistles that he shaped by hand. These had an unusually lively character and they attracted the attention of a painter in the neighboring town of Tonala. He suggested that Medrano put many of his animal figures together in a group, perhaps using a theme such as Noah's Ark. Medrano followed his suggestion and soon branched out to create other types of scenes relating to activities in his village and the neighboring towns. During the last twenty-five years of his life, Candelario Medrano, working with his sons, developed a highly distinctive style of figural ceramics, depicting the world around him with humor, joy, and celebration, as seen in this example.[23]

PLATE 242

Skeleton Musician
Artist: Felipe Linares. Mexico City, Mexico. 1995
Papier-mâché; paper, glue, paint,
ribbon, decorative trim
51½ x 31 x 24" (130.2 x 78.7 x 61 cm.)

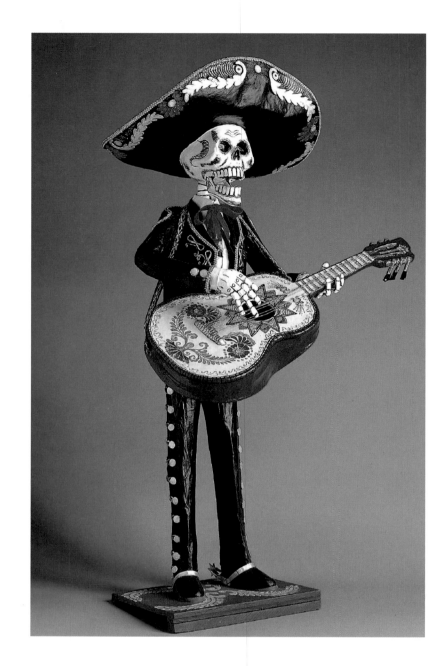

This life-size skeletal figure of a Mexican musician is an example of contemporary folk sculpture that grew out of traditional toy-making practices. Since colonial times, some workshops in Mexico have specialized in toys for festivals that take place throughout the year, such as Carnival, Holy Week, the Day of the Dead, and Christmas. For the most part these toys are used for a brief time and then discarded, smashed, or blown up as part of the celebratory activities, and thus they are made of lightweight, inexpensive materials such as paper, cardboard, and papier-mâché.

The Linares family in Mexico City began as traditional folk artists, creating papier-mâché objects used in connection with these various festivals. Pedro Linares learned the skills from his father and by the mid-1950s was passing this toy-making tradition on to his own sons. Pedro's artistic talent in creating humorous and expressive figures drew recognition from well-known Mexican artists such as Diego Rivera and José Gomez Rosas, who commissioned him to do large, one-of-a-kind pieces. Linares was introduced to the graphic work of the famous Mexican satirist, José Guadalupe Posada (1851–1913), who portrayed all aspects of Mexican society through a humorous guise of skeletons, or *calaveras*. His work grew out of traditional Mexican attitudes about death, viewing it as a vital part of life with very little dividing the living world from "the other side."

Pedro Linares identified with Posada's ideas and began translating his images into three-dimensional forms. With the help of his sons he started creating large *calavera* portraits of known political and social personalities to be blown up during Holy Week or featured as sculptured decoration during the *Días de los Muertos* festivities. The Linares family also started producing life-size multi-figured *calavera* groups portraying scenes from the everyday life of Mexico in the late twentieth century. One of their favorite subjects has been *mariachi* musicians, who wear tight-fitting suits and large hats while playing a popular style of Mexican music featuring trumpets, violins, and guitars. As seen in this example by Pedro's second son, Felipe, the craft of papier-mâché has been raised to the level of an ultimate art form with incredible detail in the shaping of the material as well as the decorative painting and added accessories.[24]

CHAPTER 13 # American Indian

BY MARY HUNT KAHLENBERG

It was snowing heavily as I drove a Japanese friend across the open desert from Santa Fe to Farmington, New Mexico. Suddenly, as we approached the top of a mesa, the snow stopped and a vista opened. You could see through the crystalline air for hundreds of miles in every direction. She began to cry out in a very uncharacteristic manner: "Infinity! Infinity!" She was seeking a way to comprehend this incredible landscape.

Wherever human beings live they must learn to adapt to their environment, a united mental and physical activity that becomes part of our cultural identity. It is not the intention of this essay to maintain that landscape is the only determining factor in the development of cultural values, rather it is more a backdrop against which life is played out. Nature can be a dense forest or broad horizons, skies soft gray or blue with billowy clouds, quickly flowing streams or parched arroyos. A continent of great natural contrasts has produced a corresponding variety of perspectives. In discussing an area as broad as this continent, I find this more than any other a convincing explanation for the combination of immense differences in thinking, as well as for the common threads.

How the diversity of the landscape has formed its inhabitants is our starting point. The necessary mechanics of obtaining food and shelter provide the interactions that shape individual personalities and the group subconscious. As I drove with my Japanese friend from Chaco Canyon, sacred ceremonial grounds of the Anasazi or "ancient ones," into the current Navajo reservation, we encountered two approaches to living within a greater desert landscape. Over several millennia the Anasazi, and their descendants, the current Zuni, Hopi, and Puebloans, became predominantly agriculturists and settled together in villages. Community members were dependent upon each other as members of an agricultural community, and all were dependent on nature for life-giving water. Both of these factors were reflected in the composition of their daily lives, their ceremonial activities, and their art.

In order to exist in an environment where the water supply was often marginal, they established rituals intended to control the climate, as well as other relationships with spirits they saw in nature – spirits of the sky, the stars, lightning, the earth, and the four directions. Spirits of ancestors and spirits in minerals, plants, animals, birds, and insects were evoked to guide and protect the community. Everything that existed had a spiritual, as well as a physical, being and the spirits could act as intermediaries to ensure the continuity of life.

Some spirits were impersonated by humans in the form of "kachinas" to facilitate the leap between concept and reality. Kachinas are the physical embodiments of the life force, hence one of their chief functions is as rainmakers or rain bringers, ensuring the fertility and abundance of the crops. Ceremony, the core of group dynamic and public life, emphasized the homogeneous community and each person's responsibility to the group. Garments used in these ceremonies emphasize this unity through their uniformity. Even the costumes for the kachina dancers, though distinguished by par-

ticular features that provide individual identities, are created within a fundamental format. There are subtle differences in the way each man might weave a plaid brown and white bachelor's cape, or a dark blue and brown manta. These differences represent varying skills and artistic decisions, but there are no highly distinctive differences. They are woven to be part of the whole cloth of the society.

The Navajo, non-Puebloans, and later arrivals in the Southwest approach the contiguous landscape differently. They were hunters and gatherers with only rudimentary crafts and no knowledge of agriculture when they began their migration from western Canada about A.D. 1000. Theirs was a tradition of extended family units organized into clans. The Navajo developed no town or village culture. Families lived in isolated units over the great expanse of canyons and desert defined by their four sacred mountains. The land itself, though sublime in appearance, remains a challenge to their ingenuity and survival skills – by necessity, their life is one of self-sufficiency. The hunting and gathering they once practiced have been superseded by sheepherding over vast tracts of arid land.

The Navajo may temporarily leave their isolated homes and travel great distances to join together for ceremonial "sings" lasting as long as nine days. The main purpose of chanting and sandpainting ceremonies is to cure illness in an individual's body or mind by restoring harmony, a balance of the person with the forces of the universe. Both the strong sense of the individual and all individuals' need for harmony in their lives are exemplified in this ceremony – this essence may be seen in their weaving.

In Navajo eyes beauty had specific, definable forms. First, it was symmetrical, based on the initial vertical growth of a plant, shoot and root, then the first set of paired leaves, right and left. This forms not only the overall quadrennial format of a Navajo blanket, but the common cruciform design as well. The blanket, worn wrapped around the body, draped over the arms and held together at the front, became an open circle. This same open circle was manifested in the Navajo house form, the circular "hogan" with its single east-facing door. It is further to be seen in the form of the rainbow god bent around three sides of a square to serve as the guardian of ceremonial sandpaintings. All of these forms have mythological parallels in the Navajo creation myth in which the First People come out through a hole in the Emergence Rim. Each of these open circles carries simultaneously the idea of creation and protection. They formed the basis of a Navajoan aesthetic that strove to be harmonious.

It has been said that "the tribes of the western Great Lakes tend to be reserved and indirect in all their personal and interrelations. It is almost as if they had taken on personalities camouflaged to melt into the deep forests where they lived."[1] Perhaps it is more than camouflage. They believe that each person is part of a great natural cycle, inseparable from every other creature on earth. Humans gain energy from their fellow creatures by eating them (in the form of animals and plants) and when human souls leave their bodies, the remains will return to the earth to provide it with nourishment. Thus the debt is repaid and an endlessly repeated cycle completed.

This cycle is also reflected in the dress of American Indian Peoples of the Great Lakes region. Wealth in the form of elaborately decorated garb for public and ceremonial events was considered representative of both spiritual and social well-being. It was highly valued and could be displayed or presented as part of a ritual gift exchange. Elaborate dress increased the wearer's status in the eyes of others. This perception empowered the wearer to act in a more authoritative manner. In a gift exchange, highly decorated accoutrements and garments were valued as much by the receiver as by the giver.

The time artisans can devote to artistic expression is directly determined by their ability to collect or produce a sufficient food supply for their maintenance. Where food is abundant in the environment, when obtaining it requires only a portion of one's day, then sufficient time remains to carve intricate designs on tools and work fine decoration into garments. Frequently, such work is seasonal. Some individuals became professional artists who obtained their sustenance in exchange for their carving, painting, and weaving skills.

The Tlingit of southeastern Alaska dwell where rugged mountains and glacial fields merge at the sea. Here wealth is provided by both sea and forest. Warmed by the Japanese current that flows along the western coast of the Alexander Archipelago, the temperate rain forest produces the great red cedars synonymous with the carved art of the Tlingit. The stringy inner bark of both the red and green cedar is used to weave capes and mats, and their roots are used for weaving baskets. Tools are decorated in a manner that reinforces their function, and also provides an integration of art with life's daily activities. A man putting to sea to catch halibut carries with him a carved hook symbolizing the spirit of the fish. The exquisitely carved bear-headed dagger reinforces the strength of the warrior. Cooking her family's meal, a woman takes dried salmon from an elaborately carved box and serves it in a dish carved in the form of a seal or beaver.

The preference is often for covering an object with decoration, a type of *horror vacui*, or distaste for the blank, as if to leave a void is to leave the object incomplete. In order to achieve this, a type of X-ray vision is provided so that we can see the inside and outside of an animal simultaneously. To create this dense design with clarity, great skill was needed, and the opportunity to achieve the necessary skills was provided by the abundance that allowed a person to become a professional carver. Thus a reciprocity existed between the creative time provided by the wealth of the community and the requirement to produce for that community objects adorned with images of spirits and ancestral totems.

Environment – the sparseness of a desert or the lushness of a rain forest – provides clues to a people's art. The broad bands of a Navajo blanket are a distillation of the horizon seen by the Navajo weaver at her loom. The strength of the surrounding tall cedars, which form a protective environment for the plants and animals living beneath them, are memorialized in the bold lines of every garment, tool, and carving of the Tlingit. The expanse of woodlands forest carpeted with delicate flowers is echoed in the gentle curving lines and realistic rendering of the local flora on the garb of those who draw their strength from it. The Pueblo, Hopi, and Zuni, the Navajo, the Tlingit, and Americans of the Woodlands, are supported spiritually and physically by their lands and their communities, and draw from them inspiration for their art.

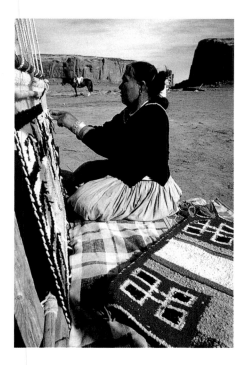

PLATE 243
Navajo weaver in Arizona. 1978. (Photo: Marsha Keegan)

PLATE 244 (detail)
Portrait Club
Penobscot People
Maine, U.S.A. c. 1870
Carved Birch
32½ x 8 x 6" (60 x 20 x 15 cm.)

This birch root club may depict a human face,
or possibly, a horned being. This club, usually
formed from the root, root tips, and trunk of a
birch tree, most often has faces and animal
beings carved into the burl and protruding root-
stocks. Elaborate chip carving may decorate
the handle. Brightly painted examples of these
clubs with feather-bonneted faces, dating from
the early twentieth century, are known, but
often have been denigrated as "only tourist art."
New research shows that root clubs have, in
fact, been used for centuries and express an
ancient, evolving, and continuing tradition. Early
root clubs, which do not appear to have had
carvings on them, were used as weapons. From
the late eighteenth to the late nineteenth cen-
turies, carvings on root clubs may have repre-
sented spirit beings just barely emerging from
the burl. Such clubs could have been carried
as status symbols, possibly representing spirit
protectors, and may have been used in healing
and other related native ceremonies. For the
Penobscot, these clubs express the life and
spirit of the tree itself, and the beings repre-
sented are referred to as "spirit faces." In the
late nineteenth century, human faces, modestly
colored, rather that spirit faces, began to be
carved on the club burl. Some of these "por-
trait" clubs may have been carved for personal
use; others given as gifts or sold to tourists. The
club seen here represents the transition from
spirit face to portrait club.[1] (Stan Neptune and
Joan Lester)

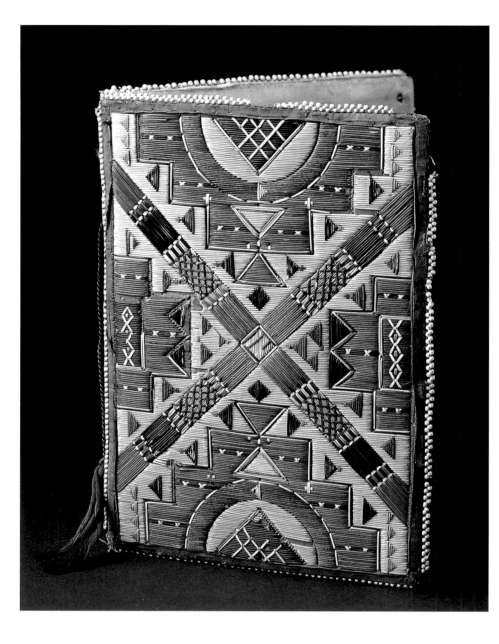

PLATE 245
Letter Holder or Book Cover
Micmac People
Nova Scotia, Canada. 1900–1925
Birch bark decorated with porcupine
quills, glass beads, and silk
10¼ x 14½" (26 x 37 cm.)

Both sides of this letter holder have the design
of a double rainbow or arc – the same Micmac
word is used to indicate both. It is the oldest
known quillwork motif and is combined with
another ancient design, the cross or "X." The
cross, recorded as a motif in the early 1600s, was
said to have appeared in a dream during an
epidemic. The wisest of the Miramichi Micmac,
who had seen the cross, were told to make one.
Those who did and respected the cross's power
were miraculously restored to health.[2] Another
variation of an ancient pictograph with an "X"
form was discovered in the late nineteenth cen-
tury and was identified as the conventionalized
representation of a juggler's lodge, a Micmac
men's society.[3] While the motifs may have been
purely decorative by the time this letter holder
was made, both the motifs used here are
ancient and were once of great meaning with-
in the culture.

The Micmac had contact with the Euro-
peans at least as early as the sixteenth century
and, possibly, with fishermen from England even
earlier.[4] This early date of contact did not bode
well for the preservation of their culture. By the
eighteenth century the European desire for
"curiosities" was being gratified by quillworked
objects made for trade. The late nineteenth-
century fad for Indian crafts, in addition to their
taste for the decorated objects, provided a
livelihood for Micmac women until the Second
World War.

OPPOSITE

PLATE 247

Parfleche Envelope

Crow People

Montana, U.S.A. 1890–1910

Painted rawhide

28 x 14" (71 x 35.5 cm.)

An oblong length of hide is folded in half and sewn up the side to make this storage envelope. It is closed with a single pair of holes in the outer flap. The hide was cleaned and dried, but not tanned. In the days of the buffalo, this was the preferred hide, but it was subsequently replaced by cowhide. Crow envelopes prior to the early nineteenth century were often decorated with patterns made by incising the hide. Later, colored decoration was added using an ingenious brush made from the sponge-like marrow at the end of a buffalo rib. This example, originally one of a pair, was made in this way.

The parfleche compositions are always bold and angular – generally based on a large diamond shape that crossed the center of the two flaps. With the addition of color, they took on an illusionist form. Here, diamond and trapezoidal shapes utilize primary colors plus voided areas to give a sense of dimension and create a suggestion of movement in an object whose function was the containment of material being moved from one place to another.[7]

The tough hide of the buffalo had long been used to make shields to protect the Crow in their battles with neighboring tribes. Early French-speaking fur traders found these hides so strong that they had the capability to "turn away" (parer) "arrows" (fleche). In time, the name became attached to the object rather than the material.[8] Parfleche were primarily used to carry meat, but they were also made for the storage of dress paraphernalia and tools.

PLATE 246 (detail shown at beginning of chapter)

Dress Parka (*Kamleikas*)

Yupik People. St. Lawrence Island, Alaska

Mid to Late Nineteenth century

Walrus gut, puffin beaks and feathers, fur and human hair

43 x 54" (109.2 x 137 cm.)

The translucent quality of walrus gut bejeweled with puffin beak pairs and small feathers has produced a garment of amazing sophistication. Garments of gut were made as protective weatherproof gear for the St. Lawrence Island Yupik people who lived on the bounty of the sea. Plain *kamleikas* were worn for everyday, but for festive dances decorated *kamleikas* were worn over the bare body. At ceremonies they were also worn by shamans, contacting the spirit world. It has been speculated that the protective quality of the gut may have served symbolically as a protection against evil spirits. If this is the case, the additional decoration of the seams might serve as a reinforcement of the closures, as well as creating a garment of beauty.[5]

A considerable amount of work went into making these parkas. The intestines were removed intact, turned inside out, scraped clean with a mussel shell, washed in water and urine, then filled with air and dried, cut into long strips that were sewn together with a double-folded seam. Sinew was used to sew everyday parkas, while human hair was used for the delicate work on the ceremonial ones. Undecorated *kamleikas* took approximately a month to make and were usually replaced every four to six months.[6]

PLATE 248

Plateau Bag

Nez Perce People. Wyoming, U.S.A. 1900–1910

Twining in Indian hemp with wool brocade, glass beaded buckskin straps

22½ x 15¼ x 1½" (57.2 x 38.7 x 3.8 cm.)

This bag, with its brightly colored design, is part of a several hundred-year tradition of durable and practical twined bags common to the plateau region of British Columbia, Montana, Washington, and Oregon. The bags were made in a circular form so that there is no seam, one of the secrets of their strength. The aesthetic preference was for a design made up of individual but related elements that could be separated horizontally and vertically. Orderliness and alignment were highly esteemed qualities of the design. This design of stepped triangles filled with bars of complementary colors fits exactly into this concept.

The bags were an essential part of a prescribed ritual of male-gathered food; (fish and game) and female-gathered food, (roots and berries) which were exchanged by the groom's and the bride's families as part of the feasts that validated a wedding. They served a utilitarian function for the gathering of food, and after the horse was introduced in the early eighteenth century they functioned as saddlebags. They were always an important trade commodity with other Indian groups and became famous due to the unsuccessful attempt by Lewis and Clark to obtain them in trade.[9] In northwestern Montana, the women of the Flathead tribe still dance the Snake Dance. It is an amazing sight to see lines of several hundred women all displaying these boldly designed bags.[10]

PLATE 249

Dance Skirt Section

Hupa People

Klamath River region, California, U.S.A.

Late Nineteenth century

Braided squaw grass with pine nuts and

blue glass beads on buckskin

27 x 20" (68.6 x 50.8 cm.)

Smooth grass braids were packed tightly across the buckskin base so as to form a full panel hanging down across the buttocks of a dancing woman. For the Hupa, life was a challenge. The woman gathered plants and acorns from which they made their staple food, a type of acorn mush. The men fished the rivers and pursued small game. Despite these simple material conditions, considerable attention was paid to the display of an individual's wealth. For their special Jump Dance the individual dancers would carry a long narrow basket with a thin opening across the top like a large money purse. Inside were their valuable possessions. This display of their wealth to the gods was part of a strictly observed ceremonial life that ensured both order and the renewal of life.[11]

The sound made by this apron is sensuous. It makes you want to be enveloped by the swishing sound of a group of Hupa women as they celebrated life through the music of their moving skirts.

PLATE 250

Cradle Model

Chukchansi Yokut or Miwok People

California, U.S.A. 1910–1930

Twining technique, buck brush, sedge root, cherry shoots, cotton thread, and printed cotton

29 x 13 x 11½" (73.5 x 33 x 29 cm.)

Children learn through observation, and to be carried in a cradle on a parent's back at adult eye level, or be set upright on the ground next to your mother who is preparing a meal or weaving a basket, was to begin an early perception of life's daily activities. This lightweight cradle made from the local sedge was strong, but it was the fibrous interior that made it light. Over the head a reinforced hood not only offered shade but protected the baby's head if it were to fall.

Across the hood the dark elements form "v" shapes, while straight lines have been added with a red stain. Traditionally, the sex of the baby was identified by these markings. Diagonal marks would indicate that the cradle supported a baby boy and diamond or zigzag patterns were used for a baby girl. The fact that this cradle was not intended for use may explain the ambiguity of the design.[12]

The Chukchansi Yokuts were prolific basket makers. Their territory lay southwest of the present-day boundary of Yosemite National Park. With the development of the park as a tourist destination at the end of the last century, their baskets and cradles found a much-expanded market.[13] Cradles, of course, were meant to be portable. This cradle was of a type that would have reclined near the mother rather than being carried on her back such as those of the more nomadic hunters and gatherers. It was made to be a simple, strong, and highly versatile device not at all dissimilar from today's plastic car seat that also reflects a nomadic sensibility.[14]

OPPOSITE

PLATE 252

Blanket (*Beeldléí*)

Navajo People

Arizona or New Mexico, U.S.A. 1850–1865

Tapestry technique, unraveled, machine-

spun three-ply and handspun wool yarns

74 x 53" (188 x 134.5 cm.)

This textile, referred to as a Moki-style blanket, is a good place to begin to tell the story of the two major influences on Navajo weaving. The Navajo migrated to the American Southwest sometime around the fifteenth century. They speak an Athabaskan language that connects them clearly to the Athabaskans of the Northwest. They were hunters and gatherers with only rudimentary craft skills and no farming knowledge. After several hundred years they settled in an area already inhabited by the Hopi, Zuni, and Pueblo. Their relationship with their new neighbors was tenuous and has always remained so. Only at one time in their history, when the Spanish became a common enemy, did they live together willingly. It was during that period (from 1680 to the early eighteenth century) that scholars believe the Navajo women learned weaving from the men of these neighboring groups.

A common style of weaving at this time was a blanket of alternating brown and blue stripes. It was actually a Spanish style woven by the Pueblo as their payment of Spanish taxes. The Spanish had been in the Southwest for close to one hundred years and the sheep they had brought for their own food and fiber had been adopted and absorbed into the American Indian people's economy. The Navajo may have begun raising sheep even before they started weaving. Thus having become familiar with wool and having acquired the skill to use it, they also observed the garments worn by the Spanish settlers. Among these was a Northern Mexican garment, referred to as a Saltillo serape. It was made in two parts sewn together along the length with a slit in the center so that it could be slipped over the head. A diamond formed by two triangles in the middle of both sides framed the wearer's face and broadened his shoulders, while the remainder draped over his saddle.

Both the design elements of this blanket are of Spanish origin, and the technique for weaving them came to the Navajo from the Pueblo. The Navajo learned how to balance the subtlety of the brown and blue stripes with the dazzle of a multicolored zigzag diamond, combining the two as had never been done before.

PLATE 251

Woman's Headdress (*Tablita*)

Jemez Pueblo People

New Mexico, U.S.A. c. 1940–1960

Paint on wood

16 x 12½" (40.5 x 32 cm.)

We know that a thousand years ago in the Mimbres area of what is now Southern New Mexico, women wore flat *tablita* headdresses very similar to this one. Fitted over the front of the head, the *tablita* is fastened under the chin with a cotton string as here or – in earlier times – with a leather thong. It is made from available materials, in this case two pieces of wood fastened together. The three primary colors, plus the white dashes represent the four directional colors. At the top of each point there was a soft feather, a prayer for rain to nourish the corn and squash.

Tablita are worn by women during the corn dances held throughout the summer months and linked to the germination, growth, maturation, and harvest of the crop. The corn dance is performed by the men and women of two different clans that compose a village. Throughout the day, one clan follows the other dancing in the open plaza under the intense summer sun. At the end of the day, the two groups join together and sometimes their prayers are answered with the appearance of dark rain clouds. Thanks are given for prayers answered and unanswered, as an old Indian has said.[15]

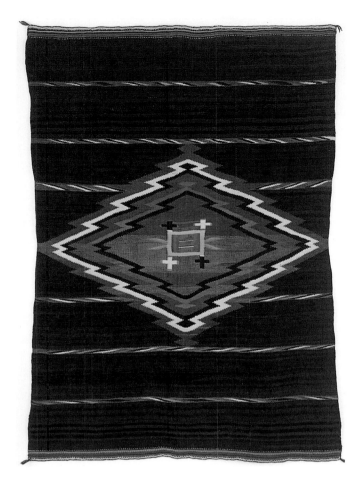

duced in Mexico. It was dyed red from the coloration of either lac or cochineal. Cochineal dye was produced in Mexico, while lac came mainly from Turkey. Frequently, the two dyes were mixed, because cochineal had a brighter quality and was, therefore, more desirable (and also more expensive). Until the arrival of the first synthetic dyes in the late 1860s and early 1870s, when the market for this precious natural red color was destroyed, it was more common to find red unraveled yarns dyed only with lac. Spectrographic analysis has been done on four of the red variations on this blanket. One is pure lac, one is thirty percent lac and seventy percent cochineal, another is five percent lac and ninety-five percent cochineal, and the last is a mixture of cochineal and logwood or brazilwood. This mix of red dyes does not ultimately help us to date this blanket precisely. Rather, it tells us that the weaver gathered, probably over a period of time, many different but small amounts of material. In addition to the four reds there are eight other colors obtained from unraveling yarns, and one that was obtained already as a yarn. The white and the light blue are handspun and, therefore, assumed to be local.

And what did this weaver do with all of this precious material? She wove an oversized blanket that was of an extraordinarily high thread count. In the center, the point that runs parallel to the spinal column, she put an opposing column of arrows with light pink triangles. A background of fine stripes, very difficult for one weaver to attempt on such a wide blanket, is broken by larger zigzag shapes that also appear as arrows as they move toward the side of the body. As the shoulder break divides the front from the back she used an expanded zigzag to emphasize the body's curve. The blanket, woven on an upright loom, would have been viewed ninety degrees differently while it was being woven than when it was worn. But the final relationship of the blanket to the body was completely understood by the weaver.

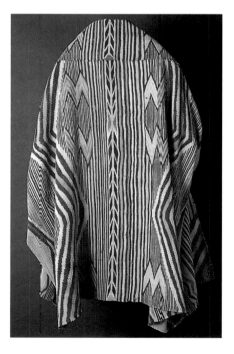

PLATE 253

Blanket (*Beeldléí*)

Navajo People

Arizona or New Mexico, U.S.A. 1830–1860

Tapestry technique, unraveled, machine-spun three-ply and handspun wool yarn

91 x 69" (231 x 175 cm.)

Existing blankets made prior to the Navajo's internment in 1863 at Bosque Redondo (or "the Long Walk" as it is referred to by the Navajo) are quite rare. Because there are few blankets documented from this period, information must be pieced together from the available technical data. The most important evidence is obtained from the dyes. Red was a very popular color with the Navajo. It was unobtainable from any local plant or mineral. The major source of red yarn was through unraveling fabric acquired as trade goods. This coarse wool cloth was sometimes brought from Europe, but it was also pro-

PLATE 254 (detail shown in Plate 2)

Blanket (*Beeldléí*)

Navajo People. Arizona or
New Mexico, U.S.A. 1860–1870

Tapestry technique; unraveled
and handspun wool

70 x 44½" (179 x 103 cm.)

It is obvious that the facing hands at the center
of this blanket are there for a reason. Most of
the literature on Navajo blankets states that
there is no symbolism in Navajo weaving, and
that blankets served a utilitarian function as
clothing or household textiles. Until blankets
began to be woven specifically for an Anglo
clientele from the East, very few displayed any
recognizable imagery. Recently, the Navajo
have examined nineteenth-century weavings in
museum collections and have added a new per-
spective. Their approach does not include the
specifics of dating, the types of materials, the
influence of outsiders on design, or the progres-
sion of design styles. They see these blankets
as part of their collective history. In traditional
Navajo thought history is animate, mystical time
recycles itself into recorded history, and the
remembered past is reinvested in the present.[16]
This circle of history, which is carried on as part
of today's weaving, is continued in order to
ensure harmony for the future.[17]

The synthesis of this cumulative thought
process does make it possible for designs to
have many meanings. Zigzag lines can refer to
rain, and beyond that to lightning and rain-
bows. The necessary acknowledgment of one's
position in the world in relationship to the four
directions is never far from the inclusion of a
cross in a blanket design. To separate out these
elements is a preoccupation of our mode of
analytical thinking, whereas – for the Navajo –
all of the parts, the zigzags, the diamonds, the
hourglass shapes, the crosses, the stripes, and
the hands form a synthesis that make a whole.

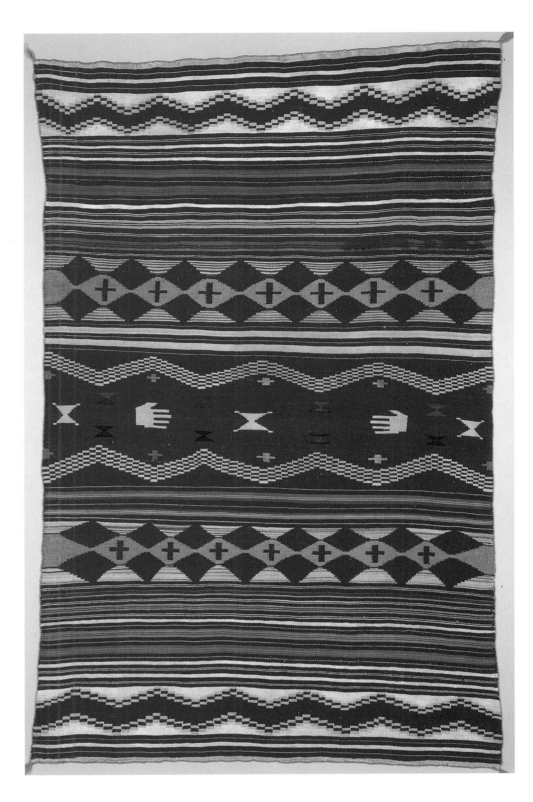

PLATE 255 (detail)

Rug

Navajo People. Arizona or New Mexico,
U.S.A. 1890–1900

Tapestry technique; handspun wool yarns

133 x 61" (338 x 155 cm.)

Commissioned perhaps for the long hallway of
a rancher's house, this rug illustrates the adapt-
ability of Navajo weavers. Because the weaving
was not intended to be worn, but rather to lay
flat and be seen from either end, the bilateral
symmetry is only in the width. Until the arrival
of synthetic dyes in the late 1860s and the sub-
sequent availability of commercially dyed and
spun yarns in the 1880s the Navajo palette was
limited. Their success with this wide range of
colorful yarns is amazing. Despite the lack of
vegetation,the Navajo landscape is filled with
color. As the sun moves across the sky, reflect-
ing down the canyon walls, light and shadows
move like the lines of this rug.

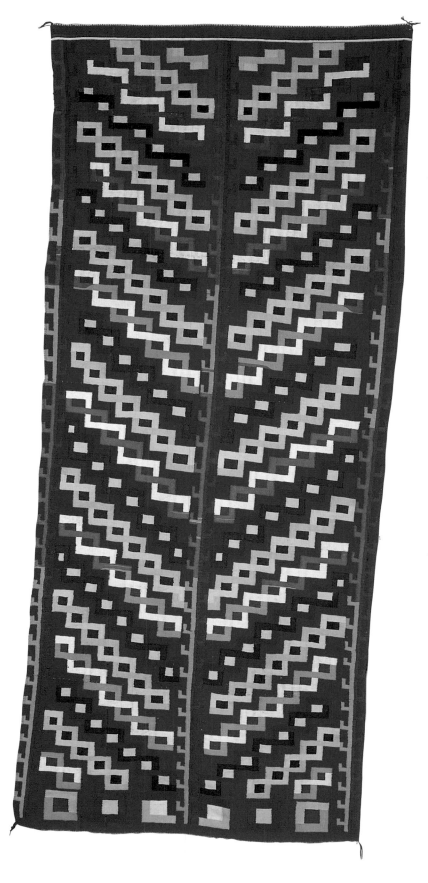

PLATE 256

Rug

Navajo People. Arizona or New Mexico,
U.S.A. 1895–1915
Tapestry technique; handspun wool yarns
93 x 52" (236 x 132 cm.)

Corn is the staple food of the Navajo. In some
areas of the reservation families will still move
from their winter house or circular hogan to a
summerhouse made of temporary materials so
that they can be near their fields. The Navajo
learned to plant corn from their neighbors,
the Pueblo, and with this knowledge came the
mythology associated with its origin.

The figures with their large hands and
raised arms are similar to petroglyphs found on
rocks throughout the Navajo lands. These draw-
ings done by the Navajo in the eighteenth or
early nineteenth century are a continuation of
an ancient tradition of Pueblo rock art – some of
which is closely related in style to these Navajo
petroglyphs. In some cases both are claimed by
the Navajo as a sign of their ancestors.[18]

This natural coloration of the background
is associated with the turn of the century period.
At that time the Reservation traders decided
that the Navajo had gone too far with the new
vivid colors. This had made their weavings un-
saleable for use in the darkened interiors of east-
ern residences, so they stopped ordering bright
colored yarns and dyes (with the exception of
red). Deprived of her accustomed palette the
Navajo weaver resourcefully used the range of
natural brown colors and varied them as she
built up each section of her weaving. On seeing
a similarly variegated blanket in a museum col-
lection, a Navajo woman recently remarked that
the shading of color and shifting of the weav-
ing direction was done "Because it shows the
progress of the people as they made their way
up to this world . . . moving from the darkness
below into the everyday sunshine."[19]

PLATE 257

Pictorial Weaving

Artist: Maria Nez, Navajo People. Arizona,
U.S.A. 1990

Tapestry technique; handspun wool yarns
50½ x 66½" (127 x 169 cm.)

In looking at this example of pictorial weaving, it is interesting to note that the composition is built up in horizontal rows, not unlike that of nineteenth-century blankets. The figures all face away from the viewer. The Navajo are usually uncomfortable in the presence of a camera. Another traditional aspect of the design is the omnipresent circle discussed in this chapter's opening essay. High points of the monumental landscape are outlined across the back so that we will be sure to sense their influence. So while this weaving was woven to be sold to an outsider, the essence of the Navajo world remains.

Weaving for the market or for trade has always been part of the Navajo economy. As soon as they learned to weave, Navajo women began to trade their weavings back to their original teachers, the Pueblo. Their well-made blankets were also part of the inventory taken to Mexico every fall by the Spanish settlers as part of their annual trade caravan. With the arrival of the Americans, and particularly the army, they had new clients – many of whom commissioned these fine blankets and paid well for them. The arrival of the railroad and the establishment of trading posts brought a much wider market that had particular tastes and needs. The Navajo adapted by ceasing to weave blankets and instead made their weavings sturdier so that they could be put on the floor as rugs. Rugs required borders and the traders supplied pictures of the currently popular Oriental style rugs and factory-produced floor tiles. The weaving of a Navajo woman always produced goods or income for the family. In a matriarchal society where the property is owned by the women, it is not surprising that the necessary adaptation to the market was accommodated. Weaving rugs is still an important part of the economy but the rug market is very competitive, so over the past few decades Navajo weavers have entered the Folk Art market, and this they have done most successfully.

PLATE 258

Mat

Menominee People. Great Lakes Area,
U.S.A. 1850–1900

Twined bass wood and rush

29 x 57" (71 x 139 cm.)

This mat was collected from an Ojibwa family
living at Red Lake, where it had served as a
wrapper for ceremonial paraphernalia. It is
most likely, however, to have been made by the
Menominee who wove mats of rush using this
particular variation of twining that forms a
reciprocal design between two colors.[20] The
placement of the two colors produces an undu-
lation that moves like a stream bordered by a
sandy bank. This reversal of imagery is an
implied visual play that is consistent with the
reciprocal and balanced relationship sought
between humans and other creatures, as well
as objects and phenomena.[21]

The flexibility and transportability of mats
made them one of a family's most important
possessions. They were used to sit on and sleep
on, and to form part of the house itself. Their
immense importance as part of daily life also
made them an appropriate holder of a sacred
bundle. The contents of such a bundle would
be a diagram of the cosmos, an expression of
balance and harmony between the sacred and
profane worlds. This reciprocal relationship
found in the design and technique of the mat,
therefore, is extended into its function.

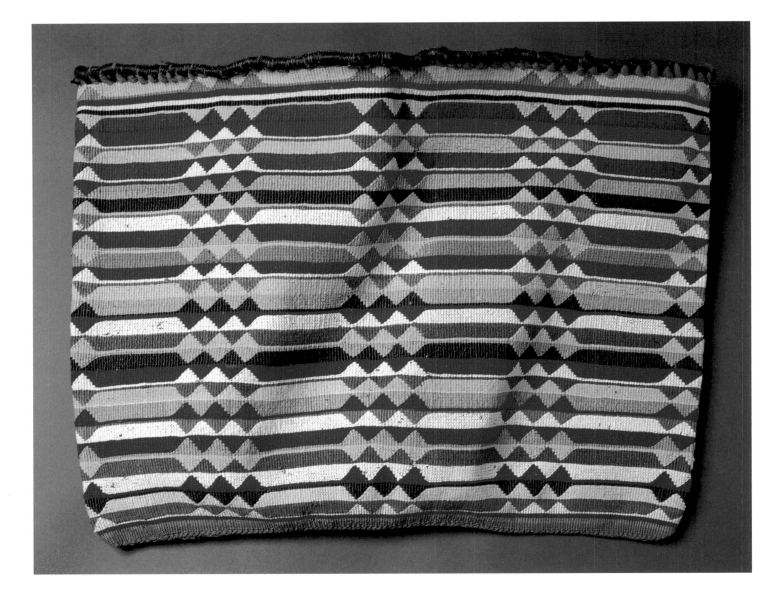

PLATE 259
Bag
Winnebago People. Wisconsin,
U.S.A. 1890–1940
Tapestry technique; twined cotton
cording with single-ply paired wool weft
30 x 22" (76 x 56 cm.)

The twining technique did not require any
equipment beyond a slender stick over which
to hang the warps. The weft yarns were totally
manipulated with the fingers. Therefore, it is
not surprising to find that examples of twining
have been found in nets, traps, and bags that
go back as far as 5000 B.C.[22]

Most of this early material was limited in
its color due to the restricted availability of
natural dyes and the necessary preservation of
their color. This bag draws from the wide range
of commercially dyed wool yarn and reveals an
acute understanding of color. As if the secrets
of color had been learned from nature, bands
of intense colors move alongside each other and
then form juxtaposing shapes at prescribed
intervals. No one color is dominant, rather each
is an essential part of a punctuated rhythm.

CHAPTER 14 # North America

BY SANDI FOX

At the end of the Revolution, the folk artist began to record the new America, rendering in paint and pencil, watercolors and ink, those accomplishments and activities the new and increasingly prosperous middle class wished to chronicle: the outer images of their success in the form of farms and homes, shops and factories; the historic events of their country and the landscape of their community and – in substantial numbers – of themselves in their personal environments. The itinerant artists who would paint these images of ordinary life were themselves often rural craftsmen, painters of signs and houses.

The renderings of this America past were simple and honest, set down not by academically trained observers but by "folk" who were themselves participants in that bold new adventure; there is a vigorous innocence in both the accomplishments and the interpretations.

American quilts and bedcovers are often defined within this genre, but the creative confidence with which folk artists (surely unconsciously) would eventually separate themselves from European traditions was not so apparent in the earliest American quilts. During the last quarter of the eighteenth century and into the early decades of the nineteenth, women were careful to see that what was fashionable in Europe was reflected in a very timely manner in their parlors and on their persons. News of such fashionable changes, particularly in aspects of dress, was eagerly received as quickly as ships bound for America from England and France could deliver just-published fashion journals and personal correspondence, the latter often containing small sketches of details and perhaps a bit of fabric. American quilts of the period utilized pieces of imported furnishing fabrics, as well as dress goods, and the binding on their outer edges often paralleled those finishing techniques in use then on fashionable dress.

The sophisticated surfaces of those early quilts and bedcovers were in fact more reflective of the formal decorative arts of the period than of the rather easy informality of the nation's folk art, emphasizing particularly careful composition and masterful technique. It was with that body of exceptional artisans that the quiltmaker shared a common vocabulary of designs. The pineapple, for example, was often quilted, stuffed, and corded on all-white quilts and bedcovers, and was elsewhere carved in wood, worked in silver, and etched on glass. By the 1840s, as domestic America moved more securely into its own national identity, new and more vigorous images had begun to parallel and eventually replace the more refined lines and workmanship of the earlier pieces. At roughly the same time the limners, those painters of "the folk," were themselves being replaced by the daguerreotype camera.

There are certain remarkable American quilts which, in concept and construction, are indeed more in the "folk" tradition, particularly those that are figurative, and occasionally narrative, in subject matter: Harriet Powers' two Bible quilts (about 1886 and 1898), for example, and the Museum of American Folk Art's "Sacret Bibel Quilt," probably worked by Susan Arrowood about 1895. But these came generally later in the century, and they are exceptions.

In the spring of 1971, an exhibition of sixty-one American pieced quilts – worked, in all probability, primarily on farms and in villages – was installed in the most urban of settings, at the Whitney Museum of American Art in New York City, in an exhibition curated by Jonathan Holstein and Gail van der Hoof, "Abstract Design in American Quilts." An earlier exhibition, "Optical Quilts," organized by The Newark Museum in 1965, had in fact addressed many of the same aesthetic issues in an exhibition of pieces drawn from its own and other collections. The New Jersey exhibition merited national attention in issues of *Time* and *Newsweek*, but until the Whitney show, quilts had continued to be only occasionally the focus of formal aesthetic evaluation. The Whitney exhibition, however, helped to bring about a profound change in the way much of America thought and talked and wrote about quilts.

Although hung in more modest surroundings in the century past, those staples of county fairs and ladies' bazaars had always been discussed in terms of color and composition, but such a discussion had generally been undertaken by the quiltmaker's peers and in a much less self-conscious manner. Now, within the framework of a formal art vocabulary, aesthetic judgments once applied principally to work on paper or canvas were applied with equal intensity to these softer surfaces.

In 1976, it was that community of early quiltmakers that was the focus of two California exhibitions: opening in July at the Los Angeles Municipal Art Gallery, "The Fabric of a Nation: Nineteenth-Century Quilts and Quiltmakers," curated by the author, and in September, at the San Francisco Art Institute, "Quilts in Women's Lives," curated by Pat Ferrero, Linda Reuther, Ann Shapiro, and Julie Silber. It was the bold graphic surfaces of the quilts at the Whitney that had captured the attention of the art community, but the two West Coast exhibitions considered in more deeply familiar form the women who made the quilts and the subtle threads – both personal and social – that bound the quiltmaker to her work. This attracted the attention of a new and more populist audience. As sentiment and sensibilities vied for pre-eminence, a more multi-disciplinary approach to the field of American quilts was in the making, creating a flurry of research both within and without the academic field. As artifacts of our material culture, quilts became a part of our national consciousness.

Within the Collection, quilts are represented in considerable number among the American textiles. The chronological composition of those presented here is roughly 1880 to 1940, the earliest a sturdy little log cabin quilt made for a child. That piece was worked nearly a century later than the architectural landscapes painted for that early middle class, and indeed it is women of the middle class who were the primary producers of quilts in nineteenth-century America. As with those itinerant image makers (and often working in the same bright colors and vigorous designs), quiltmakers were also the recorders of the history of the nation, their community, and themselves. The beginnings of our textiles industry, political campaigns and commerce, wars and the opening of the frontier, religious life and rites of passage, all impacted on the ordinary life of American quiltmakers, and in their work they chose to celebrate them all.[1]

PLATE 260

Quilting Party, by E. Wood Perry. 1876, oil.
(Photograph courtesy of Marguerite Riordan)

PLATE 261

Child's Quilt (detail)

United States of America. c. 1880

Pieced and quilted cotton and wool challis

30¾ x 25" (78.1 x 63.5 cm.)

Whirligig

United States of America. c. 1875–1900

Carved and painted wood

13 x 7½ x 12½" (33 x 19.1 x 31.8 cm.)

The log cabin, dwelling place of the American frontier, appeared in political profusion during the presidential campaign of 1840. Although William Henry Harrison had been born in a brick mansion, the log cabin was a symbol appropriated by the candidate and his Whig Party to appeal to a predominantly rural constituency that still viewed itself in the Jacksonian tradition. It appeared on multiple banners and broadsides to identify Harrison with the ordinary men who – a decade later – would be the subjects of George Caleb Bingham's paintings of political campaigning. His uniformed image on those various political textiles and tracts reminded the voters of General Harrison's distinguished service as the commander-in-chief of the North-

western Army during the War of 1812, but he was often depicted less formally near the cabin, plow at hand, identified as "Wm. H. Harrison/ The Ohio Farmer." It was an inspired strategy.

Since 1830, America's image of itself had been shaped in large part by rural and western themes in popular literature, by Currier and Ives prints, and by genre painters such as William Sidney Mount, whose work extolled the simple virtues of the yeoman farmer.[1] From those romanticized interpretations, and in remembered realities, the image of a log cabin constructed by a man with an ax in a clearing he himself had carved out of the surrounding wilderness became synonymous with those simple, honest, individualistic qualities perceived as being integral to the American character.

Mid-century, the log cabin was realistically rendered, often in imported cottons, on a handful of appliquéd quilts, but by the last quarter of the nineteenth century a quiltmaker's celebration of that sturdy shelter was more often than not an abstraction, a geometric quilt block worked with striking similarities to the construction of the cabin itself. Individual "logs" of fabric were cut and sewn around a small, red, center square that tradition holds is meant to represent the hearth and heart of a log cabin. When the blocks are joined together, the diagonal contrasts in light and dark fabrics seem to suggest those cabins and clearings in the piney woods. In other arrangements, the blocks suggest, as they do on this child's quilt, *Courthouse Steps*. *Straight Furrow* and *Streak of Lightning* are other variations that do indeed evoke images of the rural landscape.

Both rural and urban landscapes of the period were populated with sculptural objects in many forms: tobacconist figures and advertising art, decoys and weather vanes. Those dimensional delights were in fact utilitarian by nature, but perched perhaps on a fencepost one might find the work of an itinerant carver, a whirligig created solely to amuse. Pennsylvania Germans may have brought the memories of these whirling figures to America: an eighteenth-century European tradition, the earliest examples here represent Hessian mercenaries, German soldiers who remained here after fighting for the British during the American Revolution.[2] A century later, the star-holding propeller arms of Uncle Sam reached out to catch the wind.

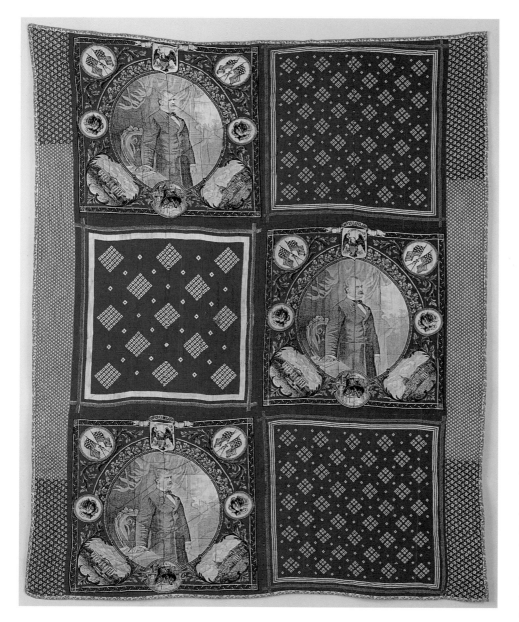

PLATE 262
Quilt
United States of America. c. 1888
Pieced and quilted cotton
65 x 53½" (165.1 x 135.9 cm.)

In a political convention hall in 1876 "…handkerchiefs were brought forth and swung to and fro like snowflakes in a hurricane."; it was a scene repeated in 1884 when "…a thousand white handkerchiefs swung over the heads of the excited audience, dotted the hall with specks of white, like caps of the breakers on a stormy sea."[3] In the 1888 presidential campaign between Grover Cleveland and Benjamin Harrison (the General/farmer's grandson), both men used that political device, but in the Cleveland campaign the white "handkerchief" was replaced primarily and symbolically with the red bandanna, the "handkerchief" of the common working man.

Children were eager participants in political campaigns and would surely have been among the 12,593 New York Democrats who paraded in the rain, bandannas tied around their necks, to welcome Grover Cleveland driving in his buckboard.[4] Years later, one would still remember that *In 1888 Grover Cleveland's running mate was an old Democrat [Senator Allen G. Thurman of Ohio] and he used none but bandanna handkerchiefs. As a mark of loyalty, millions of Democrats bought silk ones for their girls and even flew red bandannas from the buggy whips of their favorite horse-drawn vehicle.*[5] Those silk mementos were generally tucked away, but cotton bandannas often found their way onto American quilts; three of the turkey-red Cleveland bandannas were saved from the buggy whips to be used on this seemingly partisan surface.

Surprisingly, and significantly, this is a politically reversible quilt. Bunting is the inexpensive cotton used to drape political meeting halls and parade routes, and rectangles cut from a number of star-spangled varieties appear pieced together on the second side of the quilt. At their center is a bandanna-size blue and white square printed only with Harrison's slogan, "Protection to Home Industries." This economic issue dominated the campaign; on one occasion, Thurman waved his red bandanna and announced to his cheering supporters, "Well gentlemen, this is a good, honest handkerchief, and I could have bought it a good deal cheaper if it had not been for the tarriff [sic] tax."[6] Tariffs and Harrison triumphed, and bunting and red bandannas became a quilted souvenir.

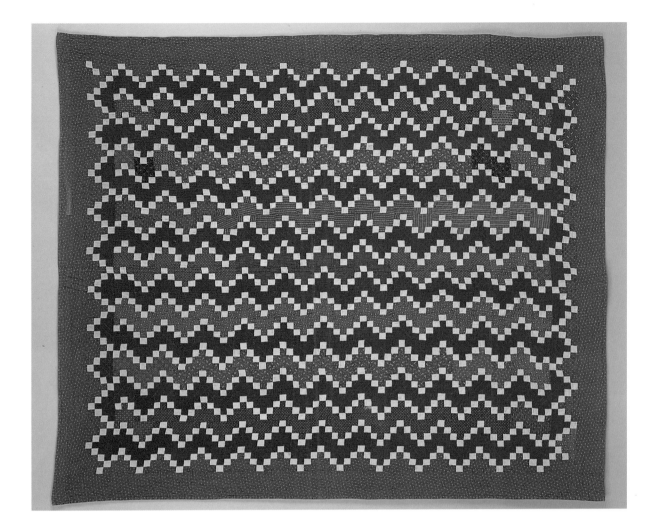

PLATE 263

Quilt

United States of America. c. 1890

Pieced and quilted cotton

76 x 64½" (193 x 163.8 cm.)

The advice manuals on which mothers relied, and their own remembrances of childhood, indicate that one of the earliest domestic skills a young girl would have been expected to master was that of "plain sewing." This aspect of her education was often begun with the piecing of a fundamental four- or nine-patch cotton quilt block. The perfection of small, even, running stitches on simple seams would be basic to the construction of her family's clothing – it would also be indispensable to the continuing tradition of this nation's quilts.

Early nineteenth-century American quilts reflected the continuing influences of their European beginnings. The fashionable preference was for imported fabrics (particularly copperplate toiles and printed and painted chintz) and the quilts were worked with diverse and sophisticated techniques: elaborate appliqué, stuffed and corded quilting, and embroidered embellishment, for example.

It was in the aesthetic development of the utilitarian pieced quilt, however, that the quiltmaker seemed most remarkably inventive. The squares and rectangles that form the visually complex design of the quilt shown here are those simple shapes from which the quiltmaker constructed her first blocks, and it is those same simple seams by which they are joined. Printed cotton is the cloth from which the majority of these quilts were worked and, as such, they have become physical documentation (and often final repository) for a significant number of American textiles.

The single red printed cotton used throughout this quilt may have been purchased new for the project, but the quilt also holds varying amounts of fifteen different blue and white prints and these may well have come from the maker's scrap basket, pieces remaining after she had cut the larger shapes that would form her dresses or her husband's shirts.

PLATE 264

Hooked Rugs
United States of America. c. 1910
Hooked cotton on burlap
Top: 28¼ x 37¾" (71.8 x 95.9 cm.)
Bottom: 29¼ x 43¾" (74.3 x 111.1 cm.)

In addition to rag carpets and braided rugs, a variety of smaller rugs began to appear on nineteenth-century floors. These yarn-sewn and shirred rugs were both based on European techniques, as was almost all needlework being done during that period. Worked by rural hands, they seem to have been indigenous to Maine and the Maritime Provinces.[8] The cotton or linen that had formed the ground fabric for those often more elegant versions was replaced with burlap sacking, widely available in North America by the 1850s. The new-found ease with which strips of fabric could be drawn with a hook through that coarser, more loosely woven, ground cloth encouraged a joyful spontaneity in design. Vigorous geometric patterns found favor, but it is the depiction of primitive flowers and farms, horses and houses, and ambitious figurative scenes on those relatively small surfaces that seem to reflect most clearly the rural origins of the rugs. They are perhaps at their most endearing in their depiction of cats and dogs, probably the family's pets and often shown on a simulated rug indicating their place within the home. Each motif offered the opportunity for extraordinarily individual interpretation; the often-used striations that surround the dog in this early twentieth-century rug are anchored by four charmingly misshapen hearts.

Perhaps because it was so specifically a rural craft, rug hooking was never embraced by those ladies' magazines that directed the more fashionable needlework being done in urban parlors. No nineteenth-century needlework manuals addressed the technique of rug hooking.[9] In an 1888 edition of the *Biddeford* (Maine) *Times,* however, Edward Sands Frost related the chronology of his contributions to the craft, and in so doing gives us some of the details elsewhere ignored:

It was during the winter of '68 that my wife, after saving quite a quantity of colored rags that I had collected in my business as a tin peddler, decided to work them into a rug. She went to her cousin, the late Mrs. George Twombley, and had her mark out a pattern, which she did with red chalk on a piece of burlap. After my wife had the piece properly adjusted to her quilting frame, she began to hook in the rags with the instrument then used in rug making, which was a hook made of a nail or an old gimlet. After watching her work a while I noticed she was using a very poor hook, so, being a machinist, I went to work and made the crooked hook which was used so many years afterward in the rug business....[10]

While testing his new hook as to size, Frost "caught the fever" and went on to develop and produce preprinted burlap patterns, the first offerings being sold from the back of his peddler's wagon. Fortunately, rural American rug hookers seem to have been unfettered by commercial designs; they continued to distinguish themselves and their craft through the naive exuberance they applied to their rural visions.

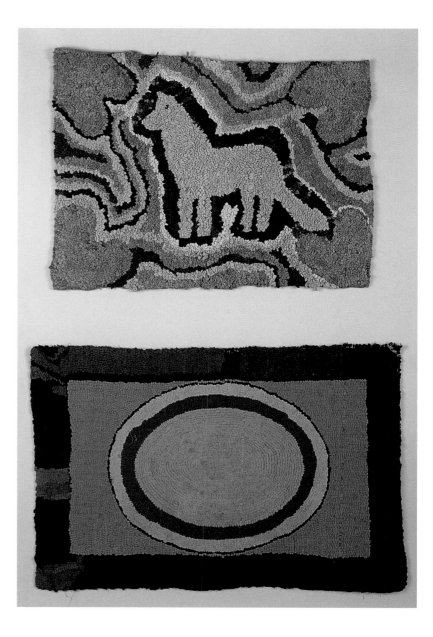

PLATE 265
Crazy Quilt
Made by or for Grace V. Myers
United States of America. 1925
Pieced, appliquéd, and embroidered velvet
74⅜ x 73½" (189.9 x 186.7 cm.)

Artists and artisans included their names and marks on paintings and porringers to let us know what they made, and travelers on the Oregon Trail were often moved to carve or scratch their names on massive rock surfaces such as Independence Rock or Register Cliff to tell us where they had been. In addition to the name or cross-stitched initials confirming her authorship of the object, a quiltmaker often secured names and signatures for the surfaces of her quilts where, as on those great rocks, they often appear by the dozen, or in the hundreds. They were scribed and stenciled, stamped and stitched; these recorded friendship and kinship and – in the case of commemorative or fund-raising quilts – a generosity of spirit and purse.[11]

The recording of names was obviously more restrained on this compartmentalized crazy quilt – only three have been inscribed: Grace V. Myers, Walter W. Myers, and Walter W. Myers Jr. The surface design is itself restrained, removed by two decades from the more elaborate crazy quilts of the last of the nineteenth century, those quilts whose surfaces were almost overwhelmed with asymmetrical pieces of silk and bits of bro-cade and commemorative ribbons, with embroi-dered images such as the vases and spiders and dragonflies made popular following the surge of interest in the Japanese exhibits at the Cen-tennial Exhibition in Philadelphia in 1876.[12] Here, using the same technique by which those earlier extravagances were constructed, large pieces of velvet were laid, overlapping, onto a foundation block. Save for the detached chain stitches and french knots on the central circle of each block, the folded edges were very mod-estly secured with the same embroidered chain stitch with which the signatures and a date, "1925," were worked.

Quilt
Upstate New York, U.S.A. c. 1885
Pieced and embroidered silk, velvet,
velveteen, and cotton sateen
69¾ x 68¾" (177.2 x 174.6 cm.)

The well-equipped Victorian parlor would have held a series of optical amusements: kaleidoscope and zoetrope, stereopticon and magic lantern. The quiltmaker found she could also simulate movement and dimension from the flat objects that were the pieces for her quilt blocks.

This New York quilt is a luminous example of the illusionary qualities occasionally achieved, by accident or by intent, through the quiltmaker's use of color and composition. It was primarily the mid-nineteenth-century's increasing prefer-ence for the block style of construction that presented these optical opportunities. Here the basic unit of construction is a simple *Fan* block, four of which were used in the visual realization of each of sixteen large circular units. The circu-lar elements were more clearly defined when the pastel feather and herringbone stitches that covered the curve of each fan were extended on across the velvet strips that held the units together. But there was a further geometric divi-sion of each outer arch, and when those touched, the quilt became additionally a field of four-pointed stars, in full and in halves. As the quilt-maker's eyes moved from pattern to pattern, from circles to stars, she may have complimented herself on the successful execution of a carefully planned visual exercise or – as surely was often the case – it may have been a stunning surprise!

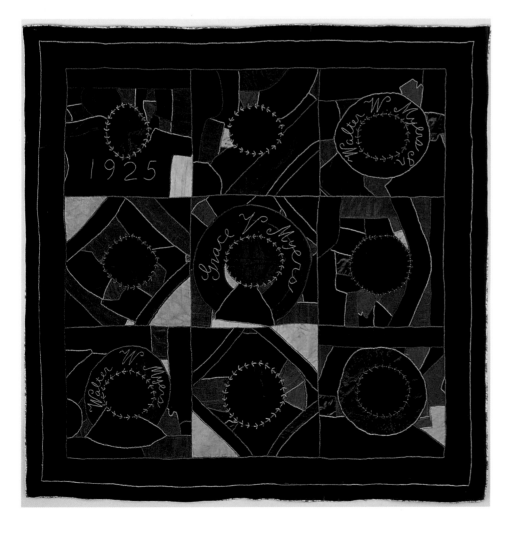

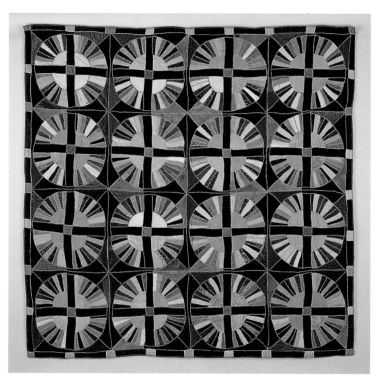

PLATE 267

Quilt

Amish. Made by Rachel King

Lancaster County, Pennsylvania, U.S.A. c. 1920

Pieced and quilted wool challis

79½ x 77" (201.9 x 195.6 cm.)

With only a few estate papers testifying to the existence of Amish quilts in the 1830s, and precious few extant early examples thereafter, the establishment of a tradition of quiltmaking in that Anabaptist community seems not to have occurred before 1870–1880.[13] Then, in those last decades of the nineteenth century and the first few of the twentieth, a number of absolutely extraordinary quilts emerged from that unexpected source. Amish quilts, especially those worked in Lancaster County, Pennsylvania, are represented in this Collection in substantial numbers.

The format of the classic Lancaster County quilt is that of the square medallion style preferred by the "English" (non-Amish) early in the century, but by this period long an outdated preference. Within that format, the earliest patterns were the *Center Diamond, Diamond in the Square,* and *Bars,* the pattern worked here by Rachel King in the twentieth century. The large squares and rectangles were cut originally from lightweight wool in rich saturated colors, the whole surface was then covered with a secondary pattern in the form of intricate quilting designs worked in tiny stitches in subtle dark thread. As on Rachel's quilt, the central field of those early quilts was usually worked in a plain cross-hatch pattern. More elaborate designs were introduced early in the twentieth century: Rachel, for example, quilted an undulating grapevine with leaves and fruit onto her inner border.

These quilts were worked within the framework of a plain, devout, agrarian society whose regulations, restraints, and rewards were encoded in their stunning, deceptively simple surfaces.[14] It is through those quilts, their presence now almost commonplace on museum walls, that we have come to define Amish sensibilities.[15] They were no less splendid hanging on clotheslines in the yards of the modest farmhouses in which they were created.

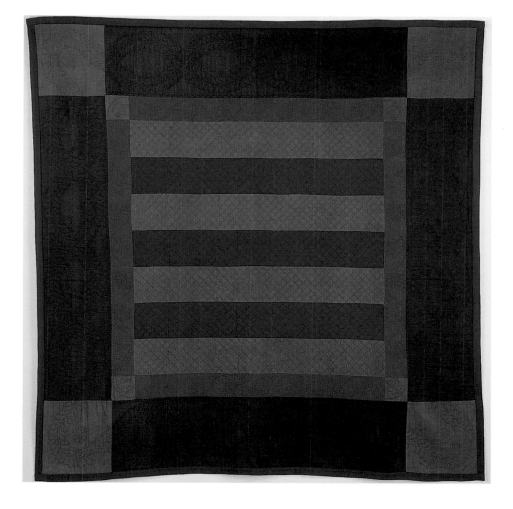

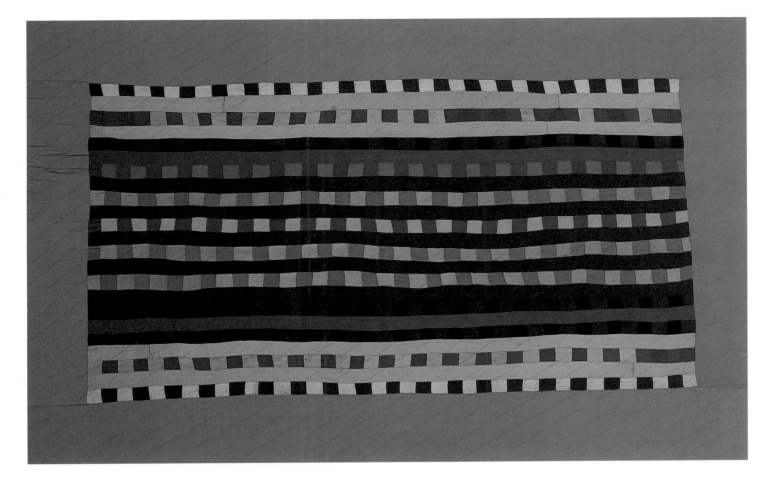

Child's Quilt
Amish. Midwest (probably Ohio or Indiana),
U.S.A. c. 1940
Pieced and quilted cotton
58½ x 36" (148.6 x 91.4 cm.)

Throughout the nineteenth century, the same pieced patterns used for full-sized quilts were translated almost intact onto the smaller surfaces of those that covered America's children. By the 1940s, when this quilt was worked, many quilt-makers chose designs more figurative in nature, motifs drawn from the scenes of childhood and often selected from the number of commercial patterns available.[16] Not surprisingly, the quilts for Amish children continued in the plainer tra-dition. In the plainest of those traditions, in fact, such quilts were a rarity; nineteenth-century Old Order Amish in Lancaster County seem sel-dom to have worked these smaller pieces. This was not the case in midwestern Amish communi-ties, and significant examples remain to document the practice, particularly in Ohio and Indiana.

The Amish had come to Ohio in the early part of the nineteenth century, and by the 1840s settlements had been established in Indiana by many of those Ohio Amish and by new waves of European Amish and Mennonite immigrants. There were new problems to be addressed (an approaching religious schism and, as with all pioneers, developing new homes and farmlands on the prairies), and as that century turned into the twentieth, there were new quilts to be worked.

The Lancaster quiltmaker had directed her creative attention to the complex quilting pat-terns she chose to work over the large and limited patterns acceptable to that Old Order commu-nity. Ohio and Indiana shared new preferences, and intricately pieced cotton quilts began to distinguish the work in more liberal church dis-tricts. The *Chinese Coins* selected for this child's quilt was from a now extensive repertoire of patterns, many adopted from outside or "English" designs and often enhanced by complex borders such as *Sawtooth* or *Zigzag*. Creative energies perhaps exhausted, the quilting stitches usually performed a purpose more functional than ornamental, often (as here) only parallel lines across the crisp, bright surface.

PLATE 269

Costume

Amish. United States of America. c. 1920

Machine- and hand-sewn cotton dress
and bonnet; knit wool stockings

Dress: 19 x 24½" (48.3 x 62.2 cm.)

Bonnet: 8 x 5½" (20.3 x 14 cm.)

Stockings: 12 x 4¼" (30.5 x 10.8 cm.)

The clothing in which the Amish are dressed is a visual symbol they wear to separate themselves from the *anner Satt Leit*, the "other sorts of people," and to bind them to their own. Amish costume, linked to a rural European tradition, is visually characterized by its plainness, but in its cloth, its cut, and its construction it is interwoven with details predetermined by general orthodoxy and by the specific community within which it is worn.[17] One's group identity, for example, might be determined by so minor an item as suspenders. The most traditional did not allow their use, others permitted only one; storebought were allowed or were not; some were crossed at the back, others were required to form a "Y."

The most symbolic element of the costume for women and girls is the white *Kapp*, essentially unchanged from those they had worn in the Palatinate, save for certain regional variations. The smallest details on these sheer organdy caps are symbolically significant to each community: the width of the front, back,

seams, and pleats. Bright colors were generally permitted for the women's one-piece dresses, as long as the color was both solid and plain. Three white buttons secure the closing of this twentieth-century child's dress, although in earlier days and in other older orders these would have been forbidden. Buttons had been rejected as ostentatious and militaristic in their European beginnings, hooks-and-eyes or straight pins being preferred. Although functional in nature, the visible white sewing machine stitches prove a probably unintentional decorative detail.

If the details of the dress and the organdy cap are symbolically prescribed, what then are we to make of these scalloped stockings? Current research suggests these complex borders were more often knit for adults, primarily in Lancaster County between 1860 and 1920, and possibly from mill end Germantown yarns.[18] They were surely a small secular tradition, but it is a tradition lost. In that brief glimpse of color – green, red, yellow, and white – we see that plainness did not preclude pleasure.

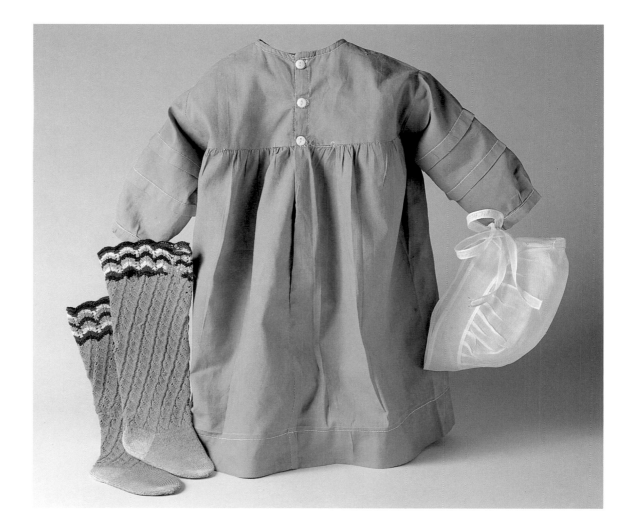

Notes

TEXT

Chapter 2
A Collector's Pleasure

1. Excerpt from *Essays on Mexican Art* by Octavio Paz, copyright © 1987 by Fondo de Cultura Economica, S.A. de C.V., English translation by Helen Lane copyright © 1993 by Harcourt Brace & Company, reprinted by permission of Harcourt Brace & Company.

2. Ibid., p. 58.

3. Curiosity Cabinets.

4. Barbara Stafford, "Cross cortical Romance: Analogy, Art and Conciousness," *Art issues,* 42 (March–April 1996): 22–24.

5. Patrice Hugues, *Le langage du Tissu* (Le Havre, Duboc, 1982): 452–453. Translated by Eudice Daly.

6. Rebecca Stone-Miller, *To Weave for the Sun* (Boston, Museum of Fine Arts, 1992): 22.

7. Diane Fane, *Objects of Myth and Memory* (Brooklyn, The Brooklyn Museum\University of Washington Press, 1991): 13.

8. William Rubin, *"Primitivism" in 20th Century Art* (New York, The Museum of Modern Art, 1984): 7.

9. Calvin Tomkins, *The New Yorker* Vol. 72 (November 25, 1996): 92.

10. Ibid., p. 92.

11. *Webster's Third New International Dictonary,* (Springfield, Mass., Merriam Webster, 1986): 882.

Chapter 3
Japan

1. Kitamura, *Senshoku: Dentô Kôgei* (Dyeing and Weaving: Traditional Crafts), *Nihon no Bijutsu* (Arts of Japan) no. 307 (1991): 21–27.

2. Reiko Mochinaga Brandon, *Country Textiles of Japan: Art of Tsutsugaki.* (New York/Tokyo: Weatherhill, 1986): 38–42.

3. Ibid., pp. 34–35, describes the *tsutsugaki* technique step by step.

4. Iwao Nagasaki, *Chônin no Fukushoku* (Townsmen's Costumes), *Nihon no Bijutsu* (Arts of Japan) no. 341 (1991): 66–68. *Machi hikeshi, volunteer fire brigades of townsmen, were established by Edo's municipal government in 1718 to protect commoners' residential areas.*

5. On mainland Japan, appliqué technique has been used mostly for functional purposes. Square patches could be sewn over a hole or to reinforce a worn area of a worker's or a farmer's garment.

6. Akira Tonaki, "Kijoka no Bashôfu (Banana Fabrics of Kijoka)," in *Ningen Kokuhô Shirîzu (Living Treasures Series)* Jo Okada, ed., no. 41 (1977): 16–36.

7. The term *yûzen* is said to come from the name of a popular fan painter of the mid-Edo period, Yûzensai, whose miniature designs within framing devices appear to have influenced *yûzen* designs.

8. Brandon, *Country Textiles of Japan: Art of Tsutsugaki*: 32. Describes the seven steps of the *yûzen* dyeing process.

9. Kitamura, "Yûzenzome (Yûzen Dyeing)," p. 18.

10. Kitamura, *Senshoku: Dentô Kôgei*: 18–20. The law includes "theater, music, crafts and other cultural products" but here we are only concerned with textile craft.

Chapter 5
South and Southeast Asia

1. A. H. Johns, "Sufism as a Category in Indonesian Literature and History," (*Journal of Southeast Asian History*, 1961): 2.

Chapter 8
Europe

1. Paul Hulton and Lawrence Smith, *Flowers in Art from East and West.* (London: British Museums Publications Limited. 1979): 11

2. Ibid., p. 16.

3. Betty Ring, *Needlework: An Historical Survey.* (New York: Main Street/Universal Books. 1975): 17.

Chapter 9
Africa–Sub-Sahara

1. See, for example, K. Anthony Appiah, *The Arts of Africa, New York Review of Books* XLIV, no. 7 (1997): 46–51.

2. Monni Adams, "Kuba Embroidered Cloth," *African Arts* XII, no. 1 (1978): 24–39, 106.

3. Lisa Aronson, "Ijebu Yoruba *Aso Olona*, A Contextual and Historical Overview," *African Arts* XXV, no. 3 (1992): 63.

Chapter 10
Africa–Congo

1. Jan Vansina, *Le Royaume Kuba.* (Tervuren: Musée Royale de l'Afrique Centrale, 1964): 98–103.

2. Emil Torday and T. A. Joyce. *Notes ethnographiques sur les peuples communément appelés Bakuba, ainsi que les peuplades apparentées: les Bushongo.* Annales du Musée Congo belge (Tervuren), Ethnographie-Anthropologie. Série IV vol. 2. [Brussels: Ministère des Colonies, 1910); cf. Mary Lou Hultgren and Jeanne Zeidler, *A Taste for the Beautiful* (Hampton, Va.: University Museum, 1993).

3. Vansina, *Royaume*: 126–134. Titleholders administered courts, represented the regions or the villages, and exercised police and religious authority. Census taken at end of 1978 recorded 199,120 persons (Joseph Cornet, *Art Royal Kuba.* Milan: Edizione Sipiel, 1982): 16.

4. Cornet, *Art Royal*: 181–248.

5. M.W. Hilton-Simpson, *Land and Peoples of the Kasai* (London: Constable, 1911): 92–94.

6. Patricia Darish, "Dressing for the Next Life," in *Cloth and the Human Experience,* ed. A. Weiner and J. Schneider (Washington, D.C.: Smithsonian Institution, [1989]), 124–127. The Kuba are matrilineal. Most villages are small, with populations of 200 to 400, composed of several lineage sections.

7. Cornet, *Art Royal*: 157–179.

8. Conway Wharton, *The Leopard Hunts Alone* (New York: Fleming H. Revell Co., 1927): 43–44.

9. Monni Adams, "Kuba Embroidered Cloth," *African Arts* 12, 1 (1978): 24–39, 106–107.

10. Donald Crowe, "The Geometry of BaKuba Art," *Journal of Geometry* 1–2 (1971): 169–182.

11. Emil Torday, *On the Trail of the Bushongo* (London: Seeley Service; Philadelphia: J.B. Lippincott, 1925): 110.

12. Patricia J. Darish, "Dressing," pp. 130–132.

13. Torday and Joyce, *Notes ethnographiques*: 189–190; Angelika Stritzl, Die Gestickten Raphia-Plüsche (Vienna, unpublished dissertation, 1971): 72–75.

14. Patricia J. Darish, "'This Is Our Wealth,'" *Bulletin/Annual Report 1993–5, Eivehjem Museum of Art* (Madison: University of Wisconsin, 1995): 60.

15. Joseph Cornet, Mission au Bushoong et Shoowa, Book 7 (1974), December 16.

16. Angelika Stritzl, Die Gestickten Raphia-Plüsche. 89–102.

17. Torday, *On the Trail,* 207.

18. Darish, "Dressing," p. 135.

Chapter 11
Andes

1. Henrique Urbano, "Wiracocha y Ayar, Heroes y funciones en las sociedades andinas." *Biblioteca de la Tradicion Oral Andina,* Cuzco: Centro de Estudios Rurales "Bartolome de las Casas"3 (1981): xxxiii.

2. See Bernardo T. Arriaza, "Beyond Death: The Chinchorros Mummies of Ancient Chile," Washington, D.C.: Smithsonian Institution Press, 1995.

3. See William J Conklin, "The Revolutionary Weaving Inventions of the Early Horizon." *Nawpa Pacha* 16, (1978): 1–18.

4. See Alan Sawyer, *Early Nasca Needlework* (London: Calmann & King, Ltd., 1997).

5. See William J Conklin, "Structure as Meaning in Andean Textiles" in *Andean Art at Dumbarton Oaks,* 2, Boone, Elizabeth, ed. (Washington, D.C.: Dumbarton Oaks. 1996): 321–328.

6. See William J Conklin, "Moche Textile Structures" in *The Junius B. Bird Pre-Columbian Textile Conference.* Rowe, Ann Pollard, Elizabeth P. Benson, and Anne-Louise Schaffer, eds. (Washington, D.C.: Textile Museum and Dumbarton Oaks. 1973): 165–184.

7. See Ann Pollard Rowe, *Costumes and Featherwork of the Lords of Chimor: Textiles from Peru's North Coast.* Washington, D.C.: Textile Museum, 1984.

8. See Veronica Salles-Reese, *From Viracocha to the Virgin of Copacabana: Representation of the Sacred at Lake Titicaca* (Austin, Texas: University of Texas Press: 1997).

9. See William J Conklin, "Tiwanaku and Huari: Architectural Comparisons and Interpretations" in *Huari Administrative Structure: Prehistoric Monumental Architecture and State Government,* Isbell, W. H., and G. McEwan, eds. (Washington, D.C.: Dumbarton Oaks. 1991): 281–291.

10. See Mary Frame, *Andean Four-Cornered Hats: Ancient Volumes* (New York: The Metropolitan Museum of Art. 1990).

11. See Rebecca Stone-Miller, *To Weave for the Sun: Ancient Andean Textiles* (New York: Thames and Hudson. 1992).

12. See William J Conklin, "The Ampato Textile Offerings" *Proceedings, Textile Society of America,* 1996 (in press).

13. See Laurie Adelson, and Arthur Tracht. *Aymara Weavings: Ceremonial Textiles of Colonial and 19th Century Bolivia* (Washington, D.C.,: Smithsonian Institution Traveling Exhibition Service. 1983).

14. See Bruce Mannheim, "A Nation Surrounded" in *Native Traditions in the Post-Conquest World.* Boone, Elizabeth, and Tom Cummins, eds. (Washington, D.C.: Dumbarton Oaks. 1997): 381–418.

Chapter 14
North America

1. Illustration and text in Sandi Fox, *Wrapped in Glory: Figurative Quilts and Bedcovers 1700-1900* (Los Angeles: Los Angeles County Museum of Art and Thames and Hudson, 1990): 136–141, 150–153.

CAPTIONS

Chapter 5
South and Southeast Asia

1. S.M, Mead, *Traditional Maori Clothing: A study of Technological and Functional Change* (Wellington, Australia: A.H. & A.W. Reed, 1969): 140–141.

2. Felix Speiser, *Ethnology of Vanuatu*: 239.

3. Ibid., p. 172.

4. David Hicks, *Islands and Ancestors*: 145.

5. Ibid., p. 149.

6. Robyn Maxwell, *Textiles of Southeast Asia*: 128.

7. Bronwen and Garrett Solyom, *Fabric Traditions of Indonesia*: 10.

8. Ruth Barnes. *The Ikat Textiles of Lamalera: A study of an Eastern Indonesian Weaving Tradition,* Studies in South Asian Culture, Janice Stargardt. ed. Vol. XIV. (Leiden: E.J.Brill, 1989): 131–135.

9. Maxwell, Idem., p. 137.

10. Hetty Nooy-Palm, "The Sacred Cloths of the Toraja: Unanswered Questions," *To Speak with Cloth* (Los Angeles Museum of Cultural History, University of California, Los Angeles, 1986): 166.

11. Ibid, p. 173.

12. Idem., Maxwell, plate 329.

13. Roy W. Hamilton, *Gift of the Cotton Maiden*: 99–111.

14. Marie Jeanne Adams, "System and Meaning in East Sumba Textile Design: A Study of Traditional Indonesian Art," (New Haven, Southeast Asian Studies Cultural Report Series 16, Yale University, 1969): 130.

15. Marie Jeanne Adams, "Design in Sumba Textiles: Local Meaning and Foreign Influences," (Washington D.C. Textile Museum Journal, Vol. 3 No. 2. 1971): 30.

16. In the late 1980s Garrett Solyom made a number of short intense exploratory trips to different parts of Lampung, and surrounding areas of South Sumatra, Indonesia. Together with preceding and succeeding research this was the initial stage towards producing a book manuscript on Lampung with Anita Spertus and Jeff Homgren which is the basis for some of the information in this and the following two captions.

17. Idem., Maxwell, pp. 379–381.

18. Rens Heringa, *Fabric of Enchantment*: 192.

19. Jasleen Dhamija, "The Geography of Indian Textiles: A Study of the Movement of Telia Rumal, Asia Rumal, Real Madras Handkerchief, George Cloth and Guinea Cloth." Delivered at the *Indonesian and Other Asian Textiles: A Common Heritage Conference,* Jakarta, 1994.

20. John Guy, *Woven Cargoes: India Trade Textiles in Southeast Asia and Japan,* (London: Thames and Hudson, forthcoming).

Chapter 7
Mediterranean

1. Elizabeth J.W. Barber, *Prehistoric Textiles: The Development of Cloth in the Neolithic and Bronze Ages with Special Reference to the Aegean.* (Princeton, N.J.: Princeton University Press, 1991): 78.

2. *Proverbs* 31.19

3. Dora Jane Hamblin, "Delicious! Ah! What else is like the gondola?" *Smithsonian* (July 1987): 96–105.

Chapter 8
Europe

1. Kathy Epstein. " Mexican Embroidery Samplers: Stitching Together Four Centuries, Three Traditions." *Piecework: All This By Hand.* Vol. V, no. 3 (1997).

2. Anne Marie Benson. Personal communication to Curator: Judith Chiba-Smith, March 1997. Museum of International Folk Art, Santa Fe, New Mexico

3. Joanne Harvey. "and those that shall inquir… An Historical Survey of Seventeenth-Century Needlework Cabinets." *Samplers & Antique Needlework: A Year in Stitches.* (Birmingham, Alabama: Symbol of Excellence Publishers, Inc., 1994): 61–67.

4. Irene Emory. *The Primary Structures of Fabrics: An Illustrated Classification.* New York: The Spiral Press. 1966: 247.

5. John Irwin and Katharine B. Brett. *Origins of Chintz.* (London: Her Majesty's Stationary Office, 1970)

6. Lettice Sandford and Philla Davis, "Corn Dollies and How to Make Them" (Hereford, England, The Hereford Federation of Women's Institutes, 1958, vol. 1): 3–5.

7. Viveka Hansen. *Swedish Textile Art: Traditional Marriage Weaving from Scania, The Khalili Collection of Textile Art:* Volume I. (United Kingdom: The Nour Foundation in association wiht Textile & Art Publications, 1996): 39.

8. Jacqueline Onassis, ed. *In the Russian Style* (New York: The Viking Press, 1976): 141.

9. Alison Hilton. *Russian Folk Art* (Bloomington and Indianapolis: Indiana University Press. 1995): 86

Chapter 9
Africa–Sub-Sahara

1. Textile patterns found in archaeological contexts illustrated on pages 78–79 of Venice Lamb, *West African Weaving* (London: Duckworth 1975), can be found in modern examples.

2. See Labelle Prussin, *Hatumere: Islamic Design in West Africa* (Berkeley and Los Angeles: University of California Press 1986): 92–93.

3. This is discussed in Lisa Aronson, "History of cloth trade in the Niger Delta," *Textile History,* II, The Pasold Research Fund Ltd. (1980): 95–97.

4. See for example, Paula Ben-Amos, "Owina n' Ido": Royal Weavers of Benin. *African Arts* II, 4. (1978): 48–53.

5. Monni Adams and I. Rose Holdcraft, "Dida woven raffia cloth from Côte d'Ivoire," *African Arts* XXV, 3 (1992): 51.

6. See Venice Lamb and Alistair Lamb, *Tissage au Cameroon* (Roxford, Hertingfordshire, Hertingfordbury 1981): 142–165.

Chapter 10
Africa—Congo

1. Emil Torday and T.A. Joyce. *Notes ethnographiques sur les peuples communément appelés Bakuba, ainsi que les peuplades apparentées: les Bushongo.* Annales du Musée Congo belge (Tervuren), Ethnographie-Anthropologie. Série IV vol. 2. (Brussels: Ministère des Colonies. 1910): 190. See also Coats & Clark's Book No 150–A. *One Hundred Embroidery Stitches.* 1975. Stamford Ct.: Coats & Clark Inc.

2. Monni Adams, "Kuba Embroidered Cloth." *African Arts* 12,1 (1978): 24–39, 106–107; for a detailed analysis, see Dorothy Washburn, *Style, Classification, and Ethnicity*, Transactions, Vol. 80, Part 3, (Philadelphia: American Philosophical Society, 1990): 30–56.

3. Patricia J. Darish, "'This Is Our Wealth' : Toward an Understanding of a Shoowa Textile Aesthetic," *Bulletin/Annual Report 1993–95, Elvehjem Museum of Art,* (Madison: University of Wisconsin, 1996): 61

4. *Weshonkanda* is given by Patricia Darish (Book Review, "Textiles Africains," *African Arts* 22, 4, 1994: 92); Joseph Cornet reports *ikatankaang* provided by Shoowa embroiderers in several villages (e.g., photograph #3210, Mission Book #7, 1974).

5. Washburn, *Style:* 57–91.

6. Darish, "This Is Our Wealth," p. 59.

7. Washburn, *Style:* 23; Darish, "This Is Our Wealth," p. 66.

8. George Meurant, *Shoowa Design.* (London: Thames and Hudson, 1986), 182, #28; Joseph Cornet, *Art Royal Kuba,* (Milan: Edizione Sipiel, 1982, 169) provides the translation.

9. Torday and Joyce. *Notes ethnographiques:* 188.

10. Cornet, *Art Royal:* 192

11. Darish, "Dressing," pp. 127–138.

12. Cornet, *Art Royal:* 188–194. *Kweemi* is a word for plaited basket. Cornet provides all the terms for skirts that are given in this caption. 13. Cornet, *Art Royal:* 191, 194.

13. Cornet, *Art Royal:* 191, 194.

14. Cornet, *Art Royal:* 189

Chapter 11
Andes

1. See William J Conklin, "Pucara and Tiahuanaco Tapestry: Time and Style in a Sierra Weaving Tradition." *Nawpa Pacha* 21 (1983): 1–44.

2. See the photographs and discussion of *chacanas* in the section of this volume on Aymara textiles.

3. Personal Communication, Eduardo Pareja Sinanis, INAR, 1997.

4. Cieza de Leon, Pedro. *1550. Del senorio de los yngas yupangues* (Secunda parte *Cronica del Peru*) 1880 edition, Jimenez de la Espada, ed. (Lima: Instituto de Estudios Peruanos. 1967).

Chapter 12
Latin America

1. D.S. Davidson, "Knotless Netting in America and Oceania," *American Anthropologist* 37 (1935): 117–134.

2. Lila M. O'Neal, "Weaving," in *Handbook of South American Indians,* Julian H. Stewart, ed. Vol. 5. (Washington D.C.: Smithsonian Institution, Bureau of American Ethnology,1949): 135 and Figs. 39 and 41.

3. Ephraim S. Alphonse, "Guaymí Grammer and Dictionary with Ethnological Notes," *Smithsonian Institution Bureau of American Ethnology Bulletin* 162 (1956): 120.

4. Michèle Labrut, *Getting to Know Panama.* (Panama: Focus Publications, 1993): 199.

5. Personal communication with Rick Hajovsky, Pan-American Traders, Houston, April 1997.

6. Teresa Gisbert de Mesa, "Andean Feather Art," in *An Insider's Guide to Bolivia*, compiled by Peter McFarren (La Paz: Quipus Cultural Foundation, 1988): 312–313.

7. Peter McFarren, Director of the Bolivian Fundación Cultural Quipus, La Paz, assisted in the analysis of the piece.

8. *L'arte de la plume brésil.* (Genève: Musée d'ethnographie, 1985): 72–73.

9. Charles Wagley, *Welcome of Tears. The Tapirapé Indians of Central Brazil.* (New York: Oxford University Press, 1977): 26–34, 50–53.

10. Ibid., pp. 107–110.

11. Ibid., pp. 110, 114.

12. Laurie Adelson and Arthur Tracht, *Aymara Weavings: Ceremonial Textiles of Colonial and 19th Century Bolivia.* (Washington D.C.: Smithsonian Institution Traveling Exhibition Service, 1983): 89–92.

13. Personal observation in the village of Cala-Cala, northern Potosí, Bolivia, February, 1997.

14. Adelson and Tracht, *Aymara Weavings:* 45–47, 92.

15. Bruce Takami, an expert in Bolivian weavings, assisted in the analysis of the mantle and the motifs.

16. Lilly deJongh Osborne, *Guatemala Textiles* (New Orleans: Department of Middle American Research, Tulan University, 1935): 23–25.

17. Patricia B. Altman and Caroline D. West, *Threads of Identity, Maya Costume of the 1960s in Highland Guatemala.* (Los Angeles: UCLA Fowler Museum of Cultural History, 1992): 80–82, 121–122.

18. Patricia La Farge, Que Tenga Buena Mano, Santa Fe, assisted in the analysis of this piece.

19. Mari Lyn Salvador, *Yer Dailege! Kuna Women's Art.* (Albuquerque: The Maxwell Museum of Anthropology, 1978), Prudence Heffron, The Friends of the Kuna Gallery, Santa Fe, assisted in the analysis of this piece.

20. This information is based on research conducted in the Junin region of Peru by Charlene Cerny, Director of the Museum of International Folk Art, and correspondence from Andrea Aranow, who curated an exhibition of these dance costumes for the Phyllis Kind Gallery in New York, 1981.

21. Carlos Espejel, *Mexican Folk Ceramics.* (Barcelona: Editorial Blume, 1975): 65–67.

22. Martha Egan, "The Retablos of Nicario Jimenez," ARTSPACE II (Summer 1987): 11–13.

23. Lenore Hoag Mulryan, *Mexican Figural Ceramists and Their Works.* (Los Angeles: UCLA Museum of Cultural History, 1982): 17–21.

24. Susan N. Masuoka, *En Calavera: The Papier-Mâché Art of the Linares Family.* (Los Angeles: UCLA Fowler Museum of Cultural History, 1994).

Chapter 13
American Indian

1. This research is being done by Stan Neptune, Penobscot carver, and Joan Lester, art historian.

2. Ruth Holmes Whitehead, *Micmac Quillwork*, 168.

3. Ibid., p. 172.

4. Ibid., pp. 15–16.

5. William W. Fitzhugh and Aron Crowell, *Crossroads of Continents*: 221.

6. Pirjo Varjola, *Etholen Collection*: 147.

7. Torrence Gaylord, *The Plains Parfleche*: 155.

8. Benson L. Landford, "Parfleche and Crow Beadwork Designs," *American Indian Art*, vol. 6 no. 1 (Winter 1980): 34–39.

9. Natalie Linn, *The Plateau Bag*.

10. Ralph T. Coe, personal communication.

11. Richard Conn, *Native American Art*: 285.

12. Rex L. Jones and Catherine Whitmore-Ostlund, "Cradles of Life" *American Indian Art*, vol. 5, no. 4 (Autumn 1980): 36–41.

13. Craig D. Bates and Martha J. Lee, "Chukchansi Yokuts Southern Miwok" *American Indian Art*, vol. 18, no. 3 (Summer 1993): 44–51.

14. Idem., Rex L. Jones and Catherine Whitmore-Ostlund: 41.

15. Bertha P. Dutton, *American Indians of the Southwest*: 16.

16. Roseann S. Willink and Paul G. Zolbrod, *Weaving a World*: 52.

17. Ibid., p. 19.

18. J. J. Brody, *Anasazi and Pueblo Painting*, Albuquerque, University of New Mexico Press, 1991: 71.

19. Idem., Roseann S. Willink and Paul G. Zolbrod: 15.

20. Andrew Hunter Whiteford and Nora Rogers, "Woven Mats of the Western Great Lakes," *American Indian Arts*, vol 19. no.4 (Autumn 1994): 58–65.

21. Ruth B. Phillips, "Like a Star I Shine," *The Spirit Sings*: 51–92.

22. Andrew Hunter Whiteford, "Fiber Bags of Great Lakes Indians," *American Indian Arts*, vol.2 no. 3 (Summer 1997): 52–63.

Chapter 14
North America

1. Ron Tyler, et al, *American Frontier Life: Early Western Painting and Prints.* Introduction by Peter H. Hassrick. (New York: Abbeville Press, 1987): 17.

2. Jean Lipman, et al, *Young America: A Folk-Art History* (New York: Hudson Hills Press in Association with The Museum of American Folk Art, 1986): 170.

3. Quoted in Herbert Ridgeway Collins, *Threads of History: Americana Recorded on Cloth 1775 to the Present* (Washington: Smithsonian Institution Press, 1979): 7. Collins' extensively illustrated survey is indispensable to the study of political textiles.

4. *New York Daily Tribune,* October 18, 1888. Quoted in Collins, *Threads of History*: 11.

5. H. J. Blanton, "The Coattail Pocket," *When I Was a Boy* (Columbia, Miss.: n.p., 1952). Quoted in Collins, *Threads of History*: 4.

6. *Wheeling* (West VA.) *Register,* August 23, 1888. Quoted in Collins, *Threads of History*: 11.

7. Charles Carleton Coffin, quoted in Nina Fletcher Little, *Floor Coverings in New England Before 1850* (Sturbridge, Mass.: Old Sturbridge Village, 1967): 5.

8. Joel and Kate Kopp, *American Hooked and Sewn Rugs: Folk Art Underfoot,* 2nd ed. (New York: E.P. Dutton, Inc., 1984): 39.

9. Margaret Vincent, *The Ladies' Work Table: Domestic Needlework in Nineteenth-Century America* (Allentown, Penn.: Allentown Museum, 1988): 115.

10. Quoted in full in William C. Ketchum, Jr., *Hooked Rugs* (New York: Harcourt Brace Jovanovitch, 1976): 14–16.

11. For illustrations and additional text, see the author's *For Purpose and Pleasure: Quilting Together in Nineteenth-Century America* (Nashville: Rutledge Hill Press, 1995).

12. Sandi Fox, *Wrapped in Glory: Figurative Quilts and Bedcovers 1700–1900* (Los Angeles: Los Angeles County Museum of Art and Thames and Hudson, 1990): 128–131.

13. Eve Wheatcroft Granick, *The Amish Quilt* (Intercourse, Penn.: Good Books, 1989): 29–32.

14. The *Ordnung* is a set of complex rules, written and unwritten, that define and direct the social order of this simple, separate society. The author particularly directs the reader to John A. Hostetler, *Amish Society.* 3rd ed. (Baltimore: Johns Hopkins University Press, 1980).

15. See Jonathan Holstein's essay "In Plain Sight: The Aesthetics of Amish Quilts" in Donald B. Kraybill et al, *A Quiet Spirit: Amish Quilts from the Collection of Cindy Tietze & Stuart Hodosh* ex. cat. (Los Angeles: UCLA Fowler Museum of Cultural History, 1996): 69–121.

16. Sandi Fox, *Small Endearments: Nineteenth-Century Quilts for Children and Dolls* (Nashville: Rutledge Hill Press, 1994): 92–109.

17. John A. Hostetler, "The Amish Use of Symbols and their Function in Bonding the Community," *Journal of the Royal Anthropological Institute of Great Britain and Ireland,* vol. 94, no. 1 (1984): 11–21.

18. Galer Britton Barnes, "A Glimpse of Color: Amish Wedding Stockings of the Nineteenth Century." *Piecework,* vol. 5, no. 2 (March/April 1997): 25–27.

Bibliography

Chapter 3

Brandon, Reiko Mochinaga. *Country Textiles of Japan.* New York/Tokyo: Weatherhill, 1986.

———. *Bright and Daring: Japanese Kimonos in the Taisho Mode.* Tokyo: Unsôdô, 1996.

Brandon, Reiko Mochinaga and Barbara Stephan. *Textile Arts of Okinawa.* Honolulu: Honolulu Academy of Arts, 1990.

———. *Spirit and Symbol: The Japanese New Year.* Honolulu: Honolulu Academy of Arts, 1994.

Dower, John W. *The Elements of Japanese Design: A Handbook of Family Crests, Heraldry and Symbolism.* New York/Tokyo: Weatherhill, 1971.

Gluckman, Dale Carolyn and Sharon Sadako Takeda. *When Art Became Fashion: Kosode in Edo Period.* Los Angeles: Los Angeles County Museum, 1992.

Kindaich, Kyôsuke and Sugiyama Sueo. *Ainu Geijutsu (Ainu Art).* Sapporo: Hokkaido Shuppan Center, 1941.

Kitamura, Tetsuo, ed. "*Yûzenzome* (Yûzen Dyeing)," *Nihon no Bijutsu (Japanese Arts)* 106 (1975).

———. "*Senshoku: Dentô Kôgei.* (Dyeing and Weaving: Traditional Craft)," *Nihon no Bijutsu (Japanese Arts)* 307 (1991).

Levy, Dana, Lea Sneider, and Frank Gibney. *Kanban: Shop Signs of Japan.* New York/Tokyo: Weatherhill, 1983.

Masuda, Shôzô. "Kyôgen no Shôzoku (Kyôgen Costumes)," *Senshoku no Bi (Textile Art).* 14 (Autumn 1981): 5–72. Kyoto: Kyoto Shoin.

Moes, Robert. *Mingei: Japanese Folk Art.* New York: Brooklyn Museum, 1985.

Nagasaki, Iwao. "Chônin no Fukushoku (Townsmen's Costumes)," *Nihon no Bijutsu (Japanese Arts)* 341 (1991).

Ogasawara, Sae. "Kasuri (Ikat Weaving)," *Nihon no Bijutsu (Japanese Arts)* 309 (1992).

———, ed. *Kijoka no Bashôfu (Banana Fabric of Kijoka)*, Ningen Kokuhô Shirîzu (National Human Treasure Series) 41. Tokyo: Kôdansha, 1977

———, ed. *Chiba Ayano: Kurume Gasuri (Chiba Ayano: Ikat Textiles of Kurume)*, Ningen Kokuhô Shirîzu (Living Treasure Series) 20. Tokyo: Kôdansha, 1978.

Rathbun, William Jay, ed. *Beyond the Tanabata Bridge: Traditional Japanese Textiles.* Seattle: Seattle Art Museum, 1993.

———. *Yô no Bi: The Beauty of Japanese Folk Art.* Seattle: University of Washington Press, 1983.

Sasaki, Riwa. "Ainu no Kôgei (Ainu Art and Craft)," *Nihon no Bijutsu (Japanese Arts)* 354 (1993).

Yoshida, Shinichirô and Dai Williams. *Riches From Rags: Sakiori and Other Recycling Traditions In Japanese Rural Clothing.* Tokyo: Yoshida/Williams/Audrey/The Design, 1994.

Chapter 4

Cammann, Schuyler V. R. "Development of the Mandarin Square." *Harvard Journal of Asian Studies* 8 (1944): 71–130.

———. *China's Dragon Robes.* New York: The Ronald Press, 1952.

Garrett, Valery M. *Chinese Clothing, An Illustrated Guide.* Hong Kong: Oxford University Press, 1994.

Hall, Chris, et. al. *Heaven's Embroidered Cloths: One Thousand Years of Chinese Textiles.* Hong Kong: Museum of Art, 1995.

Hommel, Rudolf F. *China at Work, An Illustrated Record of the Primitive Industries of China's Masses, Whose Life Is Toil, and Thus an Account of Chinese Civilization.* (Reprint. New York: John Day Company, 1937). Cambridge, Mass.: Massachusetts Institute of Technology, 1969.

Huang Lengfu, ed. *Zhong guo meishu tuanji.* (The great treasury of Chinese fine art series). Vol. 2 (Textiles). Beijing, 1985.

Mailey, Jean. *Chinese Silk Tapestry: K'o-ssu from private and museum collections: Exhibition Catalogue for the China House Gallery, March 24– May 27, 1971.* New York: China Institute in America, 1971.

———. *Embroidery of Imperial China: Exhibition Catalogue for the China House Gallery, March 17– May 28, 1978.* New York: China Institute of America, 1978.

Matsuomoto, Kaneo. *Jodai gire (7th and 8th century textiles in Japan from the Shoso-in and Horyu-ji).* S. Kaneko and R. Mellott, trans. Kyoto: Shikosha Publishing Co. Ltd., 1984.

Shih, M.H. "The Silk Industry in Ch'ing China." E-tu Zen Sun, trans. Abstracts No.5. Ann Arbor: University of Michigan Centre for Chinese Studies, 1974.

Stein, Sir Marc Aurel. *Innermost Asia.* 4 vols. Oxford: Oxford University Press, 1928.

Vollmer, John E. *In the Presence of the Dragon Throne: Ch'ing Dynasty Costume (1644–1911).* Toronto: Royal Ontario Museum, 1977.

———. *Five Colours of the Universe, Symbolism in Clothes and Fabrics of the Ch'ing Dynasty (1644–1911).* Hong Kong: Edmonton Art Gallery, 1980.

Vollmer, John E., E. J. Keall Jr., and E. Nagai-Berthrong. *Silk Roads. China Ships.* Toronto: Royal Ontario Museum, 1983.

Wilson, Verity. *Chinese Dress.* Far Eastern Series. London: Victoria and Albert Museum, 1986.

Xia Nai, "Xinjiang Xinfaxian de Gudai Sizhipin Qujing he Cixin." (New Finds of Ancient Silk Fabrics Recently Found in Sinkiang). *Kaoguxuebao* 1 (1963): 45–76.

Chapter 5

Aryan, Subhashini. *Crafts of Himachal Pradesh.*

Ahmedabad: Mapin Publishing Pvt.,Ltd., 1993.

Adams, Dr. Monni. *Threads of Life: A Private Collection of Textiles From Indonesia and Sarawak.* Katonah, N.Y.: The Katonah Gallery, 1981.

Barbier, Jean Paul, and Douglas Newton, eds. *Islands and Ancestors: Indigenous Styles of Southeast Asia.* New York: The Metropolitan Museum of Art, 1988.

Chen, Qili. *Material Culture of the Formosan Aborigines.* Taipei: Taiwan Museum, 1968.

Crill, Rosemary, John Guy, Veronica Murphy, Susan Stronge, and Deborah Swallow. *Arts of India: 1550–1900.* London: Victoria and Albert Museum, 1990.

Gavin, Traude. *The Women's Warpath: Iban Ritual Fabrics from Borneo.* Los Angeles: UCLA Fowler Museum of Cultural History, University of California, 1996.

Gittinger, Mattiebelle, ed. *To Speak With Cloth: Studies in Indonesian Textiles.* Los Angeles: UCLA Museum of Cultural History, University of California, 1989.

Gittinger, Mattiebelle. *Master Dyers to the World: Technique and Trade in Early Indian Dyed Cotton Textiles.* Washington, D.C.: The Textile Museum, 1982.

Hamilton, Roy W. *Gift of the Cotton Maiden: Textiles of Flores and the Solor Islands.* Los Angeles: Fowler Museum of Cultural History, University of California, 1994.

Hauser-Schaublin, Brigitta, Marie-Louise Nabholz-Dartaschoff, and Urs Ramseyer. *Textiles in Bali.* Berkeley-Singapore: Periplus Editions, 1991.

Heringa, Rens, and Harmen C. Veldhuisen. *Fabric of Enchantment: Batik from the North Coast of Java.* Los Angeles: Weatherhill Inc. in association with Los Angeles County Museum of Art, 1996.

Homgren, Robert J., and Anita E. Spertus. *Early Indonesian Textiles from Three Island Cultures: Sumba, Toraja, Lampung.* New York: The Metropolitan Museum of Art, 1989.

Irwin, John, and Margaret Hall. *Indian Embroideries.* Historic Textiles of India at the Calico Museum, V.II. Ahmedabad: S.R. Bastikar, 1973.

Jaitly, Jaya, ed. *Crafts of Kashmir, Jammu and Ladakh.* New York: Abbeville Press, 1990.

Jessup, Helen Ibbitson. *Court Arts of Indonesia.* New York: The Asia Society Galleries in association with Harry N. Abrams, Inc., 1990.

Kahlenberg, Mary Hunt, ed. *Textile Traditions of Indonesia.* Los Angeles: Los Angeles County Museum of Art, 1977.

Maxwell, Robyn. *Textiles of Southeast Asia: Tradition, Trade and Transformation.* South Melbourne, Australia: Oxford University Press, 1990.

Nanavati, J.M., ed. *The Embroidery and Bead Work of Kutch and Saurashtra.* Gujarat, India: Department of Archeology Museum Monograph Series, 1966

McNeely, Jeffery A., and Paul Spencer Wachtel. *Soul of the Tiger: Searching for Nature's Answers in Southeast Asia.* New York: Paragon House, 1990.

Nabholz-Kartaschoff, Marie-Louise, Ruth Barnes, and David J. Stuart-Fox. *Weaving Patterns of Life: Indonesian Textile Symposium 1991.* Basel: The Museum of Ethnography, 1993.

Rogers, Susan. *Power and Gold: Jewelry from Indonesia, Malaysia and the Philippines.* Geneva: Barbier Mullen Museum, 1980.

Solyom, Bronwen, and Garrett Solyom. *Fabric Traditions of Indonesia.* Pullman: Washington State University Press and the Museum of Art, Washington State University, 1984.

Speiser, Felix. *Ethnology of Vanuatu, An Early Twentieth Century Study.* Bathurst, Australia: Crawford House Press, 1990.

Summerfield, Anne, and John Summerfield. *Fabled Cloths of Minangkabau.* Santa Barbara: Santa Barbara Museum of Art, 1991.

Taylor, Paul Michael, and Lorraine V. Aragon. *Beyond the Java Sea: Art of Indonesian's Outer Islands.* Washington, D.C.: The Smithsonian Institution in association with Harry N. Abrams, Inc., 1991.

Chapter 6

Andrews, Peter and Mügül Andrews. *Türkmen Needlework: Dressmaking and Embroidery Among the Türkmen of Iran.* London: Central Asian Research Center, 1976.

Andrews, Peter Alford, "Crowning the Bride: Some Historical Evidence on Türkmen Women's Costume," *Folk,* Vol. 33, 1991: 67–106.

Barber, Elizabeth Wayland. *Prehistoric Textiles: The Development of Cloth in the Neolithic and Bronze Ages.* Princeton: Princeton University Press, 1991.

———. *Women's Work: The First 20,000 Years, Women, Cloth, and Society in Early Times.* New York and London: W.W. Norton & Co., 1994.

———. "The Archeological Evidence for the Origins of Weaving and Carpets," in *Papers, Presentations, 7th International Conference on Oriental Carpets, Hamburg, Berlin.* Dusseldorf, 1996: 31–37.

Barfield, Thomas J. *The Nomadic Alternative.* Englewood Cliffs, New Jersey: Prentice Hall, 1993.

Beck, Lois. *The Qashqa'i of Iran.* New Haven and London: Yale University Press, 1986.

Cockaerts, Marcel, Damien Wigny, Paul Tanghe, et al. *Dulchir: Tissus de Défense et de Protection.* Luxembourg: Kredietbank, 1995.

Emery, Irene. *The Primary Structures of Fabrics: An Illustrated Classification.* Washington, D.C.: The Textile Museum, 1980.

Fitz Gibbon, Kate and Andy Hale. "Lakai: The Bad Beys of Central Asia." *Hali* 75 (June/July 1994): 69–79.

Floor, Willem. "The Persian Textile Industry: Its Development, Products, and Their Use (1500–1925)." Unpublished manuscript.

Franses, Michael and Robert Pinner. "Portraits of King Henry VIII." *Hali,* 3, no. 3 (1981): 176–181.

Hale, Andy and Kate Fitz Gibbon. "Introduction." in *Ikats: Woven Silks from Central Asia, The Rau Collection.* Oxford: Basil Blackwell, 1988: 8–16.

Klimburg, Max. *Ikat: Textile Art from the Silk Road.* Vienna: Kirdök Gallery, 1993.

King, Donald and David Sylvester. *The Eastern Carpet in the Western World, From The Fifteenth to the Seventeenth Century.* London: Arts Council of Great Britain, 1983.

Larsen, Jack Lenor with Alfred Bühler, Bronwen Solyom, and Garrett Solyom. *The Dyer's Art: Ikat, Batik, Plangi.* New York: Van Nostrand Reinhold, 1976.

Lees, Susan K. and Daniel G. Bates. "The Origins of Specialized Nomadic Pastoralism: A Systemic Model." *American Antiquity.* 39, no. 2 (1974): 187–93.

Levy, Reuben trans., revised by Amin Banani. *The Epic of the Kings: Shah-Nama, the National Epic of Persia by Ferdowsi.* London: Routledge & Kegan Paul, 1985.

Raby, Julian. "Court and Export: Part 1. Market Demands in Ottoman Carpets 1450–1550." in *Oriental Carpet & Textile Studies II Carpets of the Mediterranean Countries 1400–1600.* Robert Pinner & Walter B. Denny, eds. London: Hali OCTS Limited, 1986: 29–38.

———. "Court and Export: Part 2. The Usak Carpets." in *Oriental Carpet & Textile Studies II Carpets of the Mediterranean Countries 1400–1600.* Robert Pinner & Walter B. Denny, eds. London: Hali OCTS Limited, 1986: 177–187.

Smith, Bruce D. *The Emergence of Agriculture.* New York: Scientific American Library, 1995.

Thompson, Jon. *Silk, Carpets and the Silk Road.* Tokyo: NHK Culture Center, 1988.

Wertime, John T. *Sumak Bags in Northwest Persia and Transcaucasia.* London: Laurence King in association with Hali Publications Limited, forthcoming, 1998.

———. "Flat-woven Structures Found in Nomadic and Village Weavings from the Near East and Central Asia." *Textile Museum Journal* 18 (1979): 33–54.

Wright, Richard E. and John T. Wertime. *Caucasian Carpets & Covers: The Weaving Culture.* London: Hali Publications Limited in association with Laurence King, 1995.

Chapter 7

Baker, Patricia L. *Islamic Textiles*. London: British Museum, 1995.

Baines, Patricia. *Spinning Wheels: Spinners and Spinning*. New York: Charles Scribner's Sons, 1977.

Barber, Elizabeth J. Wayland. *Women's Work: The First 20,000 Years*. New York, London: W.W. Norton & Company, 1994.

———. *Prehistoric Textiles: The Development of Cloth in the Neolithic and Bronze Ages with Special Reference to the Aegean*. Princeton, N.J.: Princeton University Press, 1991.

Bierman, Irene A. "Inscribing the City: Fatimid Cairo," in *Islamische Textilkunst des Mittelalters: Actuelle Probleme*. Riggisberg: Abegg-Stiftung, 1997: 105–114.

———. "Medieval Flatweaves in the Urban Middle East." in *Flat Weaves. The Arthur D. Jenkins Collection*. Vol. I. ed. Cathryn Cootner: Washington, D.C.: The Textile Museum, 1981: 161–67.

Benaki Museum, *Crete-Dodecanese-Cyclades Embroideries*. Athens: Benaki Museum, 1966.

Crowfoot, Grace M. "Methods of Hand Spinning in Egypt and the Sudan." *Bankfield Museum Notes*, 2, no. 12 (Halifax), 1931.

Gentles, Margaret. *Turkish and Greek Island Embroideries. Art from the Bustan Yost Berry Collection in the Art Institute*. Chicago: Art Institute, 1964.

Gervers, Veronika. *The Influence of Ottoman Turkish Textiles and Costume in Eastern Europe*. Toronto: Royal Ontario Museum, 1982.

Goitein, S.D. *A Mediterranean Society*. 6 vols. Berkeley & Los Angeles: University of California Press, 1967–1993, esp. Vol. 1, *Economic Foundations* & Vol. 4, *Daily Life*.

Gonul, Macide. *Turkish Embroideries*. Istanbul: Touring and Automobile Club of Turkey, n.d.

Holy Bible: Revised Standard Edition. N.Y., N.Y.: Thomas Nelson and Sons, 1952.

Johnstone, Pauline. *Turkish Embroideries*. London: Victoria & Albert Museum, 1985.

——— *Greek Island Embroideries*. London: Tiranti, 1995.

Kendrick, A.F. *Catalogue of Muhammadan Textiles of the Medieval Period* London: Victoria & Albert Museum, 1924.

Scarce, Jennifer. *Women's Costume of the Near and Middle East*. London:Unwin Hyman, 1987.

Sokoly, Jochen A. "Between Life and Death: The Funerary Context of Tiraz Textiles," in *Islamische Textilkunst des Mittelalters: Actuelle Probleme* Riggisberg: Abegg-Stiftung, 1997: 71–78.

Stillman, Yedida K. " Textiles and Patterns Come to Life Through the Cairo Geniza." in *Islamische Textilkunst des Mittelalters: Actuelle Probleme*. Riggisberg: Abegg-Stiftung, 1997: 35–52.

Tezcan, Hulye and Selma Delibas. *The Topkapi Saray Museum Costumes, Embroideries and other Textiles*. trans. and expanded by J. M. Rogers. Boston: Little, Brown, 1980.

Thompson, Deborah. *Coptic Textiles in the Brooklyn Museum* New York: The Brooklyn Museum, 1971.

Wace, A.J.B. *Mediterranean and Near Eastern Embroideries*. 2 vols. London: Halton, 1935.

Wessel, Klaus. *Coptic Art*. New York: McGraw-Hill, 1965.

Chapter 8

Brooke, Xanthe. *The Lady Lever Gallery Catalogue of Embroideries*. 2nd ed. New Hampshire: Alan Sutton Publishing, Ltd., 1992.

Edwards, Joan. *Crewel Embroidery in England*. New York: William Morrow & Co., Inc., 1975.

Emery, Irene. *The Primary Structures of Fabric: An Illustrated Classification*. Washington, D.C.: The Textile Museum, 1966.

Epstein, Kathy. " Mexican Embroidery Samplers: Stitching Together Four Centuries, Three Traditions." *Piecework: All This by Hand*. Vol.V, no. 3 (1997).

Hansen, Viveka. *Swedish Textile Art: Traditional Weavings from Scania. The Khalili Collection of Textile Art: Volume I*. United Kingdom: The Nour Foundation in association with Textile & Art Publications, 1996.

Harvey, Joanne. "and thos that shall inquir… An Historical Survey of Seventeenth-Century Needlework Cabinets." *Sampler & Antique Needlework: A Year in Stitches*. Birmingham, Alabama: Symbol of Excellence Publishers, Inc. (1994): 61–67.

Hilton, Alison. *Russian Folk Art*. Bloomington and Indianapolis: Indiana University Press, 1995.

Marshall, Frances and Hugh. *Old English Embroidery: Its Technique and Symbolism*. London: Horace Cox, Windsor House, Bream's Buildings, 1894.

Minor, Hollis Greer. "Stumpwork: Small Worlds of Sculptural Embroidery." *Piecework: All This by Hand*. Vol. IV, no.3 (1996).

Nylén, Anna-Maja. *Swedish Handcraft*. Lund, Sweden: Håkan Ohlssons Förlag, 1968.

Onassis, Jacqueline, ed., *In the Russian Style*. New York: The Viking Press, 1976.

Wilson, Erica. *Erica Wilson's Embroidery Book*. New York: Charles Scribner's Sons, 1973.

Chapter 9

Adams, Monni. 1978. "Kuba Embroidered Cloth." *African Arts* XII, no. 1 (1978): 24–39, 106.

Adams, Monni and T. Rose Holdcraft. "Dida woven raffia cloth from Cöte d' Ivoire." *African Arts* XXV, no. 3 (1992): 42–51, 100.

Adjasoo, R .A. A. *The Anlo Ewe Textile*. Unpublished thesis, Kumasi Arts Faculty Library. University of Science and Technology, 1970.

Appiah, K. Anthony. "The Arts of Africa." *New York Review of Books* XLIV, no. 7 (1997): 46–51.

Arnoldi, Mary Jo and Christine Mullen Kreamer. *Crowning Achievements. African Arts of Dressing the Head*. Los Angeles: UCLA Fowler Museum of Cultural History, 1995.

Aronson, Lisa. "History of Cloth Trade in the Niger Delta. A Study of Diffusion." *Textile History* (1980): 89–107.

———. "Ijebu Yoruba *Aso Olona*, A contextual and historical overview." *African Arts* XXV, no. 3 (1992): 52–63, 101.

Barbour, Jane and Doug Simmons, eds. *Adire Cloth in Nigeria*. Ibadan, Nigeria: The Institute of African Studies, University of Ibadan, 1971.

Ben-Amos, Paula. "'Owina n' Ido': Royal Weavers of Benin." *African Arts* II, no. 4 (1978): 48–53.

Cole, Herbert M., and Doran H. Ross. *The Arts of Ghana*. Los Angeles: UCLA Museum of Cultural History, 1977: 9–12.

Cole, Herbert M. and Chike C. Aniakor. *Igbo Arts Community and Cosmos*. Los Angeles: UCLA Fowler Museum of Cultural History, University of California, 1984.

Etienne, Mona. "Women and Men, Cloth and Colonization: the Transformation of Production-Distribution Relations among the Baule (Ivory Coast)." *Cahiers d' Études africaines*, 65, XVII , no. 1 (1977): 41–64.

Gibson, Gordon D. and Cecilia R. McGurk. "High Status Caps of the Kongo and Mbundu Peoples." *Textile Museum Journal* 4 (1977): 71–96.

Kuklick, Henrika *The Imperial Bureaucrat: The Colonial Administrative Service in the Gold Coast, 1920–1939*. Stanford: Hoover Institution Press, 1979.

Lamb, Venice. *West African Weaving*. London: Duckworth, 1975.

Lamb, Venice and Judy Holmes. *Nigerian Weaving*. Roxford, Hertingfordshire: Hertingfordbury, 1981.

Lamb, Venice and Alistair Lamb. *Tissage au Cameroon*. Roxford, Hertingfordshire: Hertingfordbury, 1981.

Picton, John and John Mack. *African Textiles. Looms, Weaving and Design*. London: British Museum Publications Ltd., 1979.

Powell, Ivor . *Ndebele: A People and Their Art*. Cape Town: Struik Publishers, 1995.

Prussin, Labelle. *Hatumere: Islamic Design in West Africa*. Berkeley and Los Angeles: University of California Press, 1986.

Ross, Doran H. *Fighting with Art: Appliqued Flags of the Fante Asafo*. Los Angeles: UCLA Museum of Cultural History, 1979.

Sheppard, William H. "African Handicrafts and

Superstitions." *Southern Workman,* 50, 1921.

Wahlman, Maude Southwell. *Signs and Symbols. African Images in African-American Quilts.* New York: Studio Books in association with Museum of American Folk Art, 1993.

Zeidler, Jeanne and Mary Lou Hultgran. "Things African Prove to Be a Favorite Theme. The African Collection at Hampton University." In Danto et al. *Art/Artifact.* New York: The Center for African Art, 1988.

Chapter 10

Adams, Monni. "Kuba Embroidered Cloth." *African Arts* 12, no. 1 (1978): 24–39, 106–107.

Cornet, Joseph. *Art Royal Kuba.* Milan: Edizione Sipiel, 1982.

Cornet, Joseph. *Mission au Bushong et Shoowa.* Book #7, November–December, 1974.

Crowe, Donald W. "The Geometry of BaKuba Art." *Journal of Geometry* 1–2 (1971):169–182.

Darish, Patricia J. "Dressing for the Next Life: Raffia Textile Production and Use among the Kuba of Zaire," in *Cloth and the Human Experience,* Weiner, A., and J. Schneider, eds. Washington, D.C.: Smithsonian Institution. 1989: 117–140.

———"Textiles Africains," *African Arts* 22, no.4 (1994): 91–92.

——— "Woman's Overskirt," in *Africa, Art of a Continent,* Tom Phillips, ed. London: Royal Academy of Arts; Munich, New York: Prestel, 1995: 276–277.

——— "'This Is Our Wealth': Toward an Understanding of a Shoowa Textile Aesthetic." *Bulletin/Annual Report 1993–95, Elvehjem Museum of Art,* Madison: University of Wisconsin (1996): 57–68.

Hilton-Simpson, M.W. *Land and Peoples of the Kasai: Being a Narrative of a Two Years' Journey among the Cannibals of the Equatorial Forest and Other Savage Tribes of the South-Western Congo.* London: Constable, 1911.

Hultgren, Mary Lou and Jeanne Zeidler. *A Taste for the Beautiful: Zairian Art from the Hampton University Museum.* Hampton, Va.: University Museum, 1993.

Meurant, Georges. *Shoowa Design: African Textiles from the Kingdom of Kuba.* London: Thames and Hudson, 1986.

Ploier, Helmut. *Textilkunst der Bakuba: Sammlung Konzett: Ehemaliger Besitz des Königs Nyimi, Kuba-Zaire.* Graz: Konzett KG, 1988.

Stritzl, Angelika. "Die Gestickten Raphia-Plüsche: eine Ergologische-technologische Untersuchungen einer historischen Stoff im Zentralen Kongo (Zaïre)." Vienna: unpublished Dissertation, 1971.

Torday, Emil. *On the Trail of the Bushongo.* London: Seeley Service; Philadelphia: J.B.Lippincott,1925.

Torday, Emil and T.A. Joyce. "Notes ethnographiques sur les peuples communément appelés Bakuba, ainsi que les peuplades apparentées: les Bushongo" *Annales du Musée Congo belge (Tervuren), Ethnographie-Anthropologie.* Série IV, 2. Brussels: Ministère des Colonies, 1910.

Vansina, Jan. "Le Royaume Kuba." *Annales du Musée Royale de l'Afrique Centrale,* Série in-8, Sciences Humaines, no. 49. Tervuren, 1964.

Washburn, Dorothy Koster. "Style, Classification, and Ethnicity: Design Categories on Bakuba Raffia Cloth." *Transactions of the American Philosophical Society* 80, Part 3. Philadelphia: American Philosophical Society, 1990.

Wharton, Conway T. *The Leopard Hunts Alone.* New York: Fleming H. Revell Co., 1927.

Chapter 11

Adelson, Laurie, and Arthur Tracht. *Aymara Weavings: Ceremonial Textiles of Colonial and 19th Century Bolivia.* Washington,D.C.,: Smithsonian Institution Traveling Exhibition Service, 1983.

Arriaza, Bernardo T. *Beyond Death : The Chinchorros Mummies of Ancient Chile.* Washington, D.C.: Smithsonian Institution Press, 1995.

Bennett, Wendell C., and Junius B. Bird. *Andean Culture History.* New York: American Museum of Natural History, 1960.

Cieza de Leon, Pedro. *1550. Del senorio de los yngas yupangues* (Secunda parte *Cronica del Peru*) 1880 edition, Jimenez de la Espada, ed. Lima: Instituto de Estudios Peruanos, 1967.

Conklin, William J "Tiwanaku and Huari: Architectural Comparisons and Interpretations" in *Huari Administrative Structure: Prehistoric Monumental Architecture and State Government,* Isbell, W.H., and G.McEwan, eds., Washington, D.C.: Dumbarton Oaks, 1991: 281–291.

———. "Moche Textile Structures" in *The Junius B. Bird Pre-Columbian Textile Conference.* Rowe, Ann Pollard, Elizabeth P. Benson, and Anne-Louise Schaffer, eds. Washington,D.C.: Textile Museum and Dumbarton Oaks, 1973: 165–184.

——— . "Pucara and Tiahuanaco Tapestry: Time and Style in a Sierra Weaving Tradition." *Nawpa Pacha* 21 (1983): 1–44.

———. "Structure as Meaning in Andean Textiles" in *Andean Art at Dumbarton Oaks,* 2, Boone, Elizabeth, ed. Washington, D.C.: Dumbarton Oaks, 1996: 321–328.

———. "The Ampato Textile Offerings" *Proceedings, Textile Society of America,* 1996 (in press).

———. "The Revolutionary Weaving Inventions of the Early Horizon." *Nawpa Pacha* 16, (1978): 1–18.

Frame, Mary. *Andean Four-Cornered Hats: Ancient Volumes.* New York: The Metropolitan Museum of Art, 1990.

Mannheim, Bruce. "A Nation Surrounded" in *Native Traditions in the Post-Conquest World.* Boone, Elizabeth, and Tom Cummins, eds. Washington, D.C.: Dumbarton Oaks, 1997: 381–418.

Rowe, Ann Pollard. *Costumes and Featherwork of the Lords of Chimor: Textiles from Peru's North Coast.* Washington, D.C.: Textile Museum, 1984.

Salles-Reese, Veronica. *From Viracocha to the Virgin of Copacabana: Representation of the Sacred at Lake Titicaca.* Austin, Texas: University of Texas Press, 1997.

Sawyer, Alan. *Early Nasca Needlework,* London: Calmann & King Ltd., 1997.

Stone-Miller, Rebecca. *To Weave for the Sun: Ancient Andean Textiles.* New York: Thames and Hudson, 1992.

Urbano, Henrique. "Wiracocha y Ayar, Heroes y funciones en las sociedades andinas." *Biblioteca de la Tradicion Oral Andina,* Cuzco: Centro de Estudios Rurales "Bartolome de las Casas" 3 (1981): xxxiii.

Chapter 12

Adelson, Laurie and Arthur Tracht. *Textiles of Colonial and 19th Century Bolivia.* Washington, D.C.: Smithsonian Traveling Exhibition Service, 1983.

Altman, Patricia B. and Caroline D. West. *Threads of Identity, Maya Costume of the 1960s in Highland Guatemala.* Los Angeles: UCLA Fowler Museum of Cultural History, 1992.

Arte Popular Mexicano: Cinco Siglos. Mexico: Antiguo Colegio de San Ildefonso, 1996.

Cerny, Charlene. "Thoughts on Anonymity and Signature in Folk Art," *Beyond Boundaries: Highland Maya Dress at the Museum of International Folk Art.* Santa Fe: Museum of New Mexico, 1984: 34–37.

Grayburn, Nelson H.H. *Ethnic and Tourist Arts: Cultural Expressions from the Fourth World.* Berkeley: The University of California Press, 1976.

Mulryan, Lenore Hoag. *Mexican Figural Ceramists and Their Work.* Los Angeles: UCLA Museum of Cultural History, 1982.

Oettinger, Marion Jr. *The Folk Art of Latin America:Visions Del Pueblo.* New York: Dutton Studio Books and Museum of American Folk Art, 1992.

Sayer, Chloë. *Arts and Crafts of Mexico.* San Francisco: Chronicle Books, 1990.

Spalding, Karen. *Huarochiri: An Andean Society Under Inca and Spanish Rule.* Stanford: Stanford University Press, 1984.

Chapter 13

Berlant, Anthony and Mary Hunt Kahlenberg. *Walk In Beauty: The Navajo and Their Blankets.* Boston: New York Graphic Society, Little, Brown and Company, 1977.

Blomberg, Nancy J. *Navajo Textiles: The William Randolph Hearst Collection.* Los Angeles: The Natural History Museum of Los Angeles County in association with The University of Arizona Press, 1988.

Bonar, Eulalie H. *Woven by the Grandmothers: Nineteenth-Century Navajo Textiles from The National Museum of the American Indian.* Washington, D.C. and London: Smithsonian Institution Press, 1996.

Coe, Ralph T. *Sacred Circles: Two Thousand Years of North American Indian Art.* Kansas City: Nelson Gallery of Art, 1976.

Conn, Richard. *Native American Art in the Denver Art Museum,* Denver: Denver Art Museum, 1979.

Dutton, Bertha P. *American Indians of the Southwest,* Albuquerque: University of New Mexico Press, 1975.

Fane, Diane, Ira Jacknis, and Lise M. Breen. *Objects of Myth And Memory: American Indian Art at The Brooklyn Museum.* Brooklyn: Brooklyn Museum in association with University of Washington Press, 1991.

Fitzhugh, William, W., and Aron Crowell. *Crossroads of Continents: Cultures of Siberia and Alaska.* Washington, D.C.: Smithsonian Institution Press, 1988.

Gunther, Erna. *Art in the Life of the Northwest Coast Indians.* Portland: The Portland Art Museum, 1966.

Hill, Tom, and Richard W. Hill Sr. *Creation's Journey: Native American Identity and Belief.* Washington, D.C. and London: Smithsonian Institution Press in association with National Museum of the American Indian Smithsonian Institution, 1994.

Holmes Whitehead, Ruth. *Micmac Quillwork: Micmac Indian Techniques of Porcupine Quill Decoration: 1600-1950,* Halifax: The Nova Scotia Museum, 1982.

Horse Capture, George P., Anne Vitart, Michel Waldberg, and W. Richard West, Jr. *Robes of Splendor: Native North American Painted Buffalo Hides,* New York: The New Press, 1993.

Kahlenberg, Mary Hunt, and Anthony Berlant. *The Navajo Blanket.* Los Angeles: The Praeger Publishers in association with the Los Angeles County Museum, 1972.

Lincoln, Louise. *Southwest Indian Silver from the Doneghy Collection.* Austin: University of Texas Press in association with The Minneapolis Institute of Arts, 1982.

Linn, Natalie. *The Plateau Bag: A Tradition in Native American Weaving,* Portland?: Johnson County Community College Gallery of Art, 1994.

Penney, David W. *Art of the American Indian Frontier: The Chandler Pohrt Collection.* Vancouver/Toronto: The Detroit Institute of Arts in association with Douglas & McIntyre, 1992.

Torrence, Gaylord. *The Plains Parflesche.* Washington: University of Washington Press in association with the Dews Moines Art Center, 1994:155.

Varjola, Pirjo. *The Etholen Collection: The Ethnographic Alaskan Collection of Adolf Etholen and his contemporaries in the National Museum of Finland.* Helsinki: National Board of Antiquities of Finland, 1990.

Whiteford, Andrew Hunter, Stewart Peckham, Rick Dillingham, Nancy Fox, and Kate Peck Kent. *I Am Here: Two Thousand Years of Southwest Indian Arts and Culture.* Santa Fe: Museum of New Mexico Press, 1989.

Willink, Roseann S., and Paul G Zolbrod. *Weaving a World: Textiles and the Navajo Way of Seeing.* Santa Fe: Museum of New Mexico Press, 1996.

Chapter 14

Barnes, Galer Britton. "A Glimpse of Color: Amish Wedding Stockings of the Nineteenth Century," *Piecework,* 5, no. 2 (March/April 1997).

Collins, Herbert Ridgeway. *Threads of History: Americana Recorded on Cloth 1775 to the Present.* Washington, D.C.: Smithsonian Institution, 1979.

Fox, Sandi. *For Purpose and Pleasure: Quilting Together in the Nineteenth Century.* Nashville: Rutledge Hill Press, 1995.

———. *Small Endearments: Nineteenth-Century Quilts for Children and Dolls.* 2nd ed., rev. Nashville: Rutledge Hill Press, 1993.

———. *Wrapped in Glory: Figurative Quilts and Bedcovers 1700-1900.* Los Angeles: Los Angeles County Museum of Art and New York: Thames and Hudson, 1990.

Fisher, Laura. *Quilts of Illusion.* Pittstown, New Jersey: Main Street Press, 1988.

Granick, Eve Wheatcroft. *The Amish Quilt.* Intercourse, Penn.: Good Books, 1989.

Green, Harvey. *The Light of the Home: An Intimate View of the Lives of Women in Victorian America.* New York: Pantheon Books, 1983.

Holstein, Jonathan. "In Plain Sight: The Aesthetics of Amish Quilts," in Kraybill, Donald B., Patricia T. Herr, and Jonathan Holstein. *A Quiet Spirit: Amish Quilts from the Collection of Cindy Tietze & Stuart Hodosh.* Los Angeles: UCLA Fowler Museum of Cultural History, 1996.

Hostetler, John A. "The Amish Use of Symbols and their Function in Bounding the Community," *Journal of the Royal Anthropological Institute of Great Britain and Ireland,* 94, no. 1 (1984): 11-21.

———. *Amish Society.* 3rd ed. Baltimore: Johns Hopkins University Press, 1980.

J.H.J. "Sweeping Day." *The Household.* 13, no. 12 (December 1880): 245-275.

Ketchum, William C. Jr. *Hooked Rugs.* New York: Harcourt Brace Javonovich, 1976.

Kopp, Joel and Kate Kopp. *American Hooked and Sewn Rugs: Folk Art Underfoot.* 2nd ed. New York: E.P. Dutton, Inc., 1985.

Lipman, Jean, Elizabeth V. Warren, and Robert Bishop. *Young America: A Folk-Art History.* New York: Hudson Hills Press in Association with the Museum of American Folk Art, 1986.

Little, Nina Fletcher. *Floor Coverings in New England Before 1850.* Sturbridge, Mass.: Old Sturbridge Village, 1967.

Rumford, Beatrix T. and Carolyn J. Weekley. *Treasures of American Folk Art from The Abby Aldrich Rockefeller Folk Art Center.* Boston: Little, Brown and Company, 1989.

Vincent, Margaret. *The Ladies' Work Table: Domestic Needlework in Nineteenth-Century America.* Allentown, Penn.: Allentown Art Museum, 1988.

Tyler, Ron, Carol Clark, Linda Ayres, Warder H. Cadbury, Herman J. Viola, Bernard Reilly, Jr. *American Frontier Life: Early Western Painting and Prints.* New York: Abbeville Press, 1987.

Wadsworth Atheneum. *Bed Ruggs/1722-1833.* Hartford, Conn.: Wadsworth Atheneum, 1972.

Index

Page numbers in *italic* refer to illustrations.

Fustat, 145, *149*
 Qasr Ibrim, 145
Ekpe society, 176, *182*
el-Bekri, *177*
elephant motif, 107, *117, 126*
ema, 20, *21, 89*
embroidery, 13, 38, 115, 136, 146, 157,
 158, 159, 160, 165, 176, 178, 181,
 182–183
 blanket-stitch, *138*
 buttonhole-stitch, *104, 127, 168, 20*.
 chain-stitch, *76, 77, 104, 127, 135, 138*
 couched, *32, 95, 97, 98, 100–101,* 143
 crewel, *32, 97, 101, 104, 127, 168,* 193,
 194, 195, 196–197, 202
 cut-pile, *16, 42, 190,* 193, *195, 196–197,*
 198, 199, 202
 cut-thread work, *185*
 darned, *100–101*
 eyelet, *201, 202, 203*
 knot-stitch, *97, 98*
 laid, *100–101*
 linear, *16, 42, 190, 194, 195, 196–197*
 198, 199, 202, 203
 metallic, *80–81, 82,* 143, *148,* 150,
 152–153, 155, 160, 171
 openwork, *202*
 running-stitch, *122*
 satin-stitch, *32, 90, 95, 97, 100–101, 122*
 stem-stitch. *see* embroidery, crewel
 stumpwork, *167, 230*
 suzeni, 157
England, *15,* 25, *166, 167, 168, 169*
environmental adaptation, *82,* 130,
 141–142, 147, 227, 229, 236, 237
Ethiopia, *13, 146*
ethnography, 34, 46
Europe, 14, *15, 17,* 20, *21,* 24, 25, 28,
 36, 53, 162, 163–164, 165–171
Ewe People, *172, 179, 180*

F

fan motif, *85*
Fante People, *181*
fashions, *83,* 144, *186,* 219, 224, 254,
 258, 259, 263
feather work, 210, 222, 224, *226–227*
felt-making, 129, 130
female role, 56, *76,* 106, *113, 116,* 131,
 175, 177, 178, 192, 193, 194, 200, 228
fenghuang motif, *92, 95*
Ferdowsi, Abo'l-Qasem
 Shahnameh, 135
Ferrero, Pat, 254
Field Museum, Chicago, 46
"fine art," 46, 48–49, 51–52

Finland, *53*
Fisher, Nora, *156–157*
fish motif, *60–61, 178–179,* 217
flags, *181*
flamskväv. see tapestry weaving,
 dove-tail
Flathead People, *241*
flax, 130, *142–143*
floor coverings
 American Indian, *43, 247,* 248
 European, *53*
 North American, *259*
 Western Asian, 130, 131–132, *132,*
 133, 139
floral motif. *see* plant motifs
Flores, Aurelio and Francisco, *230–231*
"folk," 51
folk art and artists, 51–52, 56, 58–59,
 61, *74,* 102, 224–225, 249, 253–254.
 see also urban craftsmen
Fox, Sandi, 45, 58, 253–255, *256–263*
France, *28, 166*
free will, 37
Frost, Edward Sands, *259*
functional art. *see* "decorative" art
funerals. *see* burial cloths; ceremonial
 costumes
furnishings
 African, *177*
 European, *166, 167*
 South and Southeast Asian, *111*
furoshiki, 61, 66
futonji, 57, *61, 63, 74*

G

Gansu Yangshao Neolithic culture, *94*
garden motif, *78, 100–101,* 164
garments. *see also* ceremonial costumes
 African
 Congo, *16,* 17, 23, *23*
 Sub-Saharan, 23, 37, *172, 178, 179,*
 186–187, 188
 American Indian, 234, 237, 240
 Andean, *2, 43, 208,* 211, 212, *214,*
 215, 219, 220–221
 Chinese, *98, 99*
 European, *171*
 Japanese, *15,* 15, *18, 19, 22, 34, 44,*
 48, 50, 68, 69, 70, 71, 72, 73, 76, 77,
 78, 79, 82, 83, 86–87
 Latin American, 224, *225, 228,* 229
 Mediterranean, *148, 149, 151, 155, 158*
 North American, 254, *262*
 South and Southeast Asian, 23,
 23, 40, 51, 109, 110, 113, 114–115, 117,
 124–125

Western Asian, *136, 137–138*
Garuda motif, 107, *123, 125*
Gauchat, Pierre
 Zipper Poster, 17, *17*
geometric motif, 57, 107, 131, 192,
 193, 212, 214, 221, 228, 240–241,
 260–261
Ghana, *172,* 176, *179, 180*
 Kormantine/Saltpond area, *181*
gift exchanges
 African, 175, *177,* 193
 American Indian, 237, *238, 241*
 Andean, 216
 Chinese, 92
 Mediterranean, *157*
 South and Southeast Asian, *119, 122*
gilding, *123–124*
gods. *see* individual religions
gondolas, *161*
good-luck symbols, *60–61, 66–67,* 102
"Gospel Music" (Levine), 18, *18*
Greece, *156–157, 160,* 164
 Aegean Islands, *142–143, 158*
 Crete, *148, 158*
 Ionian Islands, *142–143, 159*
 Epirus, *158*
grid motif, *148, 184, 185, 201, 202,*
 204–205
Guatemala
 Zunil region, *228*
Guaymí People, *226*
"guinea-fowl" motif, *178*
Guy, John, *125*

H

Haiti, *47*
hammocks, *180*
hand motif, *10, 150–151, 152–153, 179,*
 246
hangings
 African
 Congo, *16,* 17, *42, 194, 195,*
 196–197, 198
 Sub-Saharan, *178–179, 182*
 American Indian, *249*
 Chinese, *32, 101*
 Japanese, *65*
 Latin American, *47*
 Mediterranean, 12, *13, 146, 147, 148,*
 154, 159
 South and Southeast Asian, *49, 113,*
 116, 120, 125
 Western Asian, *38, 128, 135, 137, 138*
Han People, *90, 94–95, 96, 97, 98, 99,*
 100–101, 102, 103
Harrison, Benjamin, *257*

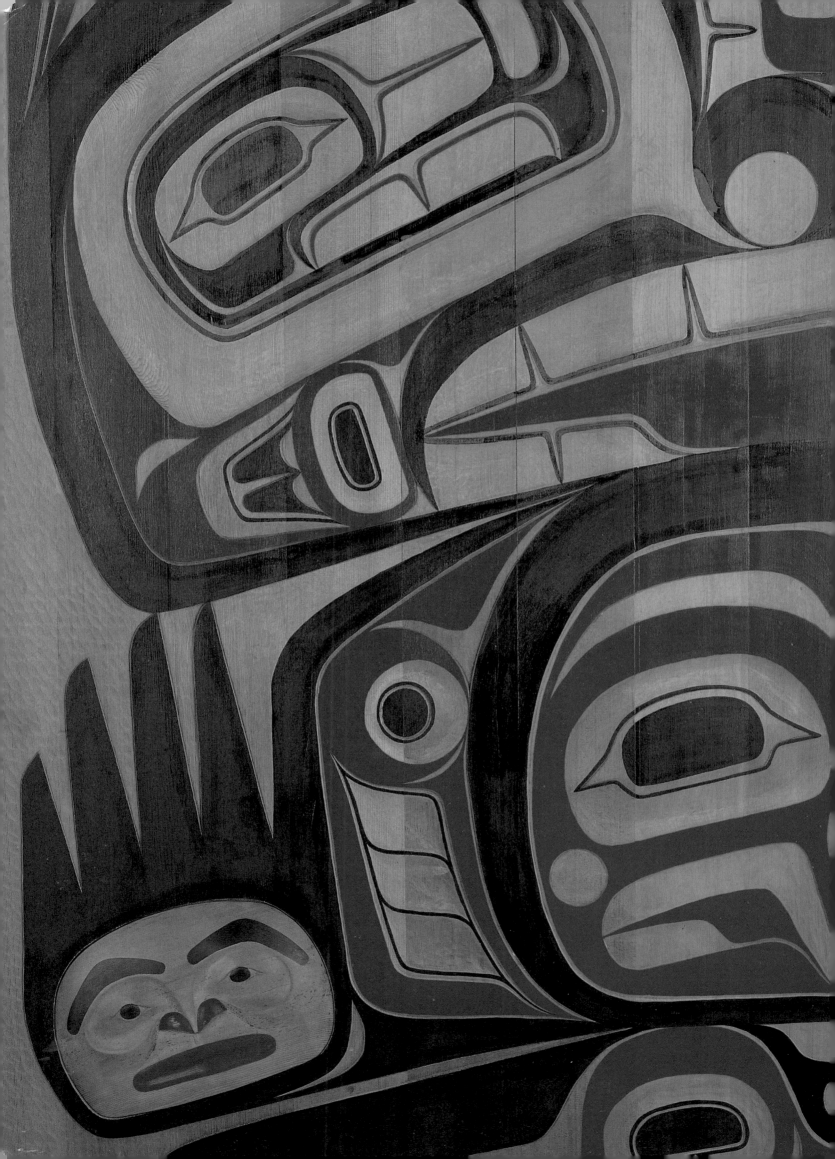